LAIR

RADICAL HOMES AND HIDEOUTS OF MOVIE VILLAINS

3/21

For Jennifer

with virus

admiral !

EDITED BY **CHAD OPPENHEIM** WITH **ANDREA GOLLIN** CONTRIBUTORS **CHAD OPPENHEIM MICHAEL MANN**
SIR CHRISTOPHER FRAYLING JOSEPH ROSA CARLOS FUEYO AMY MURPHY ANDREA GOLLIN
PHILLIP VALYS ARCHITECTURAL ILLUSTRATIONS AND RENDERINGS **CARLOS FUEYO** COVER ILLUSTRATIONS **YONEL HERNÁNDEZ**

INTERVIEWS

INTRODUCTION
CHAD OPPENHEIM

I was seven years old when my father popped a copy of *The Man with the Golden Gun* into the Betamax of our suburban Marlboro, New Jersey, tract home. It was 1978, and it was my first experience with the intriguing life of British Secret Service Agent 007. While I was certainly impressed with the accent and the spiraling car jump across a river, my true fascination was with Scaramanga's lair, carved into the jungle-covered cliffs of a remote island. Not only did this guy have three nipples, a diminutive henchman named Nick Nack, and a beautiful and deadly golden gun, but he had one of the sickest hideouts of all time. My fascination ultimately grew into inspiration; Scaramanga's lair has inspired me in my work as an architect. It was in many ways the seed for this book on the lairs of movie villains.

The influence on my work has been both conscious and subconscious. In the mmonograph *Spirit of Place* about my firm, Oppenheim Architecture, Cornell architecture professor Val K. Warke wrote that there is a resonance between the forms in our work and the work of the late production designer Ken Adam, known especially for the Bond films and *Dr. Strangelove Or: How I Learned to Stop Worrying and Love the Bomb* (1964). Warke wrote: "There are...certain perceivable allusions to films like *Dr. No* with the beachfront house in the Bahamas...There is also a fascination with the mechanical transformation of space. The mechanical wall of Canyon [a residential project in Los Angeles for the movie director Michael Bay], for example, is highly reminiscent of Ken Adam's mechanically morphing Rumpus Room in *Goldfinger*. There are even several cameo appearances of massive fireplaces with floating hoods, like those in many of Adam's Bond sets." He goes on to compare Adam's hallmark circular overhead light and its association with timelessness with that same characteristic in our work, evoked through our emphasis on engaging with the spirits of our sites. Andrea Gollin, my co-editor on the book, puts it another way. She believes that I fell under the spell of these lairs, leaving me with a choice: either become a villain or become an architect; for the sake of mankind, I chose the latter.

There are of course many great examples of villains' lairs, but the criteria for selection was idiosyncratic and personal. The lairs had to be aspirational, which for me meant a place I would want to inhabit. They had to be inspiring from an architectural standpoint, which for me meant they should be predominantly modern architecture, with very few exceptions. They also had to be the lairs of truly evil movie villains, not just your average bad guy. There were some interesting houses I would have loved to include in this book but could not justify because the characters weren't villains, or weren't villainous enough, top among them being Casa Malaparte in *Contempt* (1963), the garage in *Ferris Bueller's Day Off* (1986), and the Sheats-Goldstein house by the late architect John Lautner featured in *The Big Lebowski* (1998). Along those lines, if the lair was exceptional but the film was not particularly strong or influential, it was not included. In essence, the villains' lairs in these pages represent a list of highly personal inspirations. While I hope that people enjoy exploring this book, I welcome input from others as to which lairs they might have included.

I wanted there to be many views in addition to my own represented within these pages. We open with Joseph Rosa's wonderful essay, "Why Do Bad Guys Live In Good Houses?," in which he explores the history of American cinema's association of modern architecture with unsavory behavior and activities. Next, we have been fortunate enough to work with Sir Christopher Frayling, an expert in the work of production designer Ken Adam. His piece, "More Real Than Real: Ken Adam on Production Design," begins with introductory text by Andrea Gollin, who interviewed Frayling about Adam's work and their decades-long friendship, and continues with excerpts from Frayling's interviews with Adam. Our third essay is a wide-ranging conversation between myself and director Michael Mann, moderated by architect Amy Murphy, in which we discuss film villains and architecture.

Next are the fifteen films, which begin with four James Bond films. As this book goes to print, the twenty-fifth Bond film is on the horizon, and I could have easily chosen fifteen lairs from the Bond films alone. Narrowing it down to the four films in these pages was painful but necessary. The selection of films also includes three that feature houses designed by John Lautner, who is also a continual source of inspiration to me.

Lair includes interviews with several production designers, directors, and other film industry professionals. It is fascinating to hear from people like Ralph Eggleston, Mark Digby, David Scheunemann, Roger Christian, Richard Donner, and Gregg Henry. We have also included excerpts from an oral history with John Lautner, whose houses have made appearances as villains' lairs in many movies.

As you explore this book, you will see that we discuss each film, its villain, and its lair. Several films also include an Architects' Commentary section, which grew out of the lively conversations we had in our office as this book developed. We derived so much enjoyment from discussing these spaces, and we had so much to say, that I wanted to share highlights of those discussions in the book. Each selection is lavishly illustrated by strategically selected images from the film that focus primarily on the architecture, and by fantastic images created for the book by Carlos Fueyo of playard studios. Fueyo is a visual effects expert whose dual background in film and architecture has contributed beyond measure. His work allows us to spend time with these spaces in ways that are not available in the film itself. As he puts it, he has created "unseen and unobstructed views of these sets," seasoned with an engaged imagination that delves into the spaces in ways that are often delightful and surprising.

This book has been a true labor of love, and there are countless people to thank. Among them, the entire team at Tra Publishing that worked for months on this book. Ilona Oppenheim, my wife and muse, is not only *Lair's* publisher, but she is the driving force behind it. She grabbed the idea and stopped at nothing to make it happen. Andrea Gollin was a force of nature, developing rich editorial content, editing it, and conducting many of the interviews in these pages. My gratitude also extends to Raúl Lira's diligent and inspired work on this project. He has designed a beautiful and impressive book that is striking in its elegance. Andres Toledo was an essential part of this process in the early stages, helping to vet the movies, conducting research, and refining the concept. Many thanks to others at Tra Publishing who supported this work: Jefferson Quintana on the design side, and on the business side, Rita DelCarmen Martin, Francesca Zobele, and Stephanie Roque. Thanks also to all of the contributors, to the many individuals who graciously gave of their time for interviews, to the helpful staff at the UCLA Center for Oral History Research, and to our legal team at Donaldson + Callif, LLP. Much gratitude to Tra Publishing's valuable consultants, Terry Newell and Andrea Burnett, and to its colleagues at Simon & Schuster for their belief in this project. Finally, I'd like to thank my colleagues at Oppenheim Architecture, and particularly Timothy Archambault and Kevin McMorris, for their important contributions to this project.

WHY DO BAD GUYS LIVE IN GOOD HOUSES?

In recent Hollywood movies, modern domestic architecture has become identified almost exclusively with characters who are evil, unstable, selfish, obsessive, and driven by pleasures of the flesh. Were they still alive, this might thoroughly shock the pioneers of modernism, who envisioned their movement facilitating a healthy, honest, and moral way of life. Nonetheless, while modern architecture in film has for decades raised suspicions of less-than-ideal goings-on, filmmakers of late have raised the bar, choosing modern works as the sites for murder, gangsterism, adultery, and a catalog of other illicit and otherwise unsavory behaviors. Bad guys may no longer wear black, but they do live in white-walled modern homes.

What went wrong? If one believes Tom Wolfe's 1981 critique, *From Bauhaus to Our House*, modern design is simply anathema to the American way of living, and it therefore only makes sense that those who contest and violate American values be associated with it. The reality is actually more complicated, though it is fair to say that Americans have never fully embraced modern architecture for their homes. More to the point, Hollywood films have both reflected and shaped American views about modern domestic design.

Homes inevitably reveal something of their inhabitants' aspirations. Notwithstanding the pioneering legacy of the founding fathers of this nation, most Americans have never had a desire to "start from zero," as members of the Bauhaus suggested, at least not in terms of architecture. Americans have always been motivated to keep up with the Joneses—not to supplant the Joneses' way of life. American domestic architecture, with all of its revival styles, communicates this essential conservatism.

TRADITIONAL ARCHITECTURE AND TRADITIONAL HAPPINESS

To the American public of the 1930s, modern architecture was anything but conservative. In fact, it was a somewhat frightening sign of progress driven by technological and scientific advances. Modern architecture was considered appropriate for the workplace though unsuitable for the middle-class home. Fear of the modern—mirrored both in films and in the press—focused on the negative effects such settings could have on the family. For example, in a 1931 critique of the Aluminaire House, a prototype modern home designed by A. Lawrence Kocher and Albert Frey that was viewed by more than one hundred thousand New Yorkers, Elsie McCormick advised female readers of the *World Telegram* to be wary of the "stern, office-like effect" that would likely drive a husband to seek succor in "fluffier apartments."[1]

The elegant, urbane modernism of so many films of the 1930s—pioneered by such legendary art directors as Cedric Gibbons and Van Nest Polglase—soothed these fears, offering Depression-era audiences escape in sumptuous art deco fantasies. Even still, deco design, itself a far cry from high modernism, never really challenged the supremacy of America's historically based housing styles. In *Reaching for the Moon* (1930), *The Women* (1939), *It's a Wonderful Life* (1946), and countless other films of the period, a husband returns from the office to a happy, traditional home life with wife, children, and sometimes, domestic help. Matrimony, a traditional institution if ever there was one, was appropriately set in a traditional dwelling. Conversely, modern domestic settings—invariably urban apartments—were reserved for youthful singles, the unusually wealthy, "easy women," and terminal bachelors. Once married, even these characters left their modern quarters for more conventional accommodations.

In practice, there was a significant differentiation made between the portrayal of those living in apartments and those living in penthouses. The apartment-dweller was generally young, naïve, ambitious, in a precarious financial situation, and on his or her own for the first time. The penthouse was typically reserved for the wealthy, older, well educated, and unsentimental. The penthouse-dweller lived in the present and looked toward the future with little concern for the past—with the exception of its bearing on his or her social status. It was almost never the home for a married family with children, though a typical storyline had a penthouse-dweller coming to his or her senses, falling in love, and relocating to a more traditional home. *Susan Lenox (Her Fall and Rise)* (1931), *Dark Victory* (1939), and *Christmas in Connecticut* (1945) all feature examples of just this phenomenon.

More than anything else, though, penthouse-dwellers were rendered as eccentrics. This is best typified by Morton DaCosta's *Auntie Mame* (1958), in which the title character, played by Rosalind Russell, alters the decor of her apartment to ward off a nephew's conservative fiancée. At the beginning of the film, Mame's brother dies, leaving his young son Patrick in the care of Mame, his "irresponsible sister." The interior of her penthouse duplex on Manhattan's tony Beekman Place changes throughout the film, reflecting her whimsy. When Patrick—now in college—tells Mame of his plans to marry Gloria Upson, a girl from good conservative stock, Mame goes along with it until she visits the girl's

parents at their home in Darien, Connecticut. There she learns of the Upsons' anti-Semitic views and their dreams of a clubby lifestyle for their daughter. Mame invites them to her place in Manhattan for an intimate dinner party before the wedding and proceeds to transform her duplex into an ultra-modern space filled with Danish design, Calder-like mobiles, and cubist art. Couches in the living room are supported by hydraulic pedestals that allow them to move up and down. Not surprisingly, the decor—coupled with appetizers of grilled rattlesnake and a cast of Mame's odd-ball friends—sends the Upsons and their daughter running. (Patrick ends up marrying Mame's personal secretary.)

Meanwhile, the depiction of the traditional home became ever more entwined with notions of domestic bliss. The 1945 film *The Enchanted Cottage*, starring Robert Young and Dorothy McGuire, illustrated the magical powers that a traditional setting could provide. The film's premise: love found in an enchanted cottage can mend any problem and even render an outcast couple "normal." The cottage in question is an eighteenth-century brick, shingle-roofed structure stuffed with memorabilia, including a coat of arms from the original occupant, an English gentleman. A homely girl, played by McGuire, takes a job as housekeeper and falls for a wealthy young man who was disfigured in World War II and then rejected by his society fiancée. He takes refuge in the cottage, which he had originally rented for his honeymoon. Inevitably, the disfigured man and the homely girl fall in love. While every outsider who sees them notices their flawed appearances, they see only beauty in each other's eyes.

H. C. Potter's 1948 romantic comedy *Mr. Blandings Builds His Dream House* cemented this association between traditional architecture and traditional happiness. Looking to escape the teeming metropolis of New York, Jim and Muriel Blandings (Cary Grant and Myrna Loy) embark on a mission to build their fantasy home in the suburbs of Connecticut. After a series of calamitous miscalculations (the film was remade as *The Money Pit* in 1986), the Blandings do eventually find domestic bliss in the form of a large colonial with a steeply pitched roof. Conversely, in King Vidor's 1949 architectural melodrama *The Fountainhead*, we witness an assortment of self-absorbed ideologues inhabiting a series of supposedly spectacular "modern" homes and apartments. In the end, the architect is triumphant, but the victory is, at best, Pyrrhic.

MODERN ARCHITECTURE AND DASTARDLY DOINGS

By the late 1940s, the technology and optimism that had ushered in modern architecture in the early part of the century had been tainted by a knowledge of the destructive power of modern science and imminent fear of annihilation from the bomb. At the same time, corporate America was busily appropriating modernism—now the "International Style"—for its own needs, stripping it of its ideological content. America faced a housing shortage, but such corporate and military associations mitigated against any wholesale adoption of modern design for the home. Not surprisingly, white-walled residences rarely appeared in films featuring loving couples. *Palm Springs Weekend* (1963) typifies Hollywood's unhappy depiction of modern domestic architecture at the mid-century. In the film, a family weekend house is trashed by teenagers who crash an unsupervised party. Elegant modern furniture is hurled through the air, demolishing a wet bar and much else. Oddly, no one seems too concerned about the destroyed structure. Indeed, the film's main accomplishment lay in reinforcing the equation between a hedonistic and destructive throwaway culture of weekend living and the cool look of modern design. Ironically, Hollywood elites had been cultivating a progressive school of modern architecture since the 1930s; indeed, it was the very homes they had designed for themselves—by such architects as Rudolph Schindler, Richard Neutra, and John Lautner—that were starting to crop up in their own films as the ultimate signs of sin.

If any genre has confirmed the association between dastardly doings and modern design, it has been the action thriller—in particular the James Bond series. In these films, master criminals bent on world domination inhabit remote, precariously sited modern hideaways—in the early films these were most often sets created by production designer Ken Adam and built at Pinewood Studios, outside of London. On occasion, however, the Bond villains did find homes beyond the confines of Pinewood's soundstages and backlot. In *Diamonds Are Forever* (1971), Bond nemesis Ernst Stavro Blofeld commandeers a house of poured-in-place concrete with sweeping views of what is supposedly the Nevada desert. In actuality, it is the 1968 Arthur Elrod House, the *sine qua non* of bachelor pads, designed by John Lautner and located in Palm Springs. Lautner's signature California baroque aesthetic—soaring interior spaces, curving forms, dramatic vistas—is ideally suited for translation to film, and his houses appear with unparalleled regularity in Hollywood productions. In seemingly every case, they play host to less-than-savory characters.

In both Brian De Palma's 1984 erotic thriller, *Body Double,* and Joel and Ethan Coen's 1998 crime comedy, *The Big Lebowski,* innocent men are lured to Lautner houses where they are drugged and framed for crimes they did not commit. In *Body Double,* a naïve, struggling actor is asked by a recent acquaintance to house-sit—the house in question being Lautner's futuristic 1960 Malin House (better known as the Chemosphere) in Hollywood, a saucer-shaped domicile perched on a column over a steep slope. With its 360-degree views of the surrounding landscape, the house drives a byzantine plot in which the hapless actor becomes an addicted voyeur who witnesses the staged killing of a porn actress. In *The Big Lebowski,* the equally hapless Jeff "The Dude" Lebowski (Jeff Bridges), visits loan shark Jackie Treehorn (Ben Gazzara), who has mistaken him for another man with the same last name. Lebowski is summarily drugged while admiring Treehorn's space-age pad—Lautner's 1963 Sheats House, a spectacular poured-concrete structure of triangular forms set in the mountains overlooking Beverly Hills. In both *Body Double* and *The Big Lebowski,* the directors tease their audiences along with their guileless lead characters in games of architectural bait-and-switch. Lautner's striking modern designs are traps—highly seductive sites of crime and deception.

MORALITY VERSUS MODERNISM

In the 1990s, filmmakers continued the tradition of setting dramas in modern dwellings that symbolically signal the unstable, the transitory, and the amoral. In the 1991 film *Sleeping with the Enemy*, Julia Roberts and Patrick Bergin play a married couple (Laura and Martin Burney) living in a flat-roofed, modern beach house. Everything in the home's minimalist environment is precisely placed, from the furnishings to the food in the cabinets. Shortly after the film opens, it is revealed that Martin is an abusive obsessive-compulsive who controls every aspect of Laura's existence, from the people she sees to the aesthetics of their home. This sun-filled house quickly becomes a glass prison, forcing Laura to fake her death and move to another town. In this new location she embraces her own traditional aesthetic sensibility. She rents a cottage, paints it happy colors, and puts up kitschy patterned wallpaper. The kitchen cupboards are a mess. But it's not long before Modern Martin tracks her down, fiendishly plotting to eliminate his erstwhile bride.

In Ang Lee's 1997 film *The Ice Storm*, the morals of the various characters are similarly encoded by the architecture they inhabit. Set in the 1970s, the film juxtaposes two families that live near each other, examining their friendships and relationships. The Hoods live in a traditional house located on a suburban lot with a lawn; the Carvers live in a modern flat-roofed house in a wooded area. Needless to say, the traditional building is home to the more stable family. Moreover, it is the "modern" woman who seduces the "traditional" man—one of the film's central traumas. *The Ice Storm* is set during the Thanksgiving holiday, but only the Hoods sit down together—on their screened-in porch—for the holiday meal.

Both families have problems—Ben Hood (Kevin Kline) is unfaithful and Jim Carver (Jamey Sheridan) is sexually inadequate—but the Hoods' troubles are for the most part normal and reparable. The Carvers, on the other hand, are completely unhinged by the infidelity of matriarch Janey Carver (Sigourney Weaver), father Jim's problems in bed, and the death of their eldest son, who is killed due to a fallen live wire during the titular ice storm. Throughout the film, the Carvers' modern home is framed so that it can be seen in full through the woods. The camera stalks around the surrounding property, giving the impression that it is spying on the inhabitants. Inevitably, the modern house becomes the site of sexual indiscretions on the part of the adults and the children.

But when it comes to manipulation and downright evil, Janey Carver has nothing on Catherine Ames, the middle-aged film-diva-cum-murderess at the heart of Robert Benton's 1998 neo-noir *Twilight*. As portrayed by Susan Sarandon, Ames knows what she wants in life and goes to great lengths to get it, mostly at the expense of others. Not surprisingly, given her nature, Ames has a taste for the modern. Along with her second husband, Jack (Gene Hackman), also a well-known actor, she lives in an opulent art deco residence (the 1929 home designed by legendary MGM art director Cedric Gibbons for himself and his wife, Dolores del Rio). The Ameses' "country" home is Frank Lloyd Wright's 1948 Walker House in Carmel. As the film proceeds, the audience learns that Catherine had masterminded the murder of her first husband—at the Wright house—and that her foul play had been facilitated by Raymond Hope (James Garner), a retired detective now living well beyond his means in John Lautner's 1947 Polin House in the Hollywood Hills. The house is Hope's undoing: even after his role in the sordid backstory is revealed, he refuses to turn himself in—"And give up this house?"—opting instead for a shootout that winds up getting him killed.

The nostalgia for a past domestic ideal has always helped to define the "good" character for the audience. In Curtis Hanson's 1997 film, *L.A. Confidential*, Kim Basinger plays a high-priced call girl—a Veronica Lake look-alike named Lynn Bracken—who lives and works out of a Spanish revival house furnished in glamorous deco style. The central space of the house features a living room and bed area; this is where she conducts her business. Behind Bracken's icy persona, of course, is a warm heart. After falling in love with policeman Bud White (Russell Crowe), she invites him to spend the night and brings him into her true bedroom, which is furnished with a brass bed, floral bedding, and a pillow embroidered with sentimental maxims that reflect her nostalgia for a traditional life.

Conversely, mysterious millionaire Pierce Patchett (David Strathairn), who runs the escort service that pimps Bracken, lives in an austere modern house with a terraced garden situated on a hill near the Griffith Observatory. It's no ordinary modern box—like the Carvers' home in *The Ice Storm*—but Richard Neutra's seminal Lovell Health House (1929), one of the first American houses framed in steel. In the film, the sheer size of the house is a symbol of the owner's wealth, and the modern aesthetic signifies a cool, calculating demeanor that allows Patchett to mediate between the legitimate and corrupt worlds of Hollywood.

No film better illustrates Hollywood's bizarre love/hate relationship with its modern patrimony than the formulaic action picture *Lethal Weapon 2* (1989). Much of Richard Donner's apartheid-era film—which pits Los Angeles detectives Martin Riggs (Mel Gibson) and Roger Murtaugh (Danny Glover) against a South African smuggling ring led by one of the country's racist, murderous diplomats—takes place at what is supposedly the South African Consulate. In actuality it is yet another house by Lautner (the 1962 Garcia House), a unique structure with a bowed concrete ceiling plane and perimeter walls mostly of glass. Elegantly sited on a steep hillside, the house is supported by exposed pillars that stretch to the ground below an exterior deck. These supports become a target for the film's vigilante heroes in a sequence that forms one of the most symbolically loaded images of the modern home in Hollywood history. Stymied from searching the house by the South Africans' claims to diplomatic immunity, Riggs ties a rope to one of the pillars, hitches it to his Dodge pickup, and pulls the house from the hillside—bad guys along with it.

A NEW BREED OF VILLAIN

It was only matter of time before Hollywood and the film industry would start using the modern minimalist vocabulary of steel-frame houses with vast spans of glass and flat roofs to stage dwellings for a new breed of villain—affluent, well-educated, patrician in appearance if not in pedigree, entitled, and well-concealed. In both David Fincher's 2011 *The Girl with the Dragon Tattoo* and Alex Garland's 2014 *Ex Machina*, the villains live in minimalist glass-and-steel framed houses that sit on vast natural landscapes. The models for this iconic typology of house are Philip Johnson's own 1949 Glass House, built in New Canaan, Connecticut, and Ludwig Mies van der Rohe's 1951 Farnsworth House, built in Plano, Illinois. Both are idealized glass homes that allow the landscape to visually unfold into the dwelling. But in these two films, this trope that equates a modern and minimalist architecture with sinister behavior is taken to another level—literally the basement. The arguably easy metaphor of the underground domain—secrecy, deception, darkness— is manipulated to encode a deeper level of criminality and amorality within the modern aesthetic.

In *The Girl with the Dragon Tattoo*—based on the novel by Stieg Larsson—journalist Mikael Blomkvist (Daniel Craig) accepts an invitation from wealthy socialite Henrik Vanger (Christopher Plummer) to investigate the mysterious disappearance, forty years ago, of his grandniece Harriet. Blomkvist moves into the family estate on the island of Hedestad, in Sweden, and the architectural settings assume their roles in the film. The Vanger family home is a grand aristocratic estate, a style of home that is cinematographically synonymous with patrician families. Also on the island is a flat, minimalist, glass-and-steel framed house with idyllic views of the water and surrounding landscape that is owned by Henrik's grandnephew Martin (Stellan Skarsgård). As this psychological crime thriller's narrative thickens, Blomkvist brings in brilliant researcher Lisbeth Salander (Rooney Mara)—a.k.a the girl with the dragon tattoo—who discovers that Martin and his late father Gottfried murdered a series of women between 1947 and 1967. Blomkvist snoops around the glass-and-steel house only to get caught by Martin and brought to the hidden basement of the house, where he is tortured. Intending to kill Blomkvist, Martin spills the beans and brags about all the women that he and his aristocratic father killed, declaring, however, that they never killed his sister Harriet. Blomkvist is fortunately saved by Salander, who then runs Martin off the road and kills him. Later in the film, it is revealed that Harriet was sexually abused by her brother and late father for years and that she killed her abusive father. She is still alive, living in London, and has assumed another family member's identity.

In films like this, the modern house is the site of the criminal actions and is often contrasted with the stalwart architectural character of traditional settings. Yet in *The Girl with the Dragon Tattoo*, evil transcends architectural clichés; it is the aristocratic estate that incubated the criminal behavior of the father and son, which are realized in the modern house. The elegant steel-and-glass house in the film is actually John Robert Nilsson's 2009 Villa Överby, located in Stockholm, Sweden. Nilsson's house is a slab-on-grade and does not have a basement—the basement was a set created for the film.

If Martin Vanger is an example of an entitled aristocrat, a patrician social recluse who must, at any cost, carry on the family's traditions and keep its secrets, then Nathan Bateman (Oscar Isaac) in Alex Garland's 2014 *Ex Machina*, while also extremely wealthy, represents another facet of the economic and social spectrum. Bateman is a self-made tech tycoon and über-hip genius. Bateman's wilderness retreat is so vast it takes more than two hours to traverse by helicopter—and that's the only way to get to it. Remotely located in Alaska, the house appears at first to be a bunker situated between two large boulders, with no windows and just a door. However, inside, it reveals itself as a spacious, steel-framed house with large spans of glass that visually frame the vast views of majestic mountains and streams—all of which Bateman owns. This secluded, transparent retreat also has a basement, one that in this scenario serves as Bateman's secret research facility. The house plays a major role in the film, and it is the minimalist aesthetic of the house in contrast to its natural surroundings that offers the first clue as to what Bateman is working on in his basement—a female humanoid robot. He's exploring the limits of artificial intelligence.

At his tech company, Bateman creates an office contest in which the winner gets to spend a week with him at his extravagant, secluded estate. The winning staff member, a coder named Caleb (Domhnall Gleeson), has no idea that he has been deliberately selected to help Bateman test his newest creation: the robot Ava (Alicia Vikander). Once Caleb arrives, Bateman manipulates him into thinking they are new best friends and reveals that he wants Caleb to determine if Ava's artificial intelligence is sophisticated enough for her to think for herself and reject her servile role. Ava lives in a glass-enclosed apartment in the basement/research facility. Little do Bateman and Caleb know that Ava's intelligence, artificial or otherwise, is superior to theirs. She starts manipulating Caleb to feel emotions for her and help her extract herself from the confines of the basement and Bateman's clutches. As Caleb's weeklong visit draws to a close, a helicopter is scheduled to pick him up; this is Ava's last chance to get away. She kills her creator and captor, Bateman, refurbishes herself with parts from earlier androids, and leaves Caleb behind, locked up in the research facility. Ava then ascends from the clinical environment of the basement to the equally confining ground-floor level of the minimalist house and finally makes her exit into the expansive, majestic outdoors. She boards the helicopter to ride off into the outside world, a world presumably more suited to her newly fortified brand of humanity.

For better or worse, filmmakers can't stay away from modern buildings. By day they shoot their films in them, and by night they call them home. Perhaps there's something in Hollywood's collective psyche that demands to be understood as transgressive, dangerous, wild, even criminal—and it is this that has led to the unfortunate stereotyping

MORE REAL THAN REAL: KEN ADAM ON PRODUCTION DESIGN

BY SIR CHRISTOPHER FRAYLING
INTRODUCTORY TEXT BY ANDREA GOLLIN

For the James Bond film *Goldfinger* (1956), production designer Ken Adam (1921–2016) created a version of Fort Knox. The interior was fully imagined—Adam, of course, wasn't allowed in the building. That did not pose a problem, as he wasn't particularly interested in the reality. He found the interiors of gold vaults to be boring, and for *Goldfinger* he wanted something grand: a stylized "cathedral of gold, almost forty feet high—completely impractical; gold is too heavy for that. But it worked," he said.[1] In fact, it worked so well that many people believed they were seeing the real Fort Knox onscreen. And they protested: Why was a British film unit granted access to film inside Fort Knox when the president of the United States was not permitted to enter?

Speaking of the president, when Ronald Reagan took office, he asked to be shown the War Room underneath the Pentagon, expecting to see the space made famous in Stanley Kubrick's film *Dr. Strangelove Or: How I Learned to Stop Worrying and Love the Bomb* (1964). Wrong again, or Adam'd again, as that infamous room was also entirely imagined and built on a soundstage thousands of miles from the Pentagon, at Shepperton Studios in England. A similar story can be told of the Adam-designed interior for the grand English manor in the mystery thriller *Sleuth* (1972), which many thought was real.

These are three examples of many, and of them, Reagan seems the most surprising—after all, he had been a movie star, a man who knew about the silver screen's sleights of hand. But even he thought there was a triangular room deep within the bowels of the Pentagon with a circular table large enough to accommodate dozens of squabbling politicians. "Of course there is nothing like it, but as Ken would say, 'There is now,'" said cultural historian Sir Christopher Frayling, author of two books on Adam's work.

Adam commented on this ability of his in an interview with Frayling: "It comes back to my feelings about stylization. Being somewhat theatrical, I think I can create a reality that people accept, and people *have* accepted it." To which Frayling replied, "It's more real than real."[2]

Frayling generously granted permission to excerpt selections from his extensive interviews with Adam for *Lair*, and he was equally generous in sharing his thoughts about Adam's life and work. He is adamant about the significance of Adam's work, and especially what Adam accomplished with the Bond films. "People still underrate the Bonds. They think of them as fantasies and not serious. I completely reject that. There are deep things going on in the Bond films. They are a lot more serious than people realize," he said.

While he is best known for his work on *Dr. Strangelove* and on seven of the Bond films, Adam had a prolific and varied career in which he worked on at least eighty-nine projects, seventy-five of which were realized, according to Frayling—and many of those projects included villains' lairs that he masterfully designed. He won two Oscars, for *Barry Lyndon* (1975) and *The Madness of King George* (1994). Some of his other films include *Chitty Chitty Bang Bang* (1968), *Goodbye, Mr. Chips* (1969), *Agnes of God* (1985), *Crimes of the Heart* (1986), *The Freshman* (1990), and *Addams Family Values* (1993).

Adam's influence on the film industry has been profound, and many architects (including *Lair* editor Chad Oppenheim) routinely cite him as a major source of inspiration. Generations of moviegoers have gladly entered the worlds he's created. Steven Spielberg proclaimed the War Room to be the best set ever designed. Museum exhibitions and books have celebrated his work, and he was the first production designer to be knighted, in 2003. As Frayling said in a speech when Adam received an honorary doctorate from the Royal College of Art in 1995, "The man himself is far too modest and sensible to admit it, but he is a key contributor to twentieth-century visual culture and a very influential one. His trademark as a designer has always been a form of architectural stylization that has been called 'theatrical realism' or 'hyperreality by design.' He has even been called 'the Frank Lloyd Wright of décor noir.'"[3]

Adam was born Klaus Hugo Adam to a wealthy Jewish family in Berlin; his family fled to England from Nazi Germany in the mid-1930s. His father, who had been a World War I hero and then a successful merchant, died soon after the move. Ken knew early on that he wanted to work in film and trained as an architect with that intention before serving as a fighter pilot in the British Royal Air Force during World War II. He began working in the movie industry after the war.

Frayling interviewed Adam for his books *Ken Adam: The Art of Production Design* and *Ken Adam Designs the Movies: James Bond and Beyond*, the second of which was co-authored by Adam. He is an admirer and a champion of Adam's work, but also an interpreter of it. He theorizes that there is a direct correlation between Adam's childhood as someone whose

family escaped Nazi Germany at great cost, and his career, which centered largely on his ability in film after film to design astonishingly effective villains' lairs, or what Frayling alternately refers to as Führerbunkers and "machines for tyrants to live in."

As he put it:
> Underground, concrete, low ceilings, claustrophobia—surrounded on all sides by the devastation unleashed by the Third Reich...Later in Adam's career, these bunkers will be joined by intimidating corporate boardrooms where global organizations with scary Orwellian names decide how to hold democratically elected governments for ransom. And the world outside will come to resemble an upmarket tourist brochure rather than a bomb site: but not far behind the façade there are those Führerbunkers where mad masterminds play games with weapons of mass destruction, using elaborate gadgets disguised as consumer goodies. The swimming pool has sharks in it. The aquarium is where minnows pretend to be whales.[4]

Frayling came to know Adam very well over the course of decades of what began as a professional relationship and developed into a close friendship. With time, as he became increasingly familiar with Adam's work and life, and as the two collaborated on multiple projects, Frayling began to feel that there was more to Adam's fantastical villains' lairs than was readily apparent. "I became fascinated by the relationship between his biography and the kind of work he became famous for," Frayling said. "I thought there *must* be some connection between all of that and his most fantastic sets. Megalomaniacs who want to rule the world from a secret location. I kept asking Ken, 'Is there any deep connection between your biography and the fact that you've spent so much of your career designing what are essentially Führerbunkers?' The combination, in so much of his work, of a kitschy antiquity and a high-tech laboratory is also exactly like the Third Reich, the combination of antiquity and industrial modernity. He would say, 'It is all tongue-in-cheek; you are taking it all too seriously.' I said, 'It is a huge coincidence, Ken, that someone who had that experience ends up designing Führerbunkers.' I am convinced that at a deep level he was getting it out of his system. Even with his early films—he was designing bunkers long before *Strangelove* and Bond. So this goes very deep."

Adam typically dismissed these suggestions as unfounded. Of his work on the Bond films, he said, "I tried to give the villains' lairs a menacing look to them, but always slightly tongue-in-cheek. People have criticized me for designing enormous places for Bond villains, but they were megalomaniacs. So I built them in reinforced concrete and then put priceless paintings and antique furniture in them. I mixed it all up, and tried to have a sense of humor."[5]

Yet, he did speak about a lifelong anxiety and restlessness, which he attributed to his past. In one exchange in their interviews, Frayling asked Adam about his childhood and the possible connection, and Adam responded: "I have suffered all my life from anxieties and that certainly must go back to something. Obviously, I wasn't that affected as a child by the Nazis, but when I saw the effect they had...Yes, without a doubt. And the death of my father. Obviously, I don't like to talk about it, Christopher, but it affected me seriously. And the war was not without anxiety. So all that took its toll."[6]

The text that follows is excerpted from Frayling's interviews with Adam, which took place primarily in 2003 and appeared in *Ken Adam: The Art of Production Design. Lair* features four films on which Adam served as production designer: *Dr. Strangelove Or: How I Learned to Stop Worrying and Love the Bomb* (1964), *You Only Live Twice* (1967), *Diamonds Are Forever* (1971), and *The Spy Who Loved Me* (1977). Three of those films are discussed here.

PRODUCTION DESIGN

CF **Christopher Frayling: In August 1956, you wrote an article for *Films & Filming* magazine... and it already contained your thesis that the point of production design is to create an idea of a place rather than a real place. "When designing an apparently realistic background," you say, "I depart in some way or another from reality"...You also say that you prefer to work for directors who give you "the opportunity to be creative and less reproductive"...long before Bond and *Dr. Strangelove*, you already had a very coherent idea...of what a production designer's role should be...You say you find it boring to copy reality, so your job is to create a different kind of reality...**

KA Ken Adam: Well, at this time I decided to liberate myself from my inhibitions and the rigidity of my architectural studies. I sketched more freely and in less detail with powerful strokes...I had a good grounding in architecture, design, and composition. Drawing with

a hard pencil and a T-square certainly appealed to my pedantic sense, and these beautiful drawings, my early drawings, were a kind of self-defense, really. I was playing safe. I was inhibited. I was afraid to let go and express myself. I would usually start by drawing plans and elevations for my set designs. The drawings were certainly precise but they lacked character and atmosphere...with the help of felt pens—which had recently been invented—I changed my drawing technique completely. My designs became much bolder and more expressive...I used broader strokes and eliminated unnecessary details. As a result, my sketches became stronger....

CF **Ken, obviously, the duties of a production designer vary...but how would you define the role...**

KA If you are asking me how to succeed as a production designer, I always say there are three requirements. The first requirement is talent and imagination. Secondly, you need luck. And the third requirement is the ability to assess and cope with personalities such as the director's, the ability to communicate with people, and the courage of your convictions. I'd say those are the essential qualities....

CF **But where the Bond films are concerned, you thrive on the larger scale. You love big-budget mainstream cinema.**

KA I did! At that time, I took up the challenge and wasn't neurotic about it because I felt I could deal with it. I also felt, as a designer, that I could design anything. I had a lot of confidence in myself. What also happened was that we were getting less input from the [Ian] Fleming books and the producers relied more and more on the spectacle value of the films. Running out of Fleming stories made the designs that much more important. So they gave me a reasonably free hand, and I exploited it.

DR. STRANGELOVE OR: HOW I LEARNED TO STOP WORRYING AND LOVE THE BOMB (1964)

CF **Let's talk about the War Room. It's probably the most famous set you ever designed. Steven Spielberg once called it the best set in the history of film. It's got so many different elements: the maps on the slanted wall, the lights that give you strategic information about the bombers, the shiny black floor and its reflections, the circular table covered in baize, the circular light ring above it that illuminates the actors within this vast, cavernous bunker. It's partly a poker game, partly a strategic center, partly a nuclear bunker. Talk us through all that.**

KA ...I came up first with an idea for a two-level set with a gallery around the top, and Stanley liked it very much. So I thought I was in business. I already had people in pre-pre-production working on the set when he suddenly asked, "What am I going to do with the extra level?"...He was right, of course, because I never thought about what they'd do with a second level. I thought Stanley would come up with an idea. I remember arriving at Shepperton and walking in these beautiful gardens to calm down—they didn't have tranquilizers in those days—and when I got back to my office I started scribbling again! Stanley must have sensed that I was pretty demoralized. He came into my little office and was standing behind me while I was doodling some shapes...out of my scribbles came this leaning triangular shape with slanting walls. Stanley stopped me and said, "Hold on, isn't the triangle the strongest geometric form?" I said, "I think so, yes." He said, "If we were going ahead with it, what would I build it out of?" I suggested reinforced concrete, and he said, "Like a gigantic bomb shelter?" So that's how the idea was born. And you know, I always had this thing about having a circle somewhere. So I designed the circular table...You'll find a circle in all my designs somewhere. It was Stanley's idea that the War Room would be like a poker game, and he was fascinated by the light ring. He thought he could light the whole scene with that light ring. It resulted in our spending hours in my Shepperton office or in his flat, experimenting at nighttime....

CF **What's very clever about the War Room is that it's a cavernous space, but the light ring makes it feel claustrophobic; it pushes the ceiling down and you feel cramped.**

KA Yes. It's funny you should mention that, Christopher, because—and it's never happened to me before or since on any other set—as I was constructing the set, it was my idea to come up with this shiny black floor and these gigantic inclined maps. And I was feeling claustrophobic too! Which was the right element, because the actors felt that strange atmosphere. That's why I think it was my most successful set, because everybody became part of the set...

CF How did you begin imagining a War Room...where did you start?

KA I had some stills of NORAD, the North American Air Defense...But it wasn't at all interesting. It was less interesting than space control, mission control. So I said it was no good. So I came up with these gigantic maps. The problem was how to create them. We drew them out on an imperial-sized drawing board and, because we had the technology for photographic enlargements, blew them up to this enormous size...There were a lot of problems, but somehow, we always managed to overcome them. The overall effect of the War Room was so real that people in the highest places tried looking for it. I later learned from reliable sources that when Ronald Reagan moved to the White House, he asked his chief of staff to show him the War Room....

CF ...You're an intuitive person who works from the gut. But your description of Stanley is the absolute opposite: someone who is completely rational, who understands the technicalities, who constantly asks "why?" and takes things to pieces to see how they work...but the chemistry worked.

KA But it's very destructive, because Stanley had that incredible brain...and he reminded me of a computer. He had to permutate through every possible solution, and he had to find out what makes you tick.

CF And find out everything for himself.

KA Yes. We've talked about intuition, but Stanley would not accept that. He'd ask where it came from. He was questioning me all the time, and I can't justify every line I draw...

CF I think the seeds of future conflict were already apparent. By the end of *Dr. Strangelove*, you must have been completely worn out.

KA I was, and I said, "Never again." I thought it was a fantastic picture and my relationship with Stanley was incredible, but I thought, "Life is too short."

However, Adam did go on to work with Kubrick on the film Barry Lyndon *(1975). That experience proved so stressful that Adam had a nervous breakdown during the filming. As Adam told Frayling, "One can never put the blame on someone else because you are your own person and you can make your own decisions. But I felt incapable. For the first time in my life, I felt incapable of confronting the problems and demands of a film. I became so neurotic that I bore all of Stanley's crazy decisions on my own shoulders." Adam wound up in a clinic under psychiatric care. He described feeling "completely drained, as if all my skills and experiences had been wiped out." Perhaps ironically, it was getting back to work that restored Adam's faith in himself. As he said, "eventually there was an explosion of creativity within myself, and I went to town on films like* The Spy Who Loved Me." *Despite the stress of working with Kubrick, the two remained close. While Adam declared that he "would never— ever—work with him again," they did work together in a fashion one last time.*

CF You did in fact work with Stanley Kubrick one more time, but only...for one day. It was on *The Spy Who Loved Me*.

KA I always kept that secret.

CF Now, Ken, it can be told.

KA The first time I ever mentioned this was in a tribute to Stanley at the Director's Guild in Hollywood two years ago, and that's because he always felt that those gigantic Bond sets were never properly lit. You can't really blame the cameraman for that...On *The Spy Who Loved Me,* we had a brilliant cameraman called Claude Renoir, grandson of the painter Pierre-Auguste Renoir, but he was nervous because we had this so-called supertanker with three nuclear submarines inside...So I rang Stanley and I said, "I've got this gigantic set. We built a stage for it at Pinewood and I've got to help Claude as much as I can with lighting it. You're a friend and you owe me something so..." He said, "Ken, come on. You can ask me anything. But can you imagine me arriving at Pinewood? Everybody would know." He couldn't do it. So I said, "We could do it on a Sunday when there's nobody about. I swear, nobody would know you'd been here." After a lot of talking and soul searching, he said he'd do it. He came to Pinewood with me on a Sunday morning, and we crawled over the empty set for about four hours.

CF Was it helpful?

KA Yes, he was helpful. But Stanley said, "This must remain our secret."

YOU ONLY LIVE TWICE (1967)

KA On... *You Only Live Twice*, when I designed the interior of the volcano, everyone in the film industry said I was crazy. They told me I'd never find a cameraman...capable of lighting a set 460 feet in diameter and 120 feet high. I said, "I think I will."...In hindsight it took a lot of courage, or perhaps foolhardiness, but once I had an idea, and I was convinced it was the right thing to do...I had to go ahead with it.

CF It's also scary because of the responsibility.

KA It's enormous....

CF From *You Only Live Twice* onwards, I imagine they'd send you an outline and then you'd go location hunting together, find new gadgets, new special effects, new spectacular sequences...And then the script would be redrafted around your design. Is that roughly what happened?

KA Not entirely, but almost like that...I'd get an outline or the first draft of a script. Then it was a question of going round the world trying to find the most exotic locations. Once we found something that seemed to fit into the idea, then the script was adapted to suit what we found on location, or what I consequently came up with in my designs. But the location hunt came first...We covered half the globe looking for exciting locations...We had quite a lot of adventures in South America and Guatemala and so on...anything that was slightly dangerous and unique-looking, I wanted to see. Then Cubby [Albert Broccoli, the producer] would never let me go by myself. I'd say, "Cubby, let me go on a small plane and find this jungle village." But he would always want to come along, and sometimes it became very dangerous...

CF In 1966, you fly to Japan to prepare for *You Only Live Twice*. The budget is really big now, and presumably you are location-hunting for a castle with a poison garden, which was in the original novel. Instead you wind up with a volcano and a missile base inside it.

KA Well, it was a desperate situation...In three weeks we covered nearly two-thirds of the country. We flew about seven hours every day in these damn helicopters and landed wherever was possible, but we didn't find a thing. We decided that Ian Fleming had either never been to Japan or had not spent too much time there, because the castles were nothing like our Western idea of castles...Everyone was getting desperate...I'll never forget...We flew over this incredible volcanic area in which there must have been six or seven extinct volcanoes next to each other. It looks like the surface of Mars or the Moon...I can't remember whether it was me...but somebody said, "Wouldn't it be interesting if our villain has his headquarters underneath one of those craters?" That was the first major breakthrough. I thought it was an interesting idea, but the crater was gigantic, even if we scaled it down...I did some thumbnail sketches...and he [Broccoli] said, "That's quite good. I wonder how much it's going to cost?" I said, "I have no idea." He said, "If I give you a million dollars, will you do it?" And I said, "I'll do it."

CF That's much more than the entire budget of *Dr. No.*

KA Yes, and that's where my worries started. I said I could do it—one of those bravado things— but I didn't know how...I had to fly back post-haste—in those days it was a long journey from Tokyo to London—to start designing and building this damn volcano...I wasn't irresponsible because a) I had a very good team with me, and b) we decided this was no longer a traditional film set, because we couldn't find a big enough stage to put it in. We would have to build it on the lot, and we'd need a firm of structural engineers to advise us [on] what is, and what is not, feasible. So I went through the normal procedure. I did a more elaborate design with perspective and inclined surfaces, and the art department made a model. Then we built a bigger model and gathered the producers, the director, the cameraman, the writer—everybody—around it to come up with ideas, like the monorail and the helicopter that goes into the crater. That nearly gave me a heart attack, because when we were shooting on location in Japan, we saw that bloody helicopter disappear below the rim of the volcano, and it didn't appear again for nearly five minutes. What had happened was that the pilot had encountered down currents and had a hell of a job to get out of them, because the helicopter was so bloody light and underpowered. And then this damn

helicopter had to fly into my set—which was basically an interior set—through a sixty-foot hole 120 feet up. Nobody knew what kind of current he was going to encounter once he got into an enclosed space. So I had a few kittens. I had to see a skin specialist, because I developed eczema, and it was the first time I went on Valium.

CF I'm not surprised. [You] had to build—against the clock—a volcano forty meters high with a diameter of 135 meters topped with a sliding artificial lake. Plus a mobile heliport and a thirty-three-meter space rocket. Somebody said about the set, "Everyone believed the dimensions were in feet. But Ken thought in meters!"...In the climactic scene, you needed about four hundred stuntmen to abseil into the crater on ropes, with lots of movement on different levels and this bloody great missile in the middle of it.

KA The main problem...was that all the experts said I'd never find a cameraman to light it. But I worked with Freddie Young, one of the greatest cameramen in this country...Of course, there were other technical problems...This sixty-foot diameter artificial lake had to slide open, but I had designed it at a slant because I wanted them to see the full circle. So they had to calculate the stresses involved. They kept saying to me, "We'd know how to deal with the Empire State Building. but this is a new experience for us too." I'll never forget, Christopher, when we tried to open the lake for the first time before shooting. It was one of the most terrifying moments of my life, even considering my experiences in the Second World War. It was held by a winch down below with a steel cable. Suddenly, as we all stood around watching the lake open, there was a sound like a bomb exploding; an enormous cracking noise. I nearly fainted. We thought the whole thing was going to crash. But this time we had used seven hundred tonnes of structural steel, so you can imagine. We stopped. Nothing else happened besides the enormous exploding sound, but we had to investigate before we did anything else. Somebody had left a block and tackle on the rail, and the steel wheels of the lake had crushed it and made that horrendous noise. Fortunately, it wasn't serious. But it could have been.

CF In the film, there is a famous cut from real water to the glass water of your artificial lake. Was that shot in Japan or Pinewood [Studios in England]?

KA Both.

CF So Bond and the girl look over the ridge of the volcano in Japan, and then the cut from real water to your artificial lake was shot in Pinewood?

KA Yes.

CF That's clever, because it could have looked very hokey.

KA Yes, it's very well done. Also, I had to create a perspective mountain along the edge of the crater. Otherwise, when they tried to shoot from the set down below, there would have just been an opening and no background. It would have looked phony. That all worked pretty well, and so did the heliport that I had traveling on rails...The pressure of knowing that the film would be on release in five months' time was immense. I'm the designer, but they are the people who had to build it, working night and day. The plasterers had to work 120 feet up on an incline to cover the structure with fiberglass...

CF ...There were no preexisting models to work from. You had at least some reference points for the designs you'd done up to now, but this was new. It was the most expensive freestanding set in the recorded history of cinema.

KA Afterwards some people said we could have done it in model form. And yes, I suppose I could. But we could not have had four hundred stuntmen abseiling down a model... the fact that it was real added an enormous amount to the tension. Two hundred and fifty craftsmen worked twelve-hour shifts every day of the week from May until 28 October 1966. The next day a photograph of the volcano appeared in nearly every newspaper in the world.

THE SPY WHO LOVED ME (1977)

Adam took a break from the Bond films between 1971 and 1976, in part due to the nervous breakdown he suffered while working on Barry Lyndon. The Spy Who Loved Me *was his comeback, and of the later Bond films, it is considered Adam's masterpiece. As Frayling and Adam discussed the film, the conversation quickly turned to the design of Atlantis.*

KA I felt it was about time to start experimenting with curved surfaces instead of my usual linear designs. That happened to some extent because I'd been looking for exteriors in Sardinia, and I had found some incredible architecture by a French architect called [Jacques] Couëlle. He designed the most incredible private houses and other buildings— like the hotel Cala di Volpe, where we were staying—to fit rock formations in the landscape. So I experimented with curves and sculptural forms, and that's how the underwater structure of 'Atlantis' was conceived. Cubby had also heard of an underwater structure that was built off the coast of Okinawa and supposedly rose out of the water.

CF **The Floating City.**

KA Yes, so we flew to Okinawa. But this Floating City didn't rise out of the water at all; it was permanently on the water. It looked like a giant oil rig. So I came back to Pinewood and spent a week trying to make it work somehow, because we'd spent so much time traveling there, but whatever I did didn't somehow work. So then I came up with this original structure...

CF **It's extraordinary. It looks like a huge metal spider coming out of the water. And it incorporates a helicopter pad, shark pool, [villain Karl] Stromberg's living quarters, and a control room.**

KA But of course, the question was: How are we going to build the exterior? I knew we couldn't build it for real, so we built a very large model. I called a brilliant visual-effects man over from Hollywood, Alan Maley...He said, "The model is no problem." We shot the model in Sardinia and I built part of a full-sized leg in the actual sea off the Costa Smeralda, which covered just the shot of the speedboat arriving. Alan...invented the sequence where the helicopter takes off inside the dome. We shot it on an empty stage at Pinewood, and Alan did the rest with a combination of painted mattes. I had a lot of fun with the interiors, like Stromberg's circular, two-level apartment...I was experimenting. I used antique furniture and lamps for the lower part and the most modern lamps and settees available for the upstairs part. It was a difficult set for the plasterers to build at Pinewood, because it was curve upon curve...Then I decided for the first time to stick my neck out and design *against* the exterior, which was Stromberg's dining room. I treated it in a linear way as a very long sort of Renaissance...

CF **Baronial hall, or ducal palace perhaps.**

KA Yes, Italian: a palazzo. I designed this refectory table that was over sixty feet in length. It was beautifully done...I had this wonderful girl, Gill Noyes, whom I met at Covent Garden when I did the opera. She painted a number of tapestries based on Andrea Mantegna, Carpaccio, Piero della Francesca...And I had the *Birth of Venus* by Botticelli, behind which Stromberg watched a shark eat his secretary!

CF **It's a classic Ken Adam design. There are bare walls and huge antique objects, but press a button and there's nastiness going on behind.**

KA The idea of the tapestries was, how am I going to show the audience that we're underwater? So the idea was to have the tapestries rising up so you see you're underwater, and it works...

CF **[Comments on the relationship with director Lewis Gilbert] The chemistry worked.**

KA I think it was also...like an explosion after the breakdown I'd experienced just before. It was like releasing myself from all those inhibitions, and once I started letting myself go, I kept on letting myself go. And I think it helped the creative process. It was almost like I couldn't go wrong. The only problem I had was looking at this damn structure in Okinawa and trying to make it work as Atlantis. But as soon as I threw those sketches away and came up with an original design, I had no problems.

COMMON GROUND: TALKING ABOUT ARCHITECTURE, FILM, AND VILLAINS

CHAD OPPENHEIM AND
MICHAEL MANN IN CONVERSATION,
MODERATED BY AMY MURPHY

Chad Oppenheim, architect and *Lair* editor, learned first-hand about the critical role of place in Michael Mann's films when Mann shot part of his 2006 movie, *Miami Vice*, in Villa Allegra (2003), the Miami Beach residence that Oppenheim designed and where he lives with his family. But long before they met, Mann's evocation of place and emphasis on architecture in his work for television and film had strongly impacted Oppenheim. In the conversation that follows, Oppenheim recounts how his move to Miami was influenced by the television series *Miami Vice* (1984), which Mann executive produced. Skip ahead several years, and as *Lair* evolved, Mann came to mind—after all, who better to speak to about the habitats of villains in movies than a director, screenwriter, and producer who has repeatedly explored the criminal world in his work, and who speaks of becoming "the architect for these villains." The two met in Mann's Los Angeles office for a wide-ranging conversation about architecture and film, the types of habitats that villains (in film and in life) gravitate toward, Mann's experiences working with villains (in film and in life), their thoughts about their early influences, and more. The conversation was moderated by Amy Murphy, an associate professor at the University of Southern California's School of Architecture, whose written scholarship focuses on the relationship between cinema and the urban experience.

AM Amy Murphy: You two met through the *Miami Vice* movie. Michael, how did you choose Chad's house? What did you think about the space?

MM Michael Mann: A place needs to resonate with what will happen there. To me, the physical environment, or the house, has a function. It's going to be an expression of something—of character, or an ending, or a day in a mall, or where you want something to be. It's not just an arbitrary, "Oh, this is nice."

AM Right, so it's giving the viewers information?

MM Totally. It's the same as wardrobe. So it usually comes from character analysis, or scene analysis. The scene we did at Chad's house, for example.

CO Chad Oppenheim: It was a killing, but you only saw the remnants of it, like blood on the floor. I remember, since we were there at the filming, that Michael was pouring the blood. We were wondering whether it was ever going to come out.

AM I love the scene where you just have the guy's arm going into the refrigerator with a glove on, and you get the whole picture. I don't need to see more.

MM Yes. There is this ideal family setting, and this horrendous invasion has happened, and we're in the banal part of the information. We're not at the kicking in of the door. The guy's looking for a drink, a banana, or something in the fridge.

CO For me it was so great to have this happen, because I grew up in New Jersey, and I used to watch *Miami Vice* with my father every Friday night. The music would come on, and I would get so excited. Look at this incredible world that I knew nothing about. My experiences of Florida were Disney World and my grandmother's old-age place in West Palm Beach. And here was this incredibly sexy environment. When Michael called, it was like, "Oh my God, this is crazy!" I actually moved to Miami because of the picture you captured. For me, it was a real full circle to connect on that film. It was amazing.

AM So Chad's house was the perfect scene for a killing. Going back to your early films, Michael, can you comment on the architecture? Why have you always woven it in so tightly?

MM When you write and direct, there is this sense that I *am* this character, and I am also that character, and I am also the third character, and I am also living within the collision through two hours that I've choreographed of *all* these characters. So then you have many "the following happens." Where does this character live? Well, if I'm this guy, what appeals to me? Where do *I* want to live if I'm this character? Then another part of my brain is going, Well, where do I want this character to want to live? But then, how are the places where all my characters want to spend time and want to live, how do I get the most interesting collision of all of those? Or the most interesting complementariness? And then how does the totality of that orchestrate in the timeframe of a movie? So when I'm imagining these places, I physically have these images on four-by-eight boards. They go from Scene One to the end of the movie, so I'm able to be in a room and walk through every place we're going to go. But it starts with my character, particularly if we're talking about an antagonist. Where does my character want to be? And when I bring the audience there, it's an externalization of something happening within *him*, but it is the something happening with him that I *want* it to be.

AM One thing that's interesting about your work is that a lot of people would make more of a contrast between traditional architecture and modern architecture. You seem to really enjoy the full spectrum of modern architecture. Even your domestic spaces for families, which is rare, happen in more modern architecture. Usually, they throw them in the single-family house out in the suburbs or something like that. You seem to have a fascination with modern architecture in your work. What do you think are the roots of that?

MM I grew up in inner-city Chicago, so I had an appreciation for the rise of modern architecture. For the Institute of Design, Bauhaus architecture, Frank Lloyd Wright, Mies van der Rohe, and why that works. And I had an uncle who was *very*, very interested in architecture, who took my brother and me around when we were young to tour all the Louis Sullivan buildings and all that stuff, when there was a bit more of it around. They've been preserved, but there was a bit more around when I was a kid. We lived in a very pedestrian, small apartment when I was growing up, so I was always looking outward. I was *alive* to it, let me put it that way. But it really comes down to, where do these characters live?

AM Chad, how about you? How did your interest in film develop? Where did the idea for this book come from?

CO Growing up watching James Bond films was the root of the idea for this book on movie villains and where they live. I think it was really *The Man with the Golden Gun*. Scaramanga had this lair, which was in Thailand in these rock formations, these islands. That thing just blew my mind. I mean, besides him having three nipples, he had this insane, incredible place. The James Bond films really inspired me. Others, in particular, were *Diamonds Are Forever* with the John Lautner house and *The Spy Who Loved Me*—all these incredible fantasy places. They just got me very excited. I think what really inspired me was the relationship to nature. So, for instance, in *The Man with the Golden Gun*, it was this house embedded into mountains. In *The Spy Who Loved Me*, it was this structure that came out of the water. It was this thing that you never could have envisioned. In *Diamonds Are Forever*, it was John Lautner's Elrod house, with the fight in the main room where the rocks are part of the structure. *You Only Live Twice* is inside a volcano. So all these things—this relationship to nature, these types of things got me really excited about the possibilities. Unfortunately, it was always the bad guys who had the great stuff, right?

MM Along the same lines, for me, a major inspiration was *Strangelove*. You know, that set. Who did it?

CO It was Ken Adam, who also did many of the Bond films.

MM Right. It was so wonderful, so versatile.

AM Michael, so much of your work has dealt with subject matter that we could definitely categorize as having to do with villains. I could name so many examples, but right now I'm thinking particularly of *Manhunter* (1986), the psychological thriller that centers on a serial killer called the Tooth Fairy, and that is the first movie adaptation of one of Thomas Harris' Hannibal Lecter books [spelled Lecktor in *Manhunter*].

MM [*Manhunter*] had to do with somebody whose psychosis was a transformation of his circumstances in his human condition, and so he had a fantasy, and that projected fantasy was to create the circumstances in which he could fantasize on who he wanted to become on the road to becoming that. That is a very romantic, transcendental ambition. That's why he killed young women and then put mirrors in their eyes and imagined himself being accepted. If you do it enough times, as Lecktor tells us, if you do it enough times, if you do what God does enough times, you become as God is. So it's transcendental. It's a transformation he was wishing for. That's a very romantic notion, like church is something romantic, or Gothic architecture is romantic. So if you put that into a contemporary idiom or modernist idiom, you get the opposite of Palladio. You don't get order, you get acute angles, you get radios, you get posters, you get chairs, you get everything driving towards something.

CO It's interesting, what you're saying about this aspirational thing. All these villains are all aspiring, they're all upstarts in a way, start-ups. And they're really trying to change the world. Right? A lot of them, right? And how that becomes influential in the habitat that they inhabit.

MM Exactly.

CO I think it's kind of interesting, like you're saying, he wants to do this, he wants to be accepted and aspiring.

MM So if you become the architect for these villains, what you're saying is, "What do you want your habitat to look like?" The answer is, "Well, here's what I aspire to. It's got to make me feel, when I walk in, it has to make me feel this way. This is what I aspire to." It's kind of reverse engineering. You know, I want to create that habitat that he asked me to build.

CO Exactly.

MM The habitat makes you feel a certain way about him.

CO But it's just always interesting to me how the bad guys always have the cool habitats. Have you ever wondered why that is? Why do the protagonists not have these incredible places to inhabit? Have you ever thought about that?

MM Um, usually because—

CO Crime pays?

MM In a majority of narratives, the protagonist is us, and we're stuck. There's a villain in a nonfiction book by Elaine Shannon named Paul LeRoux. He lived in a number of different places, but mostly in Asia, and typically he would be in either the Twin Towers in Kuala Lumpur, or the Twin Towers in Manila. Penthouses, *no* furniture, just a chair with a laptop was all he needed to operate. He lived in cyberspace, basically. But he did buy an island, because he said villains should have islands.

CO Exactly!

MM I wrote the foreword. He's a three-hundred-pound, white Rhodesian. A brilliant programmer who made about $3,000,000 in gray market pharmaceuticals and then decided to really become a villain…He designed his own dark web, had three wives, eleven children whose names he forgot. Could do anything, brilliant guy, designed a navigation system to improve Iranian middle-range missiles, was dealing with North Korea in state-manufactured methamphetamine.

CO Oh, my God!

MM He built a compound in Somalia, cutting deals with warlords, put together three hit teams…He killed people. He's absolutely a brilliant, brilliant contemporary evil genius.

CO Mastermind. It's interesting, the idea that he wanted an island.

MM Oh, he bought an island.

CO Right, but probably he wanted an island because he saw it in the movies. It's interesting how film inspires reality, and reality inspires film. That kind of cycle is very interesting… Talking about islands makes me think about some of the scenes of water and beach in your films, and how it seems like you are very deliberately working with these natural elements. And you have the houses framing nature. I recently re-watched *Heat*, and the scene when he comes back to his house and it's just sky and water and the blue really struck me. Even in *Miami Vice*, where you would have the guys, the villains, and their house, and Crockett would be in the water, filming it. Or *Manhunter*, on the beach. This idea of the relationship between the architecture and nature, of the structure framing the sky, the water, seems to happen too often to be coincidental in your films. Is that something that's intentional?

MM I don't know. I mean, I don't want to say it's all functional. It's very conscious with Neil McCauley in *Heat*, the movie, because he's figured out his life in a very mechanical way, which I know that convicts do, from my experience with convicts. And it's to have no attachments so that you can walk away from it, so that he can get to that point where he can go and have some imagined paradise of his own—you know, the Fiji islands, or something. And so the aestheticism of his environment is strategic and tactical, and that's why that beach house, there's nothing in it, it's totally anonymous. He aspires to anonymity, in his suits, in his hair. "Who was that guy?" "I don't know, medium height, middle-aged, gray hair, gray suit, white shirt." Describing anybody and everybody by design, so that it's all tactical. He veers, goes totally the other way at the end of the movie

CO You research a lot in terms of villains; you speak with a lot of criminals. Do they all have this ultimate vision of finding paradise?

MM Well, the intelligent ones do, because when they're sent to San Quentin, or sent to Folsom, or sent to any other big prison, why not just commit suicide? So that takes you into the library if you have any intelligence. "Give me a book about time. What's time? Why shouldn't I just end this? Why shouldn't I just tune out or tune in to the dangerous high school kind of gang thing?" So they start to read, and then you have these insane conversations with some of them, which I've had, because they start reading serious philosophy, they start reading Karl Marx.

AM **They're piecing it together from their own perspective. It's pretty amazing.**

MM They're piecing it together, but from a certain kind of a practical perspective that's about, "I need something that can inform me about my life. I'm not interested in metaphysics for the sake of metaphysics. So I'm not going to read Schopenhauer just to read Schopenhauer. I'm going to read something because I need the information." So I've got a guy I try to cast in *Jericho Mile*, in the first dramatic thing I did, in 1979, who was 240 pounds, a big guy, weightlifter, and I wanted him in the film—a black guy. I said, "I'd like to cast you in a film." He said, "No man, I enjoy talking to you, but I can't be part of your film." I said, "Why not? You'll get $800 a week on your commissary instead of two cents an hour." He said, "Because if I was in your film, I'd be allowing you to appropriate the surplus capital of my bad karma." He was serious. He wasn't trying to impress me. You know, "the surplus value of my bad karma." Okay, so he's been reading Marx; he understands the labor theory of value. You know? But the reason he's here isn't because of an actual act he did, it's because karma has sent him here, but he's doing time as his equivalent of laboring, and that's the surplus value. And he didn't, he wouldn't take part in it. So the research I do is first person. It's kind of like a cultural anthropologist.

CO Besides *Strangelove*, what other films inspired you with architecture and set design?

MM Um, let's see, German expressionism, science cinema. Stuff like *The Cabinet of Dr. Caligari* on the one hand, and then the neo-realist stuff like [Georg Wilhelm] Pabst. And then [Friedrich Wilhelm] Murnau's *Faust*, for example, is spectacular. His visualization is so extraordinary. And his film *Sunrise*.

CO What's inspiring you today?

MM What's inspiring me today? Um—non-boxes.

CO Non-boxes?

AM **Outside the box.**

MM Shapes and forms. I mean personally, disconnected from any particular film. Shapes and forms that are—I mean, I'm always moved by—I could look at something and get gratification from it, for a long, long time. It doesn't wear thin. So spaces that are non-boxes. I mean, more organic forms.

AM **Baroque almost.**

MM Yes. I still get gratification from elegance.

AM **Applying that idea of elegance to villains. Real villains don't tend to live in these gorgeous, modern lairs. I mean, it *is* the cinematic world. In life, they tend to live in neo-classical, opulent places. I'm thinking Iraq, Saddam Hussein. It's opulence in a different way. Why do you think there's a cinematic registry of what it takes to be a villain, and then in reality they live in more traditional architecture? It feels like the modernist cool factor gets laid on top of these villains. Does that make it maybe more palatable? I wonder if it's because in film, we kind of have to feel for the villain too, right? I don't think we make them *entirely* despicable at some level. You're playing with the good and the bad of both sides, right?**

MM If you understand that they are people, they are as dimensional as anybody else. Actually, before that—if you live in a world of derivatives, and you have a villain and you're comparing him to other villains in other movies, that's fine. But I find that fairly unsuccessful. To me, I want to meet him, I want to be able to talk to him, know everything about him. I look for the anomalies. What's *unusual*? Because that defines personality and character, and I always want to go to the primary source. I don't want to be derivative.

that you're going to build.

CO I think what's so amazing about Michael's films are just the a
into, the thought, your every little—

MM Think of it from your point of view as an architect. Why *wou

CO I know! But it's amazing.

MM You're building something that somebody's going to *want* t
it. If you were digging into the past, going in the *other* direc
as you put into something that you design as an architect, if
or something that pre-existed, this moment in time for you,
same thing. Who would want to do it any other way?

CO Yes. But it's such a level of depth. I've always appreciated yo
detail, every little thought.

AM Chad, hearing Michael talk about what goes into the spaces
in his films—how does that relate to the idea of this project
movie villains?

CO I'm not sure about the relationship, but these films and TV s
an impact on me as an architect. It's often subconscious—to
something, and someone will say, "That reminds me of a so
something else. And I think that goes back to the point of wh
at one point, you have someone doing a film, and they're ge
life, and then that becomes [something] in the film, which th
happened. And these are the things that have inspired me a
fascinates me, especially, Michael, about *your* work, is it's so
But the visuals, the sound—just the idea of crafting this atm
environment that engages all the senses. And that's what w
trying to do, so I guess that's why cinema has been so inspi

MM It's apparent in your work. It really reaches out, it really seek
seeks to drop you in a great way—I say theatrical in a comp
environment. I mean, really, stand here and look at this. You

STAVRO BLOFELD
BLOFELD'S
LAIR
VOLCANO

FILM

No one would ever make the case that the fifth film in the 007 saga is one of the all-time great Bonds, but it does feature one of the cheekiest, most rug-pulling opening fake-outs in the series. After an American space capsule is consumed by the steel maw of a hostile SPECTRE rocket (kicking off a DEFCON 1 showdown with the assumed hijackers, the Soviet Union), Sean Connery's James Bond is riddled with assassins' bullets while bedding a Chinese agent in Hong Kong. "Why do Chinese girls taste different from all other girls?" he asks right before getting blown away. The film's celebrity screenwriter Roald Dahl won't win any points for political correctness here, but there's something deeply thrilling about a film that, even in jest, kills off the unkillable secret agent in the first ten minutes. Of course, 007 getting turned into Swiss cheese is just a ruse to lull SPECTRE's fiendish capo, Ernst Stavro Blofeld, into complacency. The film takes its sweet time getting to the ultimate showdown between Bond and Blofeld—a hoax wedding sequence where Connery's yellow-face makeover evokes more embarrassed hand-wringing than fascination these days. But when the climax finally does arrive, its sheer hugeness guarantees that it's worth the long wait.

Release
1967

Director
Lewis Gilbert

Production Designer
Ken Adam

Cinematographer
Freddie Young

Cast
Sean Connery
Akiko Wakabayashi
Tetsurô Tanba
Mie Hama
Teru Shimada
Karin Dor
Donald Pleasence

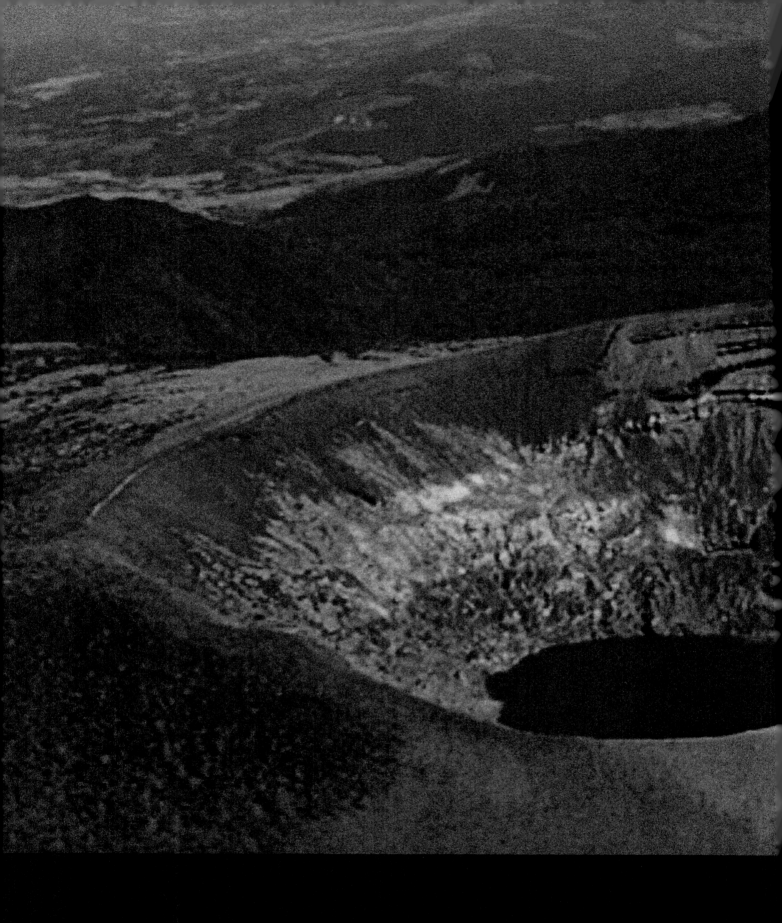

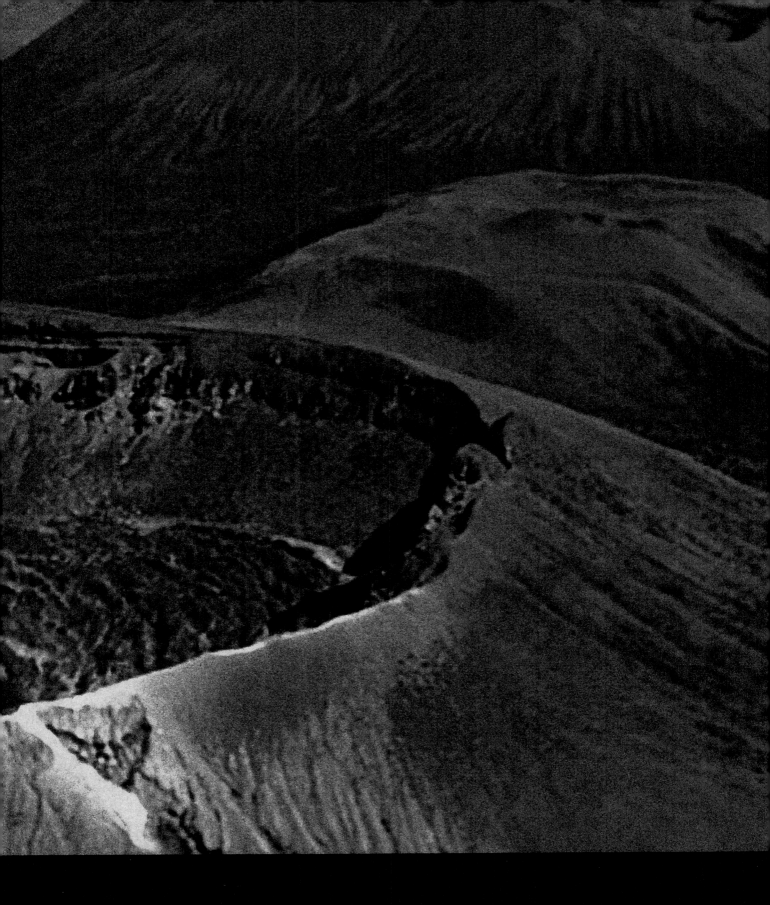

1
Aerial view of the volcanic Mount Shinmoedake
on the southernmost Japanese island of Kyushu.
It looks innocent enough, but below its crater is
the hollowed-out lair of 007's arch nemesis, Ernst
Stavro Blofeld. Still. *You Only Live Twice.*

VILLAIN

You Only Live Twice was Blofeld's third appearance in the Bond movie franchise, coming on the heels of 1963's *From Russia with Love* and 1965's *Thunderball*. And if any villain has earned the right to be called 007's White Whale, it's SPECTRE's megalomaniac in chief. In fact, the evil mastermind is so cagey and elusive, it makes a weird sort of sense that he's been played by a whack-a-mole assortment of thespians. For this outing, director Lewis Gilbert had originally cast roly-poly Czech actor Jan Werich. But Werich looked so much like Santa Claus, what with his cherubic cheeks and Burl Ives facial hair, that he was jettisoned and replaced by veteran British screen baddie Donald Pleasence. As the scheming CEO of the world's most villainous terror-and-extortion syndicate, Blofeld plots to start World War III by feeding the frosty mutual distrust between the Cold War superpowers through devious calculation. Although we hear Pleasence's sub-zero voice throughout the film and see his hands stroking a white Persian cat that sits on his lap, we don't actually see Blofeld's hideously scarred face and shark-eyed stare until there are only twenty minutes left in the film. Pleasence makes the most of his delayed reveal. Sitting in a sleek, black-leather egg chair in a camel-colored Nehru jacket, the actor slowly swivels toward the captured 007 in the impregnable command center of his secret volcano lair and purrs, "James Bond, allow me to introduce myself…" At that moment, he more than earns his place in the Supervillains Hall of Fame.

2
British bad guy for hire Donald Pleasence as Blofeld. The villain's hideously scarred, shark-eyed face is only revealed in the final twenty minutes of the film—one of the all-time great delayed reveals. Still. *You Only Live Twice.*

LAIR

Arguably the most wildly original setting in the glorious pantheon of celluloid villains' lairs, Blofeld's jaw-dropping hideout deep in the hollowed-out core of an extinct Japanese volcano was instantly iconic. Its allure is such that it later became a loving target of Mike Myers' 1997 spy-film parody, *Austin Powers: International Man of Mystery*, as well as the model for Syndrome's lair in 2004's *The Incredibles*.

Possibly the crowning achievement of legendary Bond production designer Ken Adam, Blofeld's volcano refuge is completely undetectable thanks to a hydraulic retractable roof made to look like the surface of a lake in the volcano's crater. From this camouflaged setting, which just happens to double as a subterranean rocket-launching pad, Blofeld plots his brand of global chaos. A 148-foot-tall hangar-like open space with floating staircases, helipads, and its own shiny steel monorail system (not to mention an army of henchmen in color-coded jumpsuits), Blofeld's Japanese base of operations could only belong to a true sociopath. Why? Because it also features a large, kidney-shaped indoor pond full of razor-toothed piranhas used to mete out punishment to his minions who have come up short. "This operation does not tolerate failure," Blofeld warns. One such unlucky employee is his lovely assistant, Helga (German actress Karin Dor). After failing to make sure that James Bond perished during the film's opening assassination attempt, Blofeld hints in a not-so-subtle bit of foreshadowing: "You will see my piranha fish get very hungry. They can strip a man from the bone in thirty seconds." Then, after Blofeld's Aryan enforcer, Hans, lowers a side of beef into the tank where it's immediately picked clean, Blofeld deposits Helga into the tank via a trap door. She's turned into screaming chum.

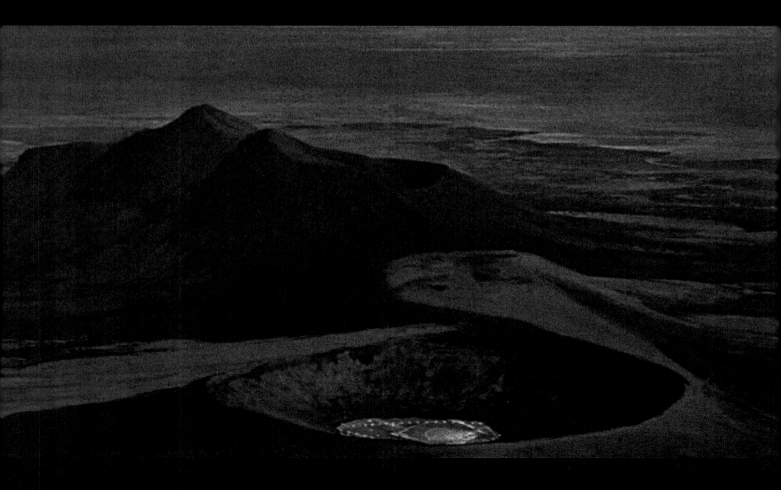

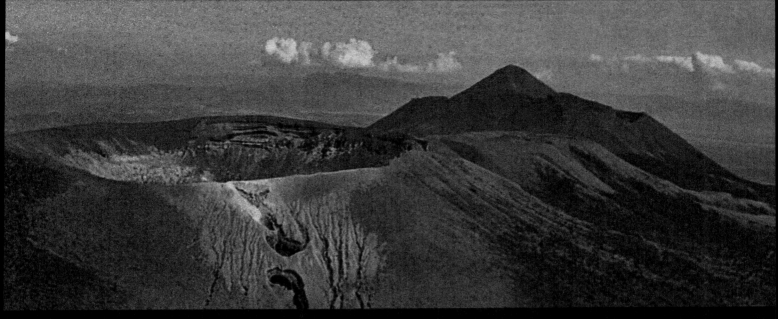

3
4 5 6
 8
7 9

3
The exterior of Blofeld's volcano base of
operations, undetectable even to a superspy
like James Bond. Designed by Ken Adam and
constructed at Pinewood Studios, England, it is
one of the most legendary film sets in the history
of cinema. Still. *You Only Live Twice.*

4, 5, 6
Blofeld's secret subterranean headquarters
includes a rocket-launching pad where he
unleashes his predatory hardware to intercept
the peaceful spacecraft belonging to the world's
superpowers. Stills. *You Only Live Twice.*

7
Aerial view of Blofeld's lair at night with its decoy
roof fully retracted, revealing the busy inner
workings of SPECTRE. Still. *You Only Live Twice.*

8
Blofeld's criminal underlings take a fateful meeting
in his quarters. Soon enough, his lovely assistant
Helga (Karin Dor) will sleep with the fishes. Still.
You Only Live Twice.

9
Blofeld's Aryan enforcer Hans (Ronald Rich) feeds
the villain's always-hungry piranhas in the deadly
indoor fish pond. Still. *You Only Live Twice.*

ERNST STAVRO BLOFELD (SPEAKING TO JAMES BOND): "THE FIRING POWER INSIDE MY CRATER IS ENOUGH TO ANNIHILATE A SMALL ARMY. YOU CAN WATCH IT ALL ON TV. IT'S THE LAST PROGRAM YOU'RE LIKELY TO SEE."

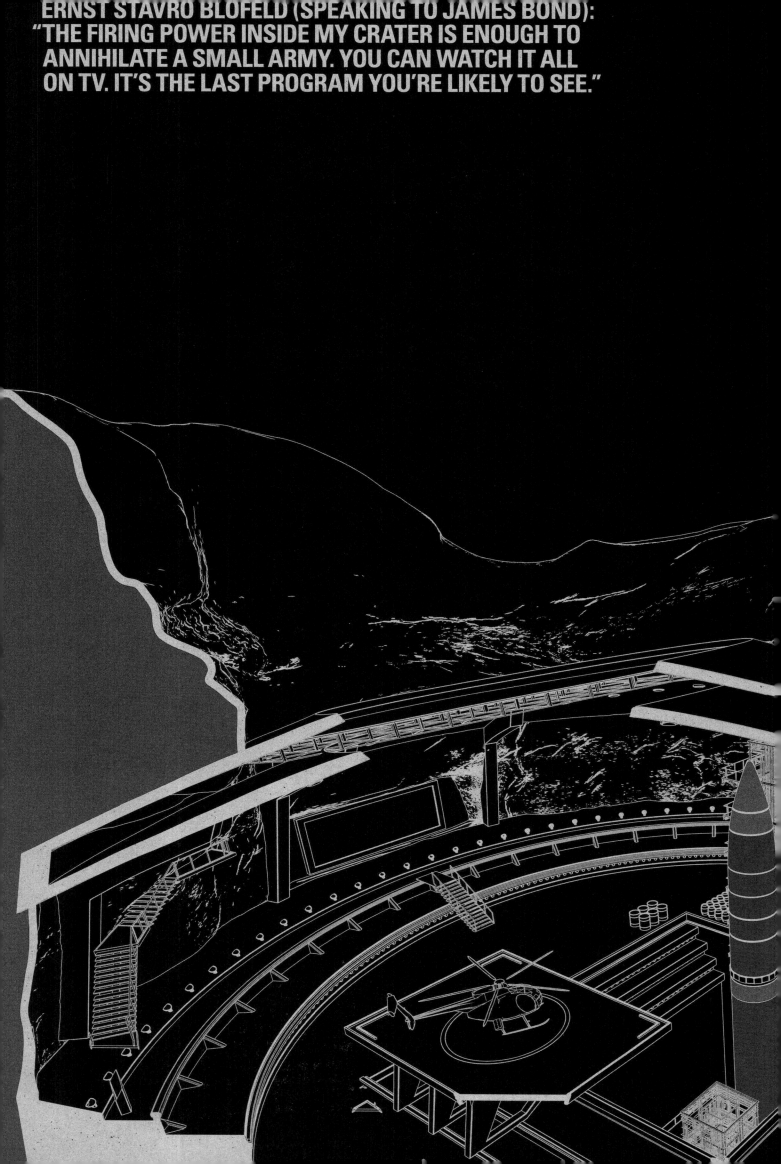

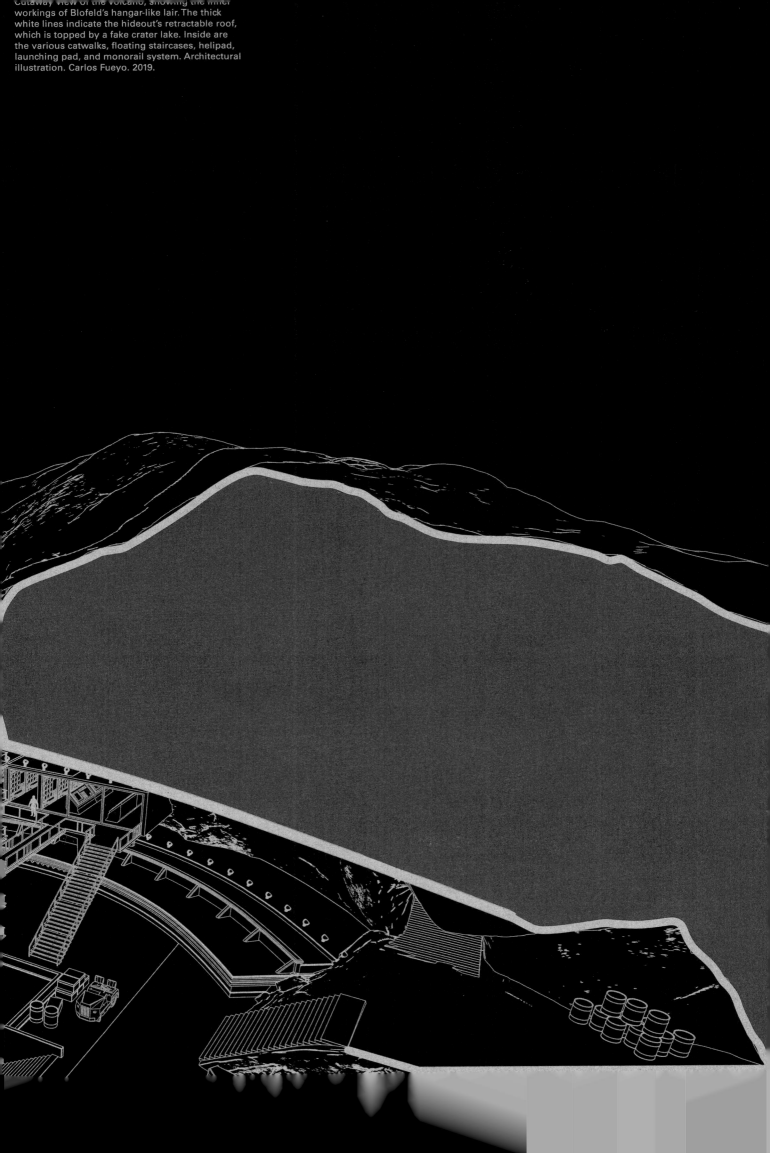

Cutaway view of the volcano, showing the inner workings of Blofeld's hangar-like lair. The thick white lines indicate the hideout's retractable roof, which is topped by a fake crater lake. Inside are the various catwalks, floating staircases, helipad, launching pad, and monorail system. Architectural illustration. Carlos Fueyo. 2019.

As nice as it would be to think that Adam and his team actually hollowed out a volcano to achieve this stunning set, it was actually built at Pinewood Studios outside of London, with a whopping $1 million price tag attached. The exterior shots of Blofeld's volcano lair were of Mt. Shinmoedake on the southernmost Japanese island of Kyushu.

Adam and director Lewis Gilbert made the most of their million-dollar sandbox, though, especially in the film's third-act climax, when a team of ninjas storms the compound, descending on ropes. It's pure action-movie ballet. It's also so outlandish and over-the-top that you can almost understand why Connery, midway through filming, announced that *You Only Live Twice* would be his final James Bond film. Of course, he would have second thoughts (no doubt motivated by a nice payday) and return four years later in *Diamonds Are Forever.* As for Blofeld, well, he escapes at the end of the film. The White Whale gets to die another day.

11
Perspective view of the interior of Blofeld's lair, focusing on his rocket-launching pad in the foreground. Architectural illustration. Carlos Fueyo. 2019.

12
The climactic siege of Blofeld's lair with 007's ninja troops descending on zip lines and the villain's minions charging into battle. Still. *You Only Live Twice.*

13
Blofeld's evil dreams of world domination—and his lair—go up in smoke with a gigantic fireball explosion. Still. *You Only Live Twice.*

14
Floor plan of Blofeld's volcano lair. Note the curved monorail track. Architectural illustration. Carlos Fueyo. 2019.

11
12 13
14

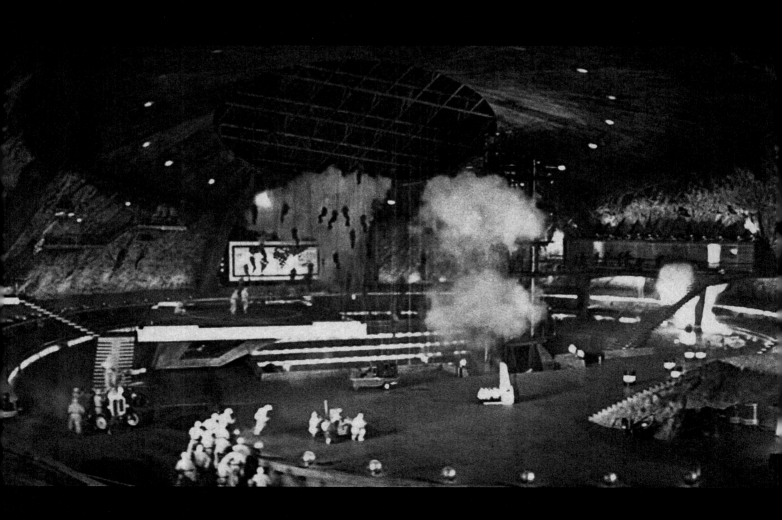

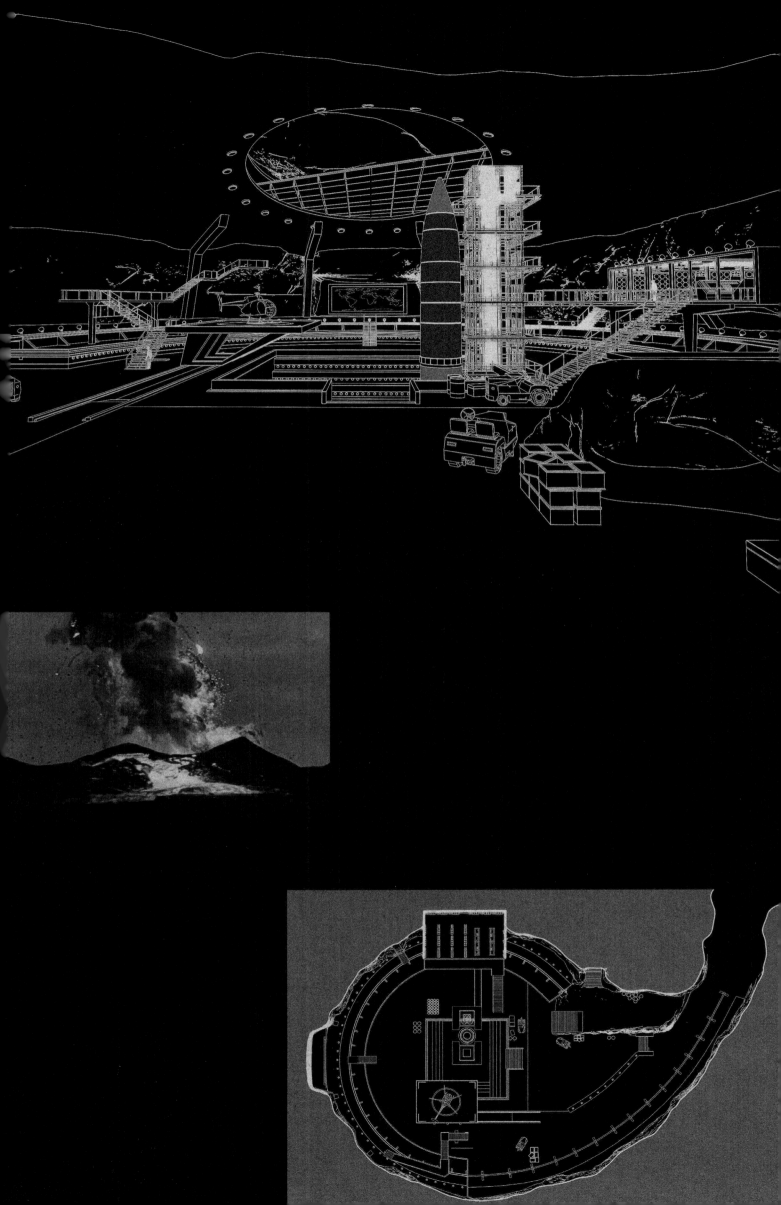

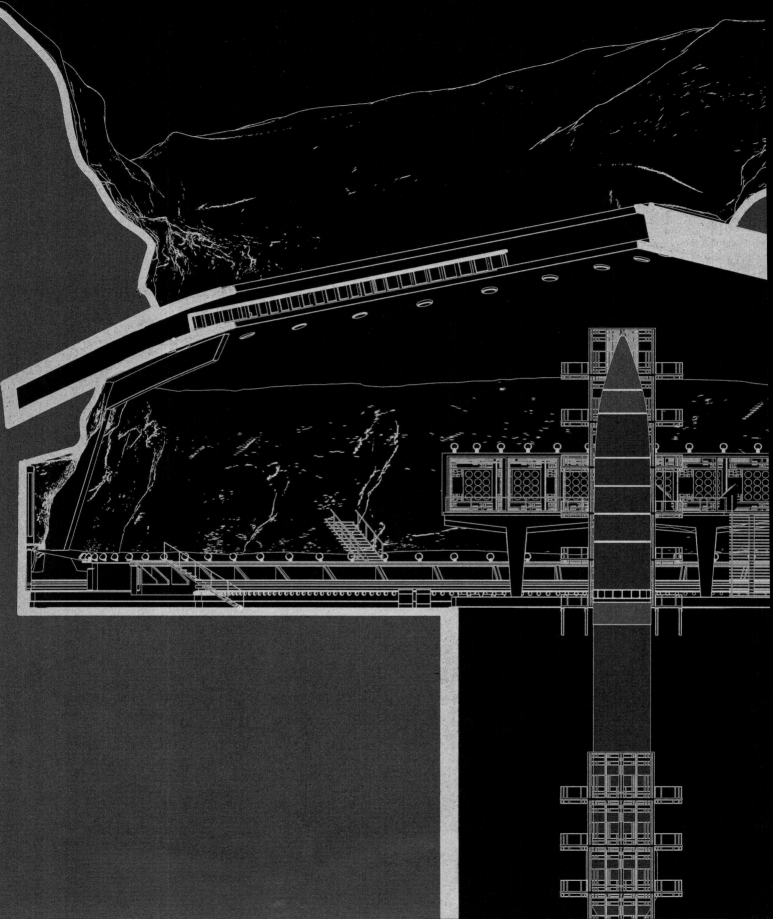

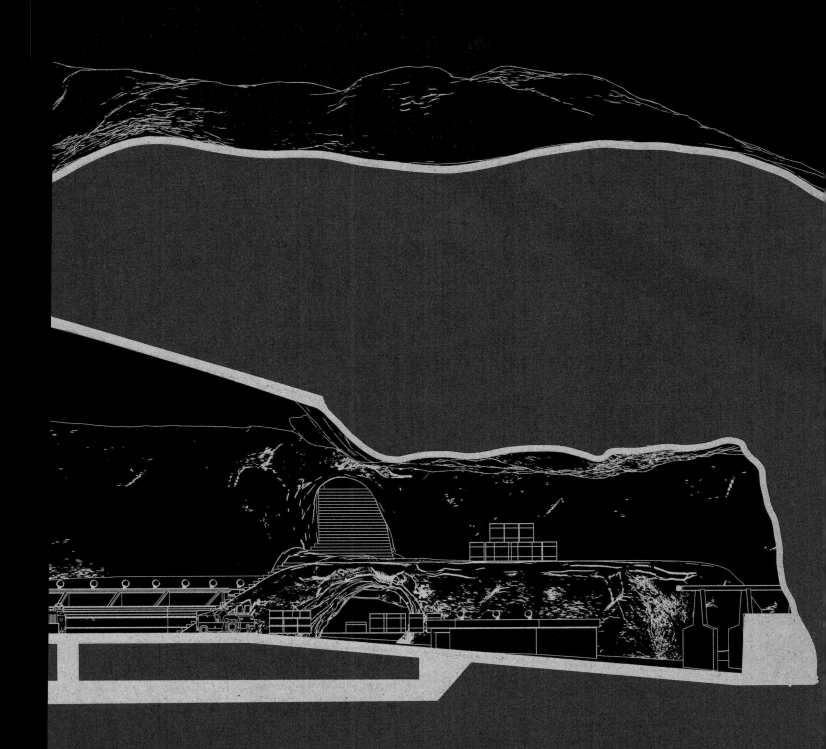

15
Longitudinal section, depicting the full sweep
and many levels of Blofeld's lair. Architectural
illustration. Carlos Fueyo. 2019.

THE MAN WITH THE GOLDEN GUN

FRANCISCO

VILLAIN SCARAMANGA

LAIR SCARAMANGA ISLAND

FILM

The ninth James Bond film, and th
the cocked-eyebrow Roger Moore
by immediately putting 007 on the
when he receives a golden bullet e
his MI6 code name on its casing—
warning that he's on the hit list of
million-dollar contract killer named
Scaramanga (Christopher Lee). Un
with being in the role of the hunte
the hunter, Bond sets off to find Sc
odyssey takes 007 first to Beirut an
(Hong Kong, Macau, Thailand), whe
Guy Hamilton opportunistically pig
the then-hot kung-fu craze while ir
of the series' most confounding Ma
the plot: the Solex Agitator. This de
allegedly harness the power of the
Scaramanga's hands. So (of course
to the debonair assassin's private i
coast of Thailand, where they will f
off—the man with the golden gun
secret agent with the Walther PPK.

Release
1974

Director
Guy Hamilton

Production Designer
Peter Murton

Cinematographer
Ted Moore
Oswald Morris

Cast
Roger Moore
Christopher Lee
Britt Ekland
Maud Adams
Hervé Villechaize

Screenplay
Richard Maibaum
Tom Mankiewicz

Studio
United Artists

Lair
Locations were filmed at Ko Khao Phing
Kan, Thailand (now popularly known as "James
Bond Island"), and sets were built at Pinewood
Studios, England.

Images
All photographs are from *The Man with the
Golden Gun*, and all architectural illustrations and
renderings are based on spaces in the film.

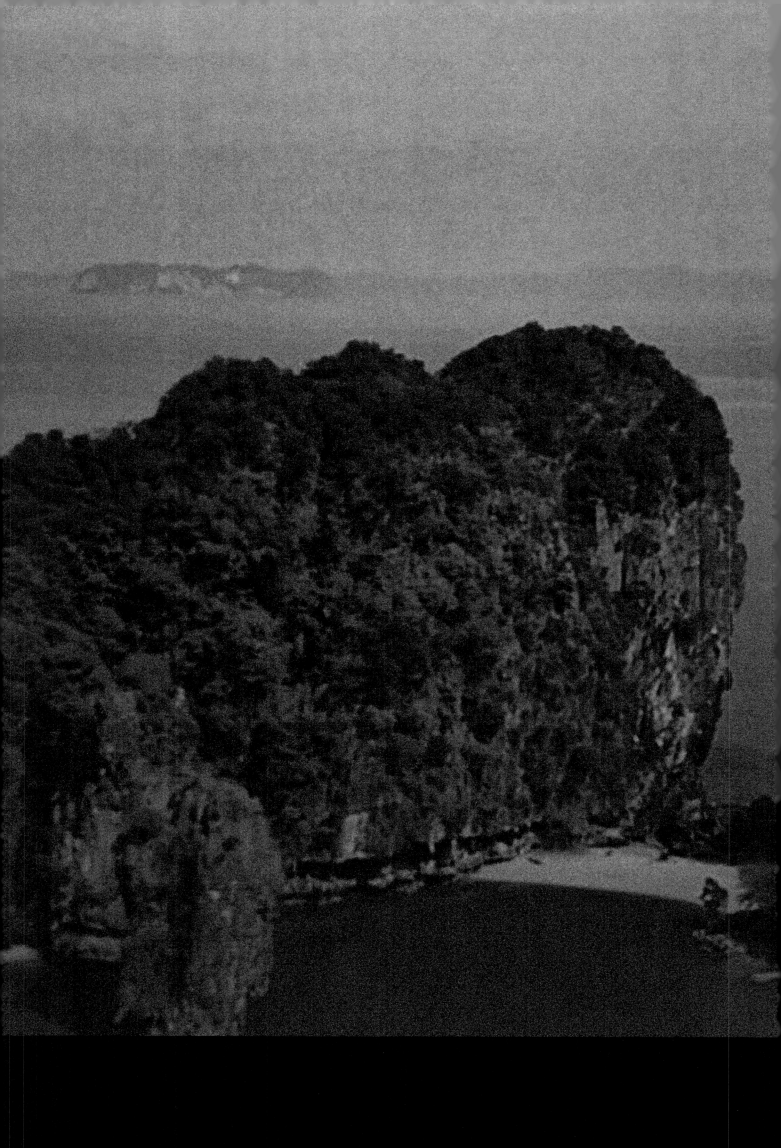

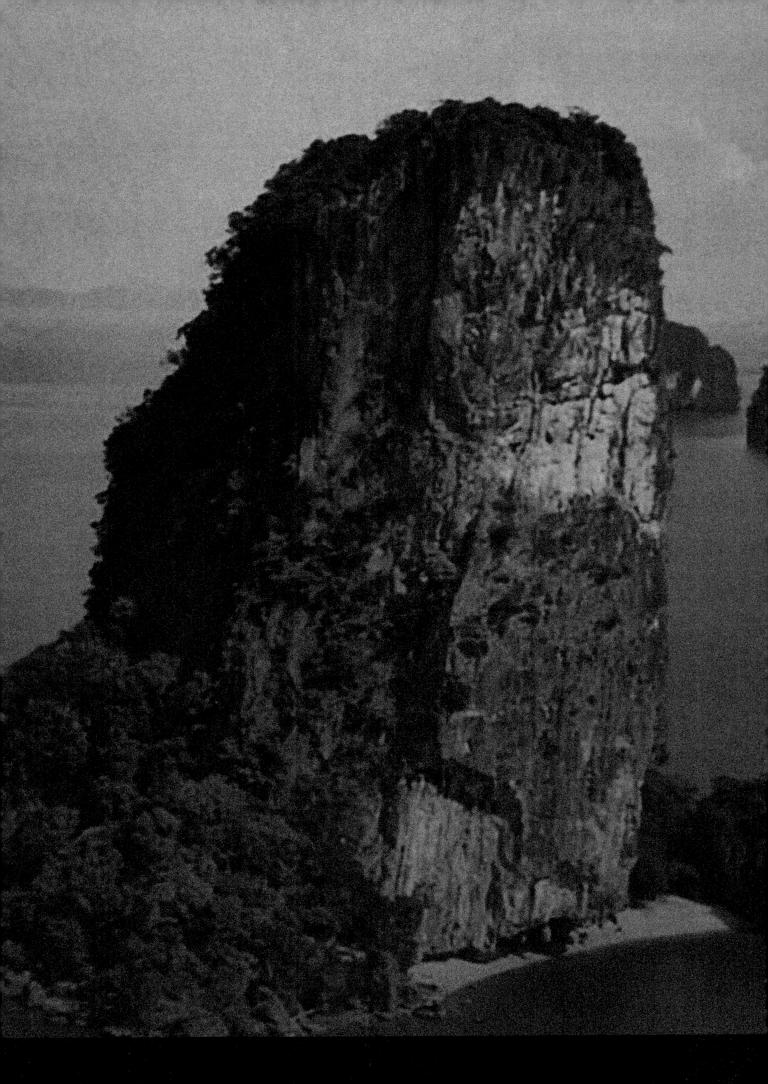

1
Aerial view of Ko Khao Phing Kan (now known as "James Bond
Island"), in Phang Nga Bay off the southwest coast of Thailand.
This rocky limestone marvel stands as a natural sentry and imposing
warning to Francisco Scaramanga's unwanted visitors.
Still. *The Man with the Golden Gun.*

VILLAIN

The Man with the Golden Gun may not be in anyone's top tier of James Bond movies, or even their top tier of *Roger Moore* James Bond movies, but there's no denying that it features one of the series' most chilling supervillains. Scaramanga is the vicious, cold-blooded yin to Bond's yang, the morally tarnished flipside of a coin that Bond himself would rather not think too much about. After all, they are both killers, as Scaramanga will remind him: "Come, come, Mr. Bond…You enjoy killing as much as I do." Bond is immediately at a disadvantage with Scaramanga, since so little is known about this mild-mannered murderer. One of the few things that is, and it's a doozy, is that he possesses a superfluous third nipple. Given that 1974 was twelve years and nine titles into the 007 film cycle, it's hard to imagine that Christopher Lee hadn't previously been tapped to play a Bond nemesis. The British actor, who had been perfecting the dark art of cinematic evil for decades in Hammer horror films, seemed almost too on the nose, even if his diminutive henchman, Hervé Villechaize's Nick Nack, is hard to take seriously. But he was only given the role of Scaramanga after Jack Palance turned down the part. Palance's pass was our gain, because Lee's Scaramanga sends chills down the collective spine of the audience with every insinuating line he delivers.

2
British horror icon Christopher Lee as uber-villain Francisco Scaramanga, with his titular weapon. Still. *The Man with the Golden Gun.*

LAIR

Scaramanga is more than just an executioner-for-hire. He wants what all great movie villains want in the end: the sort of unchecked, omnipotent power that can bring the world to its quaking knees. And he plans to accomplish this with a deadly solar-energy laser cannon he's devised on his island paradise.

In Ian Fleming's novel *The Man with the Golden Gun*, Scaramanga's lair was set in Jamaica. But since the azure waters of the Caribbean had already been exploited for the settings of *Dr. No* and for Moore's first outing as 007, *Live and Let Die*, the film's production designer Peter Murton instead looked halfway around the world for inspiration. Located off the southwest coast of Thailand in Phang Nga Bay, Ko Khao Phing Kan at the time was a relatively untouched island best known for the sixty-six-foot-tall limestone mini island off its shore known as Ko Tapu, or "Spike Island," which rises out of the sea like a nail standing on its head. Murton took one look at the idiosyncratic setting and knew that this was exactly the sort of place a villain like Scaramanga would call home.

3
Scaramanga shows off his high-tech Solex Agitator to Roger Moore's 007. Still. *The Man with the Golden Gun.*

4
Scaramanga's fiendish plot involves nothing less than harnessing the power of the sun in his bid for world domination. Still. *The Man with the Golden Gun.*

5
Exterior perspective, showing the approach to Scaramanga Island, with the villain's residence nestled into the island's geography. Architectural illustration. Carlos Fueyo. 2019.

3
4 5

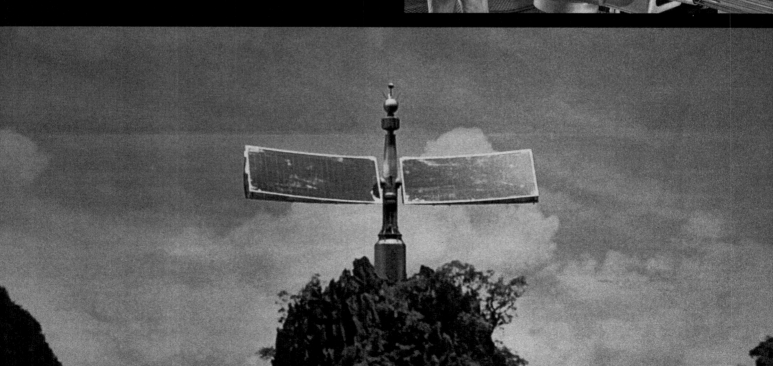

FRANCISCO SCARAMANGA:
"HOW DO YOU LIKE MY ISLAND, MR. BOND?"

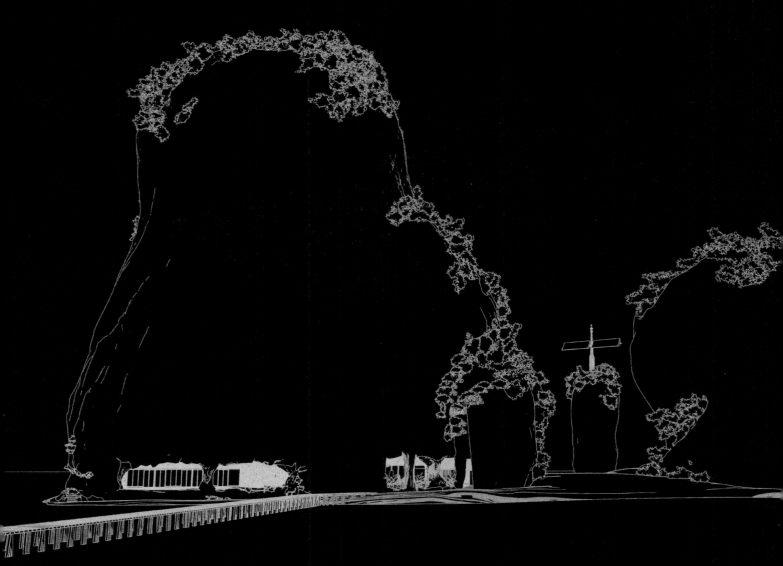

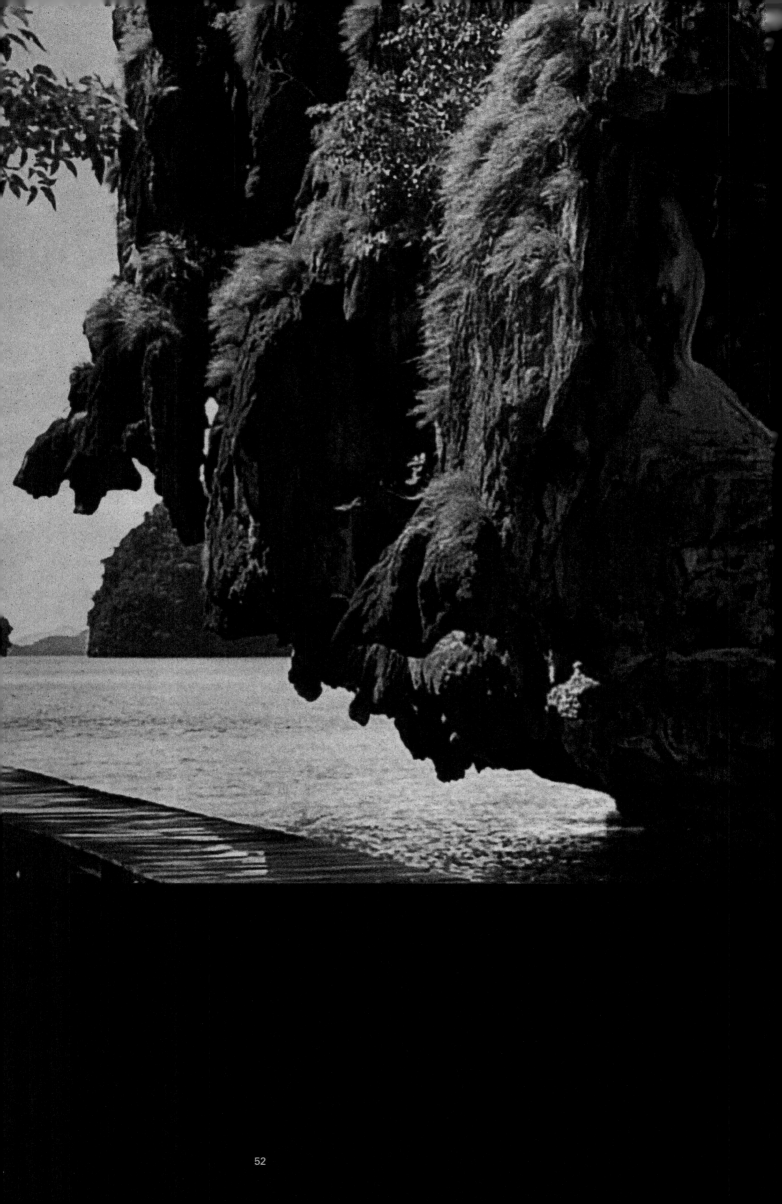

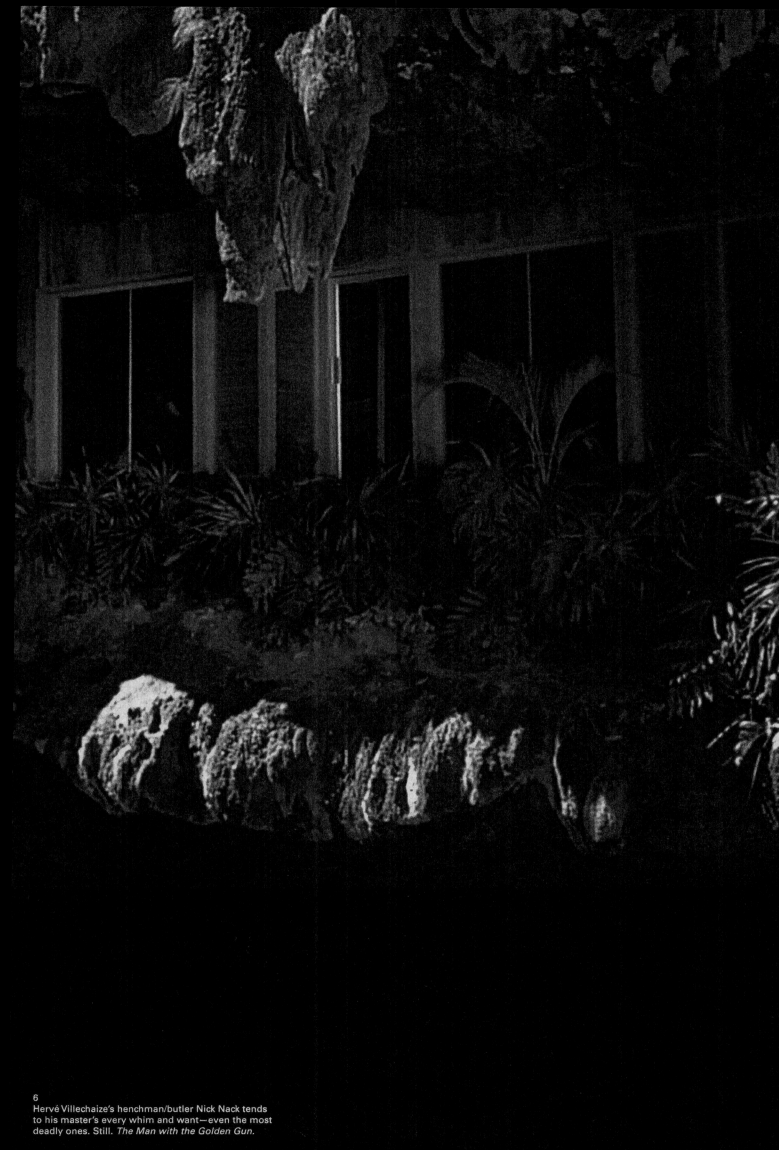

6
Hervé Villechaize's henchman/butler Nick Nack tends
to his master's every whim and want—even the most
deadly ones. Still. *The Man with the Golden Gun.*

Murton, who previously had worked as Ken Adam's art director on both *Goldfinger* and *Thunderball*, made the most of his promotion to Bond production designer and temporary fill-in for Adam, designing a modern lair for Scaramanga on Ko Khao. The hideout itself is the apotheosis of late-twentieth century cinematic villain chic, a posh oasis of curved lines, sunken sitting rooms, and chilly glass-and-chrome furnishings nestled into and camouflaged by the volcanic island's craggy terrain. And then there's Scaramanga's mistress, Maud Adams' Andrea Anders, walking around in a black bathing suit. Outside, the hideout's doorways are obscured by caves and stalactites. Inside, it's like a page ripped out of *Architectural Digest* from the JFK New Frontier era, replete with a mad-scientist laboratory and a funhouse labyrinth seemingly designed with Bond's visit in mind.

While Bond and Scaramanga's date with destiny initially plays out on the beach, where the two face off in a genteel pistol duel at twenty paces, it soon moves indoors, where Bond is pursued in cat-and-mouse fashion through Scaramanga's high-tech maze—just one of the many tricks the villain has up his bespoke, Saville Row sleeve. It's here that the film will reach its disorienting climax (Murton built Scaramanga's hall of mirrors and video screens on a vertigo-inducing canted floor that tilts and leans in an homage to Orson Welles' 1947 classic, *The Lady from Shanghai*).

In the years following the release of *The Man with the Golden Gun,* the once obscure location of Ko Khao/Ko Tapu has become known to locals and tourists alike as "James Bond Island" and receives a healthy influx of visitors year-round.

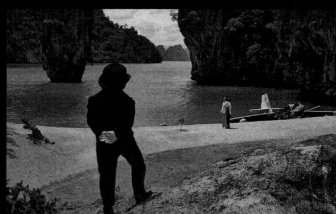

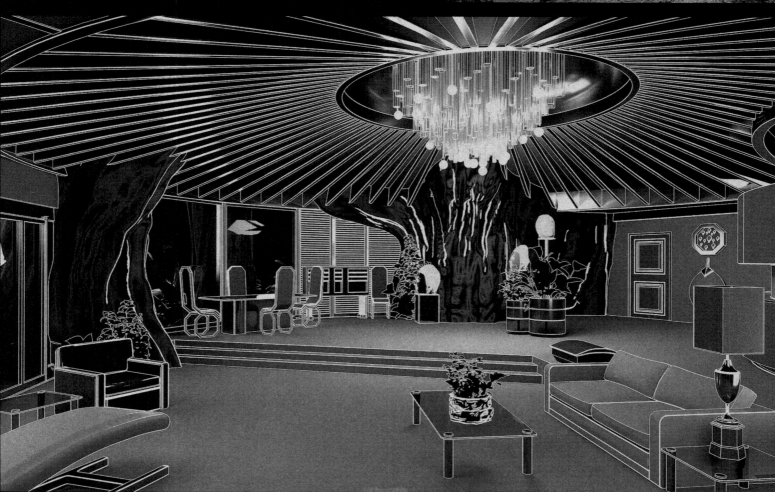

7
James Bond hunts for his prey in the sunken living room of Scaramanga's island lair. Still. *The Man with the Golden Gun.*

8
Nick Nack watches as Bond and Scaramanga get set to square off in a duel on the villain's private beach. Still. *The Man with the Golden Gun.*

9
Interior perspective of Scaramanga's retro-cool sunken living room, which is carved into the island's natural geography. Rendering. Carlos Fueyo. 2019.

10
Bond is at a momentary disadvantage inside his host's trippy funhouse. Still. *The Man with the Golden Gun.*

11
Game, set, match, 007. Bond takes down his lethal nemesis during the film's climax. Still. *The Man with the Golden Gun.*

Architects' Commentary
Highlights from Oppenheim Architecture's round-table discussion of The Man with the Golden Gun

"This is one of the films that spurred the idea for this book. This movie is what it's all about. The place is so uniquely beautiful, with the limestone islands and the cliffs. The lair is gorgeous. Maybe the storyline isn't the strongest, but the setting and the architecture are awe-inspiring. You have James Bond in his seaplane, and he lands in the protected cove, and the butler comes out. It's just so beyond that it blows your mind. If you're going to do bad stuff, do it in a cool place. That's pretty much the takeaway."

"This lair is fully concealed. It's probably the most hidden lair in the book. And that quality mirrors the mind of the villain—the concealed psychology, the not giving up anything. In contrast, there are some lairs that seem to be one thing but have hidden elements, which is more deceptive—*Ex Machina* is an example of that."

"But is this one fully *hidden*? Or is it embedded in nature? That is an important distinction. Certainly, it incorporates nature, and elements of nature become part of the architecture. It's an interesting question to explore."

"There are intriguing relationships between the lair and nature, and between the villain and domesticity. There is the contrast of the beauty of nature and the evil of the villain, and that extends into the expression of a kind of hyper-domesticity. The design plays with this idea—there are fresh flowers and the lamp that your grandmother has on her side table, and very traditional, luxurious furniture. You see it in Lex Luthor's lair, too—it's a desire for domesticity."

"So some villains' lairs, and this is one, are oases of comfort and warm domestic space and opulence, but meanwhile the villain's objective often involves destroying domesticity for others."

"Well, bad guys need love, too."

13
12 14

12
Plan view of Scaramanga's island lair
showing the villain's hideout camouflaged by
its surroundings. Architectural illustration.
Carlos Fueyo. 2019.

13
Transverse section of the Solex Agitator hidden
deep within its rocky limestone surroundings.
Architectural illustration. Carlos Fueyo. 2019.

14
Longitudinal section, showing the full sweep
of Scaramanga's hidden compound of villainy.
Architectural illustration. Carlos Fueyo. 2019.

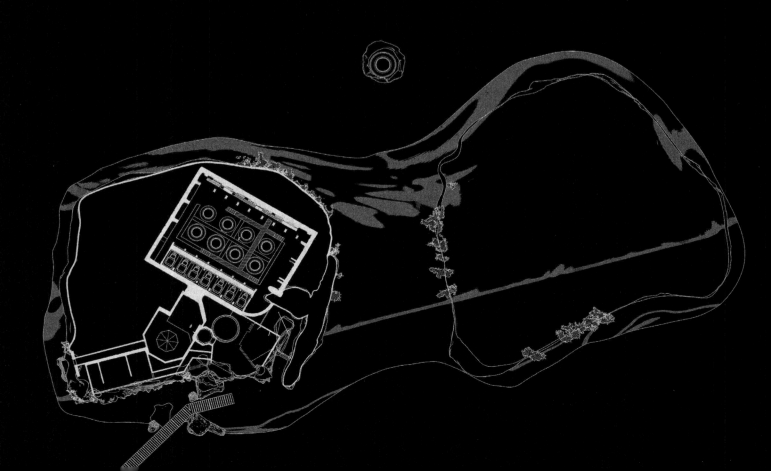

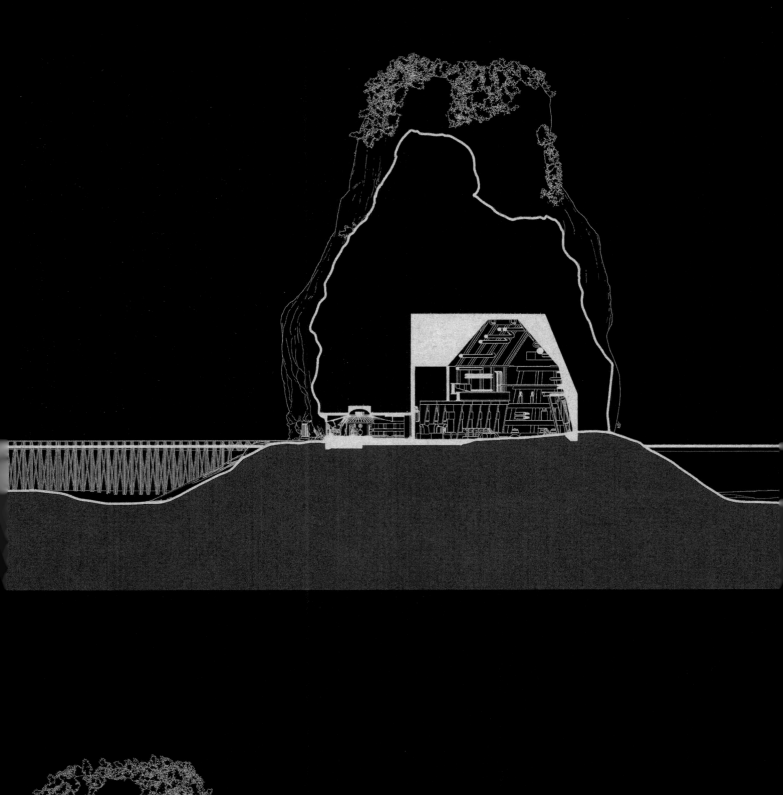
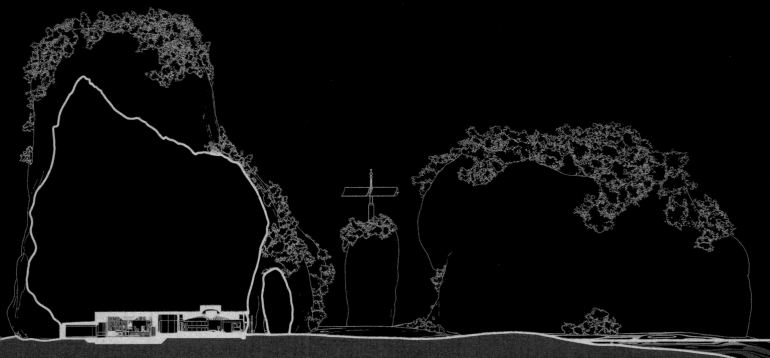

FILM **DIAMONDS ARE FOREVER**

VILLAIN **ERNST STAVRO BLOFELD**

LAIR **WILLARD WHYTE'S VILLA**

FILM

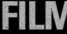

The seventh film in the James Bond saga
(and the sixth to star Sean Connery as the MI6
agent with a license to kill, replacing the one-
and-done George Lazenby) remains one of
the most underrated entries in the series. This
time around, Connery's 007 has to infiltrate a
diamond-smuggling ring that takes him from
Las Vegas to Amsterdam to the California desert
while squaring off with a bevy of Bond girls that
includes Jill St. John's Tiffany Case and Lana
Wood's Plenty O'Toole. What's so threatening
about diamonds, you may ask? Well, it turns out
that Bond's old nemesis, Blofeld, is using the gems
to create a satellite-based laser weapon to destroy
Washington, D.C., and extort the governments of
the world. *Diamonds Are Forever* was a troubled
production that included arguments about who
would direct, extensive script rewrites, acrimony
with Connery about his return and his salary, a
pool scene in which Lana Wood almost died, and
several other complications. Yet, despite it all, the
film is a success.

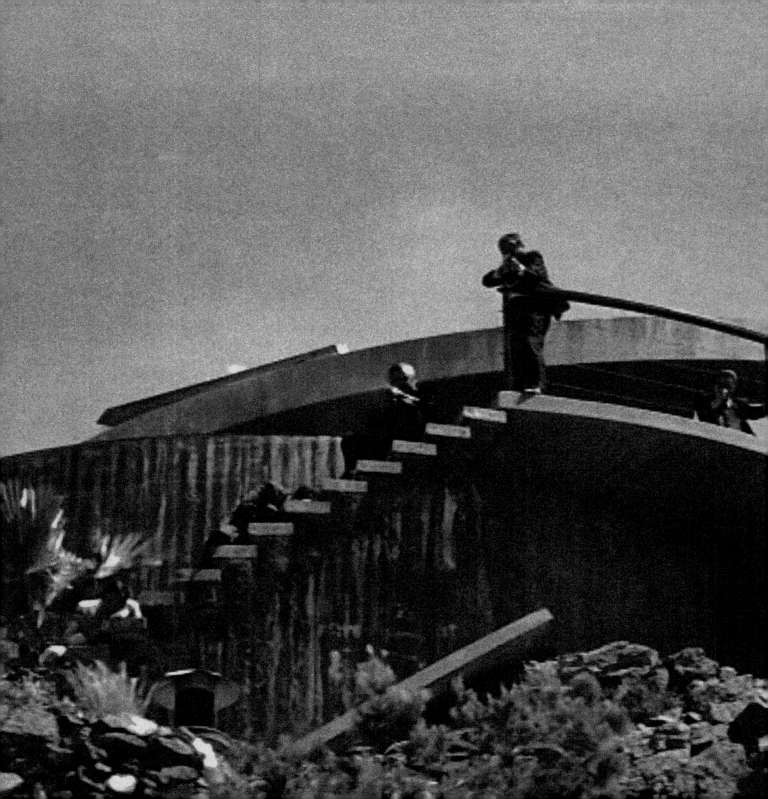

1
Reinforcements arrive after 007 and Blofeld face
off at the villain's requisitioned desert hideout,
which is the John Lautner-designed Elrod House.
Still. *Diamonds Are Forever.*

VILLAIN

Over the decades-spanning run of the 007 movie franchise, Ernst Stavro Blofeld has been the supervillain to end all supervillains and, more than any other bad guy, Bond's White Whale. The sinister mastermind behind the global criminal organization SPECTRE first appeared in 1963's *From Russia with Love* (played by Anthony Dawson) and popped up again (1965's *Thunderball*, Dawson in a brief encore), again (1967's *You Only Live Twice*, a pussycat-petting Donald Pleasence), and *again* (1969's *On Her Majesty's Secret Service*, hepcat Telly Savalas). Apparently, some Nehru jacket-wearing villains just won't die—even at the hand of an infamous, globe-trotting blunt-instrument like Bond. Played this time around by veteran British character actor Charles Gray, Blofeld's perverse thirst for terrorizing the world remains unquenchable. In *Diamonds*, he is arguably at his most devious, taking a Howard Hughes-like American casino tycoon named Willard Whyte hostage, impersonating him, and relocating his evil headquarters to Whyte's palatial winter villa deep in the desert near Las Vegas, which Blofeld has turned into his own uber-stylish honeytrap in order to lure Bond into his clutches. Of course, Blofeld will live on, returning a decade later in 1981's *For Your Eyes Only* (played by John Hollis) before finally becoming the model for Mike Myers' Dr. Evil in the Austin Powers satires.

2
British character actor Charles Gray as Bond's arch-nemesis and SPECTRE mastermind, Ernst Stavro Blofeld. Still. *Diamonds Are Forever.*

LAIR

A filthy-rich supervillain like Blofeld has no shortage of scenic locations where he can hide out and plot the next step in his devious will-to-power plan for world domination. But even so, the desert spread where he temporarily sets up camp in *Diamonds Are Forever* is an indelibly cool one—a modern architectural marvel that's not just set in the rocky desert but that is *one* with it.

Designed by American architect and Frank Lloyd Wright protégé John Lautner, the Elrod House was built in 1968 for interior designer Arthur Elrod. Located at 2175 Southridge Drive in Palm Springs, California, the house is set on a craggy ridge that affords it panoramic views of the San Jacinto Mountains. However, the words "set on a ridge" don't do its setting—or design—justice. The ridge is actually incorporated into the home, with giant boulders kept in their original place and acting as walls and room dividers within the house, bringing nature inside.

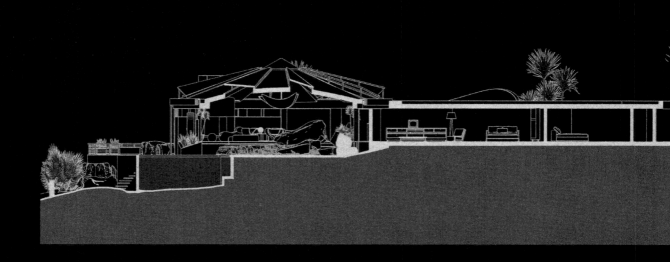

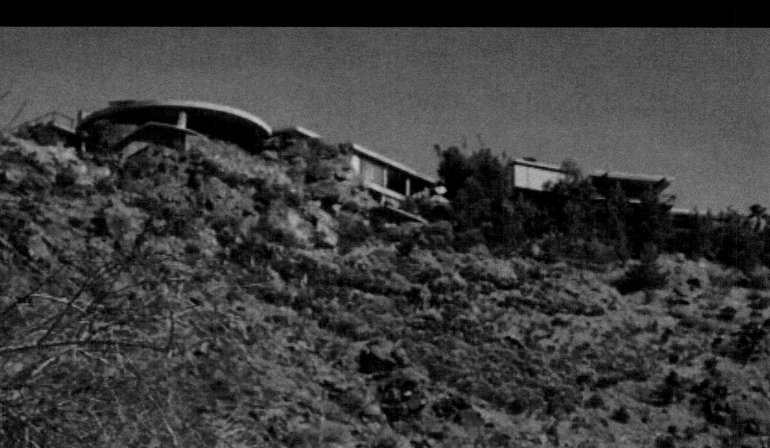

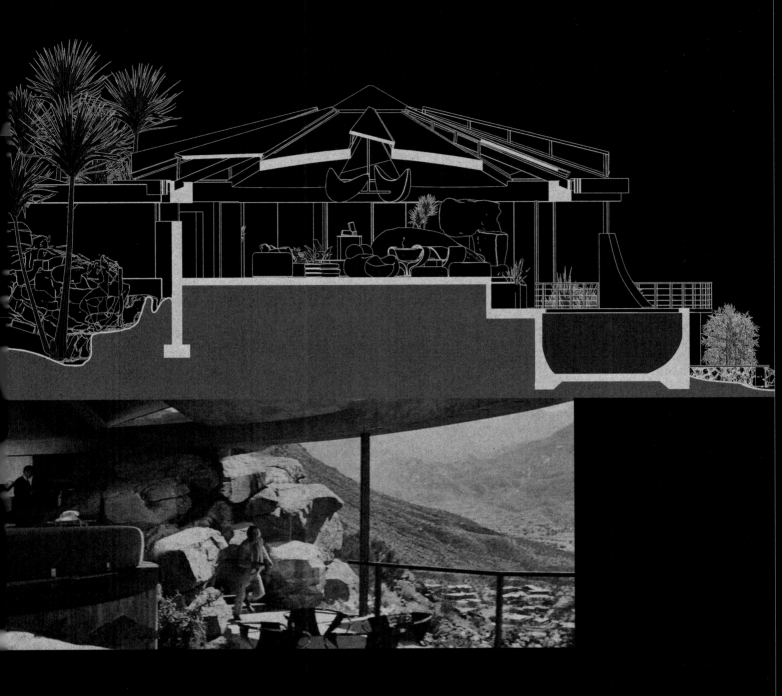

4
3 5
7 6

3
Longitudinal section of Willard Whyte's winter
villa-turned-Blofeld base of operations. The
John Lautner-designed Elrod House (1968) is built
on (and into) a rocky ridge in the Palm Springs
desert, at one with its surroundings. Architectural
illustration. Carlos Fueyo. 2019.

4
Transverse section, showing the residence's integration
into the natural terrain and its centerpiece—a jewel box
living room encased in retractable smoked-glass windows
and topped by a domed, concrete roof. Architectural
illustration. Carlos Fueyo. 2019.

5
A stylish view to a kill with the San Jacinto
Mountains in the distance. Still. *Diamonds Are Forever.*

6
Sean Connery's Bond takes in the curved exterior walls
of his target's den of villainy before discovering the dangers
that lurk within. Still. *Diamonds Are Forever.*

7
The exterior of Whyte's modernist residence majestically
perched on a desert bluff. Still. *Diamonds Are Forever.*

8
Floor plan of Whyte's villa with its circular living
room and indoor/outdoor swimming pool. Architectural
illustration. Carlos Fueyo. 2019.

9
Exterior perspective of the side of the house. Architectural
illustration. Carlos Fueyo. 2019.

8
9

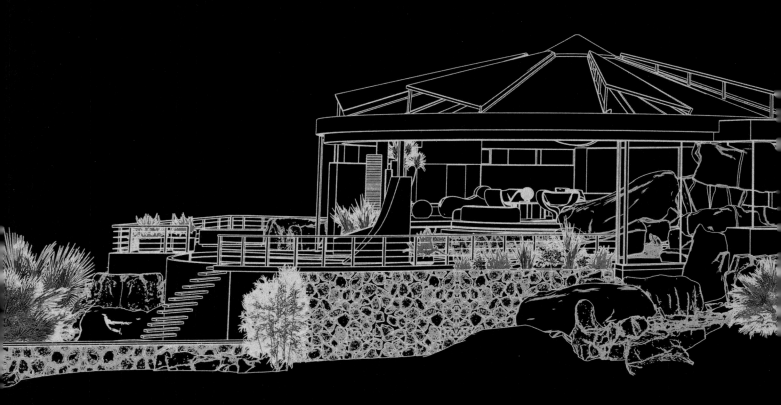

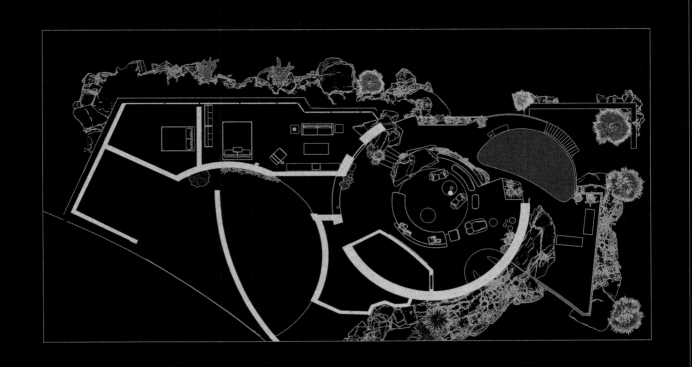
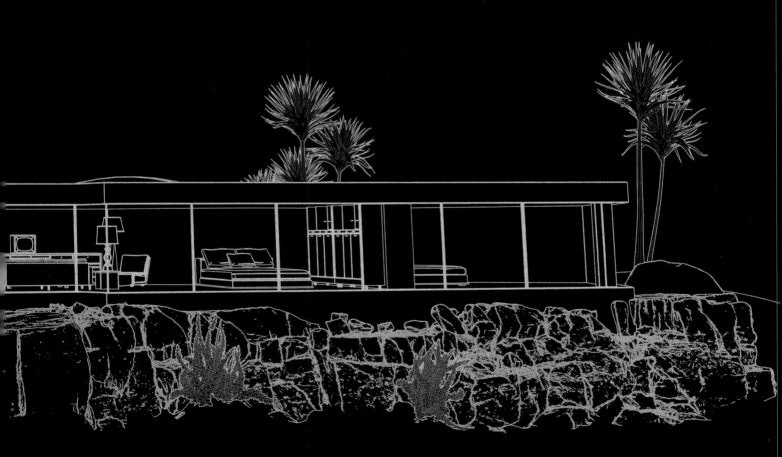

We are first introduced to the house when Connery's Bond arrives at Willard Whyte's villa and is met by a pair of acrobatic, scantily-clad female assassins code-named Bambi and Thumper, whose seductive come-ons quickly turn into a comically violent brawl in the home's breathtaking centerpiece—a spacious, circular living room that rapidly evolves into a sort of martial-arts gladiator ring. The dramatic living room of the 8,900-square-foot Elrod House is 60 feet in diameter and is topped by a slotted concrete canopy splayed out like the petals of a brutalist flower. The circular room is surrounded by retractable (at the push of a button, naturally) smoked-glass walls opening up to a terrace with a half-moon-shaped swimming pool that is partially indoors. It's here that 007, after taking his lumps from the two vixen assassins, dumps Bambi and Thumper.

When asked about the location years later, legendary Bond production designer Ken Adam said, "I wanted to give the feeling of a penthouse belonging to one of the wealthiest men in the world as well as a man who had been a brilliant designer and a brilliant engineer."[1] Mission accomplished, sir.

"I WAS LOOKING FOR A LOCATION FOR BOND'S FIGHT WITH THE TWO WOMEN…I DID FIND A FANTASTIC-LOOKING HOUSE MADE OF REINFORCED CONCRETE. IT WAS VERY FUTURISTIC AND I THOUGHT, 'I COULDN'T HAVE DESIGNED IT BETTER MYSELF'…IT LOOKS INCREDIBLE IN THE FILM."[2]

—Ken Adam

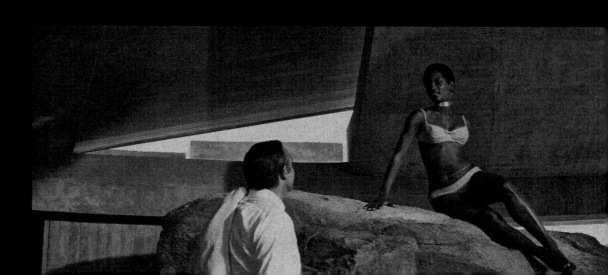

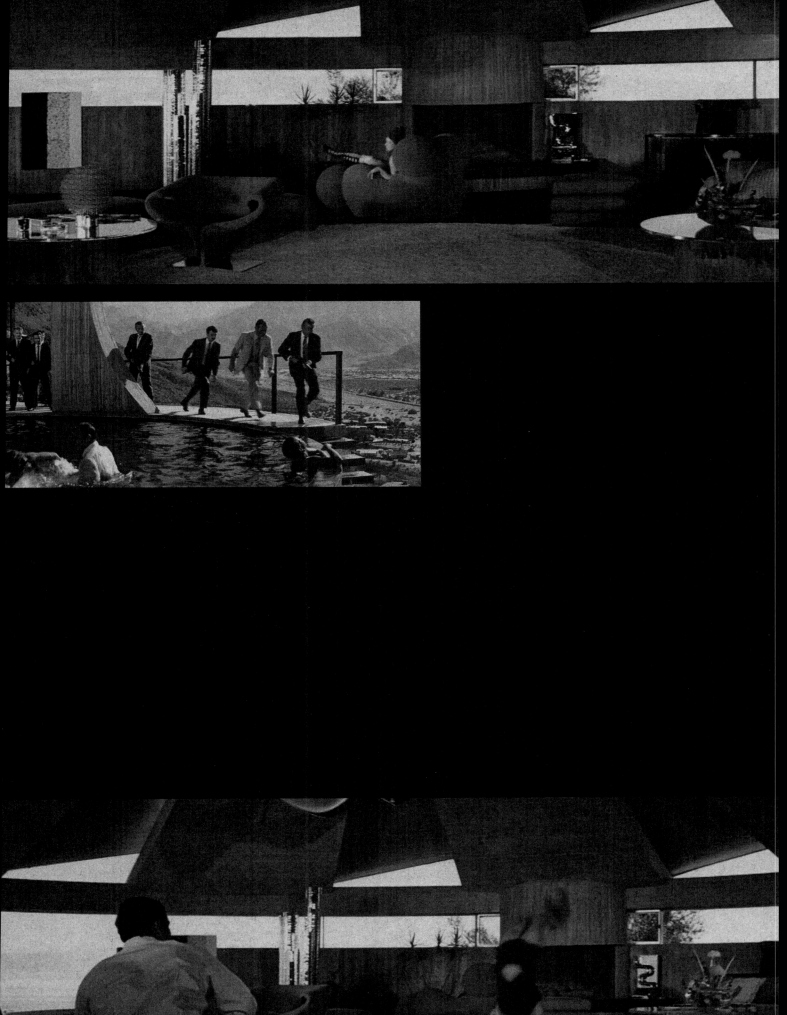

14
Exterior perspective of the Lautner-designed
Elrod House, which serves in the film as
Willard Whyte's winter villa—a stunning
example of organic architecture, where the
interior and exterior are integrated. Architectural
illustration. Carlos Fueyo. 2019.

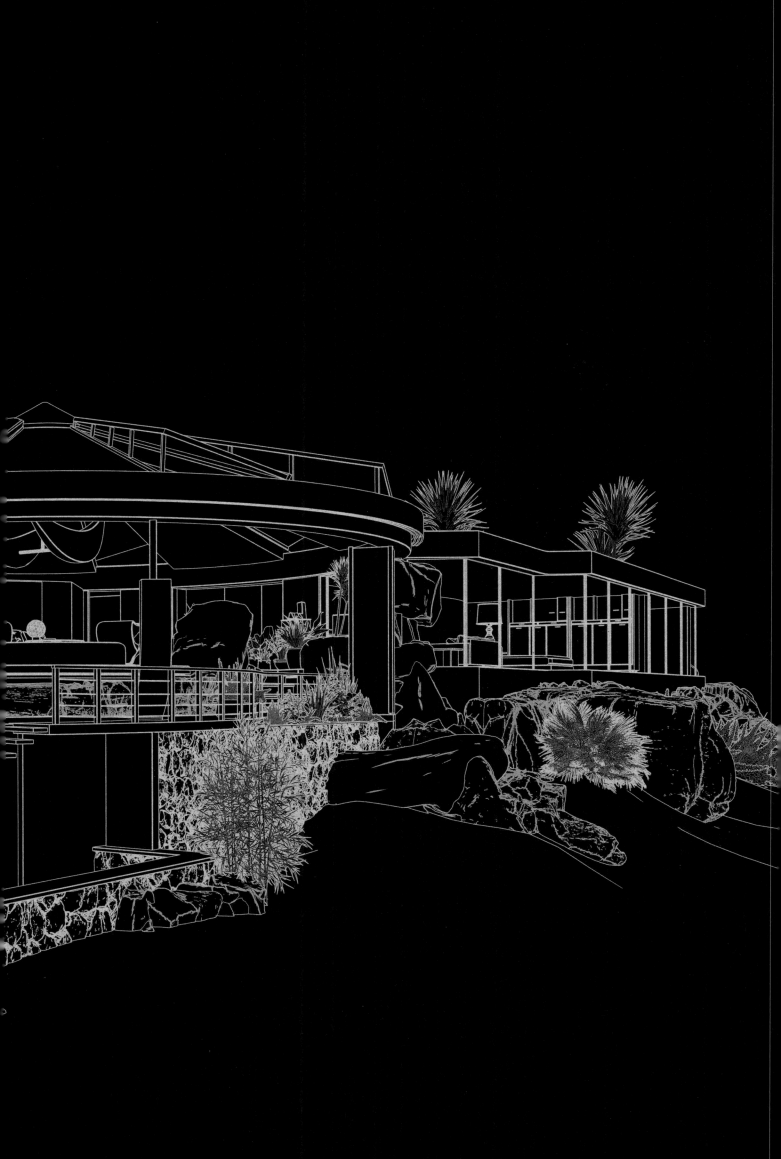

IT ISN'T ARCHITECTURE UNLESS IT'S ALIVE
EXCERPTS FROM AN ORAL HISTORY WITH ARCHITECT JOHN LAUTNER,
DESIGNER OF THE ELROD HOUSE

It's safe to say that John Lautner (1911–1994), the visionary modern architect whose distinctive houses Hollywood has celebrated for decades, did not design the Elrod House with James Bond in mind, just as his other houses were not designed with even a passing thought for the large cast of onscreen psychopaths, drug lords, pornographers, and run-of-the-mill bad guys who have called them home. Lautner's work is distinguished in part for the individuality of his designs, which were developed to respond to their sites. A protégé of Frank Lloyd Wright, who called him "the world's second-best architect," Lautner was active primarily in Southern California beginning in the late 1930s. He is best known for his houses, although his realized projects—of which there are more than one hundred—include apartment buildings, schools, offices, theaters, motels, commercial buildings, and places of worship. The Elrod House (1968), in Palm Springs, features a circular living room under a domed, concrete roof with glass inserts and the famous indoor-outdoor pool where, in *Diamonds Are Forever*, Sean Connery's Bond is deposited by two near-naked female assassins. Other Lautner houses featured in *Lair* are the Garcia Residence (1962) in *Lethal Weapon 2* and the Chemosphere (1960) in *Body Double*.

Lautner was interviewed by Marlene Laskey in 1986 for the UCLA Center for Oral History Research. Their discussion encompassed his philosophy of architecture, his education, his apprenticeship with Wright, and his subsequent career, with a focus on several projects, including the Elrod House. The following are excerpts from their talk.

ON ARCHITECTURE AND BEING AN ARCHITECT

JL John Lautner: I wanted the most free, most interesting, durable kind of life. And I discovered that architecture—I didn't fully realize it at the time, but I could see...there's food, clothing, and shelter, you know—is basic life. And so I thought, well, that's great. I can be an architect, and I'm working on one of the basic human needs and contributing to society as well as doing a special kind of work, so that it is completely legitimate from every standpoint. And it had to be, for my decision. But of course, after I got to Los Angeles, I discovered that shelter doesn't mean a damn thing. Food's the only thing that matters. And so architecture was just the first thing to save money on, or the first thing to omit, because it was a luxury instead of a basic thing. And unfortunately, it's still that way. If they considered architecture or understood the importance of its possible contribution to human welfare, it would be [as] important as food, clothing, and shelter, but now it's not...

ML Marlene Laskey: Speaking of clients, I would think that your nature, your type of architecture being so particularly personal and so unique, that your clients would have to be rather unique...

JL Well, they are. They're individuals, so I think it means that there aren't too many real individuals. Most people want something the same, you know. And that's hard for me to understand, when there is this infinite variety possible, why you should want to duplicate something. Of course, I've never been able to understand the conservative point of view anyway. I mean, that's beyond me; I just can't understand it at all. But that seems to be the dominant thing, it's all the same. So I am dependent on individuals...

ML You mentioned a little earlier in the conversation about space and your feelings about space, which I think is probably the main feeling one has when looking at one of your buildings, is the use of space—the kind of soaring arches that show up.

JL Well, to me, that's one of the biggest contributions to joy in life, to human welfare. So, when you contribute this kind of space, you're giving life, you know, to the environment. You can't ask for any more than a life-giving environment...

ML Some of your buildings look as if they have life, as if they're life forms...

JL To me, architecture is an art, naturally, and it isn't architecture unless it's alive. Alive is what art is. If it's not alive, it's dead, and it's not art. It's not quite that simple, but it's like that...

ML We're sitting here, looking out at the Hills, the Hollywood Hills. It's so pretty, and it is a challenge to make what you put in there not destroy that landscape, I would think.

JL Oh, sure. I've always been concerned with that. Usually, in the Hills, you have a panoramic view that people are interested in right away, and so most of my things are curved. The curved things just naturally go with the Hills, you know. While the boxes are just stuck there. The only thing you can do with the boxes is plant more trees. It's just fortunate that there are a lot of trees right there. If there weren't all those trees, that whole scene would be pretty ugly.

ML You have never come to terms with Los Angeles.

JL No, no. Well, I'm just one of many who are here because there is work. One way or another, there's work. I've never liked it, but I... have to be where there are millions of people to get a few individuals per year...

I always had a horror of any kind of routine, and that's one of the reasons that I ultimately chose architecture. Because I felt, when I was a student, that many professions became ruts and routines—and like there's old banker so-and-so, and old doctor so-and-so, and they're all "walking dead," as Frank Lloyd Wright would say. [laughter] But I've, since then, I've found that it's not necessary that other professions are ruts—a creative individual could do something with any kind of work. But inherent in architecture, it involves everything in life, so that there is absolutely no end to it. By the time you're seventy or eighty, you're still beginning. So, that's the kind of life I've preferred to being the expert at forty and dead, you know...

ON THE ELROD HOUSE

JL Elrod wouldn't wait for experimenting or researching something to get an ideal solution... His initial request, after he took me to see the property, was...he just said, "Give me what you think I should have on this property." And at that time, it was a flat, bulldozed hillside lot, like they make in the typical subdivisions. Nothing interesting about it except that it was a flat pad. So I got looking over the edge, and I saw these big, beautiful rock outcrops. And so I decided if he excavated about eight feet off of this pad, which had already been built, then these natural outcrops would be exposed in the house and more or less on the perimeter of [the] house. We could design something that's really built into the desert. He understood that right away and said, "You mean, those are going to be sculpture in the house?" I said, "Yes." And so he was willing to spend, I don't know, fifteen or twenty thousand more [dollars] to excavate the lot. Now that's something that most people wouldn't do...The way I looked at it, there isn't a single really integrated building designed for the desert in Palm Springs. They're all colonial or Spanish or I don't know what. They're just stuck there. They don't really have anything to do with the desert. So I decided we'd do something that really suited the desert. This circular concrete roof with triangular openings in it and triangular clerestories in it sort of fanned around, so that from the outside and the inside, it's sort of like a desert flower. And then, of course, being concrete, it would be right down on the boulders and rocks and become part of the whole scene. Once we had the concept, or the preliminary design for this one, Elrod just went straight ahead and built it, without any changes whatsoever. Just everything—no hitches at all.

ML How long did it take you to come up with the design for the roof?

JL That one wasn't too long, either. I suppose it was maybe a month before I really was satisfied with that design. But I got the idea, somehow, very soon, and I had a clay model made. One of my draftsmen at the time made pretty good models with the whole part of the mountain. Elrod came in and looked at it, and he [was] just delighted, you know. So we just went right ahead, no problem at all.

ML Did you run into construction problems? The house is actually built into the rock, isn't it? How would you form the wall after that?

JL Some of the rock becomes the wall. The main problem we had with that was that [there were] a lot of cracks in the rocks. We had a geologist check their structural value. He recommended bolting them together. So quite a few of them have long steel rods drilled right through the big outcrops, and they're bolted together. That's for earthquake [resistance].

ML How do you bolt, or drill, through a rock without cracking the rock?

JL They can. They have all kinds of drills. They used to drill for dynamite. They [can] drill a hole in the rocks (and they have long drills, twenty-, thirty-foot drills) right through the whole pile. And it's bolted together. We did all that. It's designed to resist earthquake and everything else, so it's fine. And then, of course, what really made it possible—I wouldn't have designed it that way if I didn't know who was going to build it. I told Elrod then, and I tell most of my clients, that you can't really design anything exceptional unless you know who's going to build it...I had this contractor that I originally got out from Chicago to do Silvertop [the Reiner-Burchill Residence, 1963], Wally Niewiadomski, and he's one of the best men I've ever seen in the building business...with Wally building it, it's a perfect job all the way through. Good client, good architect, and good builder, that's all you need. But that very seldom happens.

ML The glass—the pictures that I've seen of that house—that glass living room, living room walls, absolutely beautiful. Wasn't that a little tricky?

JL Oh, yes. Originally, it was faceted so that the glass would just abut glass, again without posts or mullions, so that it didn't interfere with the view. By having it on angles, and faceted, pieces would support each other, reinforce each other against [the] wind. We had certain corners where we should have had extra glass mullions, and Elrod knew this, but he didn't want to spend the money on it, and he was willing to take the chance. So we tried it that way, and it was beautiful. But they had an exceptional windstorm, like 120 [miles-per-hour] winds, and something was open, and it blew out. But he knew that could happen. But it was interesting to see [it] that way, because we had a party down there just after it was first finished—for the Palm Springs architects, actually [laughs]—and one of the older big firms there came up to me, and he said, "God, it's like being inside of a diamond." And it was; it was absolutely perfect. Then later on they used it for that movie, *Diamonds Are Forever*...

ML You were talking about the changes in the glass that you had made in the Elrod House.

JL Elrod decided he'd like to have it openable in the wintertime, so we made two twenty-five-foot-wide, curved—well, faceted, actually—glass doors and hung them on the perimeter of the roof, which fortunately had a big enough reinforced concrete beam and was strong enough—we checked the engineering—to hang these doors. We had an aircraft door company make them. The operation is motorized, electric, and counterbalanced, so you can push a button and get a fifty-foot opening to the view, to the desert and the whole situation, which is really beautiful and desirable.

ML Now, the pool goes under part of the door...

JL Yes. Well, with the glass on the perimeter, now the pool comes inside when the glass is closed, and the glass doors just have a neoprene flap on the bottom that comes down to the water, so it's pretty well sealed for air conditioning in the summer.

ML The pool looks like it was quite an engineering or a structural feat anyway.

JL Yes. The whole thing [is] on a mountainside, but it's a rock mountainside, so the foundations are all very good. The whole building is concrete, so there's nothing to go wrong with it. In fact, a lot of people—well, I guess most people don't realize at all that concrete is the best in every possible way, including earthquakes. It's better than steel....

MORE ON ARCHITECTURE

JL So I've been continually interested and experimenting with different kinds of spaces and structures and all of the values of architecture. So in these later projects that are just... they just represent further control and further experimentation in livable kinds of spaces and in durable values. That's a continuous, non-ending search, so I'm still doing it.

ML Is this something that you have to educate your clients to understand for the most part?

JL No. What has happened was that the clients came to me looking for something that comes from my work. For instance, [Kenneth] Reiner, who did Silvertop, had seen a half-dozen smaller houses I had done, and he had interviewed forty architects before he interviewed me. He decided I had the imagination and the ability that he was looking for. And I had quite a few clients like that. They were actually looking for architecture, looking for imagination, rather than the latest style, or stock, or this-or-that, or façade, or what-have-you. They wanted something real. I'm fortunate to have turned up a few clients like that, but there aren't very many. I've always complained about Los Angeles being bad architecturally and various other ways, and people say, "Well, why don't you move?" I've tried to figure out how I could move, and there's no way I could be in a place with less population because…I get maybe ten a year out of seven or eight million. The individuals who are looking for something real in architecture are very few…

I naturally like any kind of a challenge in architecture. In fact, the more challenge, the more interesting, and I think the more likely some total new, legitimate solution can come out…I'm still dependent on individual people who are not affected by the status quo or the conservative point of view…I really hate the conservative point of view; I mean, I can't understand it at all, really. Maintaining the status quo and playing it safe is absolutely doing nothing. I mean, why did we establish a free country, why are we trying to live, or why are we trying to do anything, if we're just going to be not doing anything?…

I have really had my neck out, and I don't blame a lot of architects for not sticking their neck out, because when you do, you're out of it, absolutely, you know. You get no cooperation. I mean, that's probably why I never got an interesting commercial job or an interesting public job, because I'm not part of the thing, you know. I'm not in there, I'm not on the inside…

FILM **THE SPY WHO LOVED ME**

VILLAIN **KARL STROMBERG**

LAIR **ATLANTIS**

FILM

The Cold War gets surprisingly steamy in the tenth installment in the James Bond movie cycle, the third (and undoubtedly, best) with Roger Moore in the lead. After a rear-projection ski-chase opening that climaxes with Bond jumping off an alpine cliff only to release a Union Jack parachute at the very last minute, two submarines, one British and one Russian, are hijacked by an unknown third party. The two hostile governments decide to forge a momentary détente, partnering their top agents (007 and Barbara Bach's Anya Amasova, a.k.a. Agent XXX) to track down the madman responsible while attempting to keep their sexual tension at bay. The trail of clues takes them from the bazaars of Cairo to the temples of Luxor to the coast of Sardinia, where they will finally set off to meet the "altruist" shipping tycoon Karl Stromberg (Curd Jürgens), who harbors a fiendish plan to pit the superpowers against each other while he creates a new civilization under the sea.

Release
1977

Director
Lewis Gilbert

Production Designer
Ken Adam

Cinematographer
Claude Renoir

Cast
Roger Moore
Barbara Bach
Richard Kiel
Curd Jürgens

Screenplay
Richard Maibaum
Christopher Wood

Studio
United Artists

Lair
The set and the famous 007 soundstage at Pinewood Studios, England, were designed by Ken Adam and built at the same time.

A model of Atlantis was shot in Sardinia, as was part of a full-sized leg that was built and filmed there, while another model was shot in the Bahamas.

Images
All photographs are from *The Spy Who Loved Me* and all architectural illustrations and renderings are based on the interior and exterior of Atlantis.

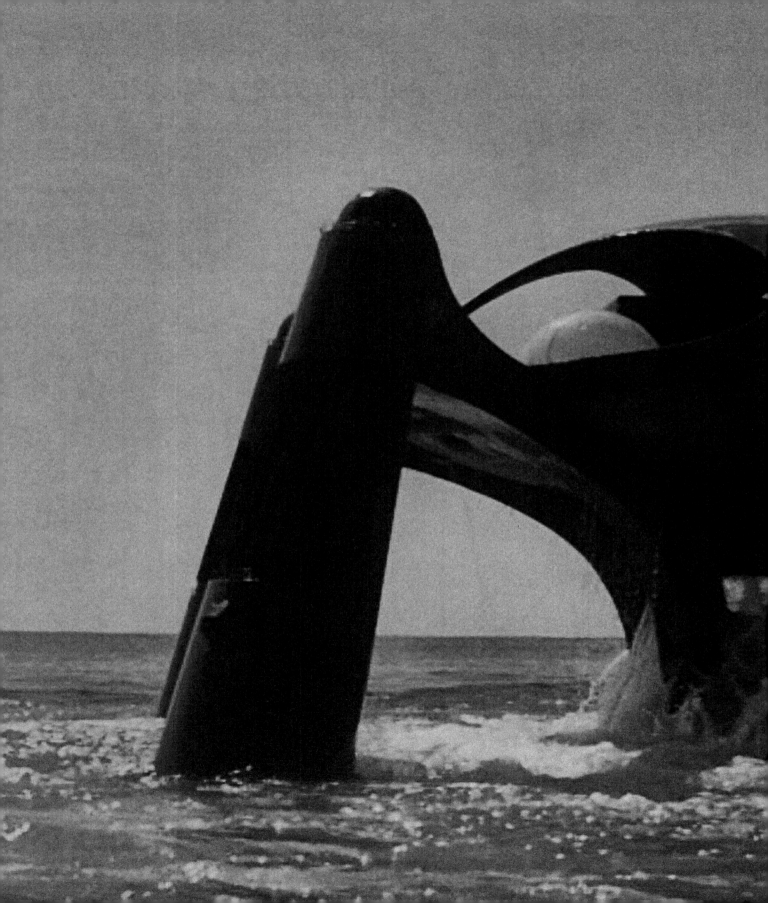

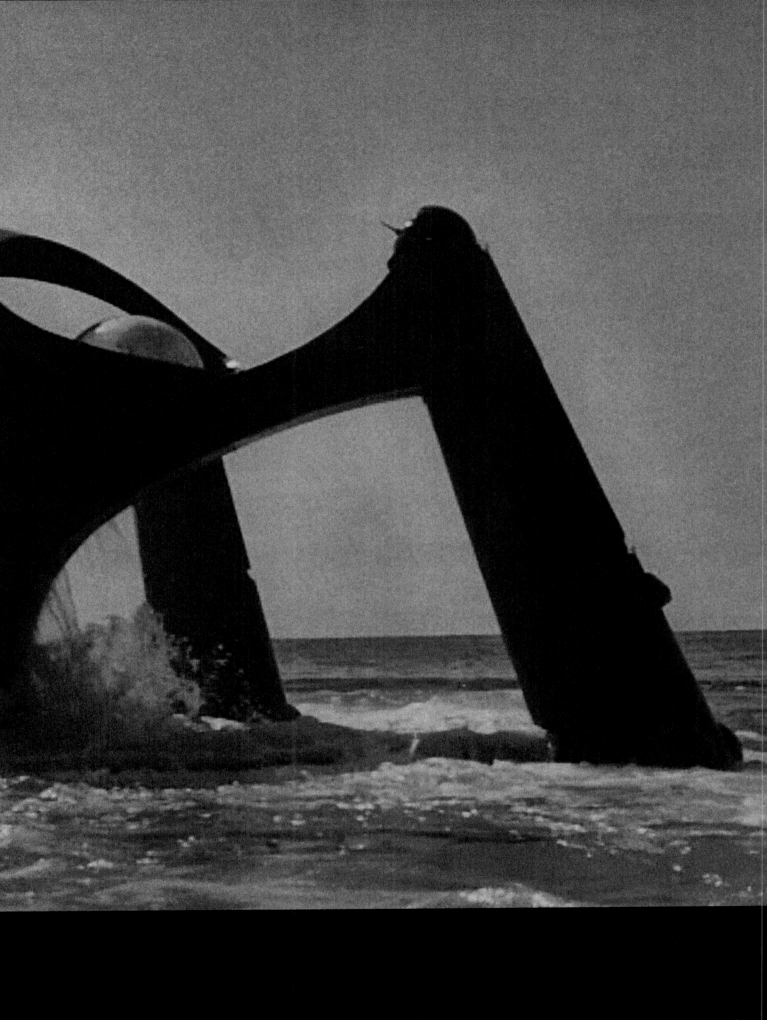

1
Karl Stromberg's evil underwater lair, Atlantis, rises
out of the sea. With its anthropomorphic stanchion
legs, it looks like a monster when, in fact, it's merely
the home of one. Still, *The Spy Who Loved Me*.

VILLAIN

While it may not pack the same freakish physiological curiosity factor as Francisco Scaramanga's superfluous third nipple in 1974's *The Man with the Golden Gun*, Karl Stromberg is believed to possess webbed fingers. This may or may not help to explain this Bond villain's particular affinity for the undersea world and its creatures. Played by the veteran Austrian heavy Curd Jürgens, who prior to *The Spy Who Loved Me* was best known for his turns in such cinematic war epics as *The Enemy Below* and *The Longest Day*, Stromberg takes a page from the Cold War-era Bond-villain playbook by attempting to pit both sides (East and West) against the middle, hoping to trigger World War III in the process. Then, and only then, will Stromberg be free to play God (or Poseidon) and create his own civilization from the underwater Eden of his submerged lair—the aptly-named Atlantis. He's like Jules Verne's Captain Nemo with a black caftan, an impressively thick Bavarian accent, and one of the all-time great henchmen: a lumbering, seven-foot-two-inch behemoth with steel-razor teeth named Jaws (Richard Kiel).

2
Austrian character actor Curd Jürgens as the marine-obsessed megalomaniac Karl Stromberg. Still. *The Spy Who Loved Me.*

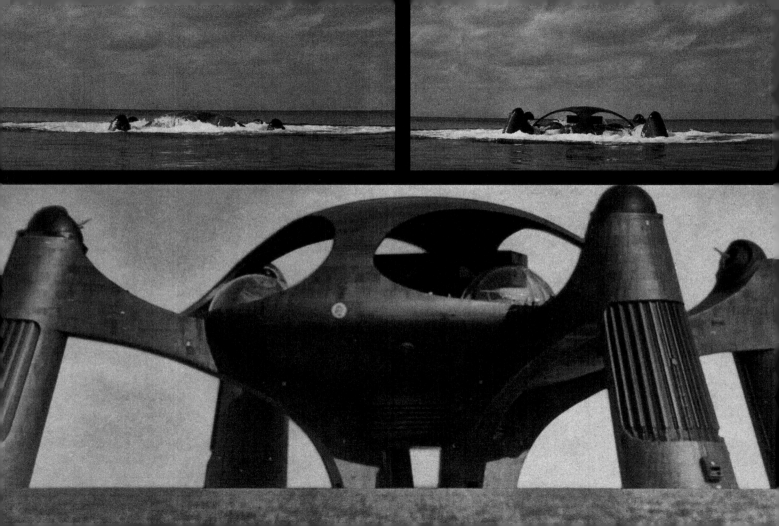

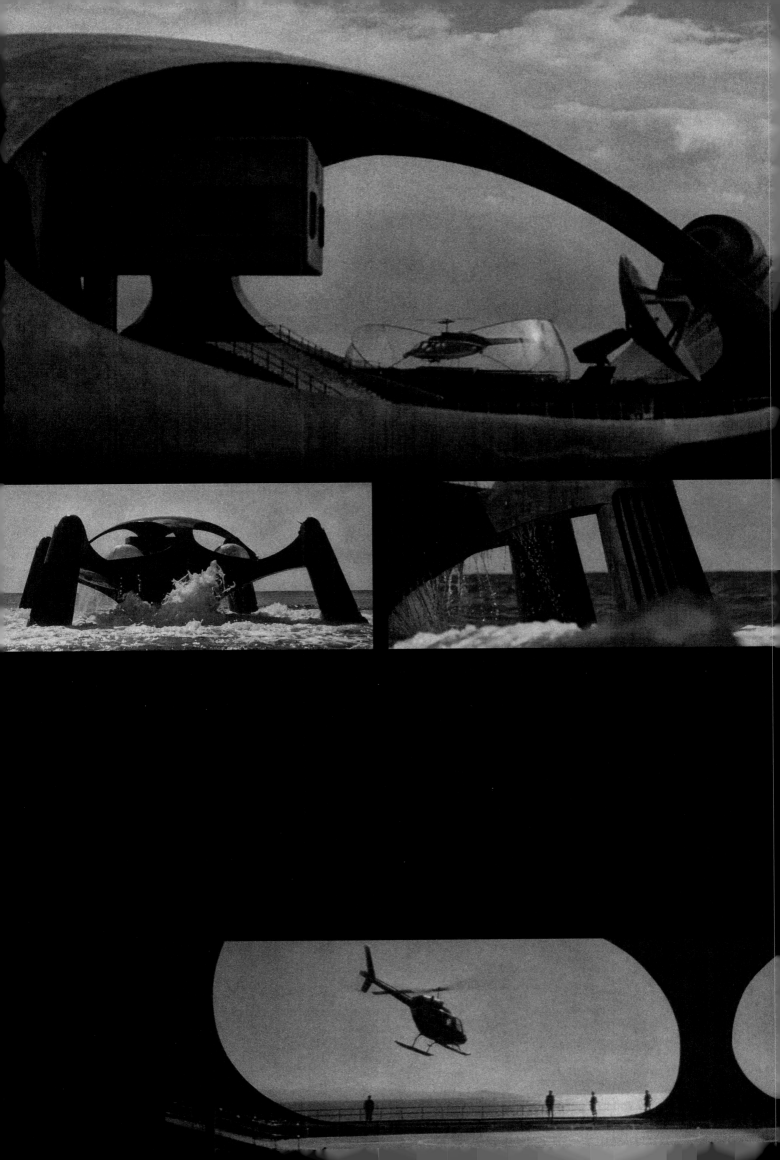

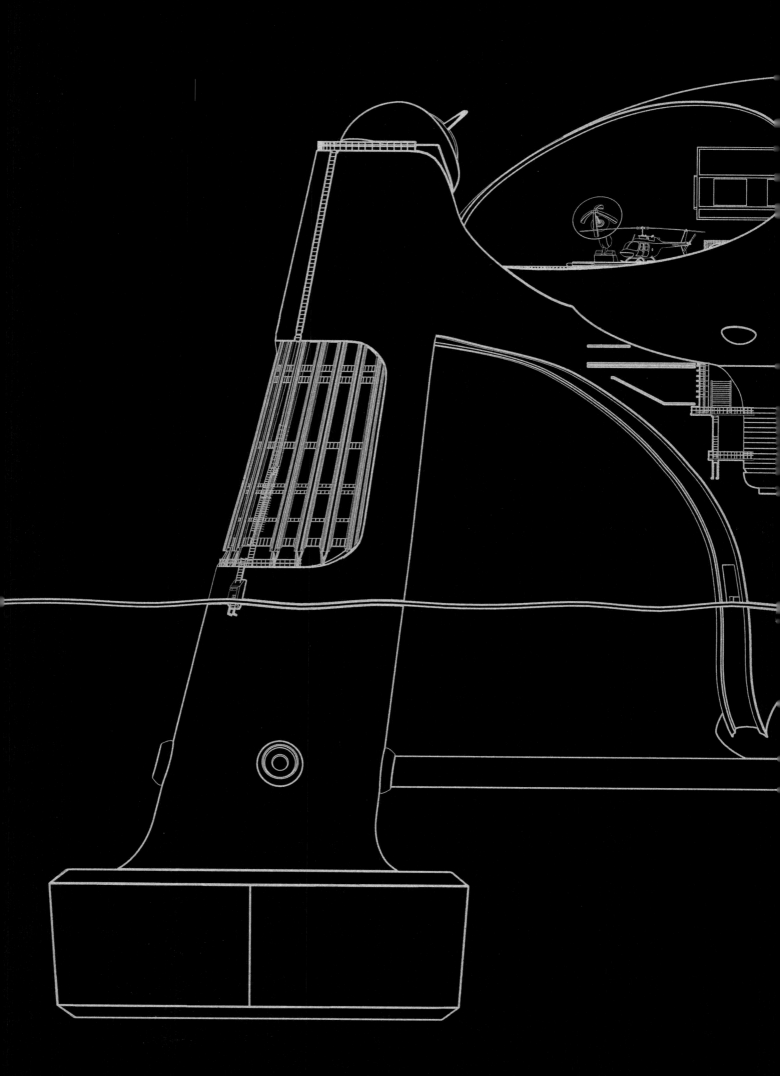

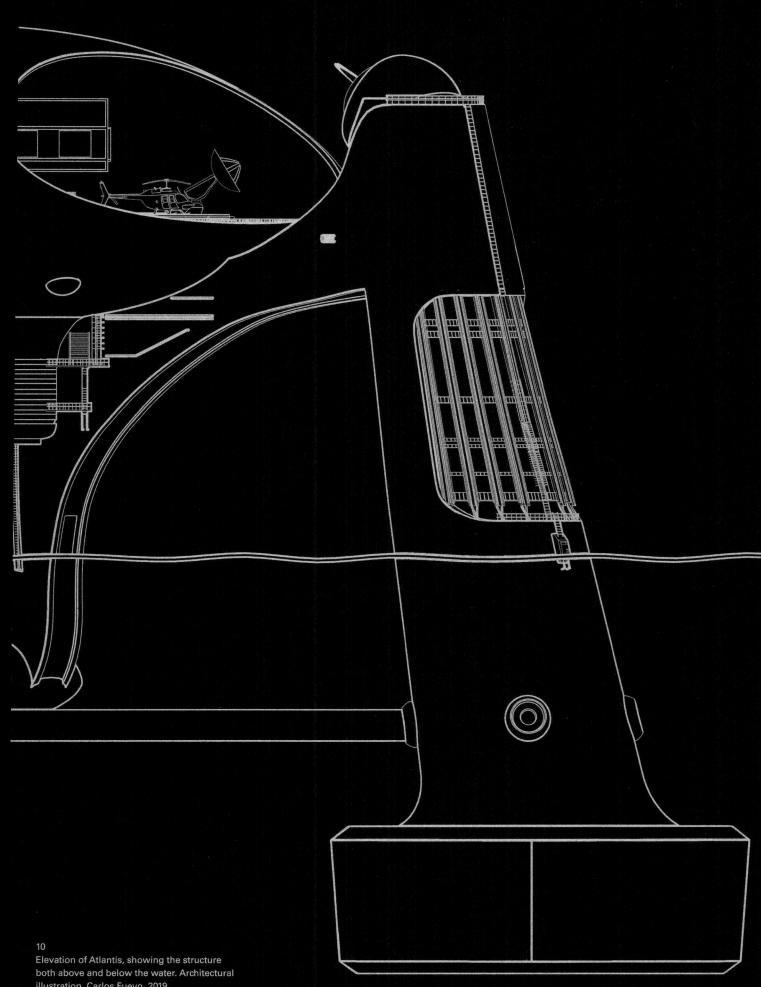

10
Elevation of Atlantis, showing the structure
both above and below the water. Architectural
illustration. Carlos Fueyo. 2019.

The inside, like the outside, is all organic curves, mirroring the wave-like textures of the deep. The chaises are white, squid-like Plexiglas blobs. The walls of the ornate dining room are lined with Old Master paintings that, again at the push of a button, retract to reveal large porthole windows with sweeping aquarium views. There are speedboat docks and a helipad on each of the stanchion legs. Everything inside matches the epic scale of Stromberg's sick, twisted ambitions, including an indoor shark tank that ends up being the chum-strewn repository for both his enemies and the many perceived traitors on his payroll (R.I.P. poor blond Stromberg assistant, we hardly knew ye). They wind up there via a stainless steel slide that is revealed by a trap door in the elevator's floor.

When Bond and Amasova first visit Atlantis, Stromberg lays out the nefarious sweep of his plan. "I intend to change the face of history," he says without an ounce of understatement. Amasova replies, "By destroying the world?" Stromberg grins and shakes his head. "By *creating* a world—a new and beautiful world beneath the sea. Today's civilization, as we know it, is corrupt and decadent. Inevitably, it will destroy itself. I'm merely accelerating the process."

In an interesting footnote to the times, not only was the character of Jaws a nod to the biggest blockbuster of its era, but producer Albert Broccoli also approached *Jaws'* director, Steven Spielberg, to direct *The Spy Who Loved Me*. He passed, and *You Only Live Twice* helmer Lewis Gilbert was hired. It goes without saying that a set as enormous and architecturally improbable as Atlantis wasn't actually built off Sardinia, in the middle of the Tyrrhenian Sea. Instead, veteran Bond production designer Ken Adam (returning to the franchise for the first time since 1971's *Diamonds Are Forever* and his Oscar win for Stanley Kubrick's *Barry Lyndon*) and model builder Derek Meddings constructed a miniature Atlantis measuring roughly ten feet in height and filmed it at Coral Harbor, Nassau, in the Bahamas. Clearly, it was the only thing about Stromberg and his fiendish plot that wasn't epic.

11, 12
Stromberg proudly shows off his underwater paradise to Roger Moore's 007 before trying to intimidate him with his Poseidon-like power. Stills. *The Spy Who Loved Me.*

13
Interior perspective of Atlantis that conveys Stromberg's flair for design (the groovy, blob-like chairs), form (the porthole windows), and function (the computerized control panel that raises and lowers his lair). Rendering. Carlos Fueyo. 2019.

11
12
13

Architects' Commentary
Highlights from Oppenheim Architecture's round-table discussion of The Spy Who Loved Me

"Atlantis is so inspiring—the shapes, the form. It looks like an insect. It's anthropomorphic, it's futuristic, it's just so out there."

"Ken Adam was the production designer, and the design of Atlantis was in part a challenge he set for himself. He usually worked with linear designs, and he wanted to experiment with curved surfaces. Also, he was inspired by the French architect Jacques Couëlle, who designed very sculptural buildings that responded to the landscape."

"The interiors of Atlantis are extremely interesting. They are a bit baroque, a bit Gothic. You have the big windows, and you're underwater, and there's a fireplace, and paintings, and candles, and there's classical music. You have that long table that's so diabolical. And then you have the shark tank where people are deposited to be disposed of. It's all so fantastic."

"The contrasts are part of what makes Atlantis so effective. There is the most futuristic exoskeleton and then this classical interior space. There is the contrast of the utilitarian nature of the ship itself as opposed to this odd baroque room within that is not practical. Thematically, the sophisticated design of both the exterior and interior contrasts with the brutality of the shark tank and, of course, the villain. Stromberg is reworking the world to his own desires, based on his malformation."

"It's interesting to look at Atlantis in the context of this book and realize that, unconsciously, it was an inspiration for some of our design work, and particularly of Sheybarah, a resort on the Red Sea in Saudi Arabia. We didn't even realize that relationship before, but it's undeniable—the correlations are so strong."

JAMES BOND:
"DON'T YOU MISS THE OUTSIDE WORLD?"

STROMBERG:
"FOR ME, THIS IS ALL THE WORLD.
THERE IS BEAUTY...THERE
IS UGLINESS...AND THERE IS DEATH."

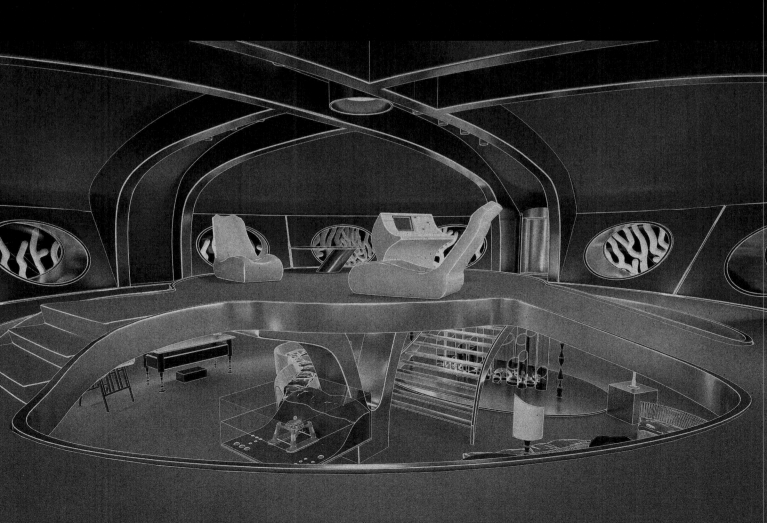

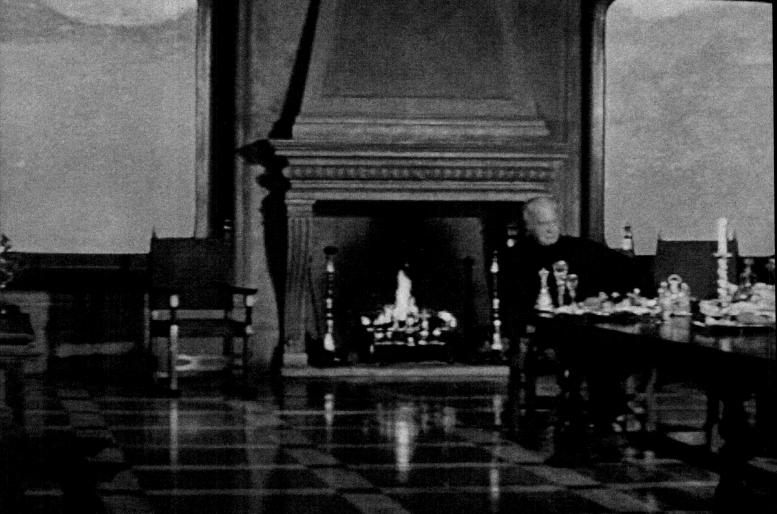

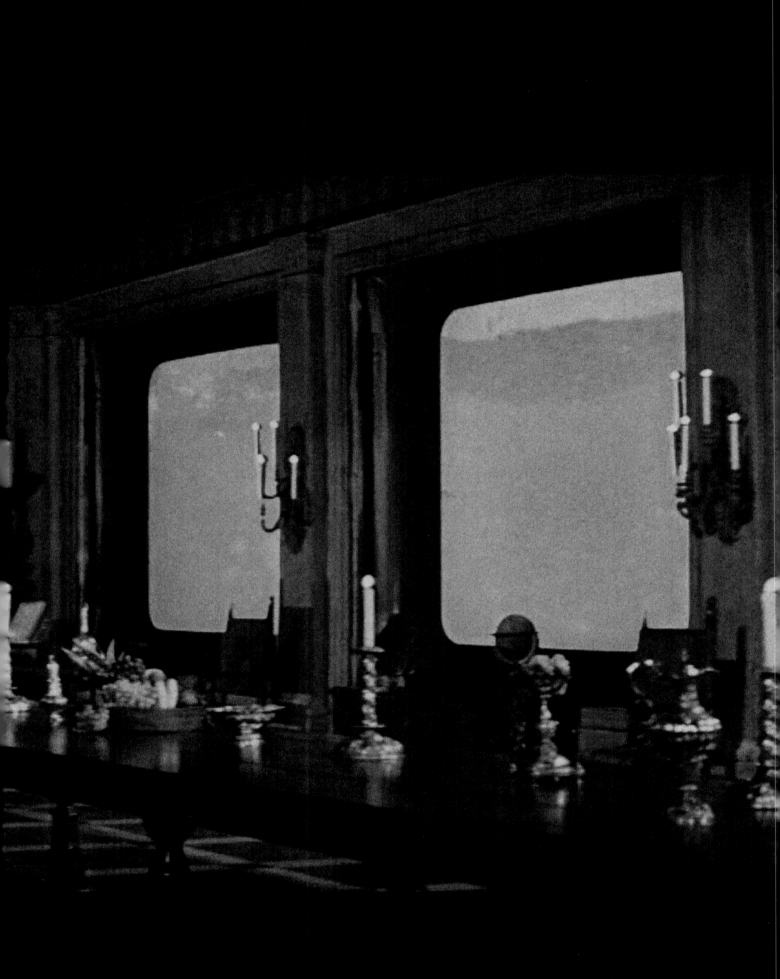

14
Stromberg at the head of his sixty-foot-long dining table, the immense size of which conveys the massive scale of Atlantis. The lobster feast, the roaring fire, and the marble floors are a testament to his refined taste—the hallmark of any great movie villain. At the push of a button, the Old Master paintings that line the walls of the room retract to reveal oversized aquarium windows, as shown here. Still. *The Spy Who Loved Me.*

15
Perspective cutaway, showing the exterior of
Atlantis with strategic cuts to reveal views of many
levels of the interior and an artistic interpretation
of the mechanical workings of the structure.
Architectural illustration. Carlos Fueyo. 2019.

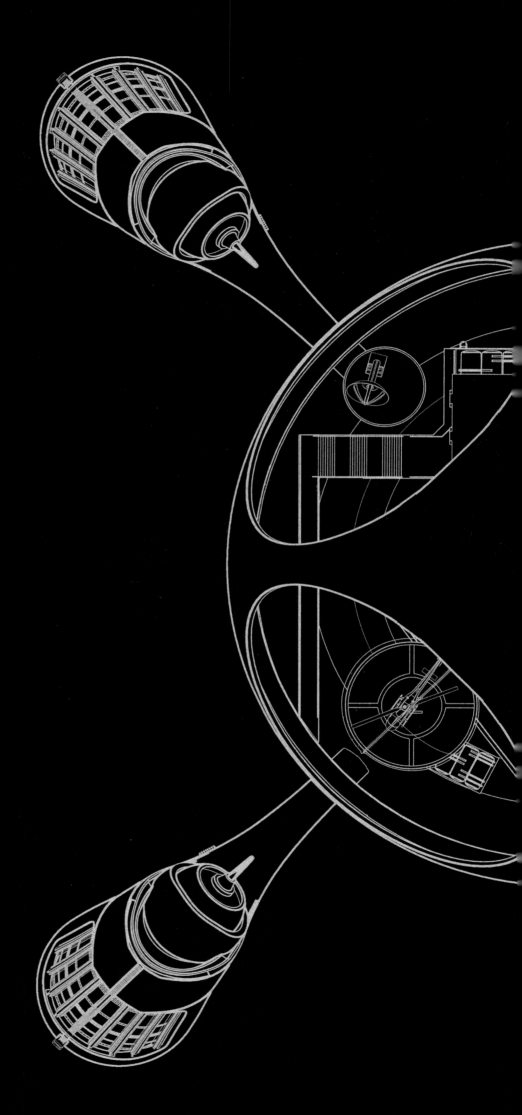

16
Plan of Atlantis. This view from above highlights
the four giant oval windows on the structure's
crown, which bring to mind the eyes of a
prehistoric underwater beast. Architectural
illustration. Carlos Fueyo. 2019.

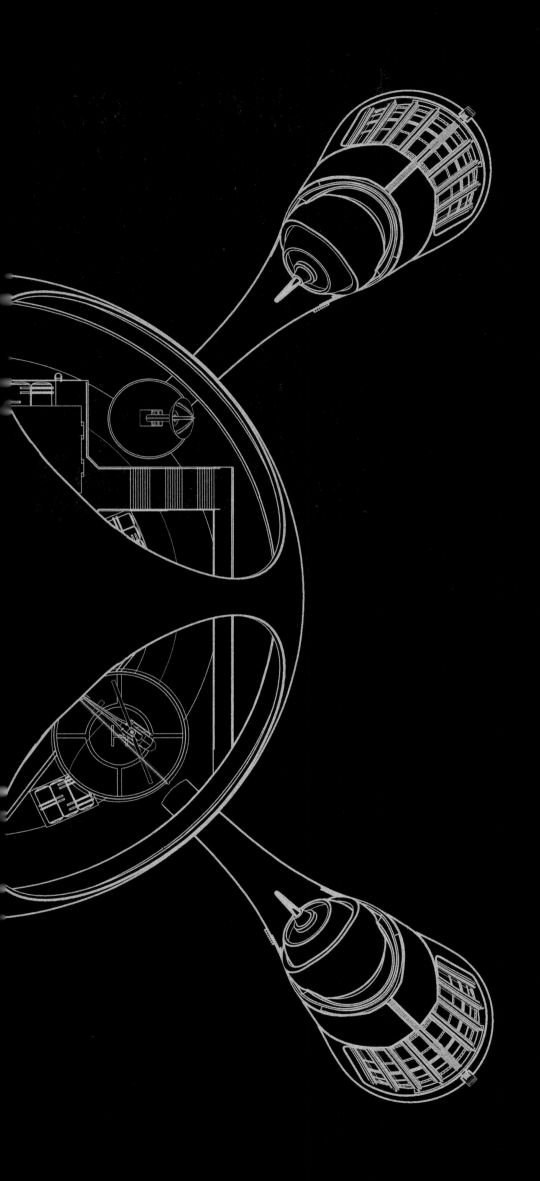

EX MACHINA

NATHAN

VILLAIN NATHAN

BATEMAN

LAIR ALASKAN

COMPOUND

Nathan Bateman (Oscar Isaac) is a reclusive digital media tycoon who invites Caleb (Domhnall Gleeson), a programmer at his company, to his hideaway bunker deep in the vast wilderness of Alaska to meet his newest invention: the sensuous robot Ava (Alicia Vikander). Caleb's task is to test Ava, to determine, through a series of interviews, whether her artificial intelligence can think for itself. If it can fool humans, she would represent "the greatest scientific event in the history of man," as Nathan so modestly claims. Of course, Ava, with her half-metal head and innocent curiosity, looks decidedly *not* human, but she certainly has desires—she wants out of Nathan's secret research facility, and Caleb just might be her ticket.

Release
2014

Director
Alex Garland

Production Designer
Mark Digby

Cinematographer
Rob Hardy

Cast
Domhnall Gleeson
Alicia Vikander
Oscar Isaac
Sonoya Mizuno

Screenplay
Alex Garland

Studio
A24

Lair
Juvet Landscape Hotel, Alstad, Norway,
Jensen & Skodvin, architects, 2007–09 and
2012–13 (exteriors and interiors); Summer
House, Storfjord, Norway, Jensen & Skodvin,
architects, 2013 (interiors); and Pinewood
Studios, England (interiors).

Images
All photographs are from *Ex Machina* and all
architectural illustrations and renderings are
based on spaces in the film.

1
Exterior view of mad tech mogul Nathan Bateman's
Alaskan compound (with Norway standing in for the
Last Frontier state), nearly hidden by the surrounding

VILLAIN

Alternately helpful and rude, brilliant and wasted, and living alone save for his mute servant-concubine, Kyoko (Sonoya Mizuno), Nathan is either a dauntless pioneer or dangerously loony. He's a man of extremes, a brooding Mark Zuckerberg with a six-pack, alternately drinking himself into a nightly stupor or working up a sweat pounding the punching bag. He stores naked androids—previous incarnations of Ava—like treasured dolls in his bedroom closet. If Nathan is Dr. Frankenstein by way of Silicon Valley, Ava is his monster, and she's no saint. Yes, Ava is beautiful, but she's a femme fatale, very creepily designed as such by a man with a God complex. If Joaquin Phoenix can fall for an operating system in *Her*, and a man in Japan can marry a hologram, there's not much disbelief to suspend when Caleb tumbles so hard for Ava, a fembot not only in possession of most of her lady parts, but one engineered by Nathan specifically for (or against) Caleb. There are so many disquieting power struggles in *Ex Machina*— Nathan manipulating Caleb, Caleb duping Nathan, Ava baiting Nathan—that while Nathan is our villain, dig deeper and perhaps human nature is the real villain. Is Ava manipulating Caleb only to slip the bonds of her inventor, or is she genuinely interested? "I gave her one way out," Nathan confesses to Caleb near the film's climax. "To escape, she'd have to use self-awareness, imagination, manipulation, sexuality, empathy, and she did. Now, if that isn't true AI, what the fuck is?" As it turns out, Ava's survival instinct is just as human as Nathan's scheming.

2
Oscar Isaac as Bateman, a brilliant hipster recluse working on the cutting-edge of artificial intelligence. Still. *Ex Machina*.

LAIR

"This building isn't a house. It's a research facility," Nathan tells Caleb on their initial tour of his isolated fortress. "Buried in these walls is enough fiber optic cable to reach the moon and lasso it." As enchanting as it is tucked away, and with an entire level hidden underground, like a docked subterranean spaceship ready to blast up and out, Nathan's modernist home incorporates a composite of two actual locations, both designed by the architectural firm Jensen & Skodvin and located in Norway: a private home in the Valldal region of the country and the nearby Juvet Landscape Hotel.

The home, used for some interior scenes, has gorgeous, expansive views of a lake and mountains, but an underabundance of trees, considering the film's Alaskan setting. Tall trees were imported and placed on twenty-meter-high stilts to create an Alaskan vibe. The hotel, perched on a steep levee within a nature reserve, is a minimalist marvel that blends into the wilderness—in building the hotel, no alterations to the terrain or rock blasting were permitted. The result is a series of birdhouse-shaped log houses that jut perilously over slopes and a collection of guest rooms that are stand-alone cubes supported by huge steel rods drilled into the rock, each with one or two glass walls that offer eye-popping views of glacial mountains.

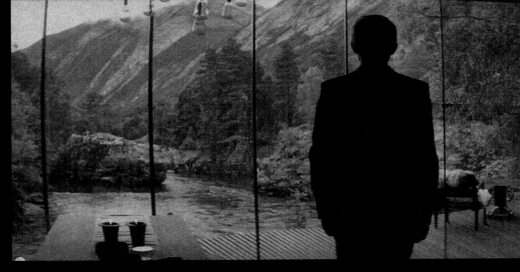

3
4 5

3
An exterior view of Bateman's hard-to-reach
compound, hiding in plain sight by virtue of the
wilderness around it. Still. *Ex Machina*.

4
The clean, precise lines of Bateman's compound
contrast with its surroundings. Bateman has
carved out a sense of order from the untamed
beauty of his environment. Still. *Ex Machina*.

5
Domhnall Gleeson's Caleb feels, at first, like a
privileged stranger in a strange land, taking in the
expansive view of the natural beauty of his host's
remote estate. Still. *Ex Machina*.

Nature intrudes everywhere in Nathan's sleek, sophisticated compound, emphasizing the tension between the natural world and technology. Glass walls in Nathan's kitchen point toward amazing views of a valley, river, and gorge. A jagged, exposed rock wall quite literally protrudes into Nathan's living room, for anyone who hasn't quite grasped the dichotomy that this home in the woods doubles as a robot-building laboratory. Nathan's hideaway is part Zen palace and part man cave, with some nifty special effects—at one point, the concrete-walled, windowless lounge morphs into a disco room—and it's all so vigorously detailed that it's in lockstep with Nathan's personality. He's a collector of things, from the android models he makes and keeps to an assortment of high-end, mid-century modern design, to highbrow art, including the $140 million Jackson Pollock painting *No. 5, 1948* in his lounge.

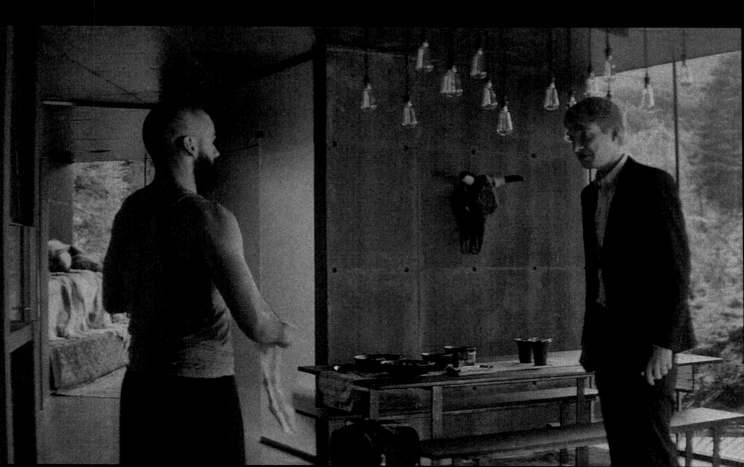

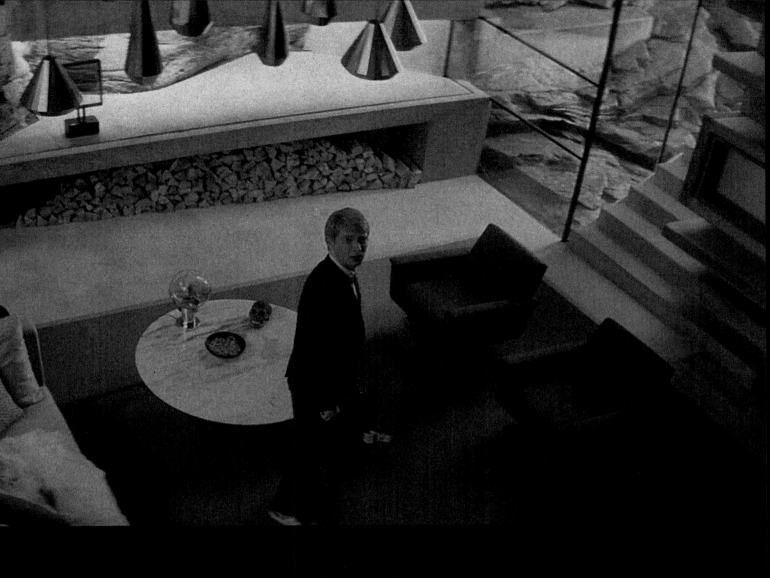

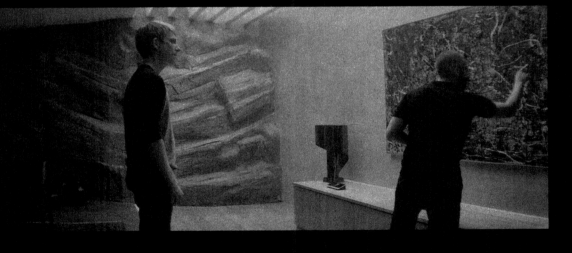

6

7 8

 9

6
Caleb in Bateman's living room. It doesn't take long for him to realize that he is not so much a lucky guest as an unlucky part of his host's latest experiment. Still. *Ex Machina*.

7
Isaac's Nathan and Gleeson's Caleb playing a cat-and-mouse game in Bateman's dining room. The mood in the interior of the home is chilly and controlled. Still. *Ex Machina*.

8
Nathan shows off the treasures that his immense wealth can buy, such as Jackson Pollock's *No.5, 1948*, which is hanging in the immaculate lounge. If it's meant to impress and intimidate his guest, it works. Still. *Ex Machina*.

9
With a God complex that rivals that of Dr. Frankenstein's, Nathan shows Caleb the fruits of his revolutionary experiments in artificial intelligence. Little does Caleb know that he's about to become part of his latest experiment. Still. *Ex Machina*.

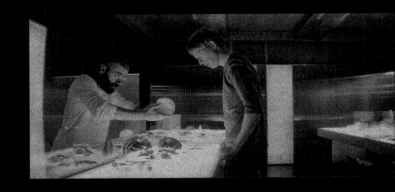

Director Alex Garland clearly likes playing with visual dualities: warm sunrises above and cold, antiseptic labs below; lush landscapes above and sterile, windowless bunker-like rooms below (the underground portion of the house, while modeled on the hotel's interiors, was filmed on soundstages). The compound is a sleek fishbowl of a world, closed off with keycards that keep Caleb locked out of most rooms. Nathan's lair, to paraphrase Nathan himself, is really a rat's maze, and Caleb is closely monitored through closed-circuit cameras in every room. As in the sunlit rooms upstairs, glass walls are everywhere in Nathan's lab, yet a persistent sense of claustrophobia lingers in the Apple-store whiteness of the rooms, which sometimes turn blood-red when Ava triggers a power outage. And of course, Ava herself is an embodiment of the conflict between nature and technology that runs through the film.

While Nathan's home exemplifies architectural splendor and tech savvy, it is also a new kind of villain's lair, according to production designer Mark Digby, a deliberate move away from the expansive spaces, opulence, and sheer over-the-topness of the kind of villains' lairs we're used to from Bond films. Nathan's home, while incredible, is also deeply practical, flawlessly designed to suit the man and his work.

Architects' Commentary
Highlights from Oppenheim Architecture's round-table discussion of Ex Machina

"This is not about being the wealthiest person and having the biggest house, which is a value you also see today in Silicon Valley. Nathan's house is nestled in nature. It seems like it's Walden, it's Thoreau. It seems innocuous. You can barely see the structures through the trees, and it incorporates natural elements around it and even within it. But then you go underneath, you descend into his lair, you're underground, and it has long, antiseptic hallways, it's claustrophobic, and you never see the architecture of that subterranean level."

"This is a vertical dichotomy, which we see in many other villains' lairs: good upstairs, bad downstairs. We have the phenomenology of the lair, of going downstairs into this other space that has no reference or relationship to what is above."

"The underground section is sectional, and that condition in the house is echoed in Nathan's life and in the technology of his company, Blue Book, which is like a combination of Google and Facebook. And it relates to our contemporary digital culture, which has this seemingly innocuous top layer, but below that it's insidious: we're being studied and watched and there is all this experimentation going on."

"And then we have the relationship with nature. Nathan has so much money that he can do anything, and he buys a portion of Alaska. With his house he seems to be saying, 'Look at me, gently touching nature.' But of course he's not doing that at all. He's manipulating nature."

10
Alicia Vikander as Ava, the AI femme fatale, in Nathan's museum-like subterranean hall of failed prototypes. Is she more machine than woman—or the opposite? Still. *Ex Machina.*

11
Caleb interrogates Ava through a glass partition. But it's not clear which one of them is the prisoner in a cage... yet. Still. *Ex Machina.*

10

11

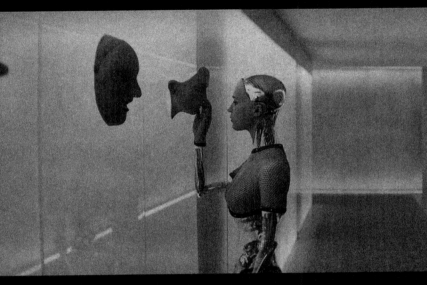

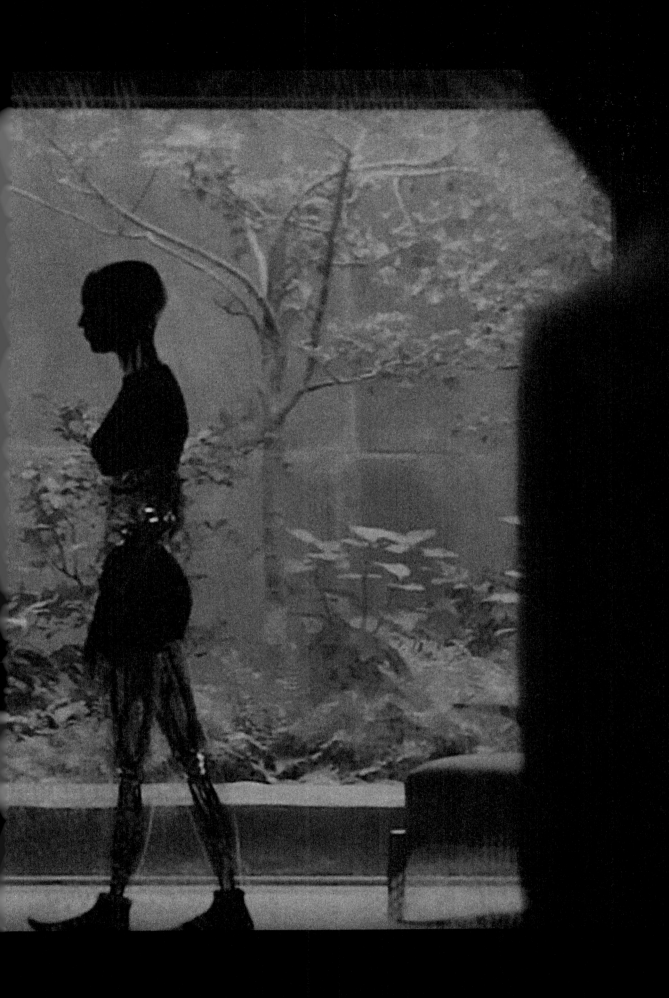

12
Initial view of Ava, from Caleb's perspective. At
first glance, she's clearly not human. But after
Caleb asks her a series of questions, he begins to
doubt that she's purely an assemblage of circuits
and computer chips. Still. *Ex Machina*.

"[NATHAN'S HOUSE] REFLECTS HIS CHARACTER. IT'S STRONG. IT'S BOLD. HE HAS EVERYTHING HE NEEDS BUT NO MORE. IT IS FILLED WITH THINGS THAT PLEASE HIM. EVERYTHING HAS A PURPOSE. THE FURNITURE IS BEAUTIFUL AND FUNCTIONAL AND IT IS OF AFFLUENCE AND IT IS BESPOKE. AND HE IS MAKING A BESPOKE PERSON."[1]

– Mark Digby

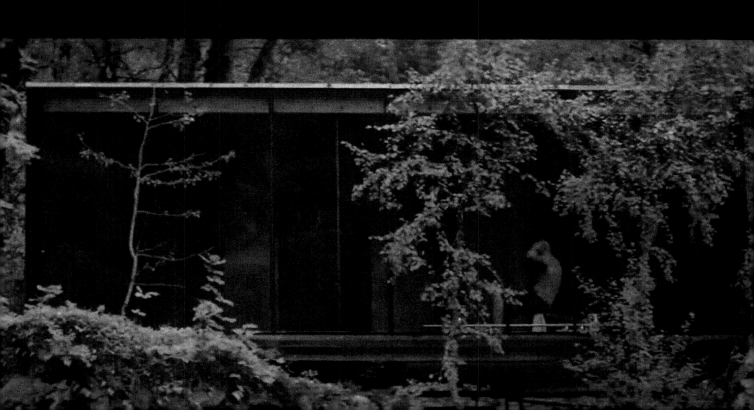

13
View of a portion of the exterior of Bateman's
glass-box compound with the owner exercising inside.
Still. *Ex Machina.*

14
Caleb and Nathan square off through a wall of glass
as Caleb begins to discover that he's playing the role
of a rat in a maze. Still. *Ex Machina.*

15
Nathan's underground lounge, which morphs into a
disco. The stone walls are a way of bringing nature
inside. Still. *Ex Machina.*

13 14
 15

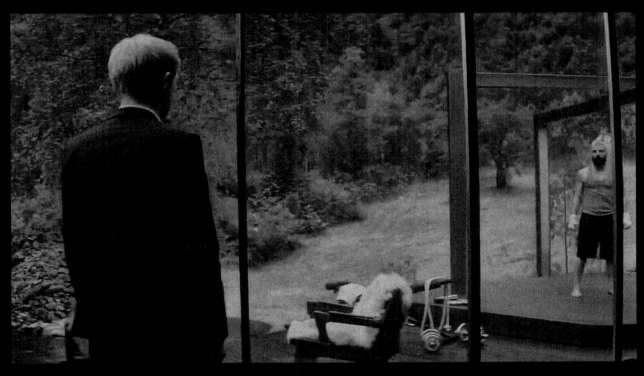

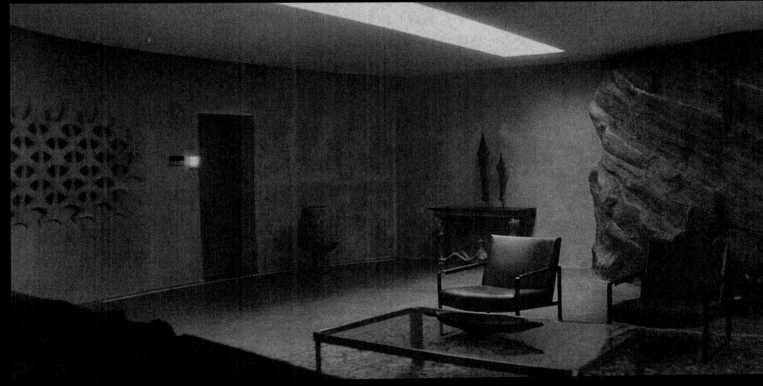

Perspective plan of Ava's quar
cameras that spy on her every move
sorts. Architectural

Perspective views of Ava's quarters.
points largely not seen in the film a
spatial information, some from Av
shows the space where Caleb c
human she is; the middle rendering
the bottom rendering references
image 12), but the space is shown f
of the window

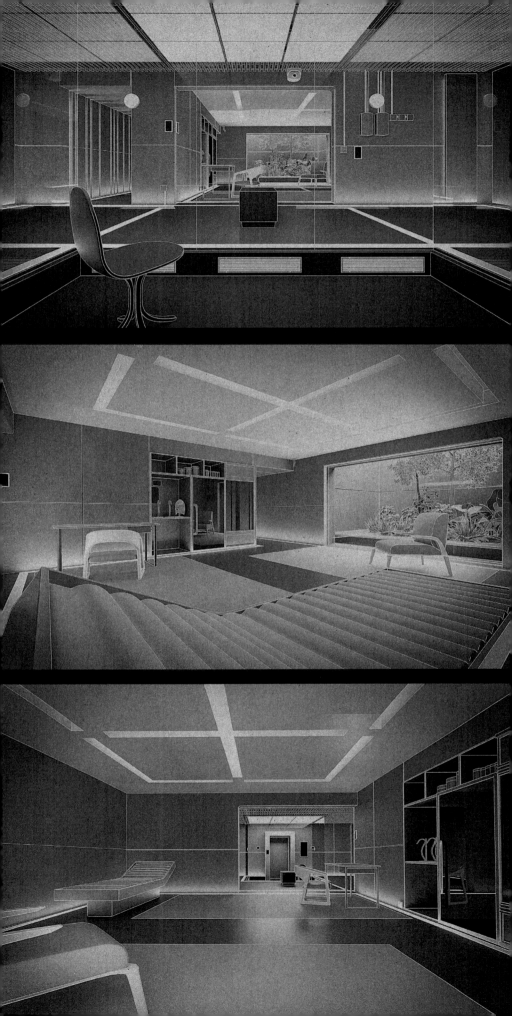

Longitudinal section of Nathan's house showing the levels of the house in
relation to each other as well as the house in relation to nature, both within
and without. The top level is above ground. Below that, the three rectangular
openings in the center expose embedded fiber optic cables. The lowest level
is the subterranean level, with the glass wall of the hallway represented
as well as Ava's private quarters and the space where she and Caleb meet.
Architectural illustration. Carlos Fueyo. 2019.

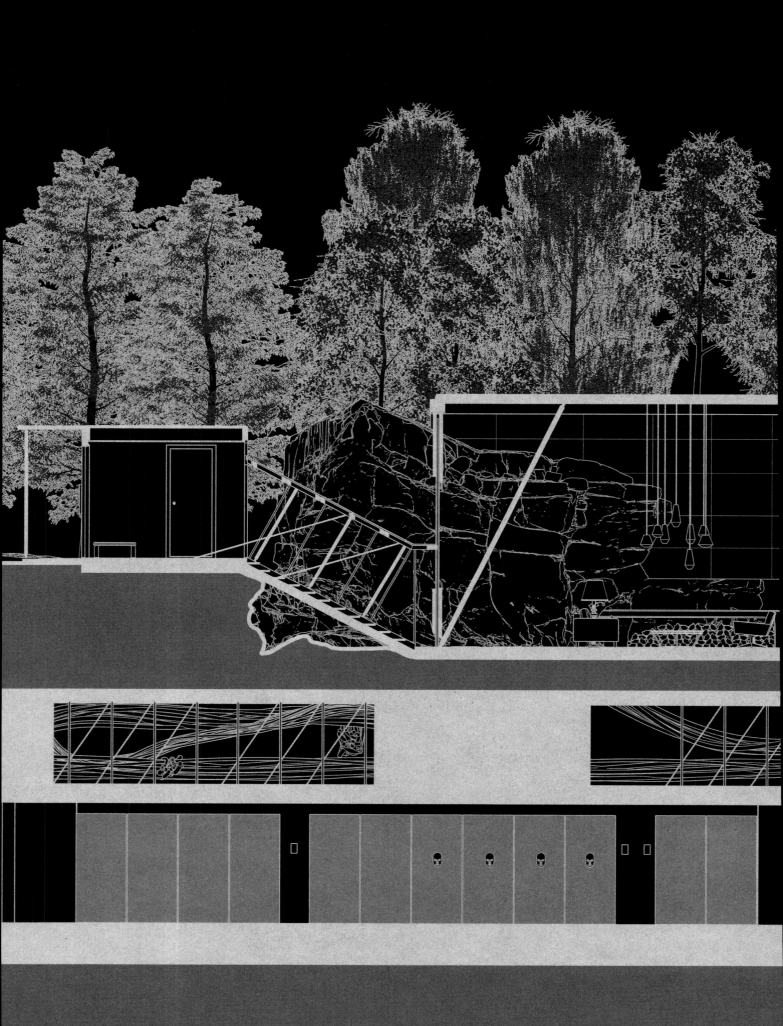

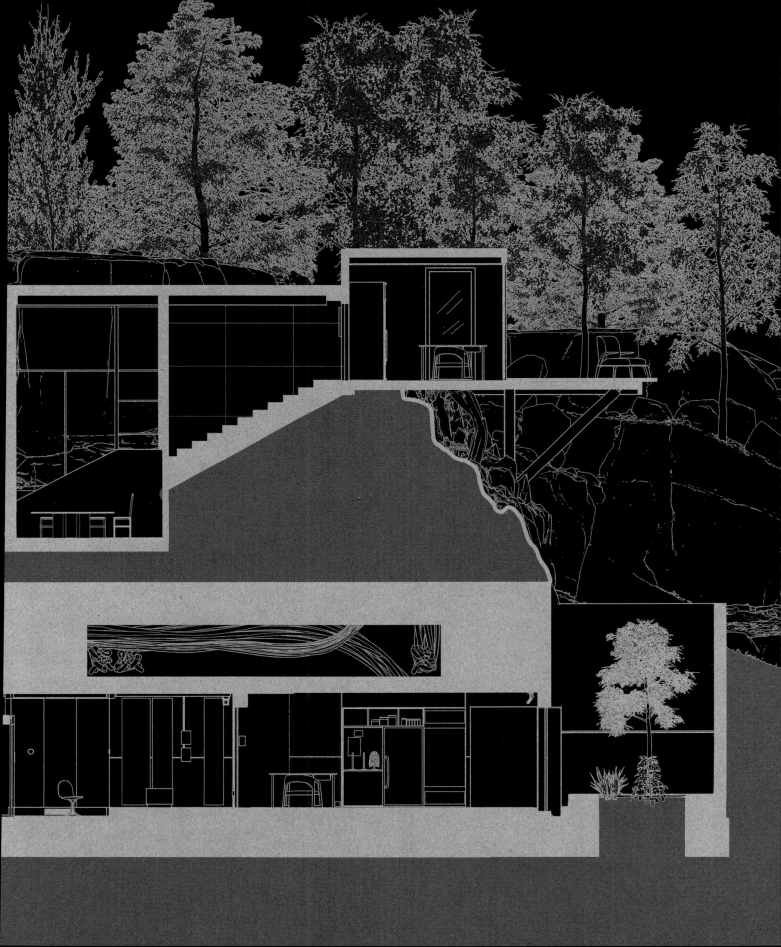

A high-tech facility hidden in plain sight deep in the wilds of Alaska. When you enter Nathan Bateman's seemingly rustic house, there's no sense of what lies below, just as you have no sense of what is beneath the façades of his creations (or, at times, even tha they *are* his creations). Throughout *Ex Machina*, production designer Mark Digby subtly plays with the dichotomy between the natural and the man-made, between what occurs organically and what is a product of technology, between what you see and what you g Digby, who has worked on dozens of films, among them *Annihilation* (2018), *Rush* (2013 and *Slumdog Millionaire* (2008), spoke with Tra Publishing about *Ex Machina*, his design process, and villains' lairs.

Tra Publishing: You originally envisioned a very different type of house for Nathan. Can you walk us through the process?

Mark Digby: Yes, and the process is a common one. It was difficult finding spaces. When you read something, you are influenced by what's gone before or what you imagine, by our cultural language. The original script called for a Colorado timber lodge house. But before we even established that, we imagined it might not be set totally in Colorado. We imagined a billionaire tech guy in a Le Corbusier-style or modernist California-style house—geometric, rectangular, white, angles, glass, one or two levels, a classic buildin of that type. And we started to look for places like that. If you look at millionaires' or billionaires' homes, you tend to find either palatial, historical style buildings or modern white buildings. We got into lots of millionaires' houses, but they weren't big enough. They were beautifully designed, and they were large but not awe-inspiring. And getting into billionaires' houses was a problem. Ultimately, that was the mistake we made, or the cliché we had in our heads. This was an interesting journey, because we realized we equated wealth purely with size and space. When we couldn't find that, we asked, what else might someone with that amount of wealth buy that others can't? And that was privacy, security, and nature.

We thought perhaps there is a type of person who is so wealthy they don't need space, they don't need to be visually ostentatious. We then moved toward Nathan's character, and we realized that he just needs *enough* space. So we started looking for interesting properties in stunning natural environments. We looked at castles in the Swiss Alps, for example. But also, before we went small and remote, we looked at large buildings with interesting design aesthetics, including some museums. We did commit to a museum, which was large and circular, but that arrangement fell apart. Then we chanced on the Juvet Hotel. Although it didn't quite have the narrative and the space we needed, the architects had designed a nearby private residence, and that was the interior of the hou with the rock formation. And we realized that both dramatically and practically we could have some of the rooms be subterranean.

How, if at all, did Nathan's identity as a villain influence your ideas about his house?

We did not want to highlight his evil. He's not a villain necessarily at the beginning of the story. He's a man potentially doing a great deed of creationist magnitude. He's doing something potentially for science. He's doing this big thing. It is not bad on the face of it. It gets darker, but it doesn't start out dark.

You've commented that in designing Nathan's house, you wanted to move away from James Bond-type of villains' houses and away from science fiction tropes. Why?

Our process always is to throw out the language of sci-fi, the language of cinema, the language of culture that we have been fed. There is a whole bunch of that sci-fi languag that was great thirty years ago, and somehow becomes the default. It's not necessarily wrong. But it doesn't have to be that. We immediately thought there was a danger we could head into a Bond-type villain here, where there's a big table with twelve people and it's the siz of a turbine hall. We imagine that's how it has to be, and it doesn't have to be like that

TP So you wanted to move away from those conventions.

MD Yes, we fight cliché, and we keep to integrity. We build from the character. I'm very pleased that we didn't end up with a white California modernist building.

TP As you think about countering clichés, why is it that movie villains so often live in fantastic houses?

MD With wealth and power, there is an element that is equated with evil and crime. Why are people evil? Why do they resort to crime? I think it's to accumulate wealth, which accumulates power, and also to show that off. It's about subliminal feelings about size, space, power. And there is a price for that, and the price is that you have acquired it through badness.

TP In terms of interior space in Nathan's house, we don't see Ava's space from her perspective, but from Caleb's point of view. Artistically, what was the thought process?

MD That space is a spatial flip-around. The immediate and natural thought was that Ava was being observed, and she would be contained, like a goldfish in a fishbowl, and Caleb would walk around her. But in fact, he is the goldfish, and she walks around him. The glass cube worked well, because we have two people facing each other, talking, which can be boring. And we don't particularly want to watch her watching him—it's her we want to watch. So she's not sitting in one place all the time. The design allowed us to go 270 degrees around her, if not 360 degrees.

TP Did your work on *Ex Machina* influence the way you've worked since then?

MD Yes, with *Ex Machina*, there was the success of that notion that you can flip things round completely, and you should do. You can take a different approach, not just a sideways approach but an upside-down approach. That feeds into now. It makes us think, how can we take that approach?

TP As you've discussed your process, it seems that it's not driven by architecture, even though you're creating spaces.

MD Our starting process is very much about emotion and what that brings. It's not necessarily architectural. A lot of our references are nothing to do with space. They often are people, and that takes you to a mood.

TP Would you say, then, that your work starts with character, and that leads to space?

MD Yes, and it's an interesting point about how things are made and what people do. I am not architecturally trained. I'm not artistically trained at all. What my team brings is a sentiment that we've gathered through life as opposed to a place of academic knowledge. We don't think about architecture. We think about characters and their space and their environment. From that comes the architecture. It is within everyone to have a style and a design and a feeling about things. It gives a little hope to everyone that everyone can do anything. They can find their talent and their feel in it.

FILM DR. STRANGELOVE OR: HOW I LEARNED TO STOP WORRYING AND LOVE THE BOMB

VILLAIN DR. STRANGELOVE

LAIR WAR ROOM

FILM

Stanley Kubrick's classic Cold War-era satire about nuclear war and the end of the world follows Brigadier General Jack D. Ripper (Sterling Hayden), a paranoid, commie-hating Air Force bigwig with sexual hang-ups who goes rogue, disobeys the president of the United States, Merkin Muffley (Peter Sellers), and starts a thermonuclear war against the Soviet Union. Arriving in theaters at a time when the Cuban Missile Crisis was still fresh in the world's collective nightmares, *Dr. Strangelove* was Kubrick's response to mankind's ultimate fear. Ripper orders a B-52 bomber to "commence Wing Attack Plan R"—basically, to drop the Big One on Russia. His justification for the attack is to stop the dastardly communist plot to use fluoridated water "to sap and impurify all of our precious bodily fluids." (It makes sense to Ripper, anyway.) Not to be outdone in the idiocy department, President Muffley directs his War Room brain trust to thwart the crisis, relying on the sneaky Soviet ambassador Alexi de Sadesky (Peter Bull), the rip-roaring General Buck Turgidson (George C. Scott), and the United States' wheelchair-bound director of weapons research, Dr. Strangelove (Peter Sellers, again), a former Nazi unable to control his Führer-saluting impulses.

Release
1964

Director
Stanley Kubrick

Production Designer
Ken Adam

Cinematographer
Gilbert Taylor

Cast
Peter Sellers
George C. Scott
Sterling Hayden
Keenan Wynn
Slim Pickens
Tracy Reed

Screenplay
Stanley Kubrick
Terry Southern
Peter George

Studio
Columbia Pictures

Lair
Set constructed at Shepperton Studios, Surrey, England.

Images
All photographs are from *Dr. Strangelove Or: How I Learned to Stop Worrying and Love the Bomb* and all architectural illustrations and renderings are based on spaces in the film's lair, the iconic War Room.

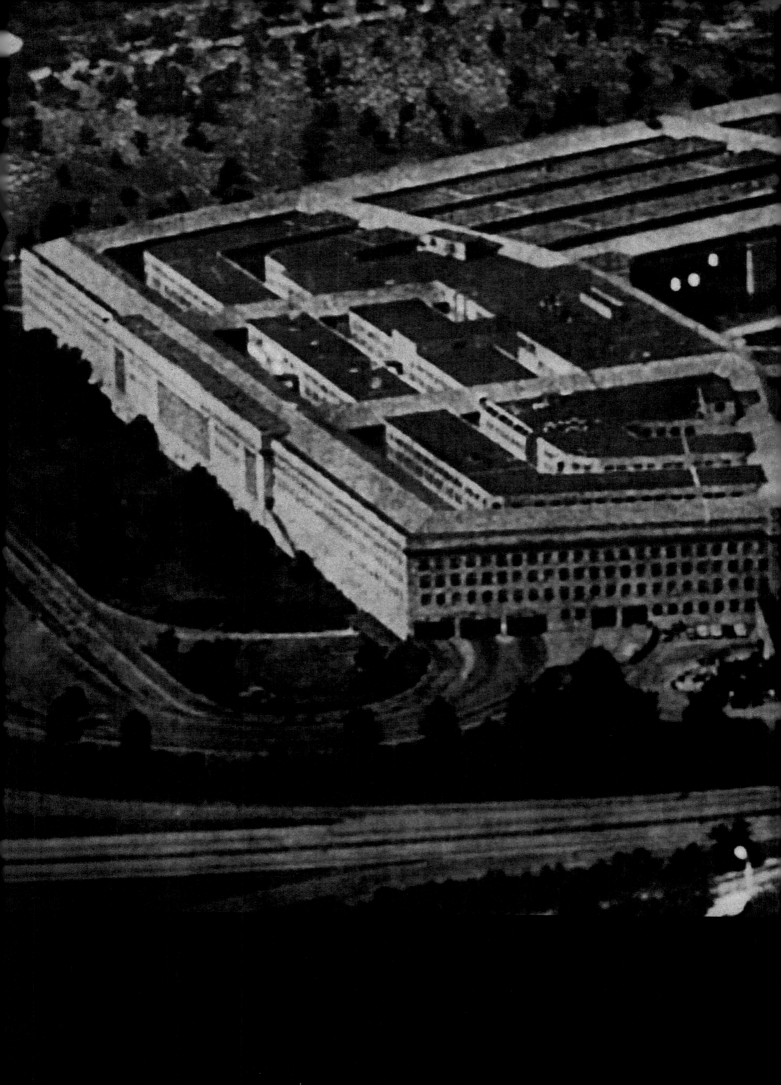

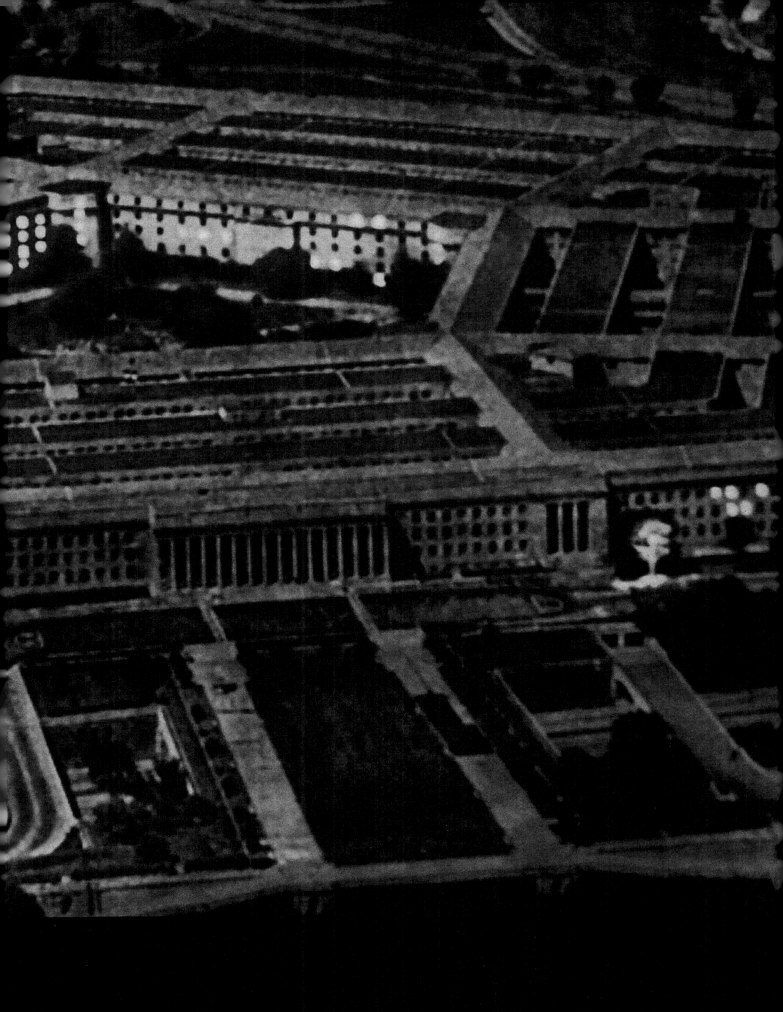

1
Bird's eye view of the Pentagon, headquarters
of the United States Department of Defense.
The fictitious War Room is located underground,
directly below the Pentagon. Still. *Dr. Strangelove
Or: How I Learned to Stop Worrying and Love
the Bomb.*

VILLAIN

The nuclear-war-mongering, gung-ho, alarmingly inept villains of *Dr. Strangelove*—and there are many, from villain-in-chief Dr. Strangelove to Brigadier General Ripper to Buck Turgidson— are in effect an extended metaphor for sexual frustration. From phallic exploding bomb imagery in the opening titles to Ripper's denying women his "essence," Kubrick's film is a calculated takedown of toxic masculinity and the hubris of men with big, honking military machines and their terrifying willingness to put them to use. The black comedy's ultimate villain is, of course, nuclear warfare, which the director masterfully and slyly conveys. With deadpan ridiculousness, cigar-chomping lunatic Ripper puts his Burpelson Air Force Base on lockdown, telling his captive, Group Captain Mandrake (yes, Sellers for a third time), that "war is too important to be left to politicians. They have neither the time, the training, nor the inclination for strategic thought." If sexuality is the butt of the joke here, the War Room is a lair in which military violence and paranoia about communism are twisted expressions of sexual repression. This is where Dr. Strangelove proposes to the room of suspicious politicos that post-nuclear survival involves living underground with representatives of the species, Noah's Ark-style, but in a ten-to-one female-to-male ratio. "The women will have to be selected for their sexual characteristics, which will have to be of a highly stimulating nature," Dr. Strangelove says to the generals, who are, of course, instantly delighted.

2
Peter Sellers as the ex-Nazi, maniacal scientist Dr. Strangelove, one of three characters he portrays in the film. Still. *Dr. Strangelove*.

LAIR

The brutalist, bunker-like War Room is a triangular structure with slanting, reinforced concrete walls and a massive round table where the inept politicians sit, lit from above by a circle of light. The space is huge—it was one of the largest sets ever constructed for a film to date, at 130 feet long and 100 feet wide, with a 35-foot-high ceiling. The table alone has a surface area of 380 square feet.[1] Yet, at the same time, the bomb-shelter-like setting, a subterranean sanctum beneath the Pentagon, is eerily claustrophobic.

The "Big Board"—a blinking, "Battleship" board game-style display of military ships—looms above and serves as a grim counterpoint to the loony forum of five-star generals and bigwigs who spend the film bickering about world destruction. In one scene, a dustup between the battle-ready Buck Turgidson and the conniving Russian ambassador prompts a bumbling President Merkin to exclaim, "Gentlemen! You can't fight in here! This is the War Room!" Squabbling in the War Room has all the intelligence of schoolyard temper tantrums, and by the end, these nattering world leaders prove so ineffectual that the nuclear bomb drops anyway.

3, 4, 6, 7
From top: Politicians bicker about world destruction as the 843rd Bomb Wing inches closer to entering USSR airspace, as shown on the blinking Big Board; Dr. Strangelove drags on a cigarette as he explains the "terrifying" power of the Soviet Union's Doomsday Machine, a nuclear weapon system triggered only if bombed; portions of the overhead circular light and round table are visible as hotheaded General Buck Turgidson (George C. Scott) informs President Merkin Muffley (Peter Sellers) and seated generals that he can't contact—or recall—the fighter wing. Stills. *Dr. Strangelove*.

5
Invited into the top-secret War Room by President Merkin Muffley, Peter Bull's Russian ambassador, Alexi de Sadesky, trolls the War Room's elaborate buffet spread. Still. *Dr. Strangelove*.

3
4
5　6 7

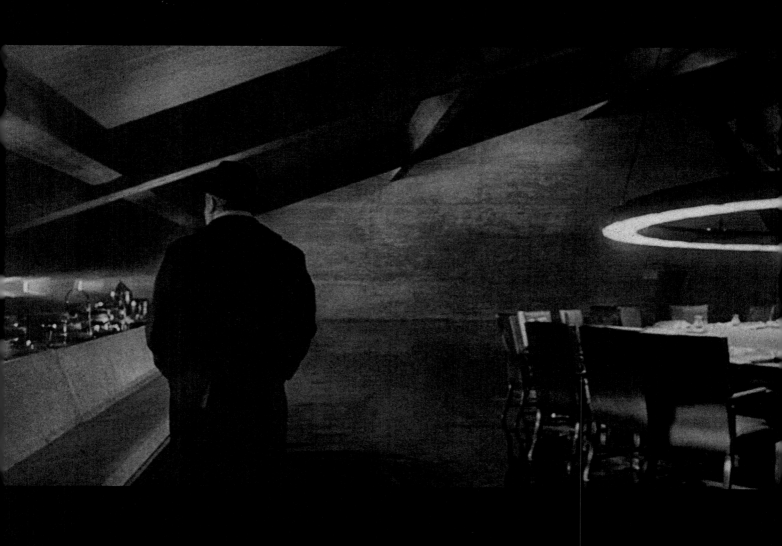

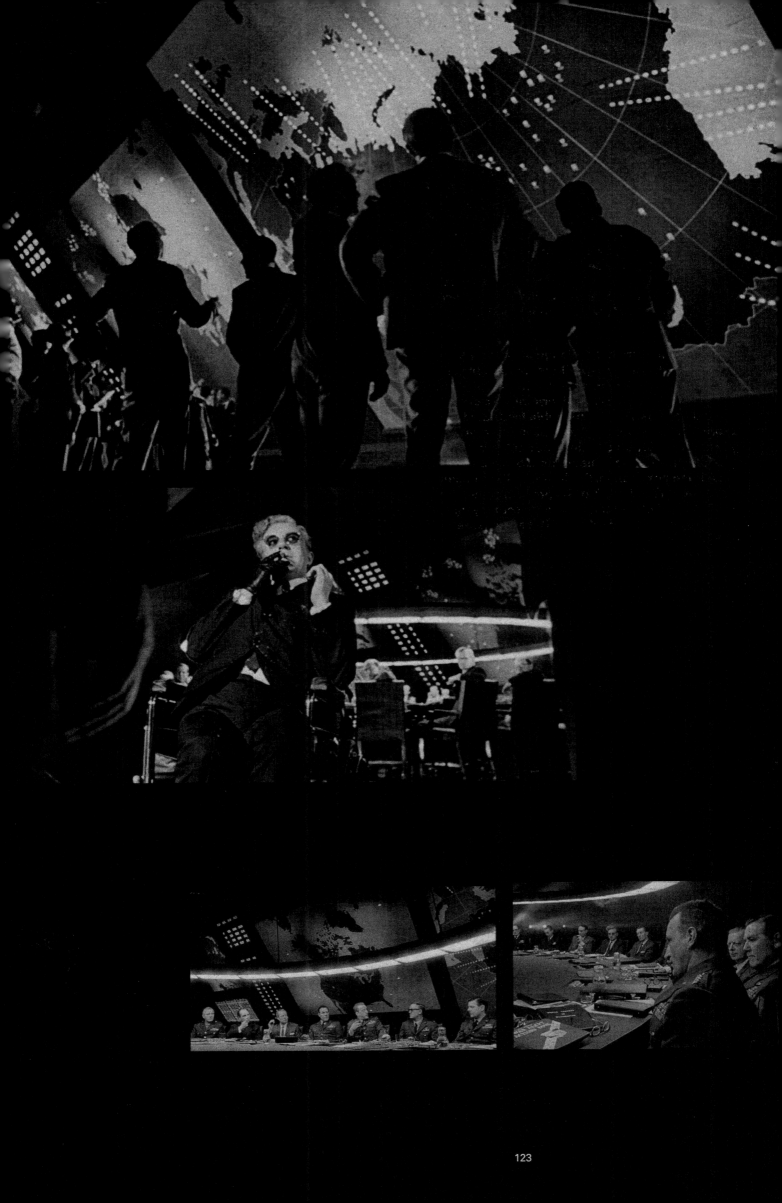

Production designer Ken Adam, whose work on the James Bond film *Dr. No* attracted Kubrick's attention, worked closely with the director on the design of the War Room. It is one of Adam's most well-known sets; Steven Spielberg referred to it as "the best set in the history of film."[2] The inspiration for the War Room, which was built at Shepperton Studios outside of London, was purely fictional. "I don't know what the government facilities are like," Adam told the *New Statesman* in a 2014 interview. "And I certainly didn't base the War Room on them." People found the War Room so real, however, that high-level politicians reportedly would look for it—including at least one U.S. president, according to Adam, who said he "learned from reliable sources that when Ronald Reagan moved to the White House he asked his chief of staff to show him the War Room."[3]

After Adam designed the triangular space, he came up with the concept of the round table as the place where the witless politicians would sit, largely because he always incorporated a circle into his designs. The circular table fascinated Kubrick, who requested that it be covered in green felt (although the film was shot in black and white), because it made the table seem like a huge poker table. For Kubrick, that imagery reinforced the notion that the president, the generals, and other staff were in effect playing with the fate of the world as if it were a game of cards.

Architects' Commentary
Highlights from Oppenheim Architecture's round-table discussion of Dr. Strangelove

"The geometry of this space is very interesting. The triangular room, the circular table, and the circular nature of the light above it, what does that tell us? It seems that it all points toward a sort of democracy here. There's no head of the table."

"You don't always recognize your own influences, but it's interesting that in *Spirit of Place*, the monograph on Oppenheim Architecture, architect and critic Val K. Warke references the overhead circular halo that you see in a lot of Ken Adam's films, and which here is the circle of light above the round table. He compares the perfect geometry of the circle to the sense of timelessness that you see in our firm's work. The power and the simplicity that we strive for in our work—you see that in the War Room, with the drama of these basic shapes and the scale of the room."

"The War Room is iconic, and has inspired so much, including other films, books, and real-world architecture. A few examples include the *Watchmen* (2009) film and graphic novel, which both feature a War Room based on *Dr. Strangelove*. The underground Pionen White Mountains office in Stockholm, designed by Albert France-Lanord Architects in 2008 for an internet provider, based some of its design on Ken Adam's set designs, including the War Room. And a room at the San Francisco headquarters of Airbnb that opened in 2013 was converted into a replica of the War Room."

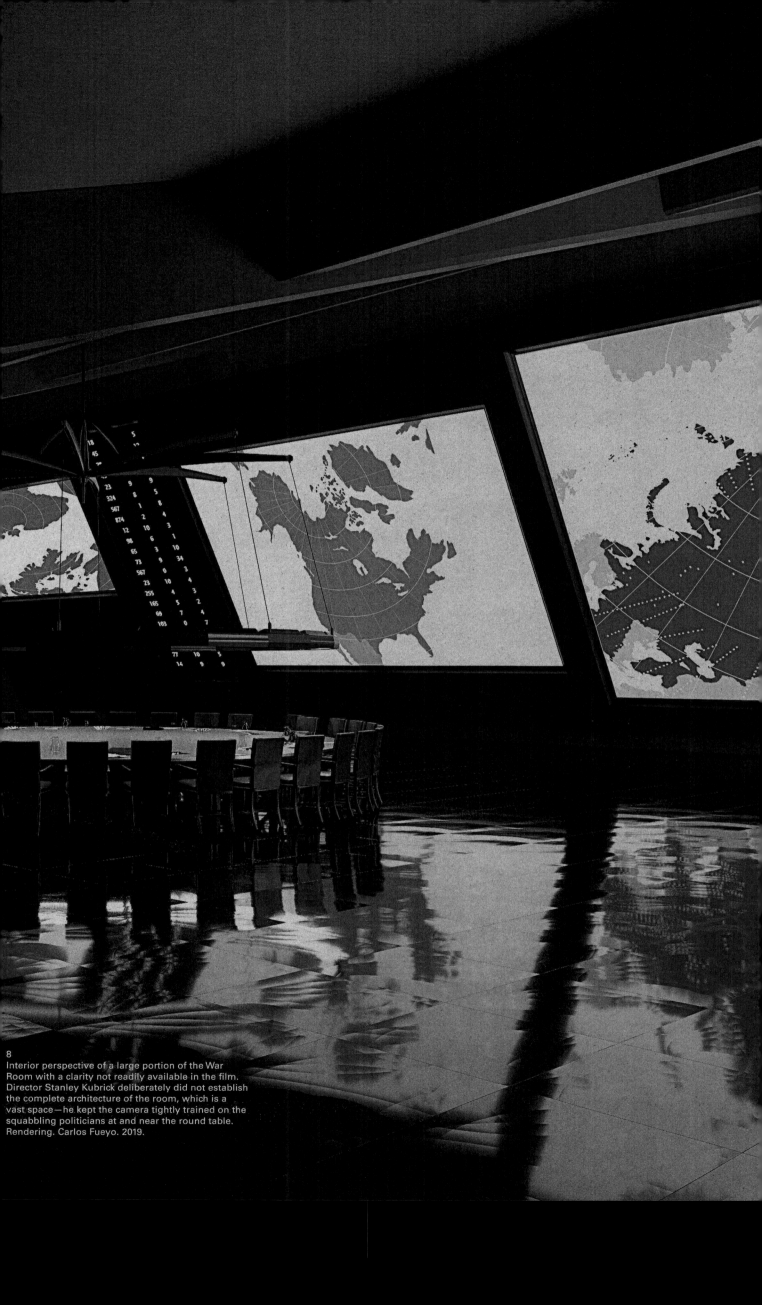

8
Interior perspective of a large portion of the War
Room with a clarity not readily available in the film.
Director Stanley Kubrick deliberately did not establish
the complete architecture of the room, which is a
vast space—he kept the camera tightly trained on the
squabbling politicians at and near the round table.
Rendering. Carlos Fueyo. 2019.

9
Plan of the War Room. The round table and the table with the feast
are shown, the thin white lines represent the maps on the wall, and
doors are apparent on opposite sides of the space. This plan and the
section that follows clearly show how vast the room is. Architectural
illustration. Carlos Fueyo. 2019.

10
Longitudinal section of the War Room showing the table and
attached bench with the feast, the round table, the circular light,
a door, and a map mounted on the wall. Architectural illlustration.
Carlos Fueyo. 2019.

9
10

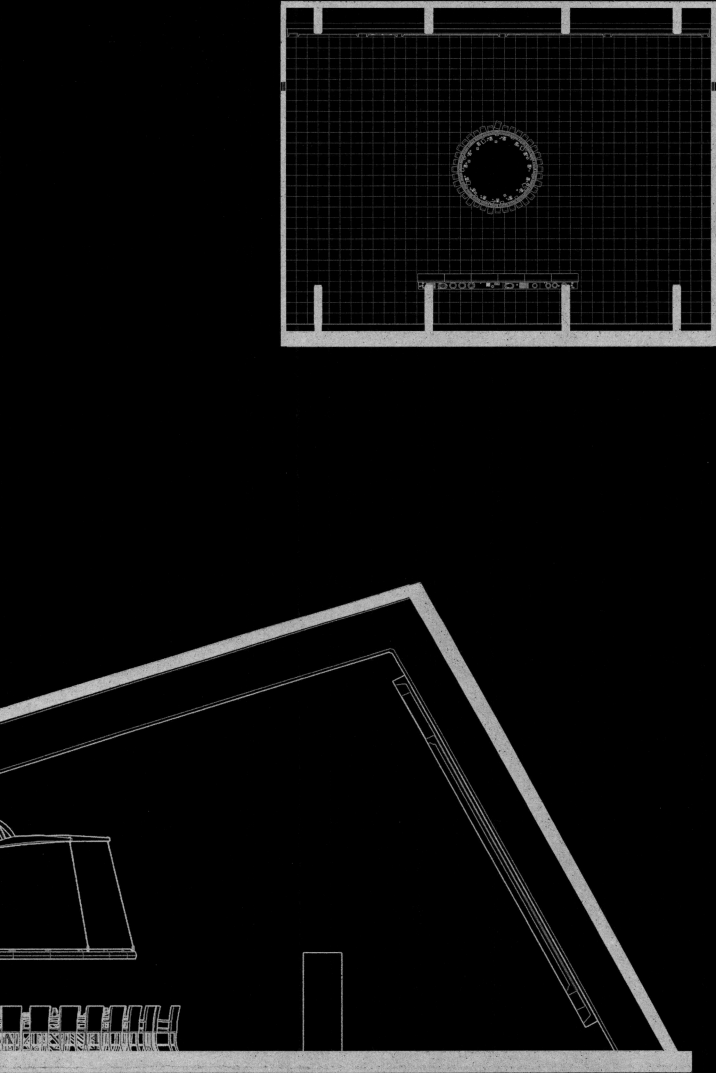

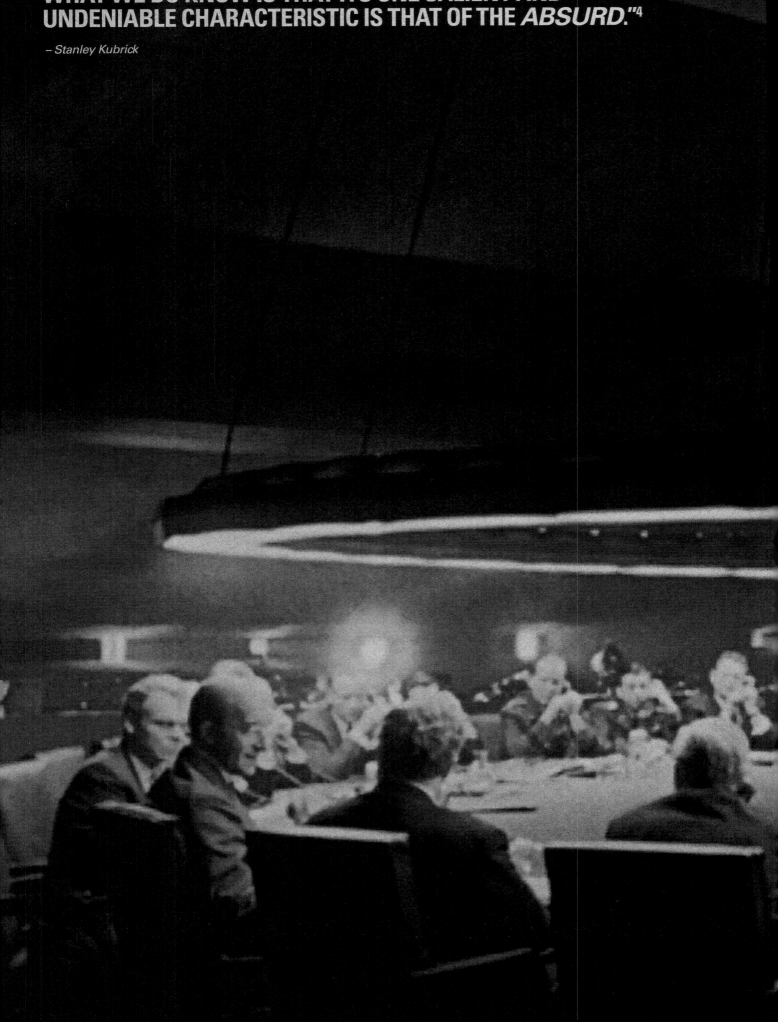

"THE PRESENT NUCLEAR SITUATION IS SO TOTALLY NEW AND UNIQUE THAT IT IS BEYOND THE REALM OF CURRENT SEMANTICS; IN ITS ACTUAL IMPLICATIONS, AND ITS INFINITE HORROR, IT CANNOT BE CLEARLY OR SATISFACTORILY EXPRESSED BY ANY ORDINARY SCHEME OF AESTHETICS. WHAT WE DO KNOW IS THAT ITS ONE SALIENT AND UNDENIABLE CHARACTERISTIC IS THAT OF THE *ABSURD*."[4]

– Stanley Kubrick

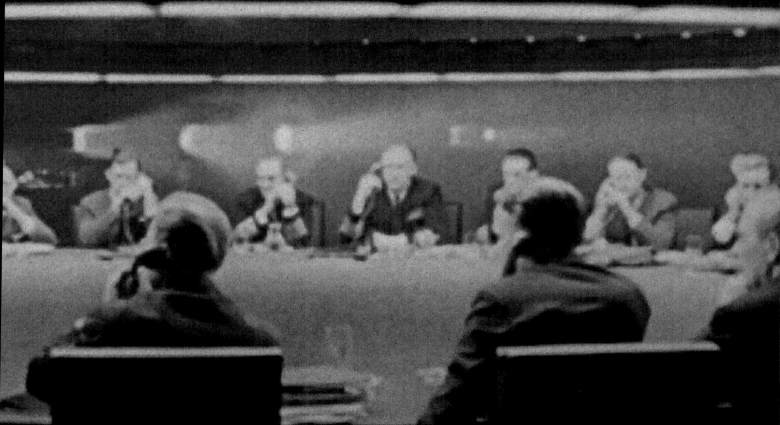

FILM **BODY DOUBLE**

VILLAIN **SAM BOUCHARD**

LAIR **SAM'S HOUSE**

FILM

Hitchcockian voyeurism meets hardcore kink
in this stylishly overheated erotic thriller from
director Brian De Palma. Craig Wasson stars as a
second-rate actor named Jake Scully who, after a
bad day on the set of a low-budget exploitation
film (he plays a punk-rock vampire), comes
home to find his girlfriend two-timing him. With
nowhere to stay, he's offered a house-sitting gig
by a new acting-class acquaintance. The ultra-
modern house in the Hollywood Hills is a stunner.
And so is the view. One of his new neighbors
is a gorgeous exhibitionist who dances in next
to nothing in front of her window at the same
time every night. Jake becomes obsessed with
watching her through his telescope. Then, one
night, he watches helplessly as she's murdered
(or is she?), and soon he's being sucked into a
byzantine set-up that involves a hideously scarred
Native American with a power drill, a cartoonish
version of the adult-film underground, and a
gum-snapping, no-nonsense Melanie Griffith in
leather chaps.

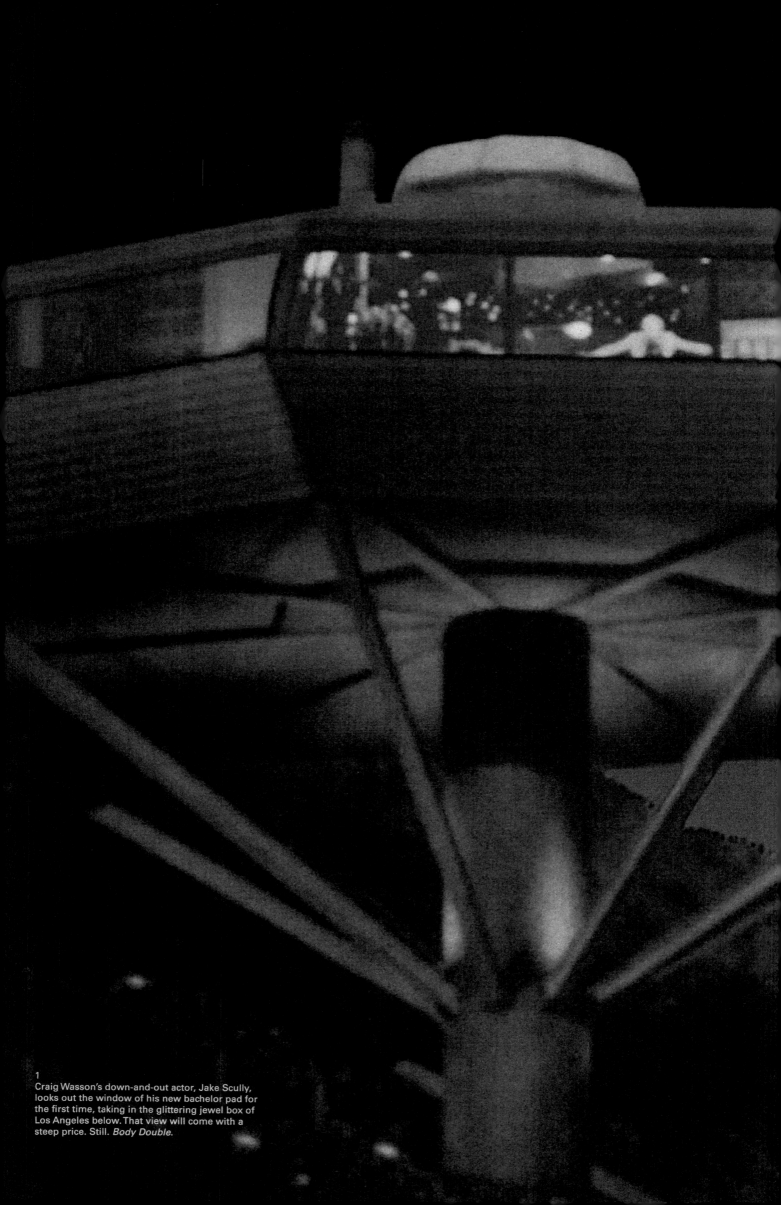

1
Craig Wasson's down-and-out actor, Jake Scully, looks out the window of his new bachelor pad for the first time, taking in the glittering jewel box of Los Angeles below. That view will come with a steep price. Still. *Body Double.*

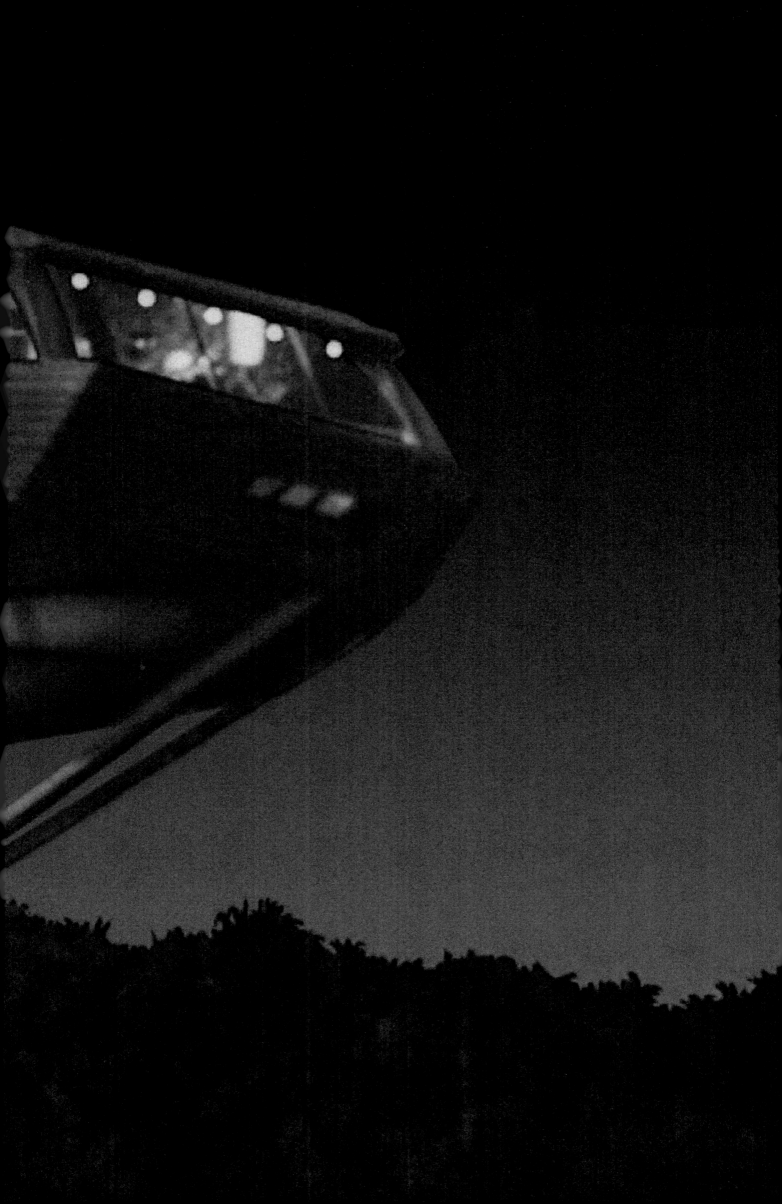

VILLAIN

Gregg Henry, who plays Jake's newly acquired acting-class friend Sam Bouchard, the one behind the house-sitting job, turns out not to be the good Samaritan he seems. His smarmy jokes, sympathetic ear, and blinding-white smile are merely a façade; behind it, Sam is the exhibitionist's scorned boyfriend and the engineer of an elaborate frame-up that could be cribbed straight out of a 1940s film noir. Like a Venus flytrap, Sam lures Jake in with the promise of easy comfort and peeping-tom cheap thrills—a Faustian bargain that will cost Jake not just his soul, but his sanity and quite possibly his life. De Palma conducts it all like an exploitation Toscanini, with thrilling, drawn-out suspense sequences and steamy, melodramatic touches. Even if you go in to *Body Double* knowing who the villain is (we warned you), it still manages to tighten the psychological screws with trashy precision.

2
Gregg Henry as seductive con man Sam Bouchard. Still. *Body Double*.

LAIR

De Palma wasn't the first filmmaker with the bright idea to use architect John Lautner's Chemosphere house as an instantly iconic movie location—nor would he be the last. Over the years, the home, which is located at 7776 Torreyson Drive in Los Angeles and is currently owned by German book publisher Benedikt Taschen, has been featured in an eclectic range of television shows and movies, from a 1964 episode of *The Outer Limits* to 2000's big-screen reboot of *Charlie's Angels*, and it was the inspiration for Troy McClure's house on *The Simpsons*. But the hovering Jetsons-esque structure was never put to such luxuriously lurid use as it was in *Body Double*.

Designed by Lautner in 1960, the Chemosphere (named after the Chem Seal Corporation, which helped subsidize its $140,000 construction) resembles nothing more than a flying saucer idling thirty feet above the Hollywood Hills. It's as if one day a bunch of curious extraterrestrials decided to show up to observe the nighttime rites and rituals of Babylon glittering like a seductive jewel box down below. Built on the San Fernando Valley side of Mulholland Drive, which snakes along the spine of the Hollywood Hills, Lautner's house is a modestly-sized, open-plan, one-story octagon, supported by a five-foot-wide concrete pole and steel struts that emanate from it like the spokes on a bicycle wheel. The sheer audacity of its design and its precarious, inhospitable setting make it awe-inspiring, which is exactly how the hapless Jake Scully feels when Sam first brings him there, approaching the house seemingly in slow motion via a private funicular from below.

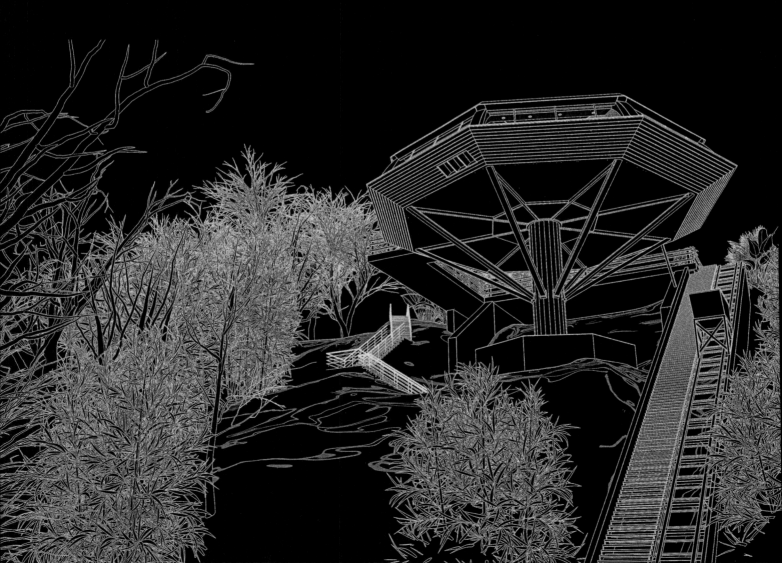

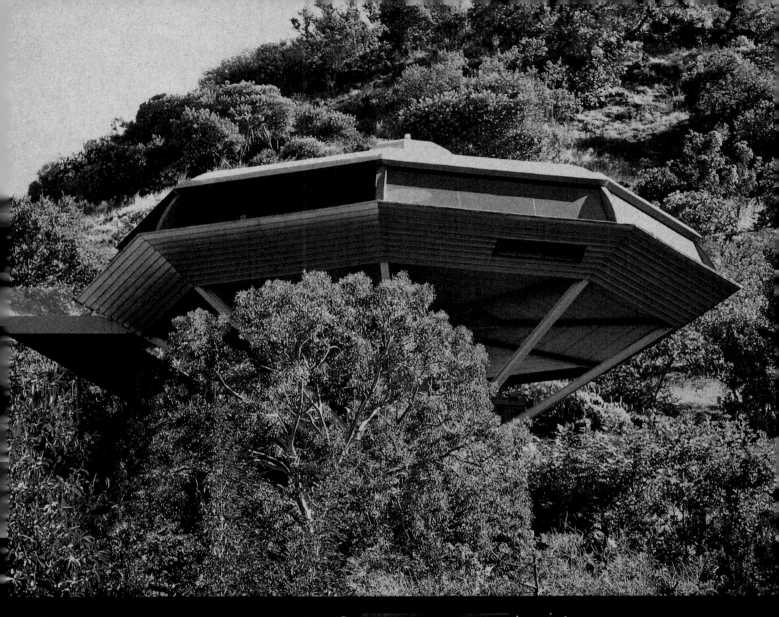

3
4 5

3
John Lautner's Chemosphere House, as seen from below.
Photograph. Courtesy C. Dernback under CC by SA 3.0. 2012.

4
Exterior perspective, showing the approach to the house. This
is the impressive vantage point from which Jake first sees
the place he will soon be calling home. The private funicular,
on the right, is used to access the house. Architectural
illustration. Carlos Fueyo. 2019.

5
Sam lures the unsuspecting Jake in by showing him the
home's best feature—the view. Still. *Body Double.*

Inside, the house is decked out in full-on 1980s bachelor tackiness. The floors are covered in thick slate-gray carpeting. The master bedroom is overwhelmed by a circular revolving bed that feels ripped from Larry Flynt's sleaziest fever dreams.

A mirrored wet bar, endless sprays of ferns, and floor-to-ceiling built-in fish tanks all give the home a pervasive Benihana restaurant vibe. But as Sam points out to Jake, "There is one very special feature to this house…" And that's the vista. With its expansive views, Sam (and now Jake) can spy on the entire city. But, of course, Jake is only interested in looking at one thing. And in *Body Double*, he will look and look and look until his obsession becomes his oblivion.

6, 7, 8
Interior views of Jake's space-age bachelor pad house-sit with the strategically placed telescope and tacky rotating bed. Jake's voyeuristic obsession drives him to track down the fantasy woman whom he watches from on high. Stills. *Body Double*.

9
Daytime view of Los Angeles from the Chemosphere House. Photograph. Julius Shulman. 1961. © J. Paul Getty Trust. Getty Research Institute, Los Angeles (2004.R.10).

9
6 7
8

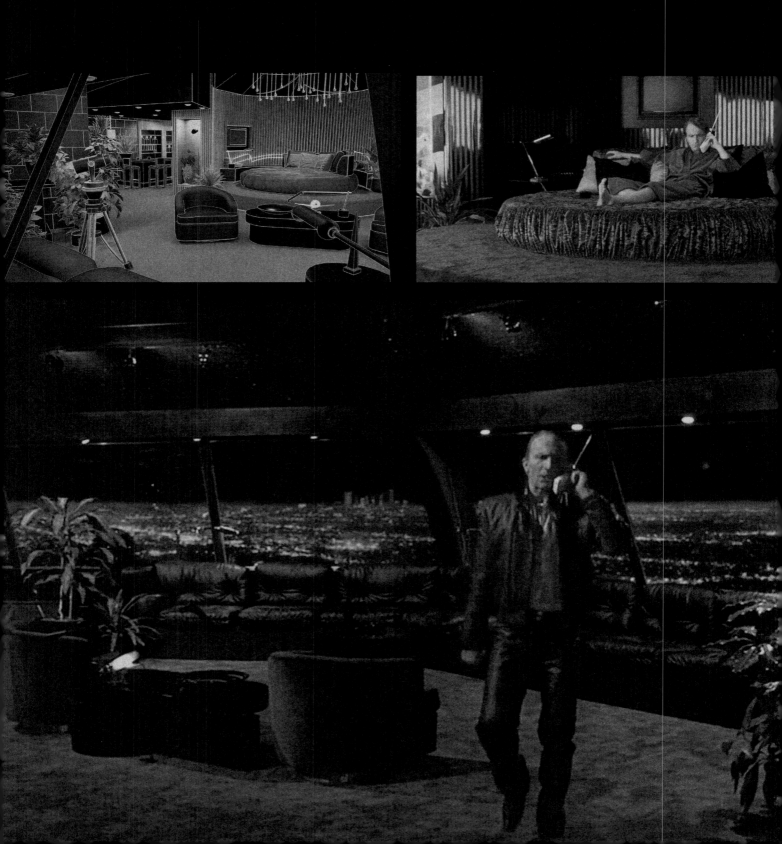

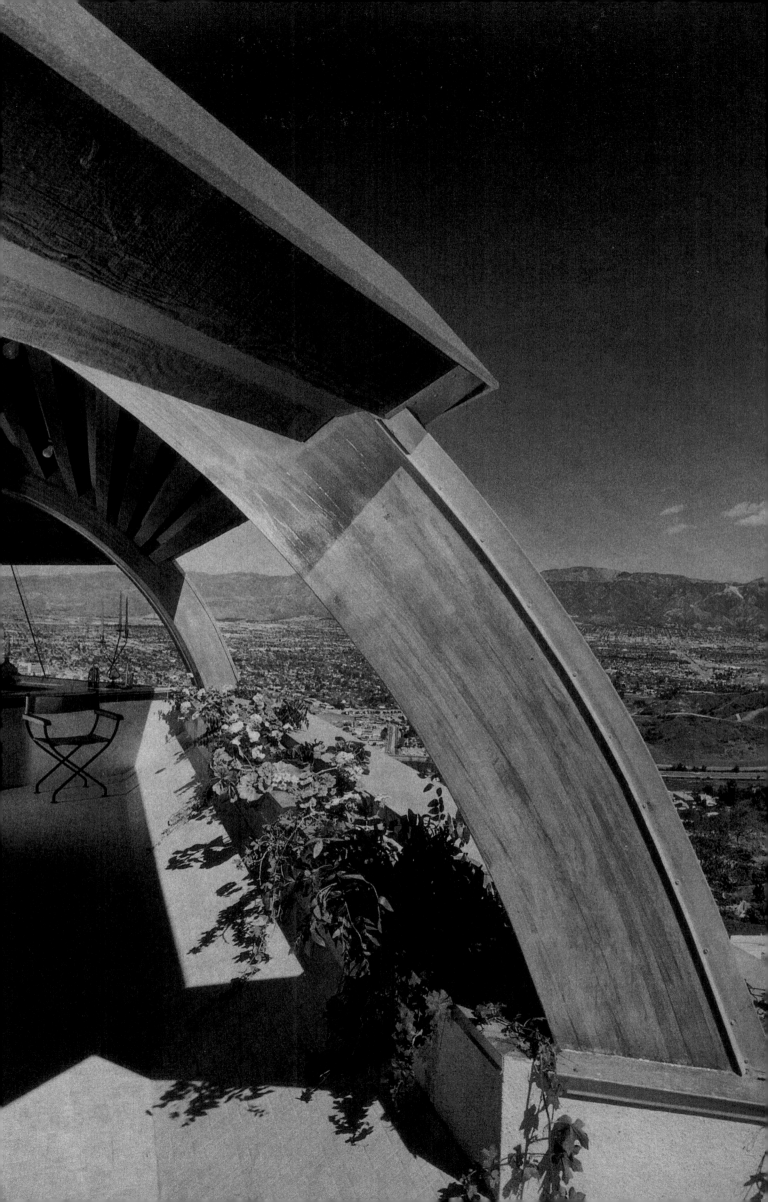

"I CAN ALWAYS RECOGNIZE A BUILDING BY JOHN LAUTNER…NOT BECAUSE IT LOOKS LIKE ANY OTHER LAUTNER BUILDING, BUT BECAUSE IT LOOKS LIKE NOTHING THAT HAS EVER STOOD BEFORE ON THE FACE OF THE EARTH."[1]

—*Betsy Speicher*

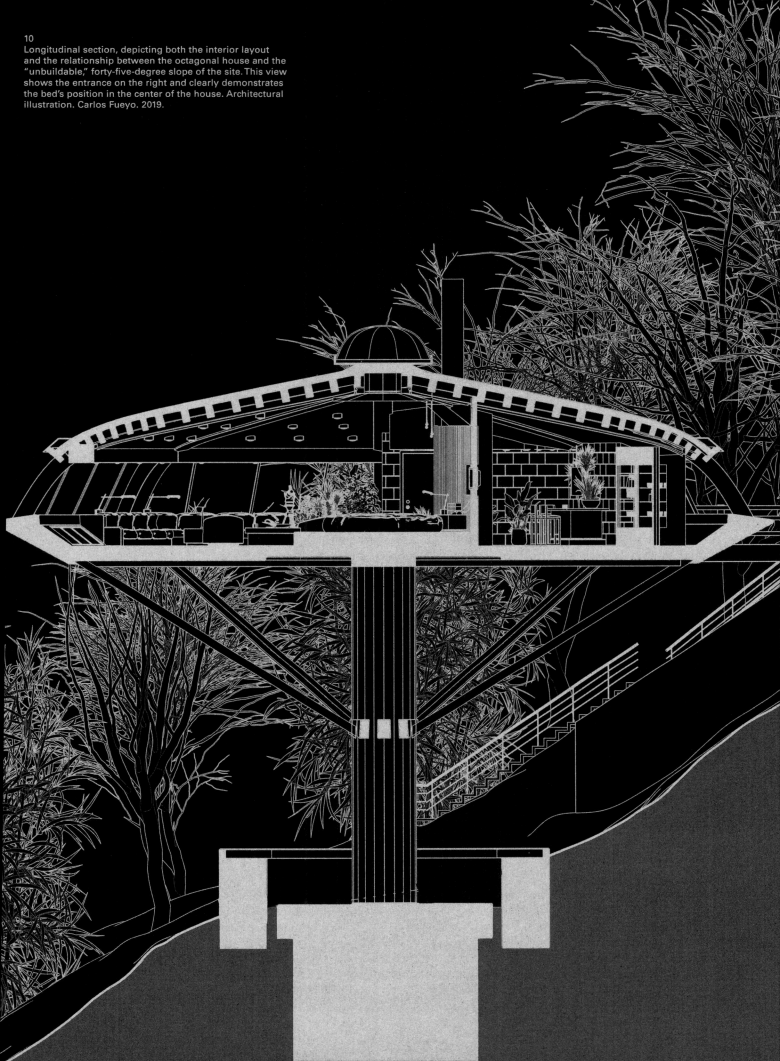

10
Longitudinal section, depicting both the interior layout
and the relationship between the octagonal house and the
"unbuildable," forty-five-degree slope of the site. This view
shows the entrance on the right and clearly demonstrates
the bed's position in the center of the house. Architectural
illustration. Carlos Fueyo. 2019.

"The choice of architecture relative to the villain's motives is central to this film. The house is so perfectly cast that it's almost a character. It looks like a watchtower, and it functions as one in the film. So much in *Body Double* is about vision and perception, the notion of the view, of glass, of reflection, and of reflectivity at night, where you have the interior of the house reflected on the Los Angeles skyline, and how that may or may not distort perception."

"What we also see at play with this architecture is the idea of looking through something. This is about viewing through a telescope, and through a window, and through another window. It's surveillance as control, as manipulation; it's deception through clarity."

"While the house helps foster the deception, it also contrasts with it. The house itself, in its architecture, does not hide anything. It does not hide its structure—you can see everything, from the central column to the interior layout."

"As architects, it's interesting to note that the house design was a response to the site. The lot was thought to be unbuildable—it's a small lot and it's very steep, with a forty-five-degree slope. To address that, John Lautner designed an octagonal house that rests on top of a thirty-foot-tall column of reinforced concrete."

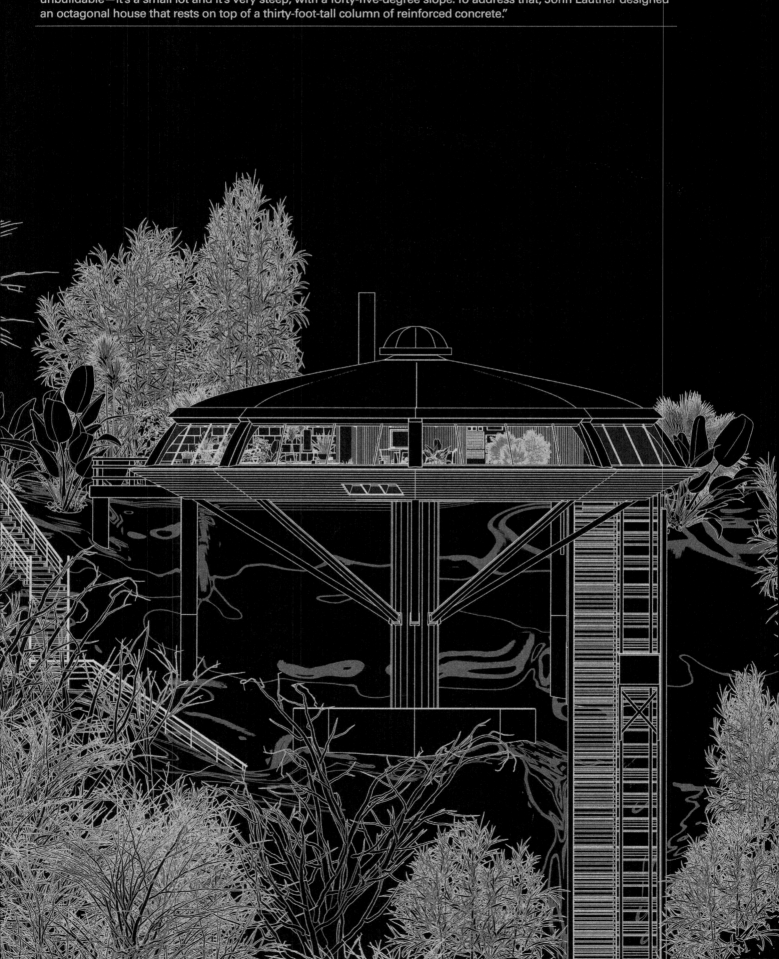

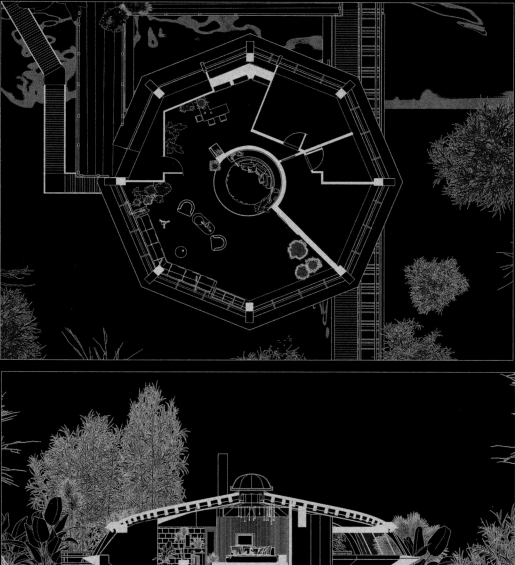
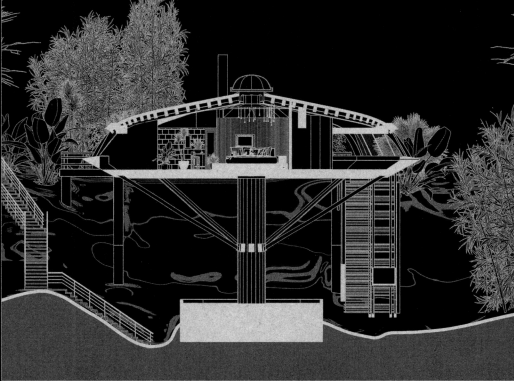

WHEN THE VISUALS HAVE A LEAD ROLE
A CONVERSATION WITH ACTOR GREGG HENRY, *BODY DOUBLE*'S VILLAIN

In the movies, there are villains who announce their evil with larger-than-life mannerisms (and lairs), elaborate monologues, or displays of sadistic violence. And then there are villains like *Body Double*'s Sam Bouchard. He's the kind of villain who lures you into his confidence with a sympathetic smile and a random act of kindness only to swallow you up before you know what's happened. Those are the ones you really have to watch out for. In Brian De Palma's erotically-charged 1980s thriller, veteran character actor Gregg Henry uses his Good Samaritan act as a set-up that will send Craig Wasson's struggling actor, Jake Scully, down a rabbit hole of voyeurism, obsession, and murder. How does he do this? With his lair, of course. Sam baits Jake by allowing him to stay at the swank, futuristic home where he's house-sitting. It's not just any home, either. It's John Lautner's Chemosphere—the octagonal flying saucer-like residence that seems to levitate above the Hollywood Hills. Henry, who has appeared in numerous films, from *Scarface* to *Guardians of the Galaxy*, spoke with Tra Publishing about playing an indelible villain in an iconic lair.

TP Tra Publishing: Do you consider Sam Bouchard to be the villain of the movie?

GH Gregg Henry: [laughs] Yes, I do.

TP What sort of discussions did you have with Brian De Palma about how to play Sam? He's the villain, but we don't know he's the villain until the big reveal.

GH I think the main thing we talked about is how it's a con. He's setting Jake up. So it's kind of a theatrical thing that he's doing, and he has to be believable for his audience. You have to believe you're the nicest guy in the world—until you're not. Oftentimes with villains there's no explaining their villainy, going all the way back to Iago. There have been many books written about motiveless malignancy. You know, sometimes it just helps in telling a story to have a guy who's got evil intent. And sometimes it really clutters up a movie to try and fill it up with a lot of backstory to explain it all. There's a duality to Sam and you need to build that tension. And, of course, that's set up with that great shot in the acting class, which is where the camera pushes in on Sam. It was a familiar shot to me, because Brian did the same thing with me in *Scarface*. That sort of long dolly-in into an extreme close-up is filled with bad intention. It was the moment when I found my guy. I knew he was going to be my mark.

TP What were your initial impressions when you first saw the Chemosphere house?

GH Maybe you know some of this history. But I think I only shot one full night at the actual house. The house has a funicular that goes up the side, and the actual house was in a tremendous state of disrepair at the time. There was terrible shag carpeting from the 1970s. And it had this awful history. The owner of the house was robbed and murdered there in 1976. That adds some villainy to it, I guess. What Brian was really going for that first night we went there were long shots: me up at the window as seen from the outside, the two of us heading up in the funicular. It seemed a lot smaller than 2,200 square feet, which is what it supposedly is.

TP Most of the interior shots we see in the film were shot on a soundstage, right?

GH Yes, Ida Random [production designer] built that Chemosphere, almost one hundred percent of it, to scale. It was a fully functional set built at Stage 16 on the Warner Bros. lot. We also built a model of the second house, where the woman is dancing and stripping, so Brian could do that great shot that connected the two houses. That second house was actually way on the other side of Mulholland in a totally different location.

TP So the Chemosphere that the production designer built back at the studio obviously looked nicer than the actual interior of the Chemosphere at the time?

GH Without question. It was a gorgeous, radical, wonderful interior design. So much fun and so decadent. And visually stunning, I thought.

TP In the scene where you and Craig Wasson's character are slowly ascending to the house via the funicular, and it's his first time seeing it, it's as if he's being ferried into this world of sin. It's like a seduction in a way. Of course, his perspective is that his luck is changing for the better.

GH Yes, the house is a very flashy package that is presented to him and he's in a state of mind to say, "Gee, how can I be so lucky?" Little does he know.

TP De Palma is obviously a guy who thinks this stuff through. He doesn't leave a lot to chance. Why do you think he chose the Chemosphere to represent the villain's lair?

GH Well, it's visual. It's all about visuals. Brian is a master filmmaker. The visuals of any scene are always the first concern with him. And it's a very impressive place. I don't know if you've seen it driving on Mulholland Drive, but it sits up there, and it makes you go, "Wow, what is that place?!" It piques your curiosity. So the audience is equally intrigued by the architecture of it and the location of it. And, of course, voyeurism plays a big role. Here's this place that has an expansive view of the San Fernando Valley, with all of these windows. And Brian does that great shot—it's a really long shot, I remember we did it like twenty-four times, from the inside of the Chemosphere to the outside of it, over to the other house, then it comes back to us in there at the telescope. The way that circular shot went in terms of completing the circle of the exhibitionism and the voyeurism is the entrapment part of the plot. That was Brian's visual way to represent that.

TP The house is up high, looking down at the city. There's a God-like power in it. I guess that's why someone builds a house like that.

GH I think so! John Lautner, the architect who designed the house, he had this unbuildable lot. He came up with this design with that center post and then he built this incredible, futuristic, amazing vision. Lautner had some amazing houses and the architecture has been a magnet for all kinds of movie makers. They're so cinematic. But in terms of what you're saying, as a visual metaphor for who Sam's character is in regards to this, it's that it sits high above Hollywood, it overlooks Los Angeles, this place of dreams, where Jake has come and he's doing these terrible horror movies and then there are these porn movies over in this corner of the Valley, and the studios doing the big movies over on the other side. The whole film is a very funny look at the film business as well as a thriller. Lautner built a house with a view. And what's the movie about? It's about the view!

TP If you think about the Bond movies where villains live in volcanoes and other amazing lairs, why do you think movie villains tend to live in such cool places?

GH There has to be some kind of temptation—the understanding of temptation and maybe a temptation for the audience within the story. If the supervillain is living in some ramshackle flat out in the Valley, you're like, "God, who cares about this guy?"

TP How did playing such a memorable villain affect how people saw you afterwards?

GH Well, it was a long time before I got a part where I got the girl again after that.

FILM **LETHAL WEAPON 2**

VILLAIN **ARJEN RUDD**

LAIR **SOUTH AFRICAN CONSULATE**

FILM

Director Richard Donner's follow-up to his hit
1987 buddy-cop action comedy reunites
mismatched LAPD sergeants Martin Riggs (Mel
Gibson) and Roger Murtaugh (Danny Glover),
upping the duo's personal stakes as well as the
original's flashes of comedy (thanks to Joe Pesci
as a motormouthed federal witness under the
partners' protection). This time around, Riggs and
Murtaugh are up against a group of South African
diplomats moonlighting as drug smugglers on
American soil, hiding behind their diplomatic
immunity. Led by steely-eyed Arjen Rudd (played
by veteran British stage actor Joss Ackland),
these aren't your ordinary Hollywood villains. For
starters, apart from their penchant for ugly racism
(mostly directed at Glover's Murtaugh), they also
kill a lot of people with extreme prejudice and no
remorse. In a shocking, third-act revelation, it's
implied that Rudd and his men were actually the
ones who murdered Riggs' wife before the events
of the first film. And yet, despite all of that, these
violent sadists also happen to have impeccable
taste, running their syndicate from a stylish, sleek
mid-century modern glass house on stilts perched
high up in the Hollywood Hills.

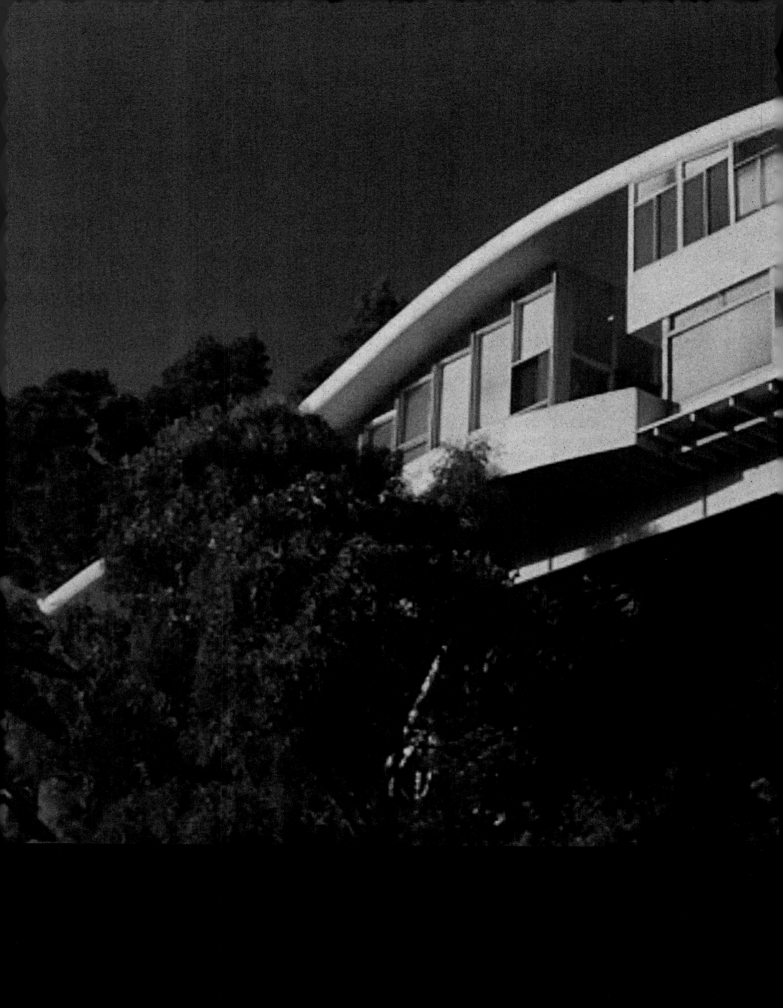

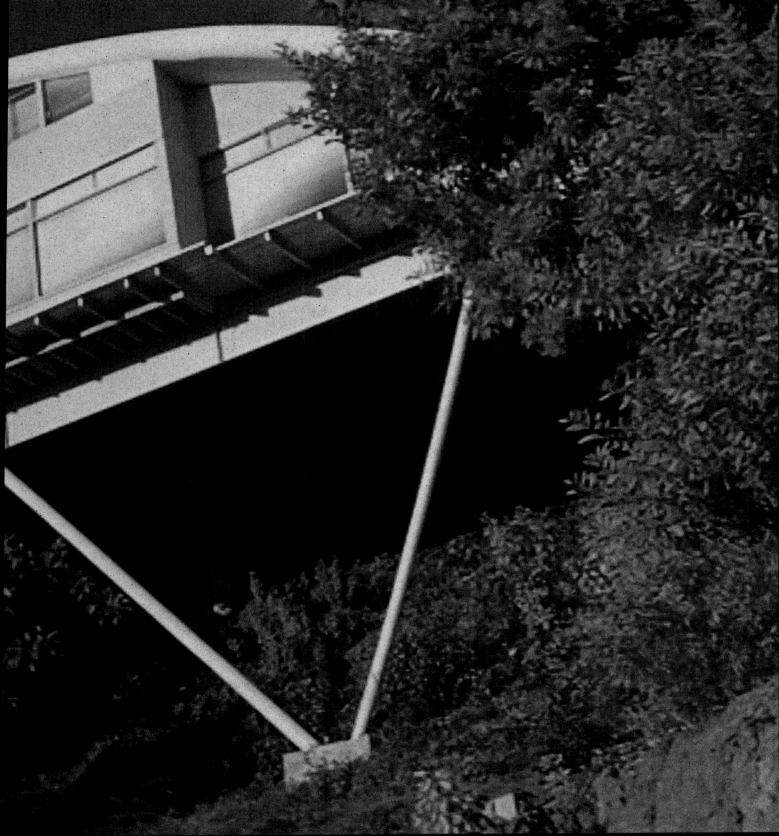

VILLAIN

With his tailored suits, menacing, jowly smirk, and stream of condescending threats delivered through a thick Afrikaner accent, Arjen Rudd seems to be straight out of the Bond villain playbook—the kind of amoral heavy who would prefer to talk at length about how he's going to kill the hero rather than actually pull the trigger while he has the chance. Seemingly untouchable by U.S. law, Rudd and his band of brutal Aryan henchmen (their Hitler Youth side-part haircuts are a nice touch) orchestrate a triangle operation in which they import drugs through Los Angeles Harbor and then launder the profits from dollars into gold Krugerrands. Rudd is a villain made to order for the late 1980s. After all, by the tail end of that decade, Nazis were long past their bogeyman prime as movie villains, and the once dependably nefarious Russians were suddenly becoming our friends. South Africa's shameful apartheid government, on the other hand, signalled a country clinging to its misguided past; its overt racism made it a target of global condemnation and divestment. Hitting theaters only a year before Nelson Mandela would be released from his Robben Island prison cell, Rudd made perfect sense as the newest embodiment of cinematic evil.

2
British stage actor Joss Ackland as the scheming racist Arjen Rudd. His diplomatic immunity gives him a sense of above-the-law entitlement that Danny Glover's Roger Murtaugh and Mel Gibson's Martin Riggs will soon dispel. Still. *Lethal Weapon 2.*

LAIR

Arjen Rudd's modern, canyon-top lair was an integral part of the *Lethal Weapon 2* screenplay from the very beginning. Its role only grew larger as the more downbeat first draft of Shane Black's script (Gibson's Riggs was originally fated to die at the end) was revised by Black's successor, Jeffrey Boam. The challenge was finding an existing Los Angeles-area structure that matched the one imagined on the page. John Lautner, the American mid-century modern master who apprenticed under Frank Lloyd Wright in the 1930s, designed Garcia House in 1962 for jazz arranger Russell Garcia. It still sits high atop the Hollywood Hills at 7436 Mulholland Drive. With its unique almond eye shape topped by a curved, parabolic roof and supported by steel stilts sixty feet above the canyon below, the house is also known as the Rainbow House, after the colorful stained-glass panels that dot its façade. Over the decades, Lautner's distinctive and dazzlingly bespoke homes have become a go-to for Hollywood location scouts looking to goose their films with a bit of groovy, retro-future eye candy. They have appeared in films ranging from *Diamonds Are Forever* to *The Big Lebowski* to *Iron Man*. These are not cozy, warm homes where one sits around the hearth reading Chaucer, but rather cool, severe jewel boxes made to grab your attention…and your respect. They practically beg to be inhabited by either the tragically hip or the downright evil, which of course makes them perfectly suited as the hideouts of celluloid villains.

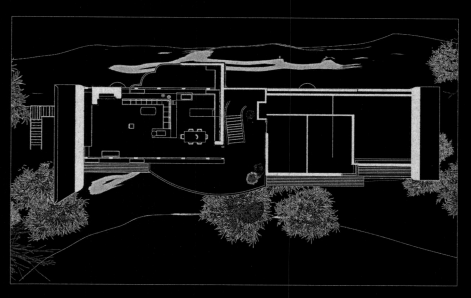

3
4
5

3
Looking up at Rudd's lair at night. During the daytime, the stilt-supported structure's wall of windows lets in an abundance of light, but in the film, this is definitely a place of moral darkness. Still. *Lethal Weapon 2.*

4
Interior perspective of the South African Consulate's living area. These are villains with style. The drug-and-money laundering racket has been good to them. Rendering. Carlos Fueyo. 2019.

5
Plan of the lower level of the structure provides a fuller understanding of the spaces, some of which are only glimpsed in the film. The area on the left shows the kitchen, dining room, and living room. The right side is purposely left blank because in the film, nothing takes place there. Architectural illustration. Carlos Fueyo. 2019.

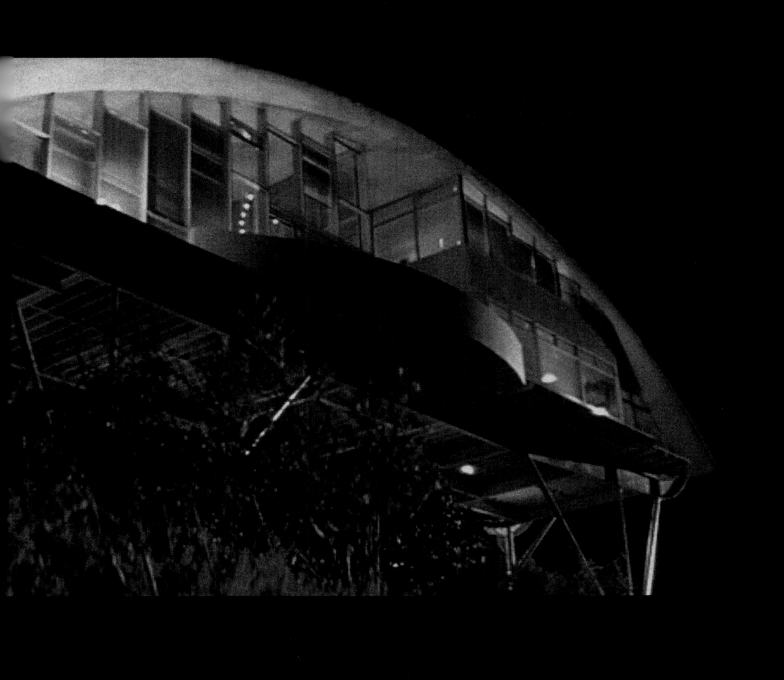

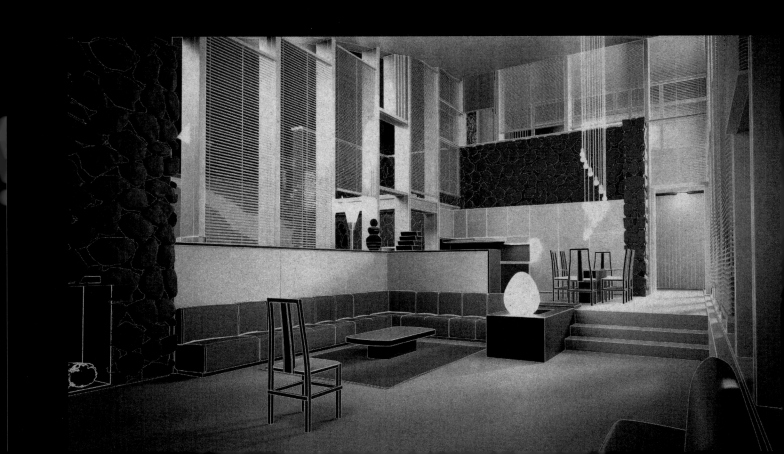

It's therefore fitting that when we get our first glimpse inside the Garcia House in *Lethal Weapon 2*, it's a buzzing hive of illegality, with imposing South African goons busily operating bill-counting machines as they riffle through stacks of ill-gotten hundred-dollar bills raked in courtesy of the drug trade. These are ruthlessly efficient bad guys up to major no good in a setting that implies that it's all part of a day's work. The floor-to-ceiling glass windows may let in an abundance of blinding daylight, but make no mistake, this is a place of moral darkness.

Lording over it all is Rudd, a man who, like 007's arch nemesis, Blofeld, seems to prefer the company of pets (in his case, tropical fish) to humans. Later, when Riggs and Murtaugh show up to arrest Rudd, he smugly informs them that the house, which is owned by the South African government, is technically South African soil. "My dear officer, you could not give me a parking ticket," he says. This, of course, provides even more ammunition for Gibson's loose-cannon cop to bring him down. Literally. In *Lethal Weapon 2*'s climax (or rather, one of its many climaxes), Riggs connects a cable from his pick-up truck to one of the house's support beams and peels off, pulling the house down the cliff and triggering a glass-and-steel avalanche. Architecture lovers, fear not. The only actual destruction was inflicted on a scale model of Lautner's Garcia House several miles away on the Warner Bros. lot.

Note: An interview with Richard Donner, director of Lethal Weapon 2 *and* Superman, *is included in* Lair's *discussion of* Superman.

6, 7, 8, 9
Tearing down the house: Gibson's Martin Riggs gets payback on Rudd and his white supremacist henchmen by tying a cable to one of the structure's stilts and pulling it down with his pick-up truck. By this point, the precariously situated modernist house has become a symbol of everything that needs to be dismantled and destroyed. This demolition scene used a scale model and not the actual Garcia House. Stills. *Lethal Weapon 2.*

6
7 8
9

ARJEN RUDD:
"THIS HOUSE IS OWNED BY THE SOUTH AFRICAN GOVERNMENT. THIS IS SOUTH AFRICAN SOIL. NOW GET OUT OF HERE!"

MARTIN RIGGS:
"I'LL MAKE YOU A DEAL, ARJEN, OR ARYAN, OR WHATEVER THE FUCK YOUR NAME IS, I'LL MAKE YOU A LITTLE DEAL. YOU FOLD UP YOUR TENTS AND GET THE FUCK OUT OF MY COUNTRY, AND I WON'T DO ANYTHING TO YOU. I'LL LEAVE YOU ALONE."

10
Exterior perspective of the entrance to the house,
with the garage door to the left of the front door.
Architectural illustration. Carlos Fueyo. 2019.

11
Exterior perspective of the front of the house, which
faces the canyon below. This view shows the exterior
and the portions of the interior that are visible through
the windows and delineates the support structure.
Architectural illustration. Carlos Fueyo. 2019.

12
Longitudinal section of the house, showing both
levels. Architectural illustration. Carlos Fueyo. 2019.

11
10 12

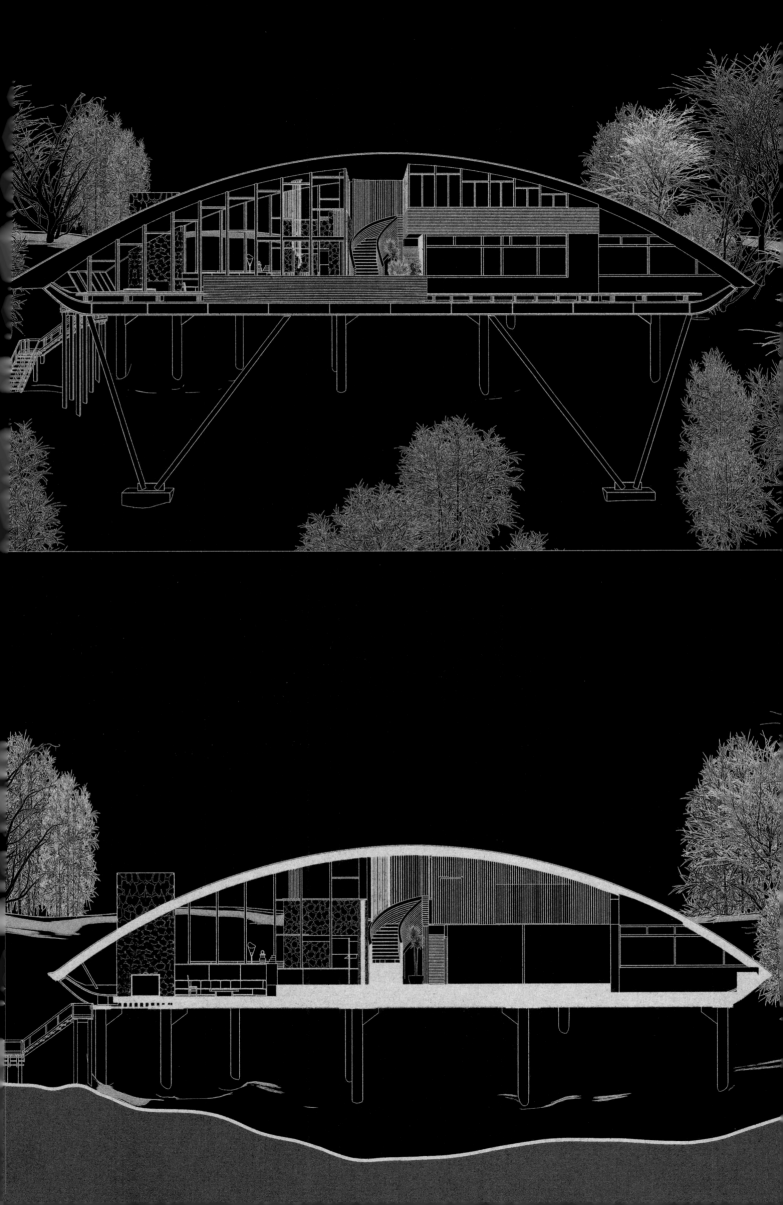

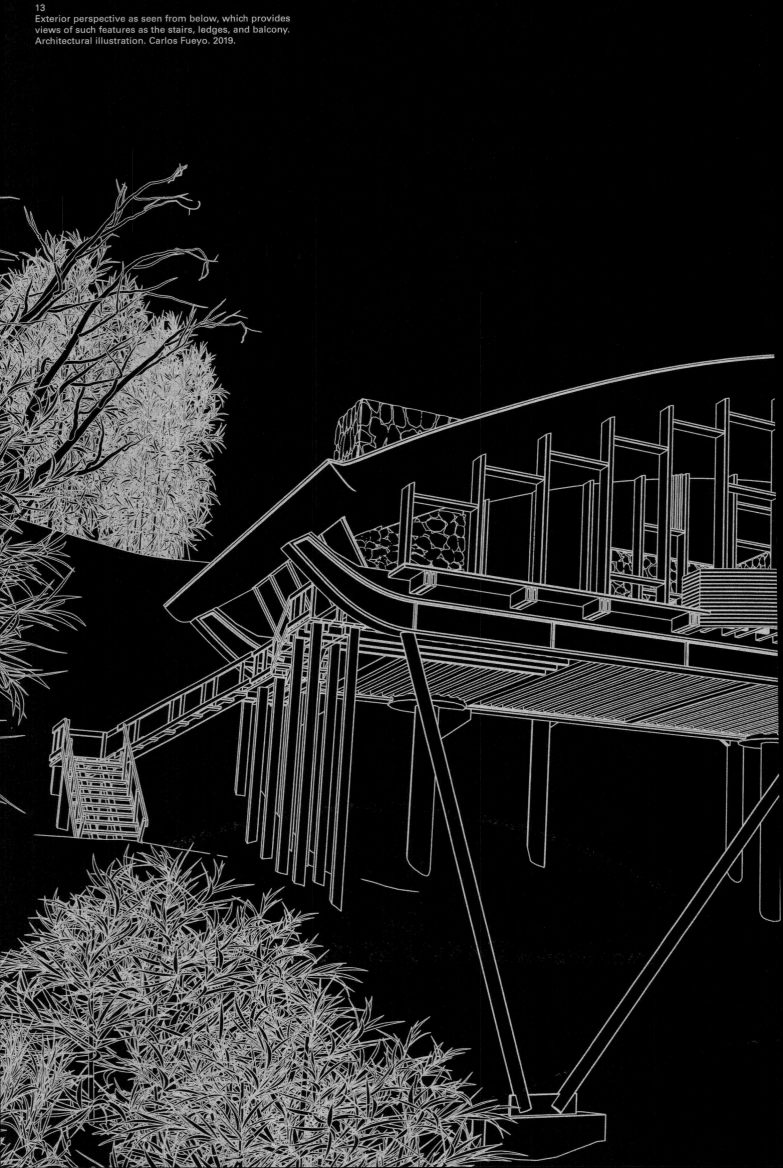

13
Exterior perspective as seen from below, which provides
views of such features as the stairs, ledges, and balcony.
Architectural illustration. Carlos Fueyo. 2019.

"You see so much of the beauty of John Lautner's aesthetic in this house. It's so much about how the structure takes advantage of the site and how it relates to the landscape and the city. It's almost as if the house is making love to the site and the context. It's a visceral relationship. What makes it even more striking is that the site is basically the face of a cliff."

"Considering that the house is used by very bad guys in this movie, it's interesting to look at it from that perspective. Is there anything about this house that seems inherently sinister? Why would the film be set here? When you ask that, you might say that in some ways, the house looks like an eye. Is it referencing the evil eye? Or you might say it looks like a frown—it is the shape of a frown."

"On the other hand, each of those notions could be seen as superficial readings, or perhaps misreadings. Conversely, the shape could be interpreted as the structure arching up, even reaching up, especially given the stilts on which it rests. And we could conclude that there is nothing at all sinister about this house."

"Perhaps the filmmakers chose this house as a locus of evil primarily because it is so visually striking and works so well with the storyline. The fact that it's on stilts is the perfect set-up for the final scene of the movie, where one of the supporting stilts is torn away and the house tumbles down."

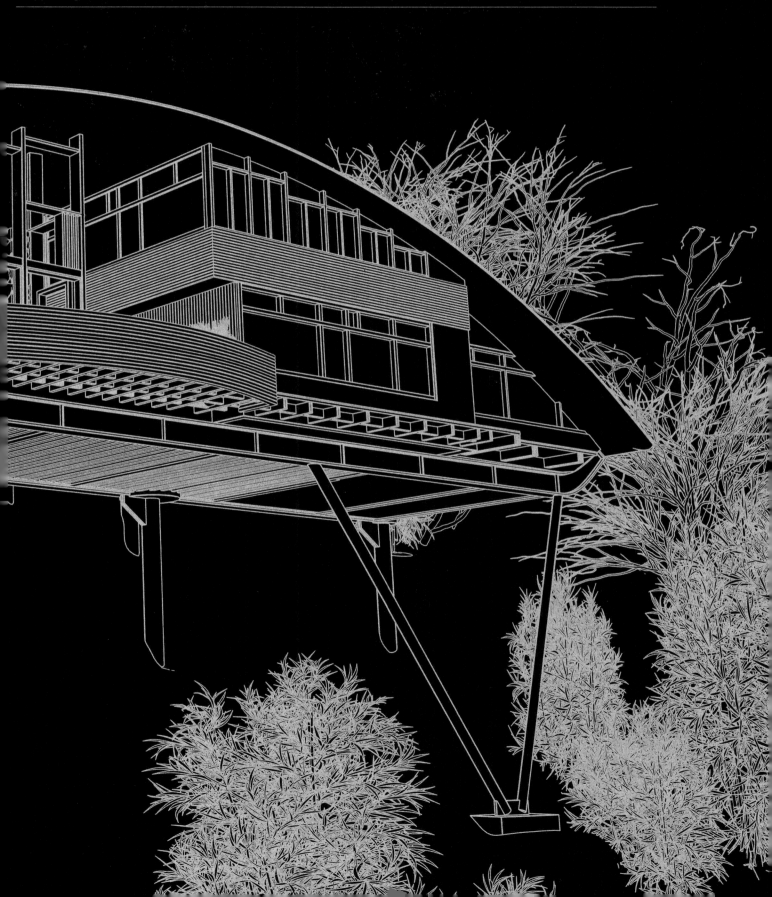

FILM **NORTH BY NORTHWEST**

VILLAIN **PHILLIP VANDAMM**

LAIR **THE VANDAMM HOUSE**

dry Madison Avenue ad exec who gets mistaken for a U.S. intelligence agent named George Kaplan and is kidnapped by a ring of well-tailored bad guys itching to snuff him out. Over the course of the dizzy, location-hopping film, Grant's Roger Thornhill gets swept up into a nightmarish web of intrigue that includes an on-train seduction of Eva Marie Saint ("How does a girl like you get to be a girl like you?"), a startling murder in the lobby of the United Nations, a narrow escape from a low-flying crop duster, and a vertiginous chase on the face of Mount Rushmore. It may be silly, but it's also one of Hitchcock's most delirious delights.

Release
1959

Director
Alfred Hitchcock

Production Designer
Robert F. Boyle

Cinematographer
Robert Burks

Cast
Cary Grant
Eva Marie Saint
James Mason
Jessie Royce Landis
Martin Landau

Screenplay
Ernest Lehman

Studio
MGM

Lair
Inspired by Frank Lloyd Wright's work and located on Mount Rushmore, the Vandamm House was a combination of an exterior matte painting and miniatures along with interior sets (the living room, part of the bedroom wing, the carport, and part of the hillside) built on an MGM soundstage in Culver City, California.

Images
All photographs are from *North by Northwest* and all architectural illustrations and renderings are based on spaces in the film.

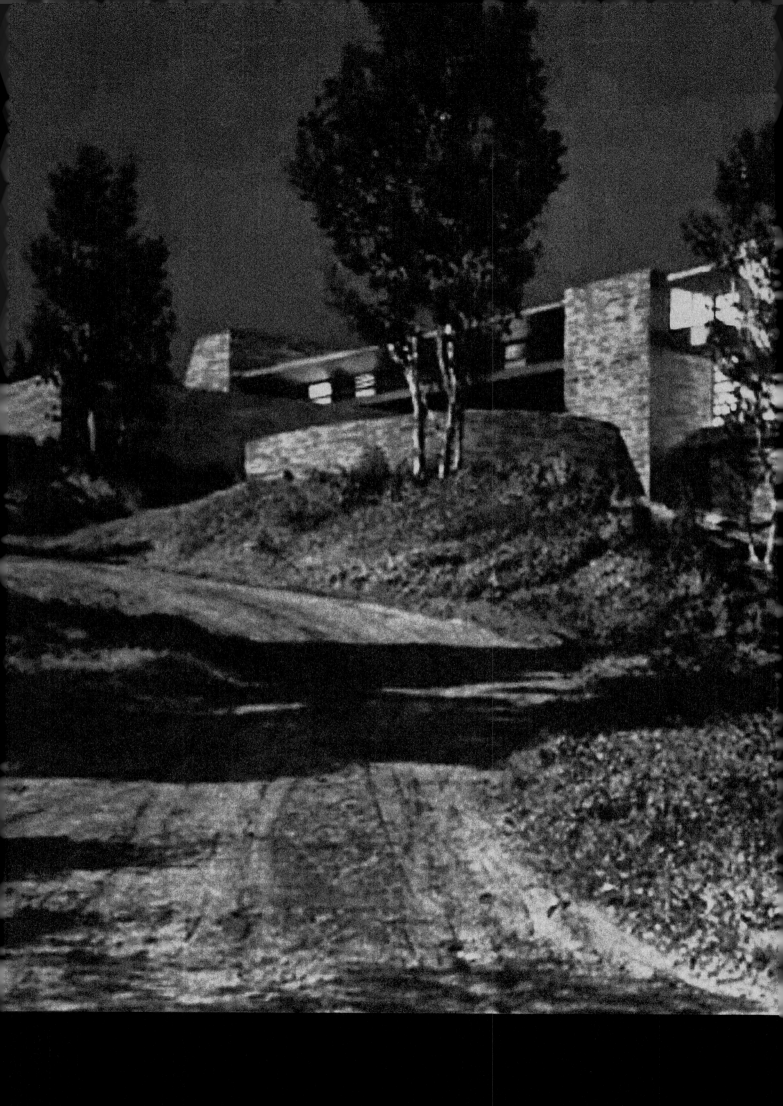

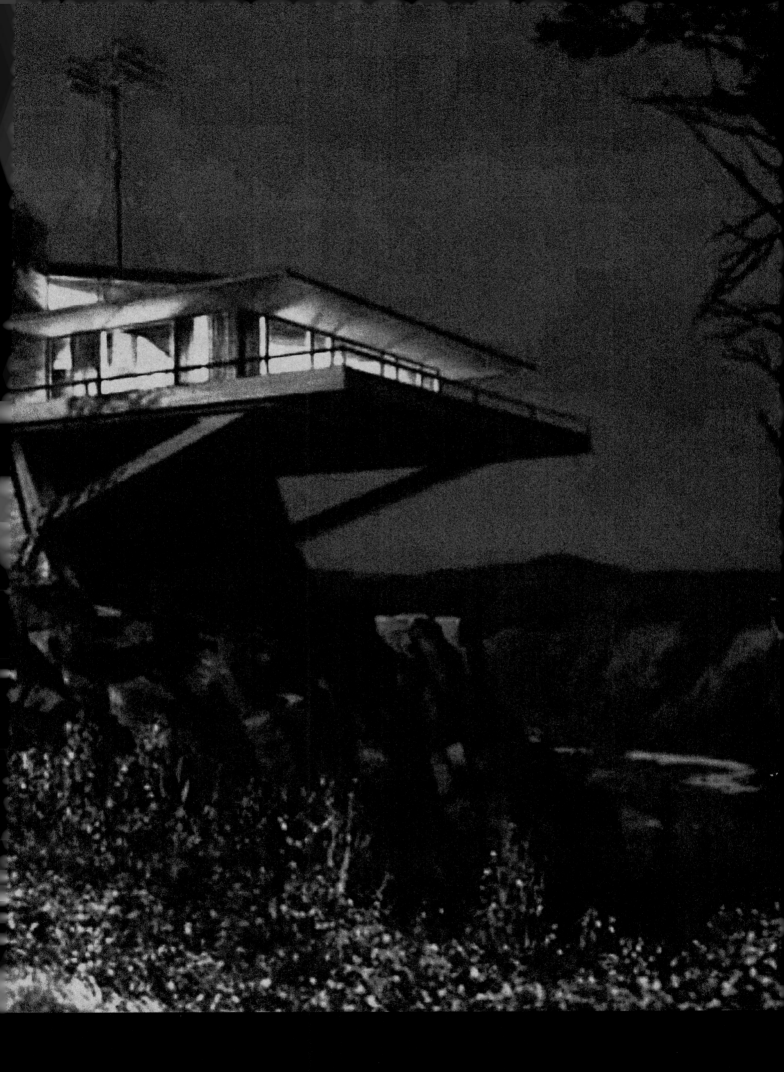

1
Exterior of the Vandamm House at night as seen from below. Perched
on Mount Rushmore, the Frank Lloyd Wright-inspired getaway of
mild-mannered villain Phillip Vandamm is both one with its natural
surroundings and seems to want to dominate and lay claim to them.
Still. *North by Northwest*.

VILLAIN

With a plummy British accent that rivals Grant's, James Mason plays Phillip Vandamm—a bespoke upper-crust gentleman of a villain dressed in tweed jackets, soft cardigans, and with the unflappable manner of a seen-it-all English butler. Every line that comes out of his mouth seems to ooze with classy menace and wicked insinuation. We never learn much about Vandamm's motives or what his grand scheme is beyond the fact that he wants the spy who goes by the name of George Kaplan dead. Vandamm is a classic movie villain in the sense that he rarely seizes the moment at hand to do away with his prey. Rather, he likes hearing himself talk (and thanks to Mason, so do we) and delaying the inevitable like a slow tease. Along with his lethal, stiletto-thin henchman, Leonard (Martin Landau, doing wonders with his character's implied homosexuality), he's so convinced that Grant's Thornhill is actually Kaplan that we almost start to believe him. Upping his villainy another notch, Vandamm's cruelty towards his lover-accomplice (Saint) is so casual that it makes him seem even more cold-blooded. Vandamm and Thornhill pursue one another across the country, from New York to Chicago to South Dakota, where Vandamm holes up in his mountain-top hideout, a lair so spectacular and in such a singular setting that it is instantly unforgettable.

2
James Mason as Phillip Vandamm, the elegant, bespoke British tormentor of Cary Grant's Madison Avenue ad man, Roger Thornhill. The very definition of chilly, mild-mannered menace. Still. *North by Northwest.*

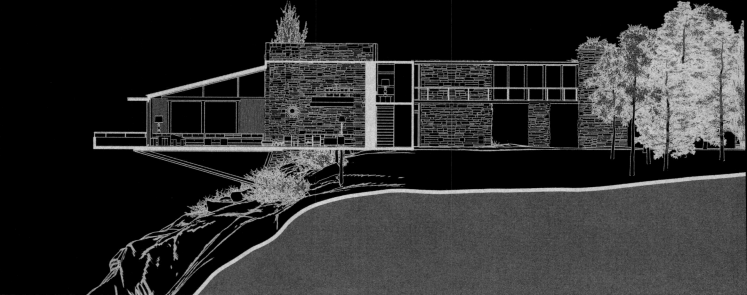

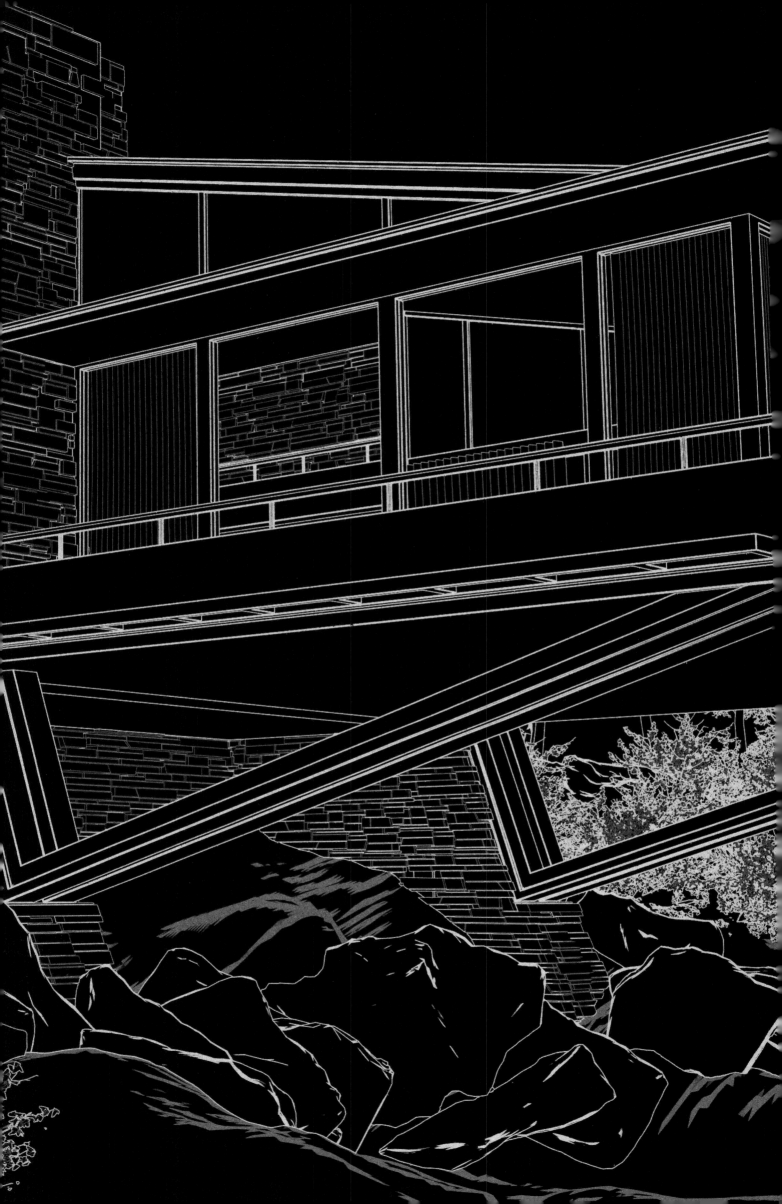

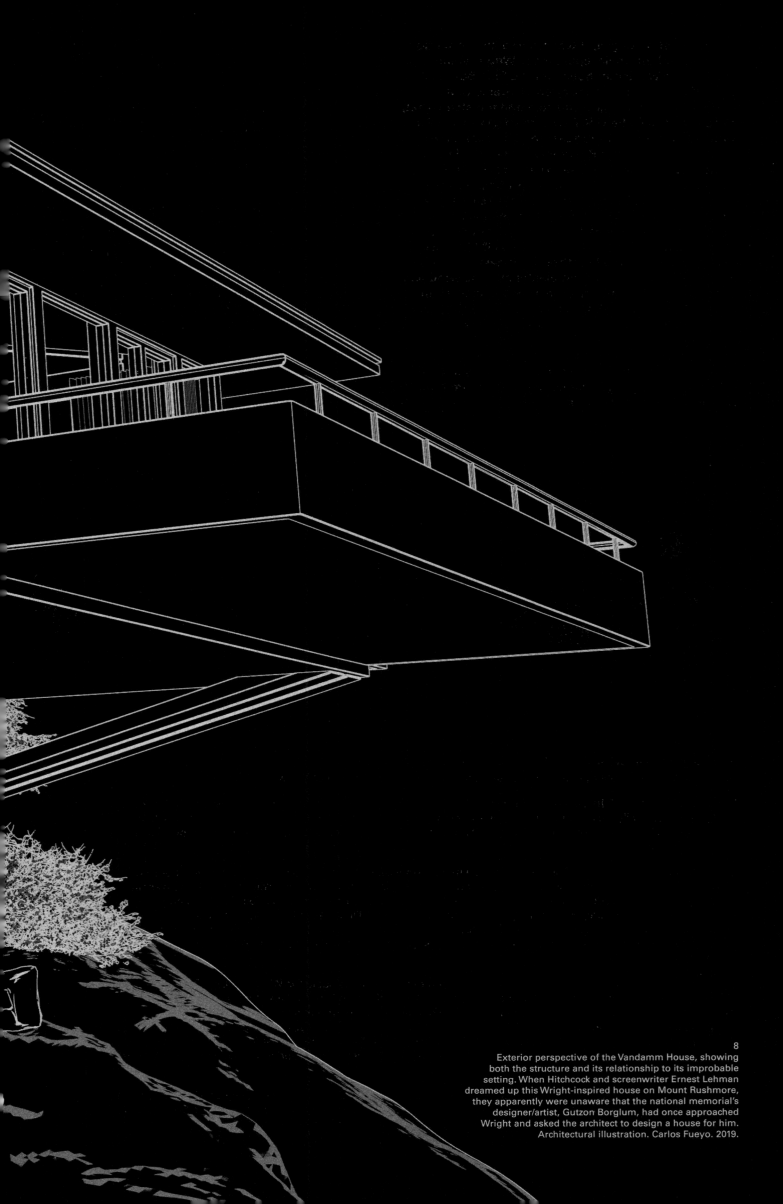

8

Exterior perspective of the Vandamm House, showing both the structure and its relationship to its improbable setting. When Hitchcock and screenwriter Ernest Lehman dreamed up this Wright-inspired house on Mount Rushmore, they apparently were unaware that the national memorial's designer/artist, Gutzon Borglum, had once approached Wright and asked the architect to design a house for him. Architectural illustration. Carlos Fueyo. 2019.

Before shooting began, Hitchcock and his production designer, Robert Boyle, approached Wright about building the Vandamm house for the film. But Wright's asking price (a reported ten percent of the film's overall budget) was deemed too steep. That, and the fact that the U.S. Department of the Interior laughed at Hitchcock's request to build a structure anywhere near Mount Rushmore, forced Boyle and his team to get creative. The exterior of the home was actually nothing more than a matte painting—a pre-digital special effect that combined real sets with detailed paintings—that was shot at night to make the trick of the eye work better. The interiors were constructed on a soundstage on the MGM lot back in Culver City. There, the breathtaking limestone walls were fashioned out of cheap plaster and the windows were glass-less to prevent camera reflections. Even Mount Rushmore itself was created for the climactic scene. The Vandamm house was so effective that it helped set a trend—modernist lairs like it would become the standard for movie villains over the next sixty years and counting. Yet, like the deadly cat-and-mouse game that fuels the film, the Vandamm house was, in the end, all an illusion.

9
Grant's Thornhill (or quite possibly his stunt double) scaling the exterior of the house and looking in at Saint's Eve. Still. *North by Northwest.*

10, 11
The interiors of the Vandamm House. On the left, the living room, which mixes design elements of a mountain log cabin with a modern take on the traditional English study. On the right, a balcony on the home's second story allows views of the open-plan living room…and is also a great place to spy on the scheming master of the house. Stills. *North by Northwest.*

12
Interior perspective of the living room and the second-floor balcony. This wide, unrestricted view affords an understanding of the full space that is difficult to make out from the film. The space is airy and open, but the mood is claustrophobic. Rendering. Carlos Fueyo. 2019.

13
Exterior perspective showing the front of the house jutting forward over the edge of the mountain. Architectural illustration. Carlos Fueyo. 2019.

9
10 11 12
13

Architects' Commentary
Highlights from Oppenheim Architecture's round-table discussion of North by Northwest

"The cultural context of the architecture is interesting to consider. Phillip Vandamm's lair is modeled after Frank Lloyd Wright and especially Fallingwater, and it was stunning and really new for movie audiences in 1959. For architects looking at it in 2019, it's a wonderful house, but it doesn't have that wow factor it must have had for movie audiences when it came out."

"Locating the house on Mount Rushmore makes a major impression. No one is going to build a house there, so what is this villain's lair doing, disrupting this monument to America and democracy? You've got George Washington, Thomas Jefferson, Theodore Roosevelt, and Abraham Lincoln. The psychology seems to be, 'I'm building my house on top of Mount Rushmore, because I'm *that* big. And while I'm at it, I'll build a private airplane runway.' It's a statement of power. It's not that he is showing respect for these giants of American democracy, and it's not that he wants to take his place among them—it's more that he's saying he can build right on top of them. Like, 'I'll park my car in the middle of your lawn.'"

"The architect Steven Jacobs writes about the setting and the house in his book *The Wrong House: The Architecture of Alfred Hitchcock.* He mentions that Hitchcock had a fascination with gigantic stone faces that came up in other films, so that may have played into the choice of location. He references an interpretation by Raymond Durgnat that, since the mountain has become this series of heads, you might view the house as a symbol of sexual repression or as a warped intelligence. The house doesn't have the kind of unsupported cantilevers typical of Wright, and Jacobs notes that it's likely because Hitchcock thought the audience would be too distracted, wondering what was holding up the house to pay attention to the action."[1]

"*North by Northwest* precedes the Bond movies but there are a lot of parallels. Cary Grant's character gets chased across the country and it's a tour, in a way, of amazing locations and buildings. And of course, you've got the uber-wealthy villain hidden away in a lair that's an incredible house in a kind of fantasy setting."

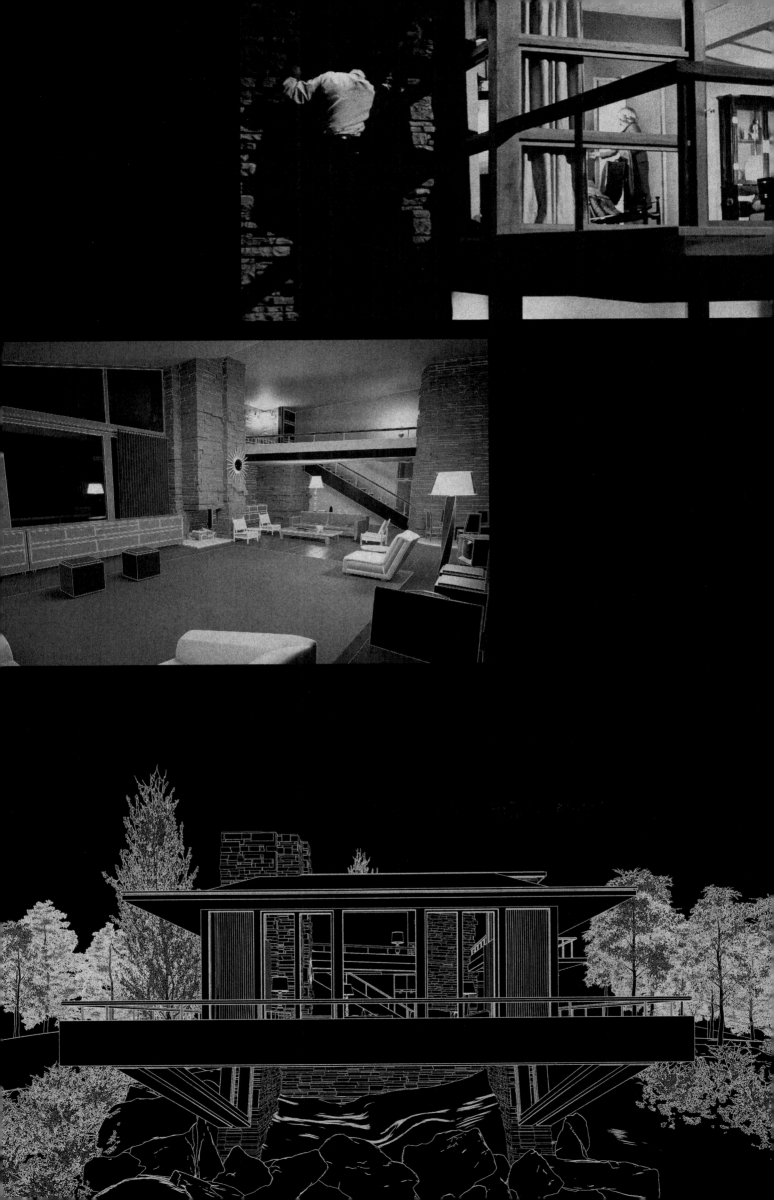

"IN THE OLD DAYS VILLAINS HAD MUSTACHES AND KICKED THE DOG. AUDIENCES ARE SMARTER TODAY. THEY DON'T WANT THEIR VILLAIN TO BE THROWN AT THEM WITH GREEN LIMELIGHT ON HIS FACE. THEY WANT AN ORDINARY HUMAN BEING WITH FAILINGS."

—*Alfred Hitchcock*

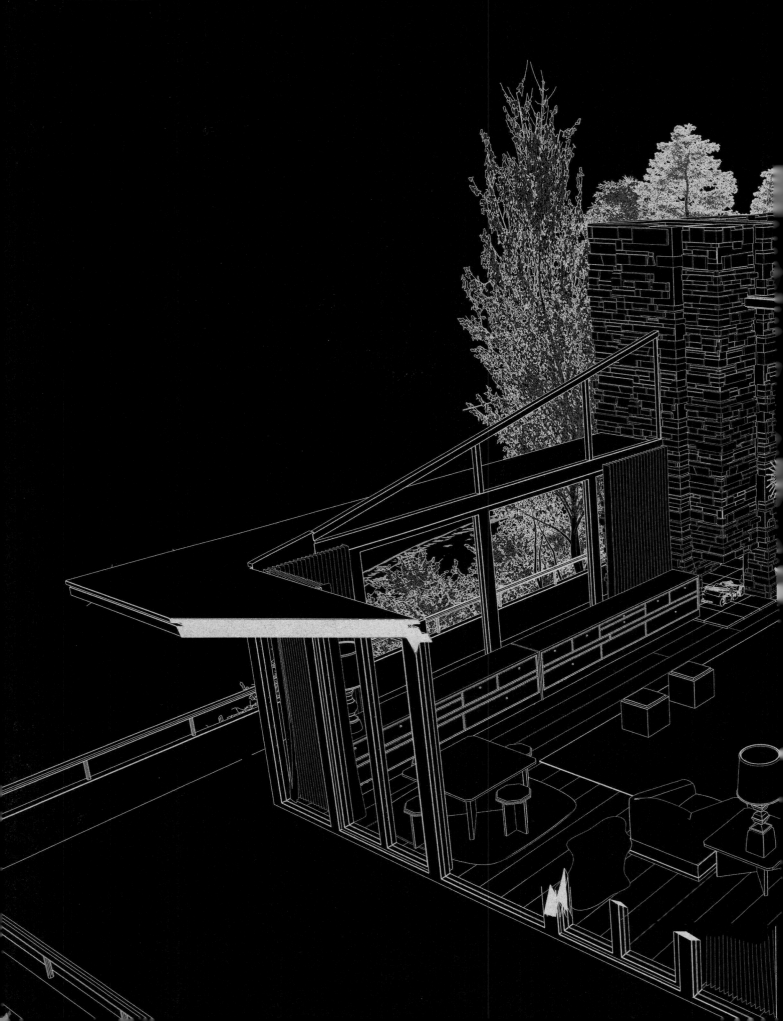

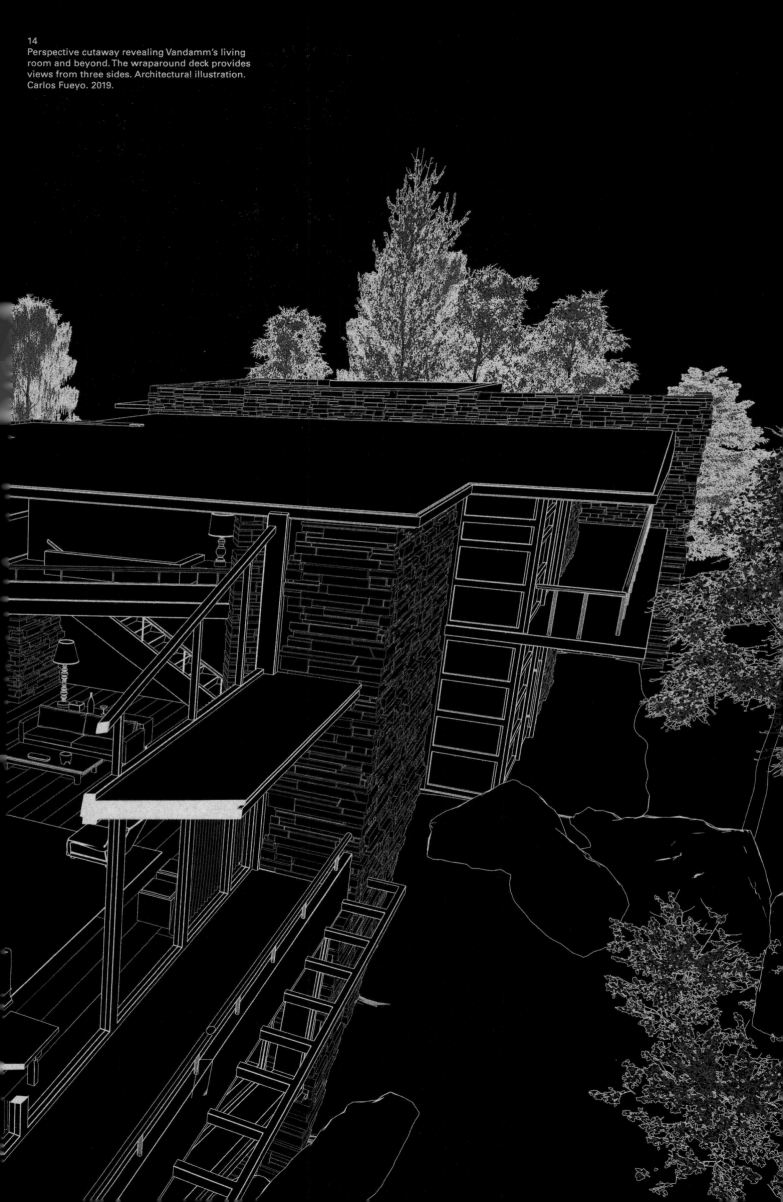

14
Perspective cutaway revealing Vandamm's living
room and beyond. The wraparound deck provides
views from three sides. Architectural illustration.
Carlos Fueyo. 2019.

FILM **SUPERMAN**

VILLAIN **LEX LUTHOR**

LAIR **GRAND CENTRAL TERMINAL**

FILM

Faster than a speeding bullet. More powerful than a locomotive. Campier and more costly than just about any movie of the 1970s…it's *Superman*! Starring a relatively unknown Christopher Reeve as the Man of Steel and his alter ego, Clark Kent, director Richard Donner's shoot-the-works, $55 million adaptation of the jewel in the DC Comics crown was not only the first time Superman was translated to the big screen, but it is considered the first true superhero movie. The film's team of writers (including *Godfather* author Mario Puzo) proceeded to pack every line of the screenplay with the extensive Superman mythos, beginning with the destruction of the planet Krypton. It's a silly, overstuffed film. But it's also a deliriously giddy one, with Margot Kidder as the gullible love interest, Lois Lane, and Gene Hackman as the ultimate baddie, Lex Luthor. *Superman* was a huge hit, taking in more than $300 million at the worldwide box office. But its real legacy is how it became the special effects-packed prototype for the superhero film genre that would become Hollywood's bread and butter thirty years later.

Release
1978

Director
Richard Donner

Production Designer
John Barry

Cinematographer
Geoffrey Unsworth

Cast
Christopher Reeve
Gene Hackman

1
Little do the rush-hour commuters in Metropolis'
Grand Central Terminal know that hidden two
hundred feet below its marble floors is a world of
greed and villainy—the secret lair of Superman's
arch-nemesis, Lex Luthor. Still. *Superman.*

VILLAIN

The character of Lex Luthor made his first appearance in Action Comics #23, in April, 1940. Since then, the criminal genius has repeatedly plotted his way into becoming Superman's arch nemesis, a state of affairs that made him the only logical choice to face off with our caped hero in his first celluloid outing. With a wild assortment of toupees and his tongue firmly planted in his cheek, Hackman has a ball with the role, chewing on his overblown dialogue with obvious relish. If he had a mustache, he'd be all but twirling it. With no help from his dim sidekick, Otis (Ned Beatty), or his conscience-stricken girlfriend and Gal Friday, Eve (Valerie Perrine), Luthor's fiendish scheme revolves around real estate and America's nuclear warheads. Basically, he plans to buy up all of the desert land east of the San Andreas fault and then blow the California coastline off the map—or at least someplace far into the Pacific Ocean—thus becoming the world's largest (and wealthiest) owner of beachfront property. Of course, Superman has other plans for Luthor.

2
Gene Hackman as the devious Lex Luthor, at home in the stately office of his underground hideout. Still. *Superman.*

Between the lavish renderings of the planet Krypton and Superman's Fortress of Solitude, the *Superman* filmmakers would be forgiven for cheaping out when it came time to dream up Luthor's lair. Instead, they came up with one of the most creative sets in the entire film. Luthor's hideout is two hundred feet below the streets of Metropolis (in the film, clearly New York City) in a condemned, abandoned concourse of Grand Central Terminal.

Luthor has turned this forgotten Beaux-Arts gem, with its cream-colored Botticino marble staircases and Tennessee marble floors, into a palace fit for a Roman emperor. There are arched walls lined with books, palm trees, ornate parlors filled with oriental rugs and antiques, and a marble staircase that was formerly a track entrance, the lower level of which is now submerged in water and has been transformed by Luthor into an opulent swimming pool. It's like his own version of Hugh Hefner's grotto. There, he can swim laps in a lime-green bathing suit (and matching bathing cap), relaxing as he fine-tunes his evil master plan.

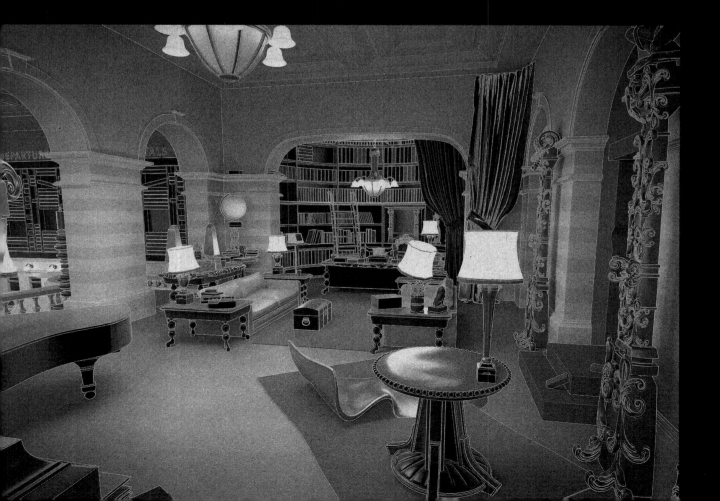

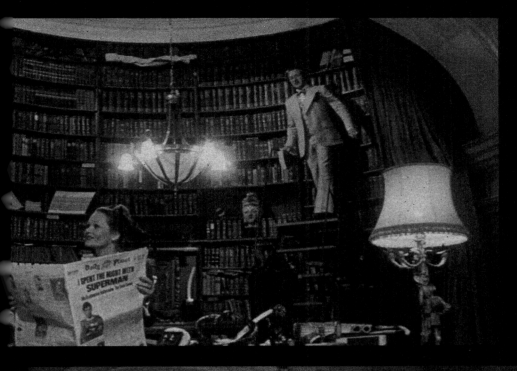

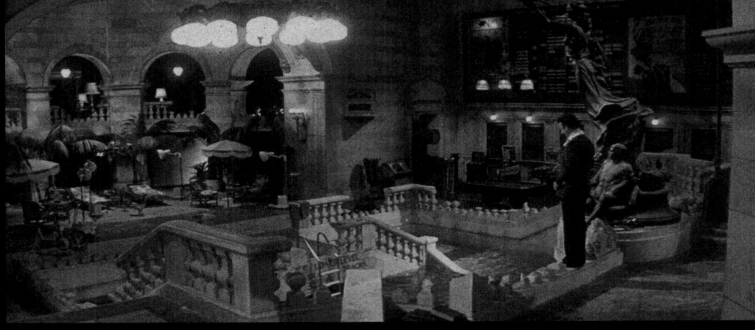

3
4
5

3
Luthor in the well-appointed library of his lair as he informs his
partners in crime (Ned Beatty's dim-witted Otis and Valerie Perrine's
Gal Friday Eve) of his real estate scheme and his plan to thwart the
Man of Steel, subject of the lead story in that day's newspaper.
Still. *Superman.*

4
Luthor surveys his subterranean kingdom of crime, including his
swimming grotto, repurposed from a long-abandoned concourse.
Still. *Superman.*

5
Interior perspective of Lex Luthor's luxurious living room and
library, which are chock-full of antiques and high-end furnishings. He
may be a modern-day scoundrel, but he aspires to Old World class.
Rendering. Carlos Fueyo. 2019.

6
Luthor emerges from an afternoon dip in his pool. Before the villain
turned the Beaux-Arts lower level of Grand Central Terminal into his
swank clandestine residence, the cream-colored Botticino marble
staircase led to tracks 11 and 12—now relics of commuter days gone
by. As with the rest of his lair, Luthor repurposed the abandoned
concourse, turning it into his personal pleasure palace. He has
everything any villain could possibly want deep below the busy
streets of Metropolis. Still. *Superman*.

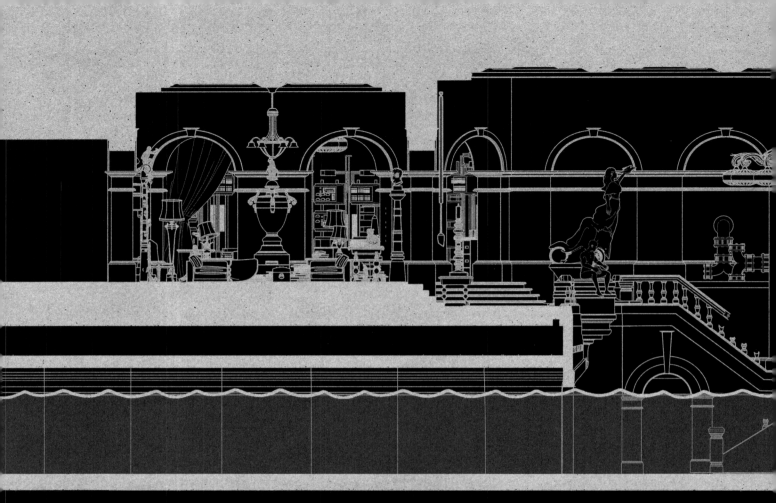

Architects' Commentary
Highlights from Oppenheim Architecture's round-table discussion of Superman

"Lex Luthor's lair is a bit of a departure for this book. It's the only example we have that's classical in terms of the architecture. It's in the Beaux-Arts style, and it's opulent and powerful and monumental. We chose it for the book because it's so inspiring. You have this massive, Roman-scale, palatial lair underneath the city. And it has a pool—or grotto. It's so outlandish."

"Despite its scale, there's a domestic feel to it. You sense that Luthor cares very much about his surroundings. He has incredible furniture and decorative objects, and a lot of it. There are couches everywhere, rugs, lamps, urns, sculptures. It's kitschy, and it's tongue-in-cheek—there's a sense of humor to it, which you don't see in most villains' lairs."

"There's an interesting relationship between the opulence, the domesticity, and the cutting-edge technology. There are plenty of electronics, all kinds of monitors, and of course there's state-of-the-art weaponry. So you've got kind of homage to both the classical past and to futuristic technology. And it's the technology that makes this classical-style lair possible."

"Luthor lives underground, so this is one of several examples of hidden lairs in the book. However, the subtext seems to be not so much about being hidden but about repurposing real estate, which correlates with Luthor's evil plot. The lair's existence plays with the idea of desirable real estate—who has that much space in the city? It's pretty much the deal of the century. And Luthor's scheme is centered on real estate, specifically, on repurposing not simply a single home, but the entire state of California in order to create a whole new coastline."

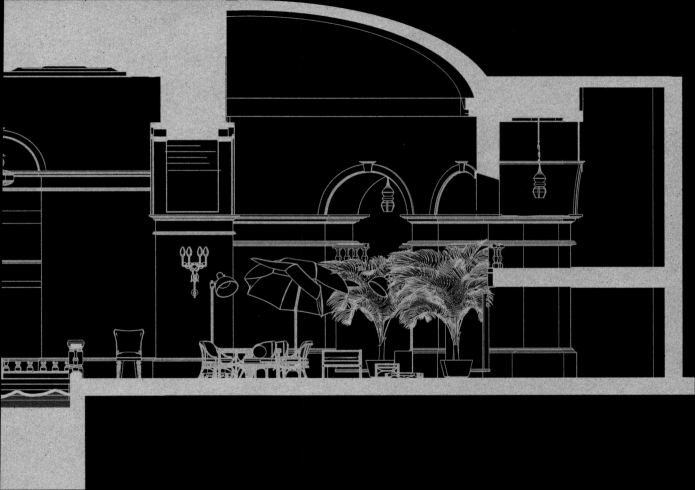

The first part of that plan, unsurprisingly, involves luring Superman to—where else?—his lair. When the Man of Steel arrives, Luthor, like virtually all movie baddies, explains his avaricious end game in great detail. Superman's reply: "You're a dreamer, Lex Luthor. A sick, twisted dreamer!" But for now, it's Luthor who gets the last laugh, producing a glowing, emerald-green chunk of Kryptonite that renders Superman helpless while Luthor chuckles: "Mind over muscle!"

While some of Donner's film was, in fact, filmed in Grand Central Terminal, the palatial interiors of Luthor's lair were constructed in a soundstage at Pinewood Studios, just outside of London. Production designer John Barry (*Star Wars, A Clockwork Orange*) and his Oscar-winning partners in the art department, Stuart Craig (*The English Patient, Dangerous Liaisons*) and Norman Reynolds (*Star Wars, Raiders of the Lost Ark*), spared no expense creating Luthor's unlikely underground palace—and why should they pinch pennies? After all, Hackman reportedly earned $2 million to play Luthor, and Marlon Brando pocketed even more—$3.7 million for two weeks' work playing Superman's father, Jor-El. In a way, it seems fitting that the film's resident real-estate swindler should call the film's most memorably exorbitant set home.

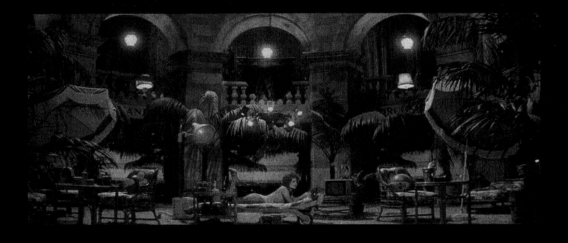

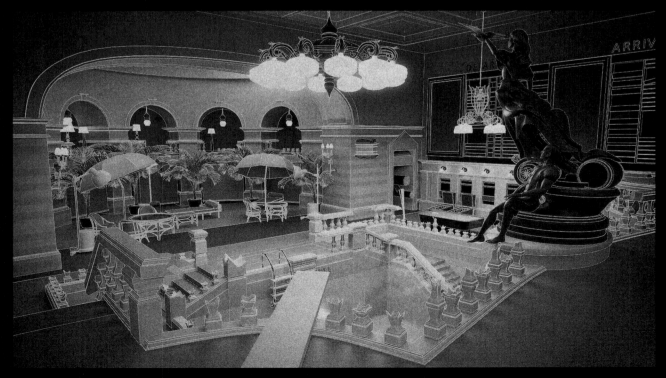

inlaid map of the United States on the floor—
ap that will look drastically different if Luthor's
eme comes to pass. Architectural illustration.
los Fueyo. 2019.

nsverse section, cutting through the pool
s showing the multiple levels of Luthor's lair,
urposed from the once-stately lower level of
nd Central Terminal. Architectural illustration.
los Fueyo. 2019.

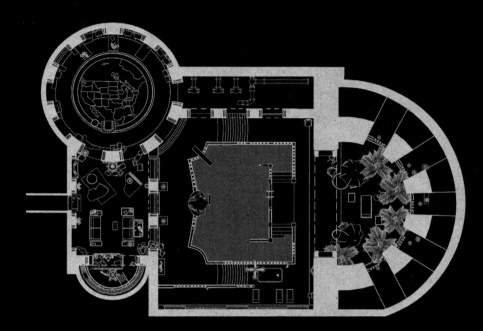

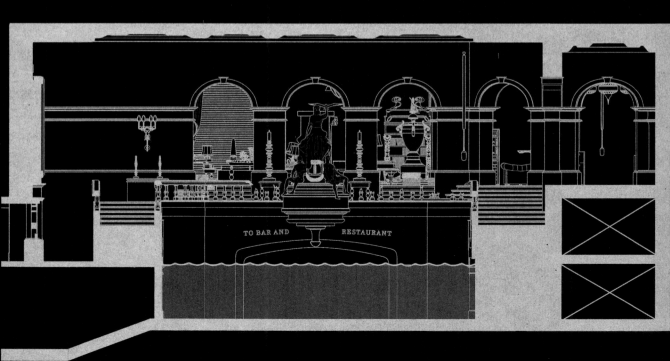

LEX LUTHOR:
"HOW MANY MEN DO YOU KNOW WHO HAVE A
PARK AVENUE ADDRESS LIKE THIS ONE?"

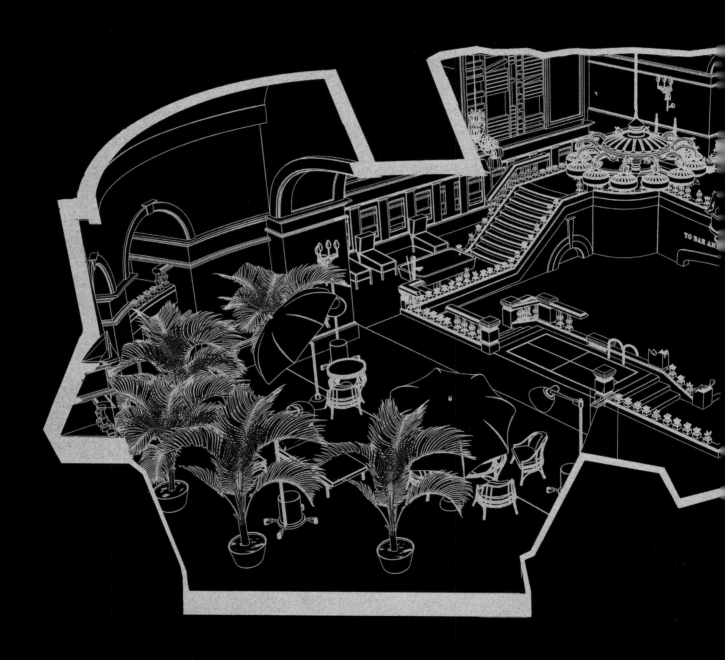

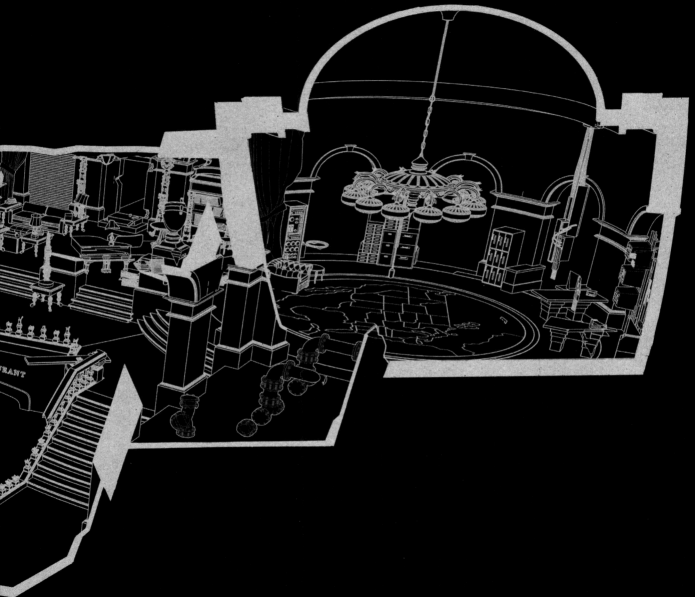

WHEN PLACE CREATES THE CHARACTER FOR YOU
A CONVERSATION WITH RICHARD DONNER, DIRECTOR OF *SUPERMAN*
AND *LETHAL WEAPON 2*

Few directors have been able to pick and choose the projects they want to work on with the same carte-blanche freedom as Richard Donner. It helps, of course, when your feature directorial debut is the 1976 satanic blockbuster *The Omen*—a movie that tapped into the public's fascination with the occult. Since then, Donner has explored evil in virtually all of its forms, which may explain why two of his films are featured in *Lair*. Those films, 1978's *Superman* and 1989's *Lethal Weapon 2*, couldn't be more different. One is the big-budget, candy-colored superhero movie that kicked off the modern era of big-budget, candy-colored superhero movies; the other showcased the most hilariously mismatched partners in a decade rife with buddy-action movies. What those two films have in common—aside from the man behind the camera, of course—is an impeccable eye for architecture, style, and visual grandeur when it comes to the bad guys putting our heroes through their paces. The eighty-eight-year-old filmmaking legend spoke with Tra Publishing about how he came up with his classic villains and the places they call home.

TP Tra Publishing: When *Superman* came out in 1978, its $55 million budget was considered to be absurdly high. Did you feel like you had a lot of money to play with when it came to building the film's sets, like Lex Luthor's lair below Grand Central Terminal?

RD Richard Donner: No. You have your limitations on everything, of course. Budgets that you try to abide by. But that was just a brilliant stroke of, well, I can't say luck, but of genius on the part of our production designer, John Barry. We happened to be in New York, scouting locations to try and find things, and somehow or other the conversation came up about the people who live underground in steam vents in New York City. We looked in Grand Central Terminal and John said, "Oh my god, this is where Lex Luthor lives!" I said, "What are you talking about?" And he said, "I have a great idea!" And he didn't say anything else to me for a couple of days, until he came up with these drawings, which were just brilliant. It gave the movie something that wasn't in the script. We looked at these strange drawings of Grand Central when it was the *old* Grand Central and how they built the new one right on top of it. I never knew what John was going to do with it, how far he was going to go. But I trusted him. It was wondrous when I finally saw the drawings.

TP You built those sets at Pinewood, correct?

RD Right. It was a huge undertaking. They were *big* sets. We'd gotten a really good deal in Canada for the sets of where Superman lived as a youth—Smallville, USA. So we saved a fortune there. And we were able to apply a lot of the budget to John's underground Grand Central Terminal. I have no idea what they cost us, but they were worth every penny.

TP What was a bigger undertaking, creating Lex Luthor's lair or creating the planet Krypton that we see at the beginning of the movie?

RD Krypton was a lot less than Lex Luthor's lair because a lot of it was done with projection. We had no computers, really, in those days. And a lot of it was just projection and smoky skies and limited backgrounds. We really took over Pinewood. We had the whole thing. We had seven units going at the same time. It was a crazy endeavor, and I never realized what I was getting into. But it was a lot of fun.

TP What do Luthor's surroundings tell us about who he is?

RD That he's got a lot of class, a lot of style, and he likes his solitude. The fact that he lives in that incredible place, I mean, those are always great enhancers of how a character is going to work onscreen. They create the character for you, really. Embellishing a character.

TP What did Gene Hackman bring to Luthor that made him so memorable?

RD He's probably one of the best actors that we've ever had. Gene created a character that was only partially on the page. He brought him to life like no one else possibly could have. And he had a ball, which you can tell just by watching his performance.

TP Switching villains and their houses: you also directed *Lethal Weapon 2*. The South African villains in that movie live in John Lautner's famous Garcia House in the Hollywood Hills.

RD It was cool wasn't it?

TP Why did you decide to make South Africans the bad guys? There was a lot of anti-apartheid sentiment in the news at the time, but Hollywood hadn't seized on that until this movie.

RD When we did *Lethal Weapon 1*, at the time I was upset—as everyone was—with what was going on in South Africa, and I had a green-and-yellow bumper sticker on my car that said "End Apartheid." I had an extra one, so I put it on the refrigerator in the home of Roger Murtaugh, Danny Glover's character. When the movie came out, it got such reaction that I received death threats! I went to our writer for the sequel, Jeffrey Boam, and said, "This thing raised incredible controversy, and I would love for you to think about incorporating some problem with South Africa into the script." And he took off with it and made it a world of its own.

TP Tell me about casting Joss Ackland as the South African villain Arjen Rudd.

RD He was wonderful, wasn't he? There was a very special woman at Warner Bros. for many years named Marion Dougherty. She was an amazing casting director who discovered everyone. When I was casting a movie, the first thing I would do was go to Marion and say, "What are your thoughts, how do I get the perfect cast?" She brought up Joss. And the moment she showed me his work, that was it. He was just a great character—a lot of dignity in his hate. Mild-manner, evil, chilling.

TP Why did you choose John Lautner's Garcia House as Arjen Rudd's lair? What does his physical environment say about his villainy?

RD You're being too analytical for me. It was just the perfect visual, really. Especially for the climax where Mel tears it down. We decided right away, as soon as we saw it up on Mulholland Drive and the owners agreed to work with us on it. We did shoot a little bit at the house, because it had such a nice entrance, but most of the interiors were on a set. We actually rebuilt it from scratch out near the Six Flags amusement park in the hills outside of Los Angeles. We built that house planning how we were going to tear it down so there would be no surprises.

TP You only get one shot at something like that.

RD You're damn right!

FILM **THE INCREDIBLES**
VILLAIN **SYNDROME**
LAIR **NOMANISAN ISLAND**

FILM

Pixar's sixth animated feature was a departure
for the animation studio and its most logistically
complex film to date. Rather than focusing on
anthropomorphized toys, bugs, or fish trying to
find their way home, writer-director Brad Bird's
The Incredibles tells the clever, caffeinated story
of a family of superheroes forced to give up
their crime-fighting ways forever, refrain from
using their superpowers, and go into hiding by
assuming their secret (i.e., civilian) identities.
Bob and Helen Parr (voiced by Craig T. Nelson
and Holly Hunter) are no longer known as Mr.
Incredible and Elastigirl. They have retreated
into anonymous, middle-class suburban exile
in Metroville after a backlash by the public—
lawsuits against superheroes snowballed, kicked
off by an irate would-be suicide who was rescued
mid-attempt by Mr. Incredible ("You didn't save
my life! You ruined my death!"). The government
couldn't afford the ongoing defense costs and
instead initiated the Superhero Relocation
Program. Mr. Incredible is now a clock-punching
cubicle drone at a large, heartless insurance
company, and Elastigirl is a harried housewife
straight out of *Leave It to Beaver*, struggling to
corral their three children (who also happen to
possess forbidden superpowers). Life as ordinary
mortals is bearable, if dull. While Helen has
adapted fairly well (she's Elastigirl, after all), Bob
is having a hard time with the mundanity of it all,
at least until a dastardly new supervillain named
Syndrome (voiced by Jason Lee) lures the gifted
clan back into action.

Release
2004

Director
Brad Bird

Production Designer
Lou Romano

Art Director
Ralph Eggleston

Cinematographer
Andrew Jimenez
Patrick Lin
Janet Lucroy

Cast
Craig T. Nelson
Holly Hunter
Sarah Vowell
Spencer Fox
Samuel L. Jackson
Jason Lee

Screenplay
Brad Bird

Studio
Buena Vista Pictures

Lair
Architectural inspiration includes Oscar
Niemeyer's work, particularly the Niterói
Contemporary Art Museum in Brazil, and
Eero Saarinen's TWA Flight Center at JFK
International Airport.

Images
All film images are from *The Incredibles* and all
architectural illustrations and renderings are
based on spaces in the film.

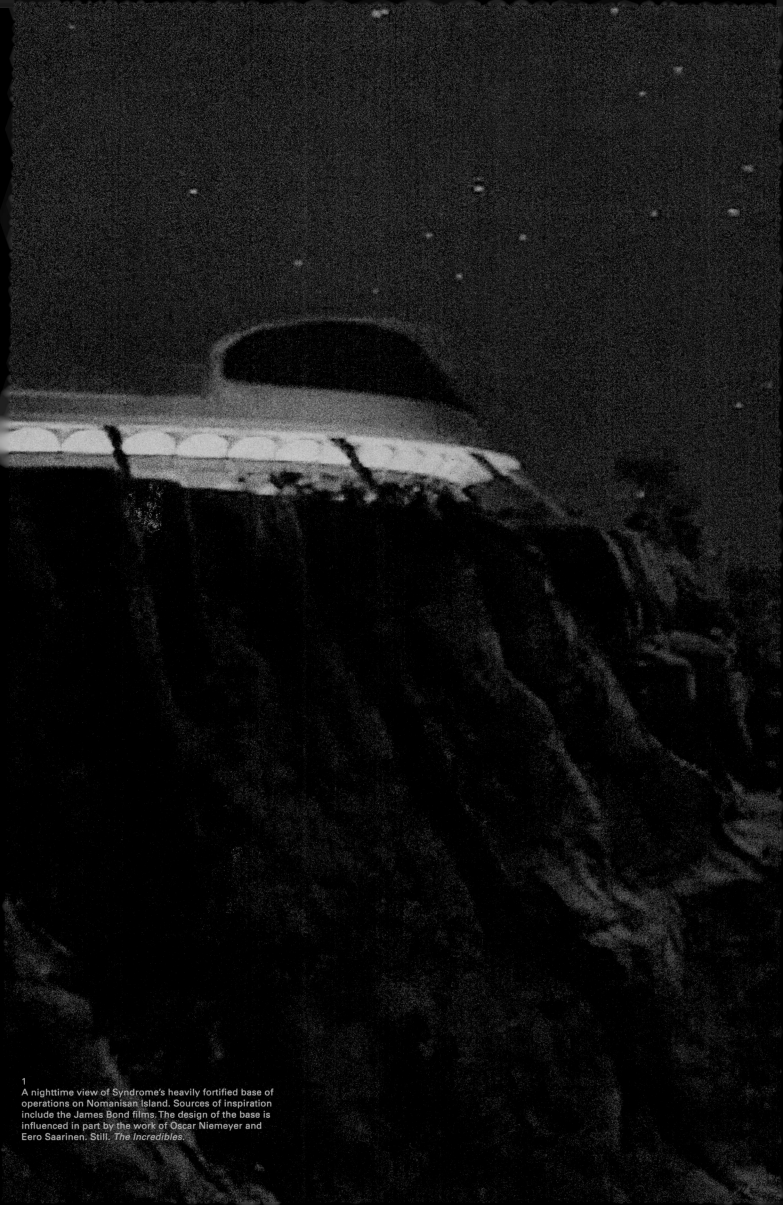

1
A nighttime view of Syndrome's heavily fortified base of operations on Nomanisan Island. Sources of inspiration include the James Bond films. The design of the base is influenced in part by the work of Oscar Niemeyer and Eero Saarinen. Still. *The Incredibles*.

VILLAIN

As a kid, Buddy Pine was a freckle-faced, wannabe superhero with big dreams. We first meet him when he petitions Mr. Incredible to take him on as his sidekick, Incrediboy. His credentials? He's Mr. Incredible's "number one fan." Mr. Incredible bluntly squashes those ambitions while engaged in an extended episode of crime fighting that's exacerbated by Buddy's stubborn obliviousness to everything but pleading his case. Since then, Buddy has had a massive chip on his shoulder, and has privately and patiently plotted his revenge. Now grown up (although that's debatable), he has assumed the villainous, mad-scientist alter ego of Syndrome, a flame-haired menace outfitted in a black-and-white spandex superhero costume with an impressive cape. He is in possession of an arsenal of deadly, high-tech, ingenious weapons and accompanying gadgetry that he has designed to systematically kill the world's retired roster of do-good avengers. Once he's knocked them all off—and he's well on his way—the defenseless world will be at his mercy, desperate for a hero to save the day, and he'll oblige, becoming the very thing that Mr. Incredible wouldn't let him be as a cloying tyke. When he's old and has had his fill of glory, he'll aim one last killing strike at the Supers by selling his inventions "so that *everyone* can be superheroes…and when everyone's Super, no one will be." The nefarious Syndrome tricks Mr. Incredible into traveling to his private island dotted with volcanos, intending that his vengeance will be a dish served molten hot. Elastigirl goes to the rescue, unwittingly bringing along two of their stow-away children. Much ensues…

2
The nefarious Syndrome, voiced by Jason Lee.

LAIR

The Incredibles is set in the retro-futuristic world of the late 1950s. Oscar-winning art director Ralph Eggleston lavishes the film with a groovy *Mad Men*, space-age bachelor pad aesthetic. The Parrs' suburban home is a classic, split-level slice of mid-century modernism. Still, it's Syndrome's lair, Nomanisan Island, where the film's aesthetic vibe flourishes—the sheer sci-fi inventiveness and appeal of his vast complex and the arsenal of streamlined vehicles, weapons, and gadgetry is so impressive that it can be difficult at times to remember that he's the bad guy.

The Sean Connery-period 007 movies are clearly the primary touchstone. Syndrome's fortified tropical compound, surrounded by lush foliage, feels like a cross between Dr. No's hideout on Crab Key and SPECTRE's cavernous headquarters in the volcano in *You Only Live Twice*. Meanwhile, the sleek, undulating wing-shaped curves of his cliff-top villa clearly nod to Oscar Niemeyer's work, particularly the Niterói Contemporary Art Museum in Brazil, and to Eero Saarinen's TWA Flight Center at JFK International Airport, perhaps with a lighthearted dash of Gerry Anderson's *Thunderbirds* TV show for good measure.

3
View of Nomanisan Island, the volcanic jungle paradise that is home to Syndrome's lair. The villain's tropical volcanic island is a direct nod to James Bond films, particularly *Dr. No* and *You Only Live Twice*. Still. *The Incredibles*.

4, 5
A monorail system ferries visitors to the lair—part of the journey includes going directly through a waterfall. The system is also used by the security guards to monitor the property. Stills. *The Incredibles*.

6, 7
Views of the compound, showing how it relates to its surroundings, and a closer look featuring one of the many security guards that monitor the property. Stills. *The Incredibles*.

3
4 5
6 7

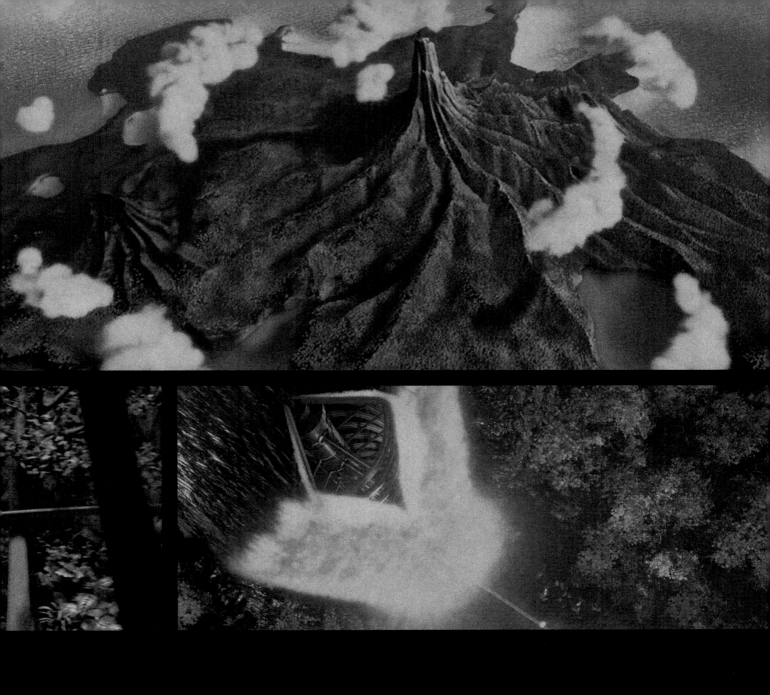

But Syndrome's lair doesn't stop there—the countless rooms, passageways, landing docks, and launch pads appear at times to be flashing before our eyes. Because the world of animation allows a profound level of design freedom, Syndrome's hideout includes its own monorail transportation system with tram cars in the shape of Wiffle Balls and a track that winds its way through the heart of a waterfall. There's an atrium/dining room the size of a football field, replete with a glowing orange wall of molten lava that parts to reveal a secret passageway. The conference room has a retractable wall to the outdoors—convenient for tricking unknowingly trapped Supers like Mr. Incredible into thinking he is early for a meeting, when in fact he is bait for the ominous Omnidroid (Syndrome's massive, octopus-like, robotic killing machine). Weapons can pop out of walls and fire weirdly expanding sticky balls of a metallic-looking substance that are persistent enough to fell Mr. Incredible. It's the sort of evil clubhouse an imaginative twelve-year-old might sketch while trapped inside on a rainy Saturday afternoon, complete with multiple rockets, one of which is on a countdown to head for Municiberg and launch an Omnidroid attack on the city.

The décor inside Syndrome's lair does not disappoint. As with *The Incredibles* as a whole, it features a carefully curated selection of mid-century furniture (even the airplane that transports Mr. Incredible to the island is sleek) and art callously looted from the world's culturally significant sites, such as the Easter Island statues that stand sentry at the lava wall.

The Incredibles is a wildly original film—one of Pixar's best, which is saying something. But even if it wasn't as fiendishly clever as it is at building its villain's inner and outer worlds, we'd know the extreme seriousness of Syndrome's wickedness simply based on the chilly cinematic inspirations he's chosen to surround himself with. It's a smorgasbord of villain shorthand, served with a wink and a nudge to the ribs.

Landing dock for the monorail's streamlined, pod-like cars. Still. *The Incredibles.*

9
Taken prisoner—this pod opens to reveal that Mr. Incredible is being held inside. Syndrome is taunting him, as is the news of the world that is being projected on the large television screen on the left. Still. *The Incredibles.*

10
From a viewing balcony, Syndrome admires one of his creations—a rocket that is being prepared to launch and wreak mayhem. Still. *The Incredibles.*

11
Mr. Incredible in the well-appointed, mod conference room, waiting for a fictious meeting to start—the wall has just opened, revealing the Omnidroid that's about to attack him. Still. *The Incredibles.*

8
9
10
11

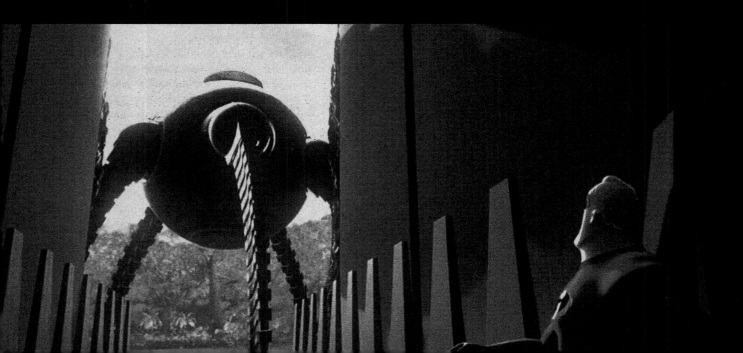

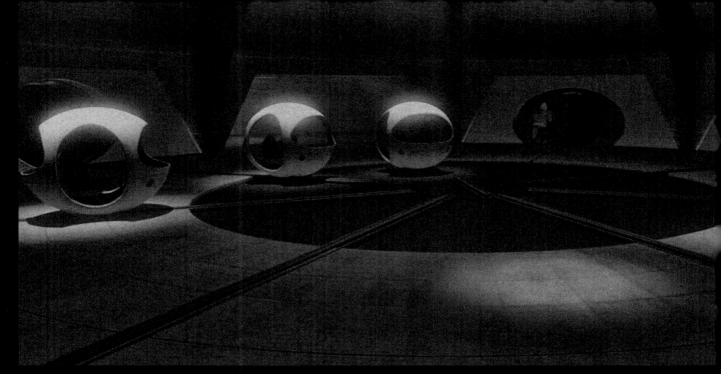

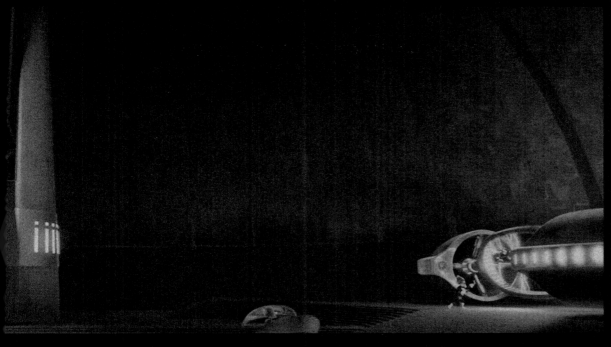

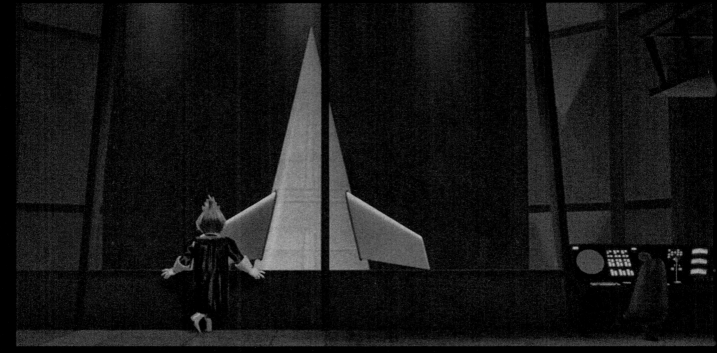

wall and the spaces surrounding it—the dini
front and the secret room behind the lava. This
narrow room where Mr. Incredible accesses
files and learns that many of the Supers have I
Architectural illustrations. Carlos F

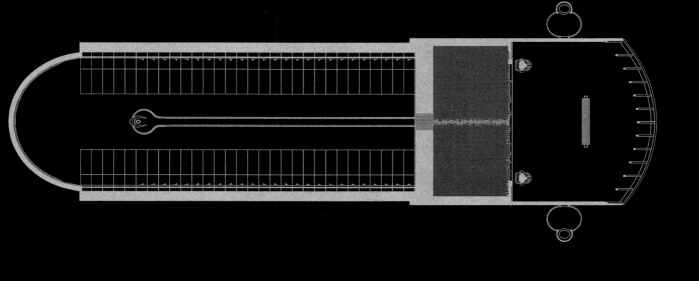
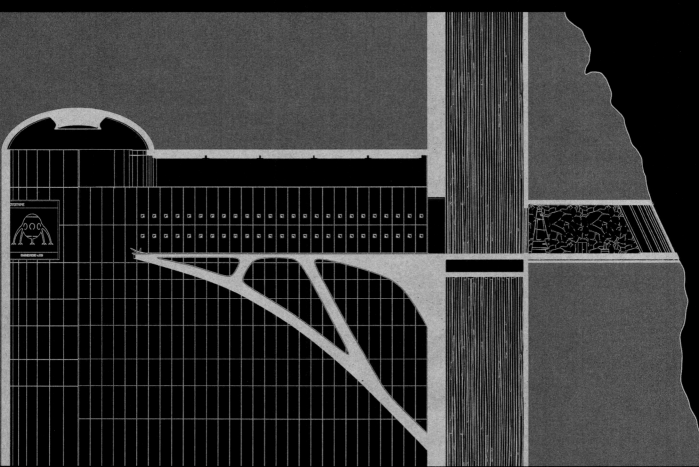

MR. INCREDIBLE:
"NO MATTER HOW MANY TIMES YOU SAVE THE WORLD, IT
ALWAYS MANAGES TO GET BACK IN JEOPARDY
AGAIN. SOMETIMES I JUST WANT IT TO STAY *SAVED*, YOU
KNOW? FOR A LITTLE BIT. I FEEL LIKE THE MAID.
I JUST CLEANED UP THIS MESS. CAN WE KEEP IT CLEAN
FOR TEN MINUTES? PLEASE?"

16
Mr. Incredible in the room beyond the lava wall—he has
just learned what Syndrome's been up to. As he rushes off
to fight crime, an alarm is triggered, causing portions of the
walls to open. Miniature cannons emerge, and spheres of
a sticky, metallic-like, expanding substance are fired. Still.
The Incredibles.

IF PEOPLE NOTICE THE VISUALS, THEN YOU HAVEN'T DONE YOUR JOB

A CONVERSATION WITH RALPH EGGLESTON, *THE INCREDIBLES'* ART DIRECTOR

Talking to Ralph Eggleston about *The Incredibles* is probably a lot like talking to Buddy Pine back when he was still Mr. Incredible's self-proclaimed "number one fan," a wildly creative kid lobbying to be taken on as Incrediboy. But after being spurned by Mr. Incredible, Buddy went bad and morphed from a Super-wannabe into an evil villain, leaving Eggleston, art director of *The Incredibles*, to assume the role of Mr. Incredible's number-one fan—and a wildly creative one at that. Eggleston, who has been with Pixar Animation Studios since 1992, has had pivotal roles in many of the studio's films, including *Toy Story, Finding Nemo, WALL-E, Inside Out,* and *Incredibles 2,* in addition to winning an Oscar for his directorial debut on his short film, *For the Birds.* "I'm so lucky to get to do what I do. I love making movies," he told Tra Publishing during an in-depth conversation about the making of the captivating world of *The Incredibles.*

TP **Tra Publishing: For *The Incredibles,* you created an entire world. How do you get started on a project like that?**

RE Ralph Eggleston: You're just trying to figure out what the director wants and what's cool and what's going to work for the story. One of the truisms I learned from Richard Sylbert—who designed *Chinatown* and *Dick Tracy* and *Who's Afraid of Virginia Woolf?*— is that no one cares what a film looks like. They really don't. They want to be caught up with the characters and the characters' emotions. That is kind of depressing to hear as a film production designer, but it's very true. And it's also very freeing. It doesn't make the job easier. What it means is you have to spend more time attempting to get hold of the emotional content and the idea of the story in order to distill what you need to design, build, and produce the story.

TP **You have referred to the amazingly inventive look and feel of *The Incredibles* as 1950s–60s retro-futuristic. It's going back in time, and yet it's envisioning the future. What were the origins of that aesthetic?**

RE It's funny. They don't have cell phones, but they have manta jets and velocipods. It really was a matter of what *felt* right. And then Brad's inspirations [Brad Bird, writer-director of *The Incredibles*] as a child were always Jonny Quest and James Bond. So that was a big part of it. The world of *The Incredibles* is a direct descendant of those films and of the work of the wonderful production designer Ken Adam. There is a direct lineage. It was always intended to be this bigger-than-life world that is impossibly cool.

TP **How did you create an animated world in *The Incredibles* that people connect to, with characters that resonate?**

RE Animation, not just in terms of designs and the visuals, but even in terms of the story, is caricature. It's like ballet. Ballet isn't about realistic movement, it's about stylized movement. And that's what we do. On every level, it's about caricature. What's real are the characters' emotions. The audience can read right through that if it isn't sincere. Our biggest grounding element is the audience's ability to connect with the characters. And if the world looks cool, that's a plus. So as we're writing, characters fall away or they change drastically. I would love to be able to answer your question as if we knew exactly what we were doing when we started, but we really didn't. It's not as though we didn't know where we were trying to go, but boy did the details change a lot along the way.

TP **What is your process like at the beginning of a project like *The Incredibles*?**

RE Every film is different, but there are a lot of similarities. I hate reading scripts. I find it interminably dull. Instead, I love to have the director tell me the story. A script is going to change, sometimes radically. But when the director is pitching the story—and I have them pitch it to me every few weeks—when they pitch, I can hear emotionally what they're excited about and I jot it down, and I know it's important. It gives me ideas for design. I spend a lot of time roughing stuff out. I paint on the computer sometimes, but I prefer to use those big fat Sharpie markers on newsprint and sit and doodle and not use my hand and my fingers to draw, but use my body to draw. Sometimes it's just shapes and then I'll cut and paste and rearrange. I do a lot of research, too. You have to go out and see and experience the real thing and talk to people and interview people.

RE There's a part of the process that they've taken to, and I disagree with it vehemently. Having a big screen you can touch and move things around is a wonderful tool, but it's being used at the expense of printing stuff out and pinning it up on the wall. Yes, it's messy, and yes, it's time consuming, and yes, it requires a production assistant or for you to get there early or stay late to put the stuff up. But what I love about it and why it's important and why we can't stop doing it is because if all you're doing is seeing one thing at a time on a screen, that is all that people are going to see and remember. But if you have a roomful of inspiration—photos, art work, textures, whatever—this stuff is hanging up on the wall. The more they [the director, etc.] see it, the more they get used to it, the more their eyes wander around, and it inspires them, and it makes their imagination travel. I'm a big believer in overloading them, at least initially, and that changes over time, because you do have to make decisions, and you do have to move forward, but it is invaluable. Once they start liking things, I print them really large and hang them where everybody, especially the director, has to walk by them every day. Because again, the more they get used to it, the more the chances are that it will stick.

IP Was the city in *The Incredibles* modeled on a particular city or cities?

RE It wasn't. It was based not necessarily on real 1950s and 1960s architecture, but on your *memory* of it. Then you go back and do research and find things to support your vision. In the world of *The Incredibles*, Municiberg is the future. So it's front-lit. It's steel and glass and cement. That is our palette right there. And the city was very much about the fight with Syndrome and the Omnidroid and the family and Frozone.

IP Although you say people shouldn't notice it, so much attention is lavished on design in *The Incredibles*, from the cityscape to the architecture and interior design, to fashion, and even to landscape, such as the lush jungle foliage on Nomanisan Island. What were your inspirations for these design elements?

RE The starting point is *all* of that stuff. Our job wasn't to create that stuff. It already existed. With the architecture, [Joseph] Eichler and [Eero] Saarinen, these folks existed. Our job was not to steal their work, but we wanted to be inspired. One thing we could do that they couldn't is we didn't have to worry about building to code or safety issues, because we literally can do anything. Although actually, it's not that you can do just anything in animation. It does have to have a sense of weight and scale and believability. We do a lot of research and then we respond to the storytelling elements.

IP Do you mean you respond to the storytelling in the architecture?

RE Yes. For example, look at the Parr home [Parr is the Incredible family's surname]. It's based on an Eichler. Those things exist. But if you look at the front of the Parr home, it's cantilevered. It goes down in the middle. And the reason it does so is that it's angry. The house is angry. The family is angry that they have to live in this small place. They're superheroes. And they're stuck in this fifteen-hundred-square-foot Eichler. No disrespect to Eichler, but they are glorified trailers. We talk a lot about distilling ideas from the story's point of view, and we hope that none of that gets in the way of telling the story. If anyone has noticed what you're doing, then you really haven't done your job. It should be in the background. It's visual subtext.

TP Although the house is angry, and Mr. Incredible's job at an insurance company is super depressing (as is the building he works in), and they are basically banished to suburbia and barred from using their superhero gifts, it does not feel as if the movie is commenting negatively on suburban life.

RE Oh, no, no. It was not about that. It's really about the family stuff. That's why when you go into the house, it's a tight space, for poor Bob [Mr. Incredible] especially, since he's six foot eight, but there's a certain warmth in the house. There's a very intentionally limited palette with just a little warmth, and that is mostly Helen [Elastigirl]. And Bob's office is down in a basement, with no windows. It's very, very small. When you first see the house, there is a grey sky. We're using all of the things at our disposal as filmmakers to underscore the point we're trying to make in the story.

TP Switching topics from superheroes to supervillain, was Syndrome's lair, Nomanisan Island, envisioned as ultra-modern from the outset?

RE Yes. Although at first we had another villain, and Syndrome actually worked for that villain—

TP Syndrome is probably bad enough. You probably didn't need another bad guy.

RE Originally the opening of the film was Syndrome trying to steal Jack-Jack. It was very creepy, and he was almost like a serial killer in a way. I mean, why kidnap a baby at the beginning of a movie? It's horrible.

TP But he does that—or tries to—at the end of the movie.

RE By then you know he's the villain. You don't want to start off with a bad taste in the audience's mouth. It's ok once you get to know characters that you end up there, because you know they're the bad guys, and you're rooting for someone to stop them. But you don't know anyone at the beginning of a film.

TP What was your inspiration for Nomanisan Island?

RE James Bond. The one set inside the volcano crater [*You Only Live Twice*]. We wanted to take that idea and do all the cool things that Ken Adam [production designer on *You Only Live Twice* and many other Bond films] wanted to do but couldn't afford. And we did. A lot of Nomanisan Island was Brad-driven in terms of story. The question would be, "What do you need?" "Well, I need a place for a rocket to launch. I need an office here. I need a prison of some sort." We would do lots of drawings, sometimes hundreds.

TP What is your favorite part of Nomanisan Island?

RE That's a hard question. I love everything. Some of my least favorite parts were some of the one-off rooms, because they're time consuming, and they're expensive, and they're on the screen for about three seconds. But that's just process. My very favorite part was approaching the island, seeing the entire island from a distance, landing on the island. I really love the entire rocket area. I love the prison that Bob was in. And I love the lava room. They're all just so fun. They really get your imagination going.

TP Is there a relationship between Syndrome's lair and his personality?

RE Bob must have grown into feeling not so great about how he treated Buddy Pine, which is Syndrome's real name, because he may have been an annoying kid, but look at how *creative* he was. Bob was annoyed by this little brat who was only trying to help and was an enormous fan. Once Buddy Pine realized he was going nowhere with Bob, and Bob got him taken away by the police, his anger about that turned to bitterness, and his creativity turned from trying to help to trying to do harm. Where better to start developing that and begin the process of killing all the Supers than a remote island somewhere in the South Pacific? Syndrome really did use all of the creativity that was so obvious when he was a kid to build this lair and start plotting his revenge on those he perceived had wronged him, the number one person being Mr. Incredible.

TP Looking back, is there anything about the film you would like to change?

RE The things I would love to redo when I see the film are some of the jungle stuff, probably some of the city stuff, and the fight at the end of the movie. And it's kind of a dumb thing, but the crowds. There are probably seven extras in the entire movie, and that's because doing humans is hard and doing hundreds of humans is even harder. It's more manageable now. We had an entire department on *Incredibles 2* that did nothing but crowds.

TP Why is doing humans hard?

RE You, as a human being, innately know what human beings look like and how they act and how they move. When it's not right, it's uncomfortable to watch. One of the things Brad very wisely said was that we weren't going for realism. We were going for caricature, not just with the world but also with the humans. So, if Bob is six feet wide and has a chest that's a mile wide and has two-inch ankles, that will never work [in real life]. But Brad was adamant that we would make it work with the acting and the animation and having details grounded in reality. And it was the same with the world of *The Incredibles*. There are impossible buildings in that world. The form was very caricatured. The lighting and the texture were very real.

TP There were so many milestones with this film. It was the most complex computer-animated film to date. And it was the first Pixar movie with characters that were fully human. Can you comment on those developments?

RE It *was* complicated. But technically, it was not as complicated as some people think. We had four times as many sets as any other Pixar movie until then. And yes, it's true—with *The Incredibles*, here comes Brad with a story that is all humans, and humans that are really hard to build and animate, and the hair was not as good as we are able to do now. It was a cornucopia of things we didn't know how to and couldn't technically do. But once you decide that you're going to try to do this, it's a matter of breaking it down into smaller and smaller components and figuring out how to do it, and then it becomes manageable.

FILM **STAR WARS:
EPISODE IV —
A NEW HOPE**

IN **DARTH VADER**

LAIR **DEATH STAR**

FILM

A long time ago in a galaxy far, far away...
With those words, the modern-day Hollywood
blockbuster was born. Yes, *Jaws* had come
out two summers earlier, but George Lucas'
swashbuckling, special effects-driven space opera
truly charted the course for a new kind of event
movie, one that dressed heady mythology in
the guise of popcorn escapism. *Star Wars* made
audiences believe that cinema could take them
literally anywhere—a desert planet graced with
twin suns, a cantina packed with lethal, oddball
aliens, or even a moon-like space station known
as the Death Star. The plot of Lucas' film was
so simple even a seven-year-old could wrap his
or her head around it: a ragtag band of rebels
desperately plot to overthrow the Evil Empire. But
what makes the movie almost radical is the fact
that it presents a rare "hero's journey" in which
the hero (Mark Hamill's Luke Skywalker) pales
next to the story's scene-stealing, riveting villain,
Darth Vader.

Release
1977

Director
George Lucas

Production Designer
John Barry

Set Decorator
Roger Christian

Cinematographer
Gilbert Taylor

Cast
Mark Hamill
Carrie Fisher
Harrison Ford
Alec Guinness
Peter Cushing

Screenplay
George Lucas

Studio
20th Century Fox

Lair
Interior sets built at Elstree Studios, London;
model for exterior shots built in Van Nuys,
California, by designers at what later became
ILM (Industrial Light & Magic).

Images
All photographs are from *Star Wars:
Episode IV – A New Hope* and all architectural
illustrations and renderings are based on
the Death Star.

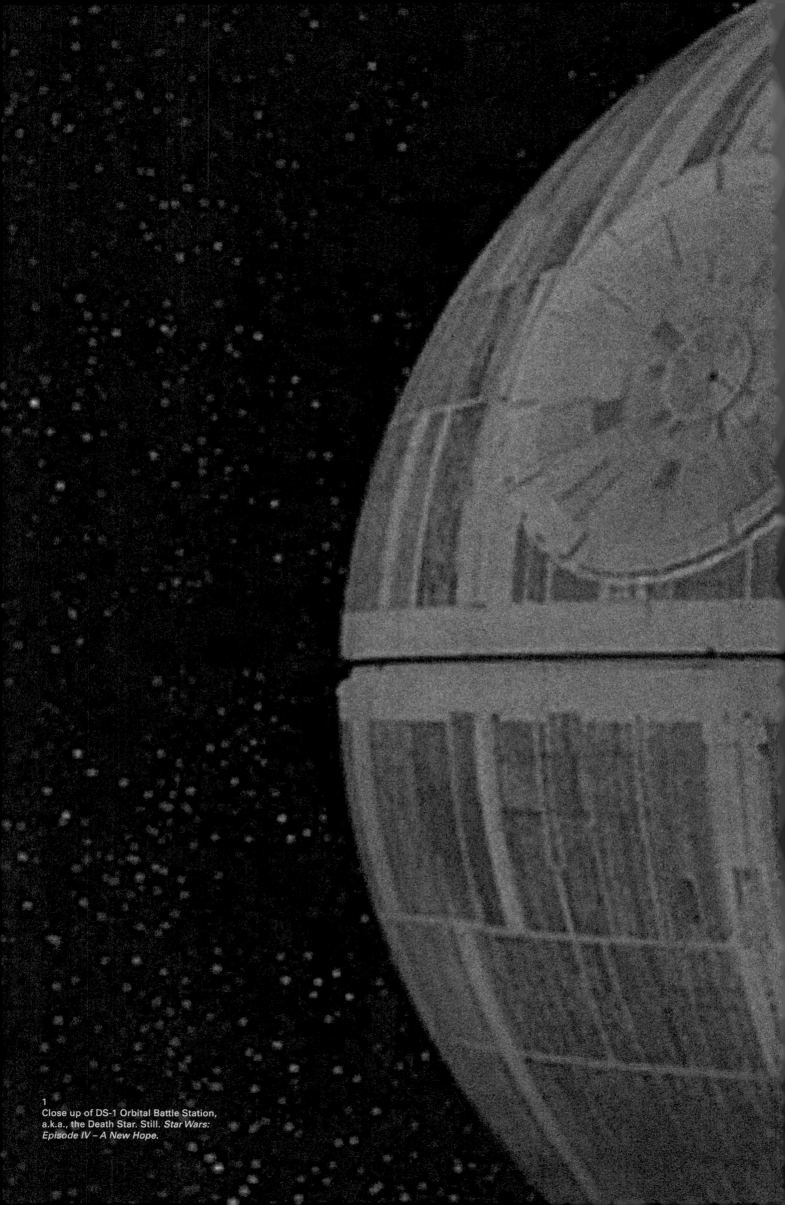

1
Close up of DS-1 Orbital Battle Station,
a.k.a., the Death Star. Still. *Star Wars:*
Episode IV – A New Hope.

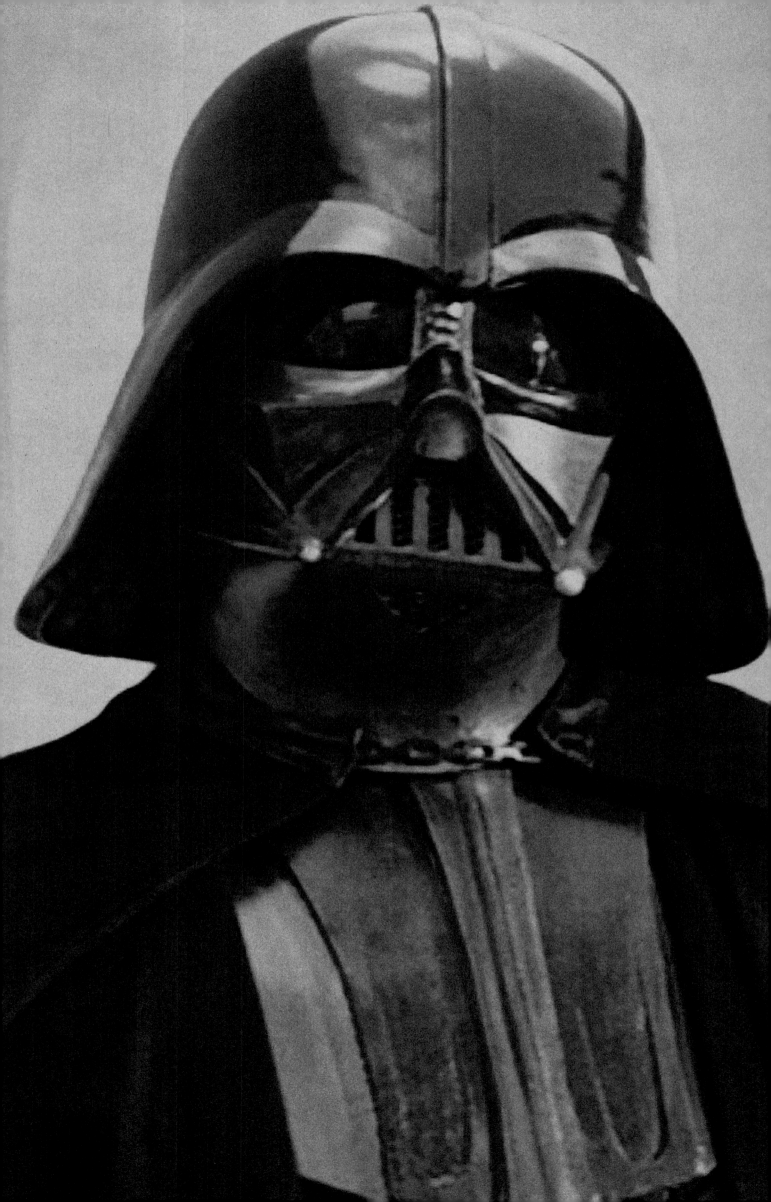

VILLAIN

Darth Vader's introduction comes just shy of five minutes into *A New Hope*. We haven't even met our hero yet (he's still daydreaming about picking up some power converters at Tosche Station), but we immediately, viscerally know that this specter will fuel our collective nightmares. Accompanied by John Williams' menacing death-march music cue, this towering masked figure clad entirely in black—his cloak, his gloves, and of course his helmet all the same ominous shade of onyx—is instantly iconic. All we hear from him at this point is the portentous rhythm of his labored mechanical breaths. When Vader finally does speak (in the deep baritone voice of James Earl Jones, no less), it's positively chilling. Every word is an insinuation or an outright threat. Only later will we learn just how complex this antihero is—how he was once Anakin Skywalker, a righteous Jedi, the Chosen One meant to bring balance to the Force, who became seduced by the Dark Side. By the outset of *A New Hope*, Anakin is a distant memory, one that will never return. As Obi-Wan Kenobi says, Vader is "more machine now than man." That someone so good can become something so evil is part of what makes Darth Vader arguably cinema's greatest villain.

2
The greatest movie villain of them all, Darth Vader. Still. *Star Wars.*

LAIR

In *Star Wars*' signature opening crawl, the Death Star is called the Empire's ultimate weapon—"an armored space station with enough power to destroy an entire planet." It's no idle boast, either, as the citizens of Princess Leia's peaceful home planet of Alderaan will quickly learn when the Death Star's newly operational laser blasts them to oblivion.

Shaped like a battleship-grey moon measuring ninety-nine miles in diameter, the crater-pocked Death Star (or DS-1 Orbital Battle Station, as it's officially known) isn't merely Vader's lair, but also the emblem of his might—an apocalyptic weapon of intergalactic mass destruction protected by a tractor beam and a buzzing aerial armada of TIE fighters (starfighters propelled by Twin Ion Engines).

The Death Star was designed in keeping with the overall aesthetic of *Star Wars*, which broke from the standard, plastic, uninhabited look of sci-fi fare in favor of a more realistic look. As Lucas has explained, "The trouble with the future in most futurist movies is that it always looks new and clean and shiny. What is required for true credibility is a used future."[1] This sensibility is part of why Roger Christian was hired as set decorator. His initial conversation with Lucas was about how "spaceships should be things you see in garages with oil dripping, and they keep repairing them… because that's how the world is."[2]

One of the Empire's Imperial Star Destroyers approaches its ominous home base. Still. *Star Wars*.

4
The opening crawl of *Star Wars* describes the Death Star as having "enough power to destroy an entire planet." The unfortunate citizens of Alderaan are about to find that out as the Death Star activates its lethal laser. Still. *Star Wars*.

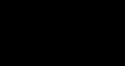

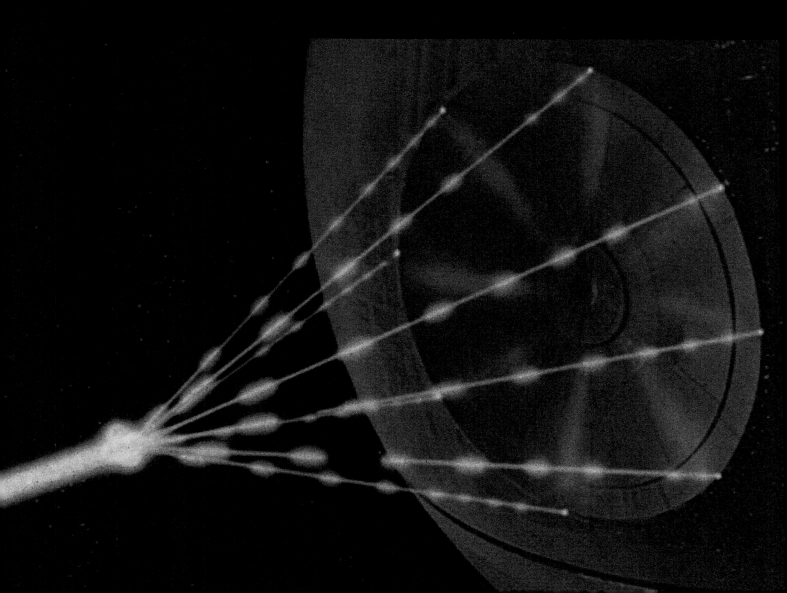

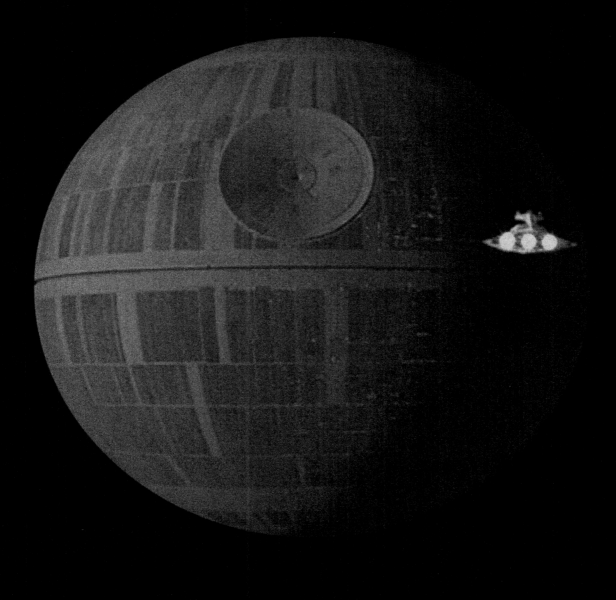

Architects' Commentary
Highlights from Oppenheim Architecture's round-table discussion of the Death Star

"With the Death Star, one thing that stands out is how much the villain's lair contrasts with the hero's home. The hero archetype is given to selflessness and doesn't need to be ostentatious, because the reward of helping people is enough. It's classic—it's David and Goliath. The Death Star dwarfs the Millennium Falcon. They look completely different."

"We see that divide in other films, such as in *Superman*, where Lex Luthor's lair is so much cooler than the Fortress of Solitude, but it's so starkly emphasized here. If you look on the official *Star Wars* website, it describes the Millennium Falcon's 'humble origins and shabby exterior' and says it 'looks like a worn-out junker,' and it calls the Death Star the 'ultimate weapon' and a 'technological terror.'[3] How are the good guys going to win?"

"This is our only lair in the book that's in outer space. It's like a moon, but it's a moon that kills, a moon that can destroy your planet. It's a weapon. It's kind of like Atlantis from *The Spy Who Loved Me*, which is our only underwater lair. They are alike in that they are so outlandish. And they are both meant to intimidate, to get everyone to fall into line. The Death Star could not be more intimidating."

"In terms of design, it's a sphere. It has inspired architecture, and it's inspired by architecture, with clear links to the Third Reich. It's massive and technologically extremely complex, and that contrasts with its functional minimalism. It's so powerful in its simplicity."

"Darth Vader was good, and he went to the dark side. How does that play itself out in the Death Star? It's not clear in terms of its design. What is clear is the lack of ambiguity—he's all bad, and so is the Death Star."

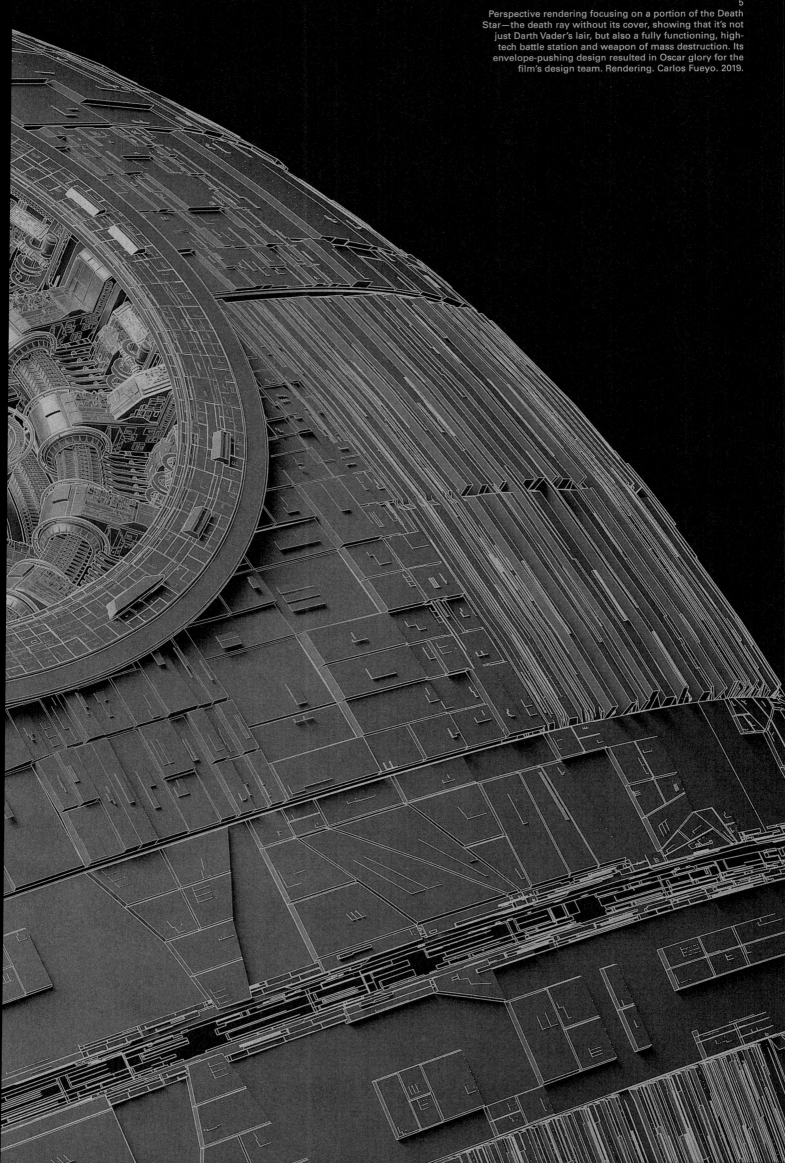

Perspective rendering focusing on a portion of the Death Star—the death ray without its cover, showing that it's not just Darth Vader's lair, but also a fully functioning, high-tech battle station and weapon of mass destruction. Its envelope-pushing design resulted in Oscar glory for the film's design team. Rendering. Carlos Fueyo. 2019.

AS LUKE, HAN SOLO, OBI-WAN, ETC. APPROACH THE DEATH STAR IN THE MILLENNIUM FALCON...

OBI-WAN:
"THAT'S NO MOON...IT'S A SPACE STATION."
HAN:
"IT'S TOO BIG TO BE A SPACE STATION."
LUKE:
"I HAVE A VERY BAD FEELING ABOUT THIS..."

6
The Millennium Falcon may have made the Kessel Run in less than twelve parsecs, but it's no match for the Death Star's tractor beam. Still. *Star Wars.*

The task of designing the Death Star was deeply collaborative, involving several designers. The production's illustrator, Ralph McQuarrie, sketched out the initial concept drawings. Production designer John Barry, art directors Les Dilley and Norman Reynolds, and Christian worked around the clock at Elstree Studios just north of London to construct and dress the interior of the Death Star (all four would share an Academy Award for Best Art Direction – Set Decoration). Six thousand miles away in Van Nuys, California, the team at what would become ILM (Industrial Light & Magic, the visual effects company founded by George Lucas) was tasked with building the fifty-four-inch model that would be used for the Death Star's exterior—and would eventually be blown up for the film's big fiery climax. Team members included concept artist Colin Cantwell, who had grabbed the director's attention with his work on Stanley Kubrick's *2001: A Space Odyssey*, and John Stears, an Academy Award winner for *Thunderball*, who had designed the tricked-out Aston Martin DB5 (including the passenger-side ejector seat, rotating license plate, and oil-slick dispenser) that Sean Connery drove in *Goldfinger*. Stears, who shared a second Academy Award for his work on *A New Hope*, had an uncanny ability to bring Lucas' imagination to life; he also designed Luke Skywalker's Landspeeder, the bickering droids R2-D2 and C-3PO, as well as the film's samurai-inspired lightsabers.

Crewed by 1.7 million military personnel, 250,000 civilians and contractors, 400,000 droids, and one very hungry, trash compactor-dwelling squid beast known as the Dianoga, the Death Star is a spectacle right out of Nazi architect Albert Speer's darkest Third Reich fantasies—a soaring monument of imposingly chilly fascist design replete with spit-polished obsidian interiors, hangar-sized engine rooms, and soaring elevated catwalks. The film's art department was inspired by Speer's awe-inspiring (and fear-instilling) buildings, a correlation that underscores that the similarities between the Reich and the Evil Empire were not coincidental. Interestingly, Nazis had plans in the works for a "sun gun," an orbital satellite and weapon of mass destruction clearly in the Death Star family.[4]

7
Alec Guinness' Obi-Wan Kenobi is a Jedi on the run in the Death Star's endless, spit-polished corridors. Still. *Star Wars*.

8
This is not the droid you're looking for. Still. *Star Wars*.

9
A stormtrooper conducts a security sweep on one of the Death Star's less glamorous, more utilitarian levels. Still. *Star Wars*.

10
The Empire's stormtroopers assemble—a monochromatic blend of pop science fiction and chilling Third Reich symbolism. Still. *Star Wars*.

11
A captured Chewbacca in shackles (but not for long) on one of the Death Star's vertiginous catwalks. Still. *Star Wars*.

12
Once friends, now enemies, Obi-Wan and Darth Vader face off for the future of the galaxy in the film's climactic, samurai-inspired lightsaber duel. Still. *Star Wars*.

7 8
9
10 11 12

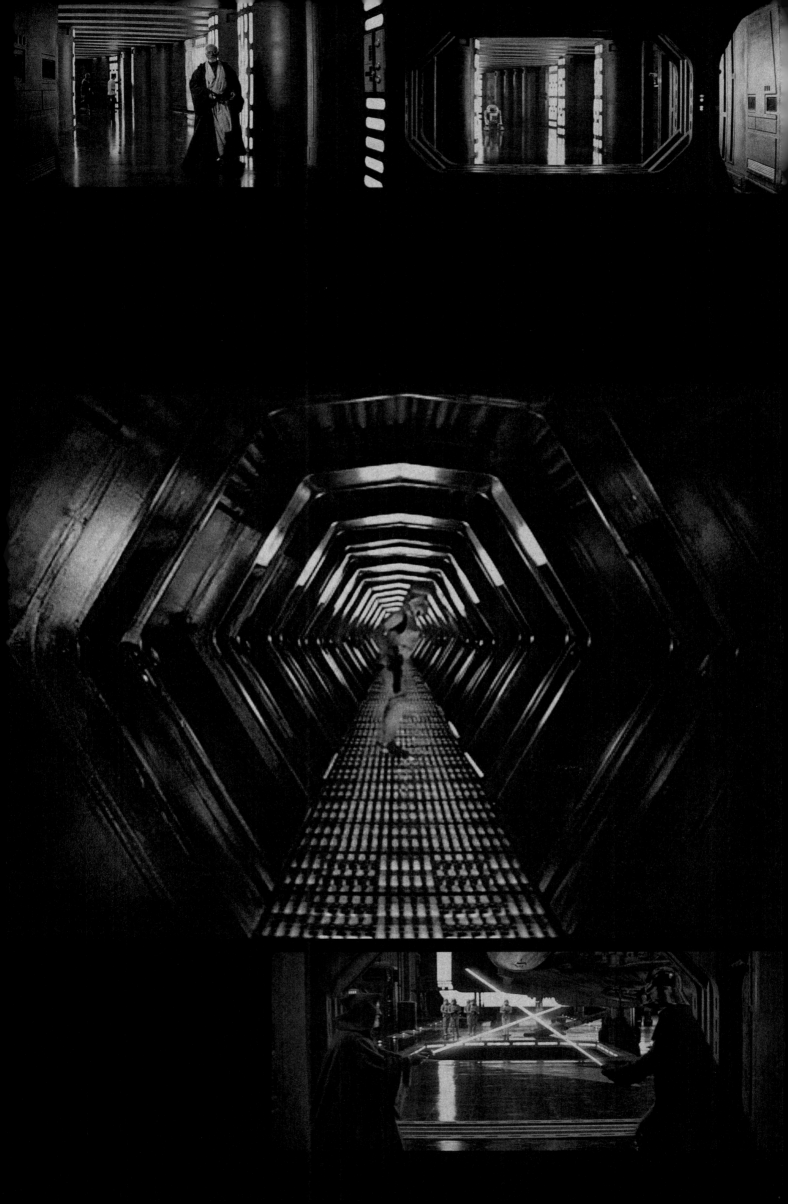

13
The captured Millennium Falcon idles in space dock, dwarfed by the endless, overwhelming hugeness of the Death Star's ominous hangar. Even the Empire's garages are spotless and antiseptic. Still. *Star Wars*.

14, 15
Perspective cutaway (14) and plan (15) views of the Millennium Falcon in the Death Star's vast Docking Bay 327, showing the hangar-like space as well as its control room and tractor beam projector. The space also functions as an assembly hall for Darth Vader's Nuremberg-like rallies to his Stormtrooper minions. Architectural illustrations. Carlos Fueyo. 2019.

14
15
13

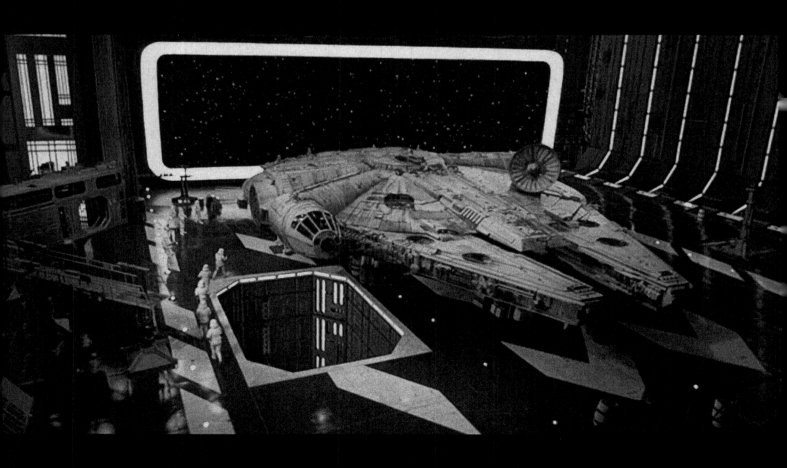

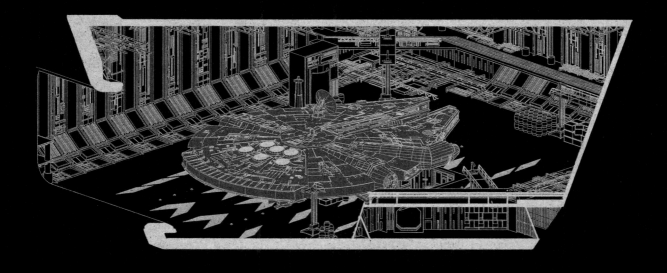

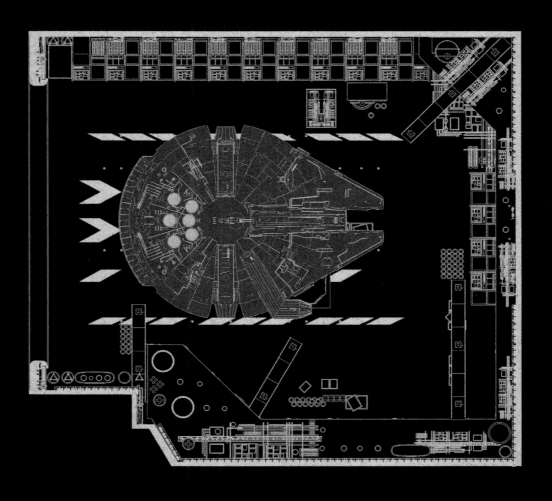

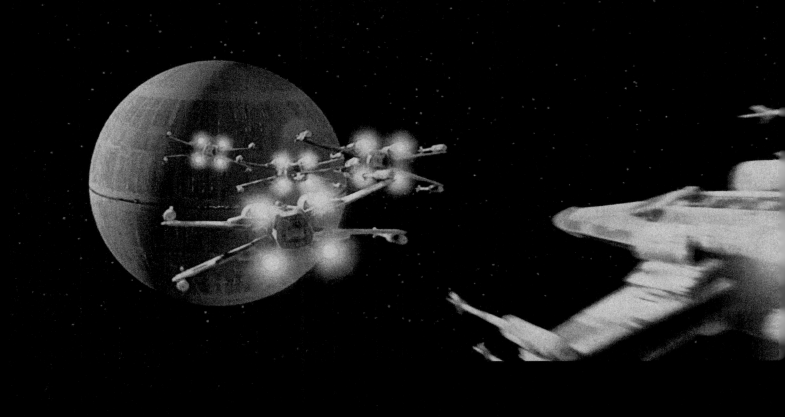

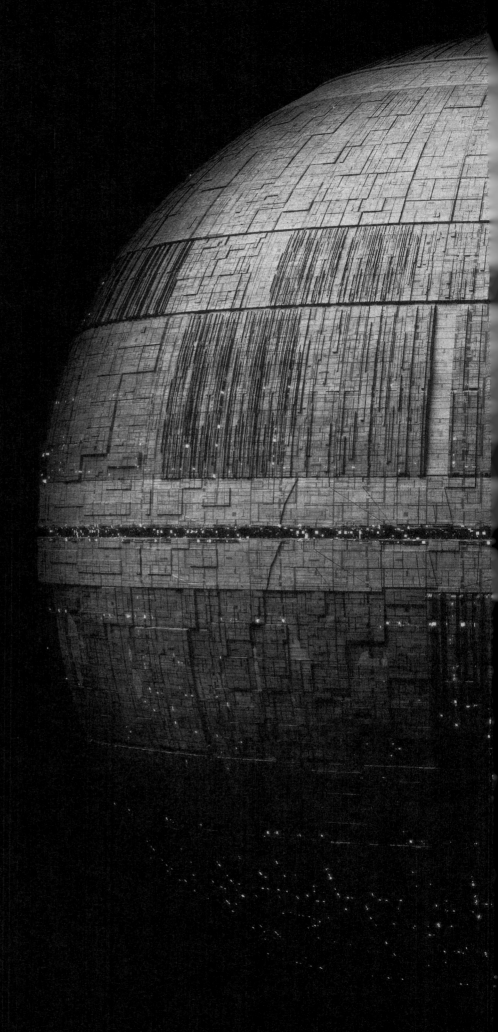

22
A chilling perspective rendering of the Death Star, capturing
its massive, haunting scale. There is nothing organic,
natural, or alive about its appearance—much like Darth
Vader himself. It is pure, mechanized evil. Rendering.
Carlos Fueyo. 2019.

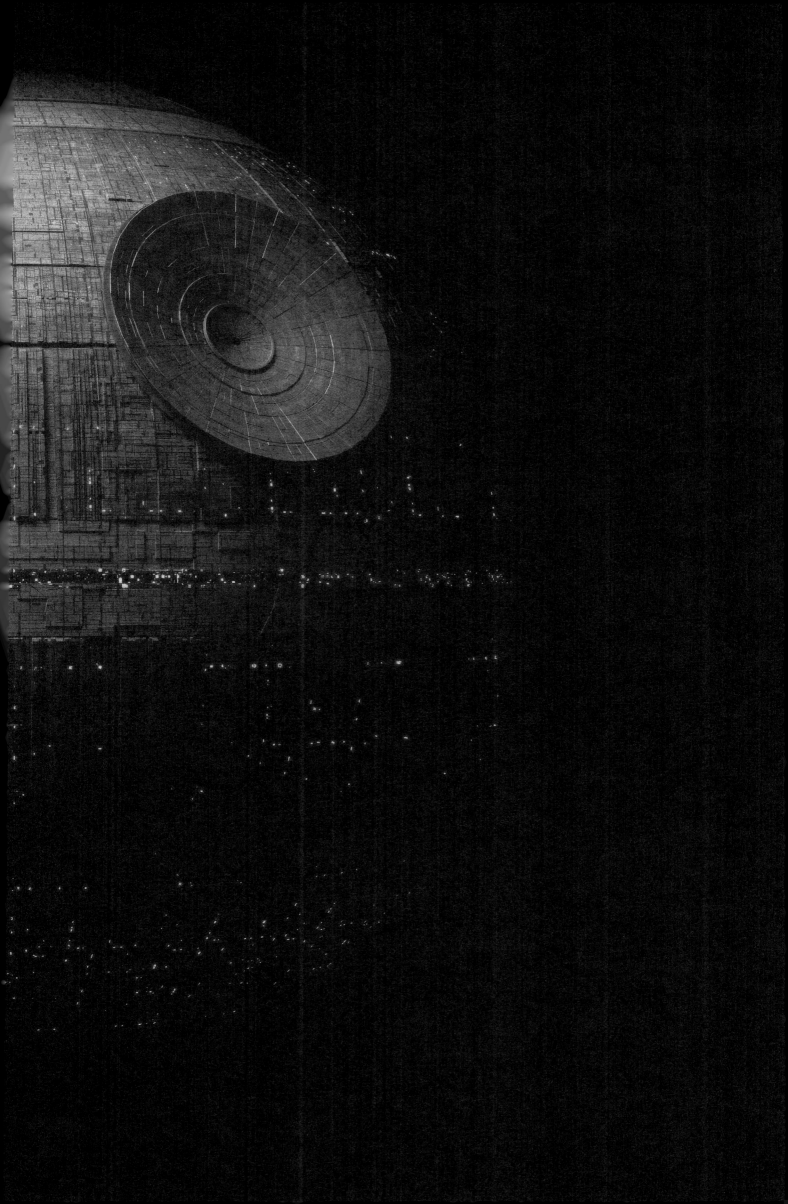

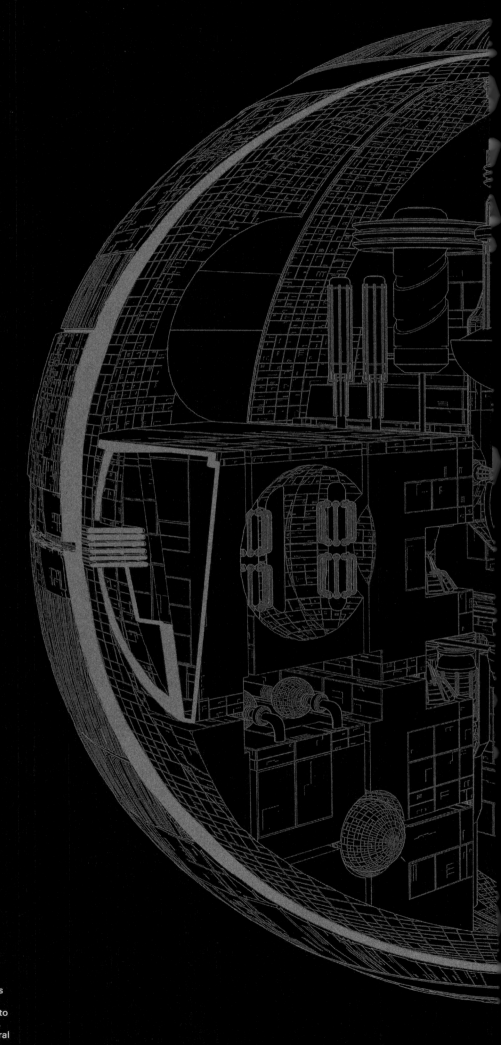

23
A perspective cutaway of the interior, clock-like workings
of the Death Star. This perspective is a glimpse inside of
Darth Vader's personal doomsday machine, allowing us to
see that what appears to be a planet from the outside is,
in fact, a highly advanced weapon at its core. Architectural
illustration. Carlos Fueyo. 2019.

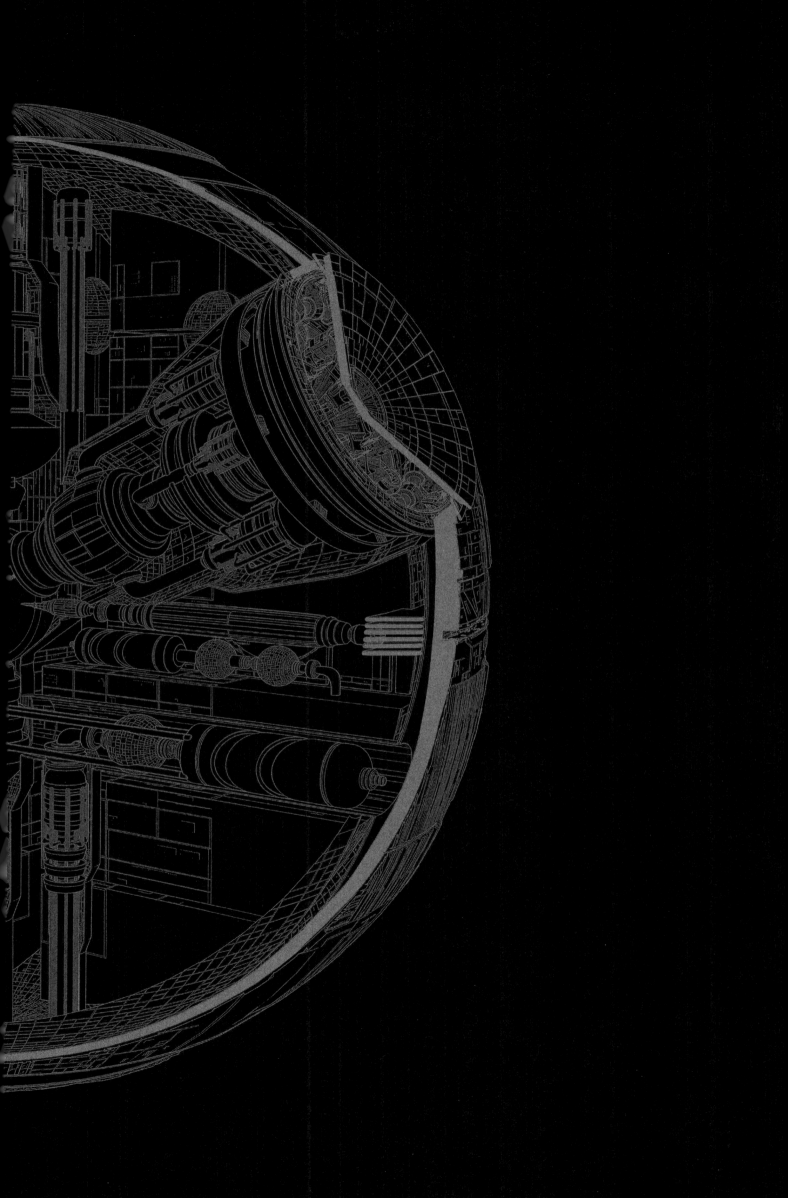

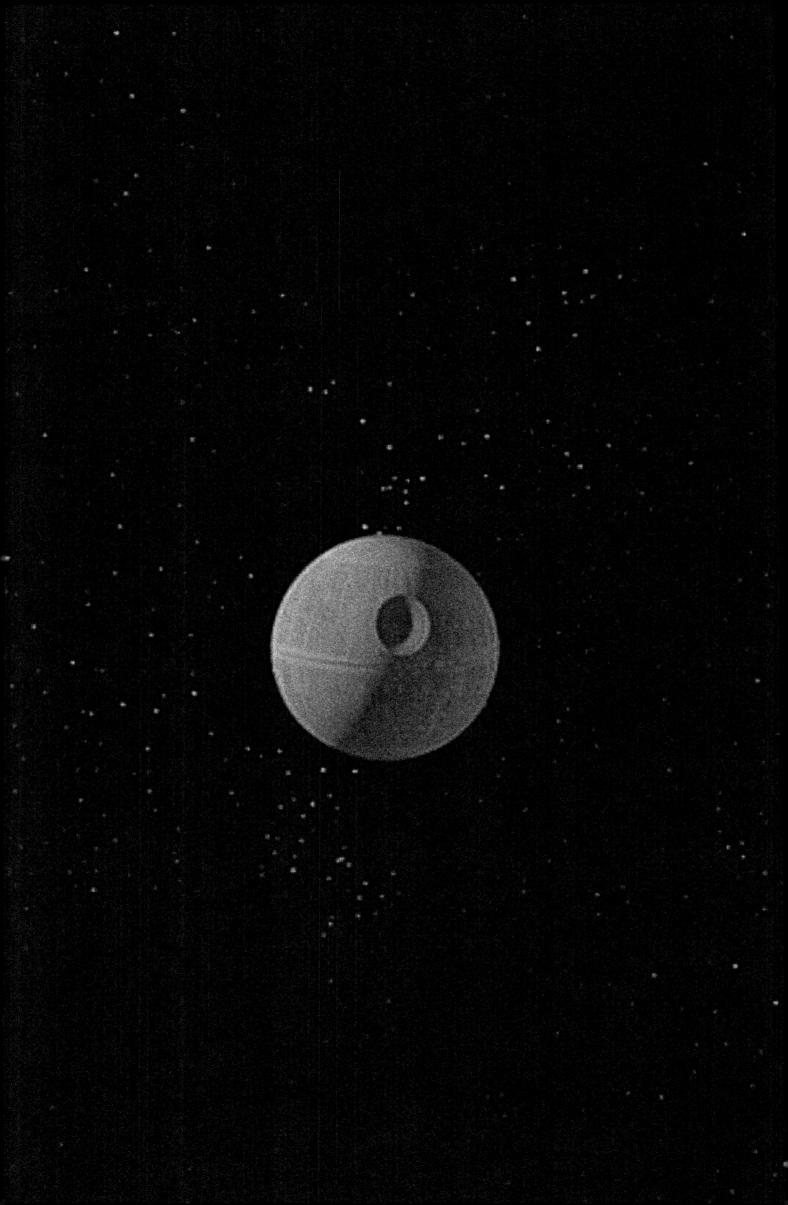

24
The seemingly indestructible Death Star about to be blown
to smithereens. Still. *Star Wars.*

25
The Death Star is destroyed...at least until the sequel.
Still. *Star Wars.*

INTERVIEW
DESIGNING THE EVIL EMPIRE
A CONVERSATION WITH ROGER CHRISTIAN, *STAR WARS*' SET DECORATOR

In the hundred-plus-year history of cinema, no movie villain has captured the public's imagination—and haunted its collective nightmares—with the same force as Darth Vader. Part fallen angel, part samurai, and part fascist bogeyman, the half-man/half-machine once known as Anakin Skywalker steals every second that he's onscreen in George Lucas' *Star Wars: Episode IV – A New Hope*. When it came time to design Vader's lair in the film, the perfectly named Death Star, it fell on the film's Oscar-winning set decorator, Roger Christian, to dream up an environment that was the ultimate big-screen embodiment of intergalactic evil. Christian, who has also worked on such films as *Alien* and Monty Python's *Life of Brian*, as well as *Return of the Jedi* and *The Phantom Menace* in the *Star Wars* franchise, spoke with Tra Publishing about making a giant mark on movie history with a very small budget.

TP **Tra Publishing: How did you get hired on *Star Wars*?**

RC Roger Christian: I was in Mexico working on a movie which had kind of gone out of control called *Lucky Lady*, and George Lucas came down to look at what we were doing. *Star Wars* wasn't green-lit yet, but Fox was only going to give him about $4 million. He said he wanted a world that wasn't designed. He wanted it to look like a space Western. We had dinner that night, and I got hired as the set decorator. I was literally the third person hired on *Star Wars*.

TP **What happened next?**

RC When we got to London and I read the script, I thought, "My god, how are we going to do this?!" John Barry [production designer], Les Dilley, and I got to work right away on R2-D2 and C-3PO, because if we couldn't make those work, we didn't have a movie. All we had to go on were six sketches from Ralph McQuarrie [production illustrator]. We built a landspeeder out of plywood. Anything we could find from the garage, really. We literally had no money. The pressure on the art department was horrendous. I had to create the Millennium Falcon out of scrap. The lightsabers and weapons, I had to take old weapons and stick bits on them. I bought tons of junk, truckloads.

TP **What was your inspiration for the look of the Death Star?**

RC We were shooting the world of the Jedis on Tatouine, in Tunisia. It had the look of a Western. But when it came to the Death Star, that was inspired by the Reich architecture of Albert Speer, obviously. When you look at Nazi architecture, it's very black with red on it. Very simple and very daunting—and strangely beautiful. And that's exactly the Death Star. George showed everybody *2001* and *Once Upon a Time in the West*, the Sergio Leone film. Those two were the contrast looks: the cold clean look of *2001* for the Empire and Leone's Western for the Jedis.

TP **How much of the Death Star's architecture and environment was spelled out in the script?**

RC Not very much. It was more laid out in the Ralph McQuarrie sketches. The thing with science fiction is you don't have anything to reference. When you're doing a period film you can say, "Oh, it's the 1840s," and you know the right clothes and furniture. With *Star Wars*, there was nothing. Only George's descriptions in the script as this kind of evil world. Quite simple. But Ralph McQuarrie's original paintings included a Death Star corridor and a beautiful sketch of Darth Vader with a lightsaber, fighting. Those gave us the key to it. John's [production designer John Barry] problem was the scale. We just didn't have that kind of money. So we took a massive gamble and bought a machine that could print out panels in cheap plastic. And we could stamp out these panels and staple them onto wood frames. The look had to be the opposite of the Millennium Falcon. The Empire were the cold people—sterile and dark. I remember going to the place where I used to get guns for films. There was a two hundred-year-old samurai uniform. A black one. And the helmet. I brought it in. It had a lacquered look, which was exactly what we based Vader's helmet on. There was a lot of luck on this film.

George's first film, *THX-1138*. Absolutely. And, of course, Stanley Kubrick's films. I th
Kubrick is ingrained in our DNA. *2001* was a monument in science fiction, particularl
ook that he was able to create. We discussed it at great length. With George, it was t
sci-fi-like for what we had in mind for *Star Wars*. In addition, John Barry loved *Barba*
He had architectural training, so in the script, where it said that the Death Star had h
ong corridors, his advice was, "Let's make them curved because it's a Death Star, it's
planet sized." That made them more interesting, I thought. He also designed the roun
table where Vader and the officers of the Empire sit, and that was meant to be remin
of King Arthur's Round Table.

**The first time you see Darth Vader is so visually striking. He's a figure in black marchin
nto a room that's totally white. It makes his evil immediately clear, before he says a w**

Exactly. John Barry designed *A Clockwork Orange* for Stanley Kubrick, and you can t
that by looking at the Death Star. What was clear to us was that we didn't want a sor
James Bond villain interior. We wanted something much darker. The Death Star was
place of worship, if you like, so it had to be iconic.

How big was your team in the art department on Star Wars?

Surprisingly small. I was alone as the set decorator. We would meet in my office at
seven in the morning. I had a kettle of tea and chocolate biscuits, which is what the a
department ran on. There were two and a half months to get everything ready. C-3P
still being put together on the first day of the shoot. Same with R2-D2, whom we en
up pulling mostly on fishing wire because the radio control wasn't working. The film
made that way.

**What does the physical environment of the Death Star tell us about the villain
who lives there?**

Obi-Wan lives in a little cave and he gets emotional when he's talking about the ligh
and Luke's father. The Jedis are emotional. And Tunisia gave it a warmth. When you l
at all of the Evil Empire, they're completely unemotional. Darth Vader has no emotio
He's a true villain. It had to be a cold environment. When you enter the Death Star, it'
immediately cold. It's calculated and built for a function. The Death Star had to look l
machine. A pristine machine. A place where you didn't want to be—like a prison cell
been all around Albert Speer's buildings in Germany. They're incredibly impressive.
but also appealing. It's a double-edged thing. I think the Death Star succeeded in get
that double feeling.

Why do movie villains live in such cool places?

think there's an attraction to the villain. Villains are often the more interesting chara
Look at the hero of *The Lord of the Rings*. What is he? He's a Hobbit with big feet wh
becomes a hero. Even King Arthur, he's just a simple man who becomes a king. It's
usually the villains who stand out. Religions teach you about Satan, and people are
fascinated by what is evil. Look at [William] Blake's illustrations of hell—fallen angel
incredible visions. Artists have a more interesting world to create when it's evil than
do in the good world. You can really let your imagination run wild

FILM **BLADE RUNNER 2049**

VILLAIN **NIANDER WALLACE**

LAIR **WALLACE CORPORATION HEADQUARTERS**

Scott's 1982 sci-fi cult classic, set i
futuristic 2019. When K tracks dow
replicant Sapper Morton (Dave Ba
uncovers a disconcerting nugget o
that threatens to upend the world
robot-slave dynamic: replicants ca
Does this make them human, perh
human than we are? Meanwhile, o
production of a new—and extreme
of replicants is mad scientist Nian
(Jared Leto), a blind industrialist w
of universal domination. He is abe
maniacally overachieving assistan
Hoeks), an advanced replicant wh
primary foil. To the delight of both
new fans of this bleak world, blad
Deckard from the original film, a g
Harrison Ford, shows up cloistered
of an art deco casino in Las Vegas.

Release
2017

Director
Denis Villeneuve

Production Designer
Dennis Gassner

Cinematographer
Roger A. Deakins

Cast
Ryan Gosling
Harrison Ford
Ana de Armas
Sylvia Hoeks
Jared Leto
Robin Wright

Screenplay
Hampton Fancher
Michael Green

Studio
Warner Brothers

Lair
Some of the interior sets were built at Origo
and Korda studios in Hungary; many of the
exteriors, including the Wallace Corporation,
were miniatures created by Weta Workshop
in New Zealand.

Images
All photographs are from *Blade Runner 2049*
and all architectural illustrations and renderings
are based on spaces in the Wallace Corporation.

1
K's flying police cruiser, or spinner, is a minuscule
dot glowing against the backdrop of the Wallace
Corporation Earth Headquarters, which looms over
a dystopian Los Angeles. Still. *Blade Runner 2049*.

VILLAIN

A billionaire android-maker with a God complex, scientist Niander Wallace is the architect of a super-race of obedient replicant slaves ("I make good angels," he brags). His replicant army, although vast, isn't vast enough to satisfy his grandest ambition: to colonize new planets and replace the off-world human workforce with synthetic servants. "Every leap of civilization was built on the back of a disposable workforce, but I can only make so many," Wallace laments to Luv. He's consumed by what he views as his replicants' fatal flaw—they can't sexually reproduce—and with envy when he discovers that his predecessor, Eldon Tyrell, had achieved this. As in the original *Blade Runner,* and as in the novel that gave rise to the films, Philip K. Dick's *Do Androids Dream of Electric Sheep?*, *Blade Runner 2049* raises ethical dilemmas about fertility and the very nature of humanity. While Wallace has, through his scientific genius, resolved a global food crisis, he's no humanitarian, and the distinction between what is human and what isn't doesn't keep him up at night. Replicants, for him, are a means to an end. But are they? The film explores this territory through K and Luv. K is a stoic, lost soul searching for meaning, and Luv (an echo of Rutger Hauer's Roy Batty in the original *Blade Runner*) is intensely empathetic. Luv believes that replicants are more vividly human than humanity itself. She weeps human-like tears of sheer horror when Wallace slices open the barren womb of a newborn replicant ("Dead space between the stars," he mutters). K and Luv are both replicants on quests for self-discovery, fighting for the same cause—breaking the shackles of their programming—but trapped on opposing sides.

2
Jared Leto as Niander Wallace, a blind (and blindly ambitious) billionaire who dreams of creating a vast army of replicants. Still. *Blade Runner 2049.*

LAIR

Niander Wallace's brutalistic Wallace Corporation
Earth Headquarters towers over 2049 Los Angeles,
a gloomy dystopia—an apocalyptic, haunted, yet
oddly beautiful landscape lashed with dirty rain
and hologram porn dolls, radioactive smog and
neon-tinted favelas. Glowing billboards from Atari
and Pan Am loom over the city's grimy underbelly.
(In this alternate reality, both companies are
global giants.) DNA sequences are printed on
microfilm and iPhones don't exist. It's even more
joyless than the Los Angeles of the original *Blade
Runner*, which is saying something.

The scale of Wallace's dark and foreboding
lair puts every skyscraper around it to shame
with its trio of slanted towers framed by squat,
pyramid-like buildings (a visual nod to the
Tyrell Corporation's ziggurat in the original *Blade
Runner*). Production designer Dennis Gassner
used the word "brutality" as a touchstone in
developing the film's aesthetic; that was director
Denis Villeneuve's guidance when Gassner
asked for a one-word directive. As he told *Vanity
Fair magazine*, "I developed a pattern language
we used to create the rest of the city…the tower,
police station, and other elements reflecting a
more brutal universe—things that were robust
enough to fight against the elements and remain
standing, like pyramids."[1] Filming took place
in part in Budapest, among the city's massive,
brutalist architecture, which perfectly served the
film's visual mood.

3
4
5 6

3
Ryan Gosling's K passes a glowing Pan Am billboard,
one of the anachronistic global giants still existing in
Blade Runner 2049's universe. Still. *Blade Runner 2049*.

4
The gloomy exterior of the Wallace Corporation, with
its towers and ziggurat-like buildings, dwarfs all other
Los Angeles skyscrapers. Still. *Blade Runner 2049*.

5
Even the imposing, brutalist-style Los Angeles Police
Department headquarters is small compared to the
Wallace Corporation, a commentary on the law's
waning authority in this apocalyptic environment.
Still. *Blade Runner 2049*.

6
Engaged in the quest for answers, K maneuvers
past throngs of people inside the Los Angeles Police
Department headquarters. Still. *Blade Runner 2049*.

In contrast, the interiors of the offices and archives of Wallace's lair are sleek and ultra-modern. Shadows streak across triangular, sharp-angled ceilings in the vast hall of records, where endless rows of digital files on replicants are stored. Shot on soundstages built at Hungary's Origo and Korda studios, these interiors were inspired by a design from Estudio Barozzi Veiga for the unbuilt Neanderthal Museum in Spain—a nod, as with Niander Wallace's name, to the film's themes of humanity and evolution.

Crucial to nailing the design of an apocalyptic Los Angeles is an emphasis on showing class economics; metal and neon are the textures of the underclass, while access to wood is rare and sought after by the wealthy. The elitist Wallace Corporation is covered in wood-grained opulence, a striking statement of vast wealth in the movie's smog-factory of a world. (Agent K's carved wooden horse, one of the film's plot devices, raises eyebrows; one character suspects it's even worth a fortune.) When Luv escorts K through the bowels of Wallace's lair, we see smooth wood walls everywhere: inside a hall of replicant prototypes, juxtaposed with their skinless bodies on display behind glass like an anthropology museum, and in Wallace's office itself. The massive scale and luxe interiors are moody and oppressive, and Gassner has said he chose the yellow-dominant color palette because the color represents envy, underscoring Wallace's envy that his replicants cannot breed.[2]

7
8
9

7
An archivist escorts K into Wallace Corporation's imposing hall of records, where digital files on replicants are stored. The muted, gloomy yellow tones prevalent throughout the interior of the Wallace Corporation are symbolic of envy. Interiors were based on Estudio Barozzi Veiga's design for the unrealized Neanderthal Museum in Spain. Still. *Blade Runner 2049.*

8
Luv (Sylvia Hoeks), Niander Wallace's henchwoman, in her spare, minimalist office as she meets with a prospective replicant buyer. The patterns on the walls are created by reflections from the water, which symbolizes fertility. Still. *Blade Runner 2049.*

9
Designed to intimidate: K asks a Wallace Corporation archivist seated at a massive and foreboding desk for a DNA test to be conducted from the hair of an earlier replicant. Still. *Blade Runner 2049.*

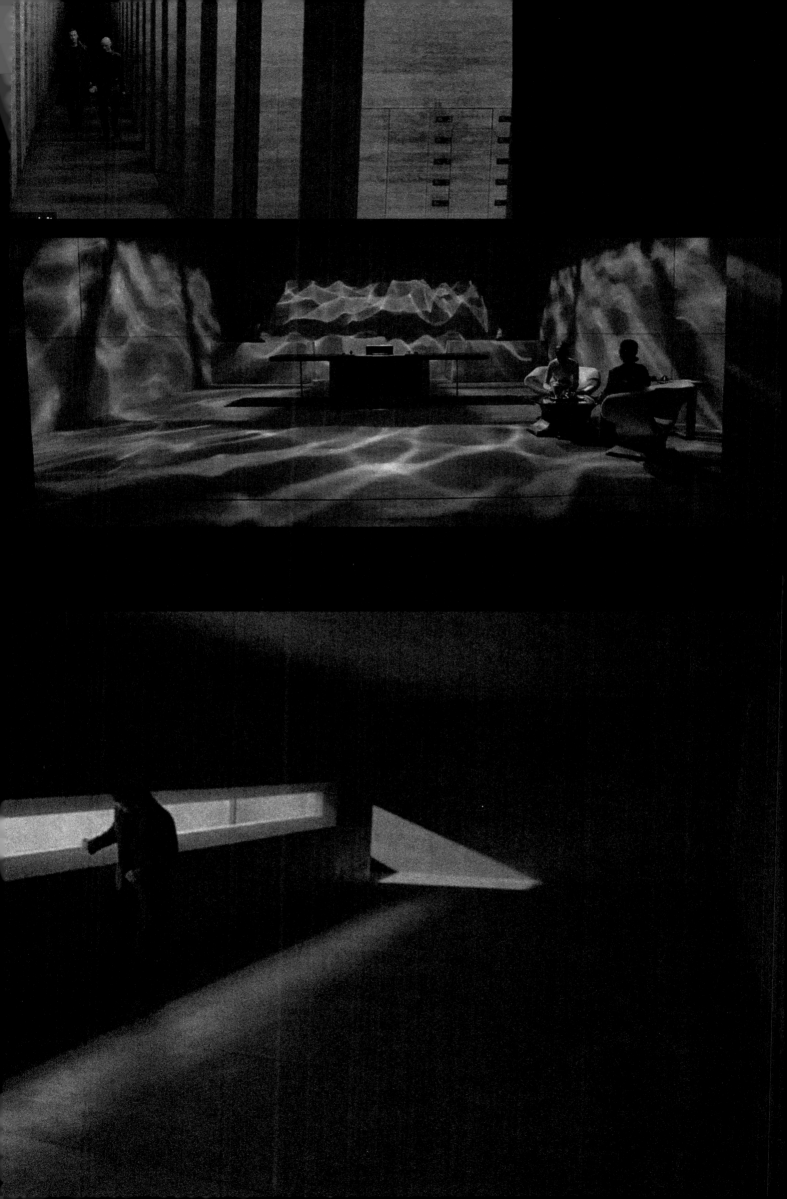

10
Wallace Corporation's mammoth library of past and
present replicant files is built largely from wood,
a rare material and therefore a statement of great
wealth and status. Still. *Blade Runner 2049*.

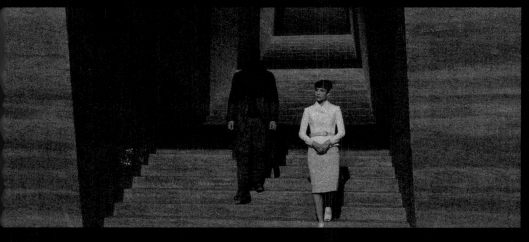

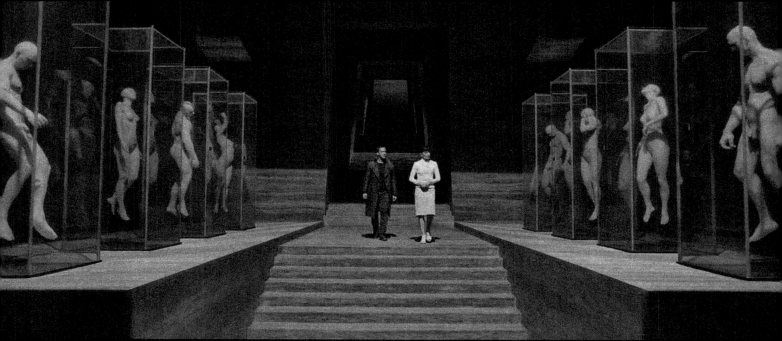

the Wallace Corporation's sleek, ultramodern,
interiors. The vast scale and abundant use of
ize the corporation's status and wealth. Here,
down a staircase to the hall lined with replicant
e skinless bodies are in vitrines as if part of a
ay, perhaps as a deliberate nod to the fact that
s inspired in part by Estudio Barozzi Veiga's
unrealized Neanderthal Museum in Spain.
unner 2049.

...llace's minimalist, palatial office—a lounge
...ounded by water where Rick Deckard is
...rrogated later in the film—resembles a dark
...mb, with the water's reflections rippling along
...d walls. In designing the office, Gassner
...w inspiration from an ancient temple in Kyoto
...t, despite exquisite craftsmanship, had floors
...t deliberately squeaked as part of a nighttime
...m system—a sensory feature fitting for the
...d Niander Wallace; the idea behind the water
...ment was to enhance the ability for sound
...ravel.[3] The theme of fertility is further brought
...he fore in a scene in which a plastic sleeve
...cends from a ceiling like an amniotic sac and
...s out a newborn adult replicant.

...llace's blindness is, of course, another theme
...ning throughout. He sees when he so chooses,
...nks to science, with the aid of a cybernetic
...lant and two hovering, drone-like robots. How
...d, then, is his vision? How blind is he? Does
...scientifically enhanced vision make him
...e than human? Less than? Where do we draw
...line?

15
Muted light and long bars of dark shadows
pattern the hall Luv and K take on their way to a
storage room containing memory fragments of old
replicants. Still. *Blade Runner 2049.*

16
In the Wallace Corporation's birthing room, an
engineered amniotic sac delivers a newborn
replicant—a nude, adult female. After discovering
his "angel" is barren, Niander Wallace promptly
stabs her in the gut. Still. *Blade Runner 2049.*

17
Niander Wallace's vast, Zen-like office, an "island"
surrounded by water—the design amplifies sound,
an advantage for a blind leader. The water feature is
inspired in part by an ancient temple in Kyoto. Still.
Blade Runner 2049.

18, 19
Plan and section views of Niander Wallace's
office convey the vastness of the space.
Architectural illustrations. Carlos Fueyo. 2019.

15 16
18 17
19

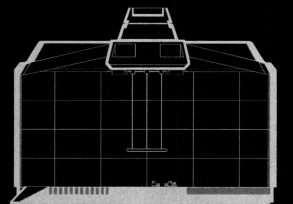

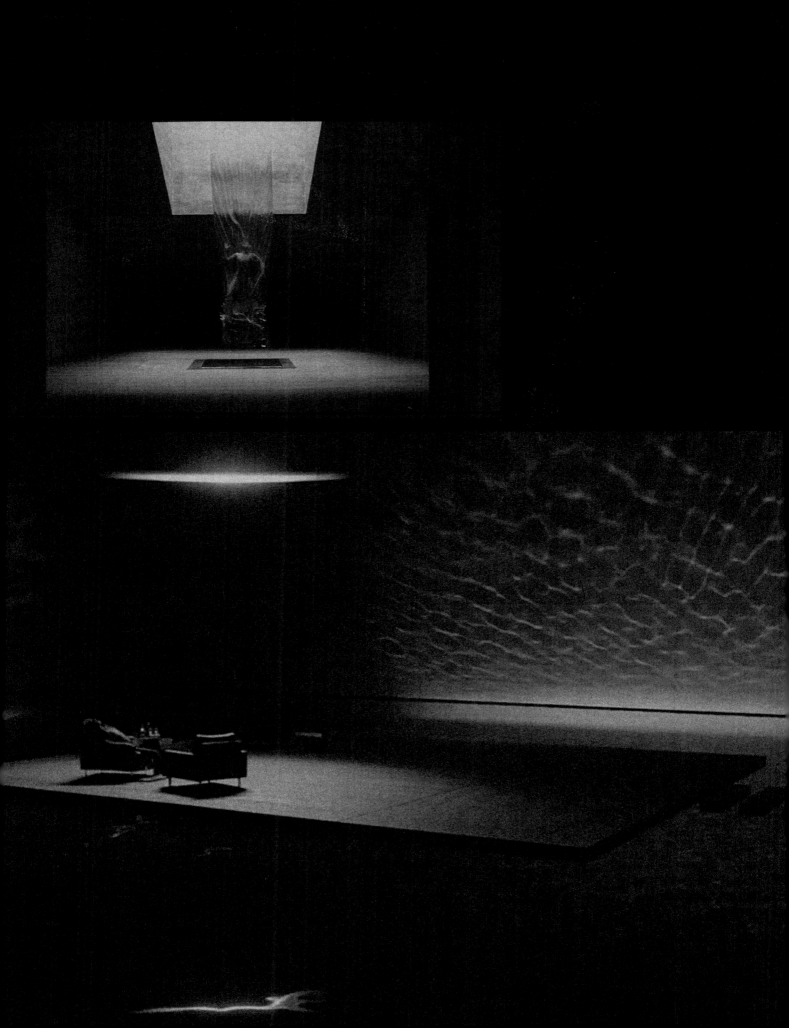

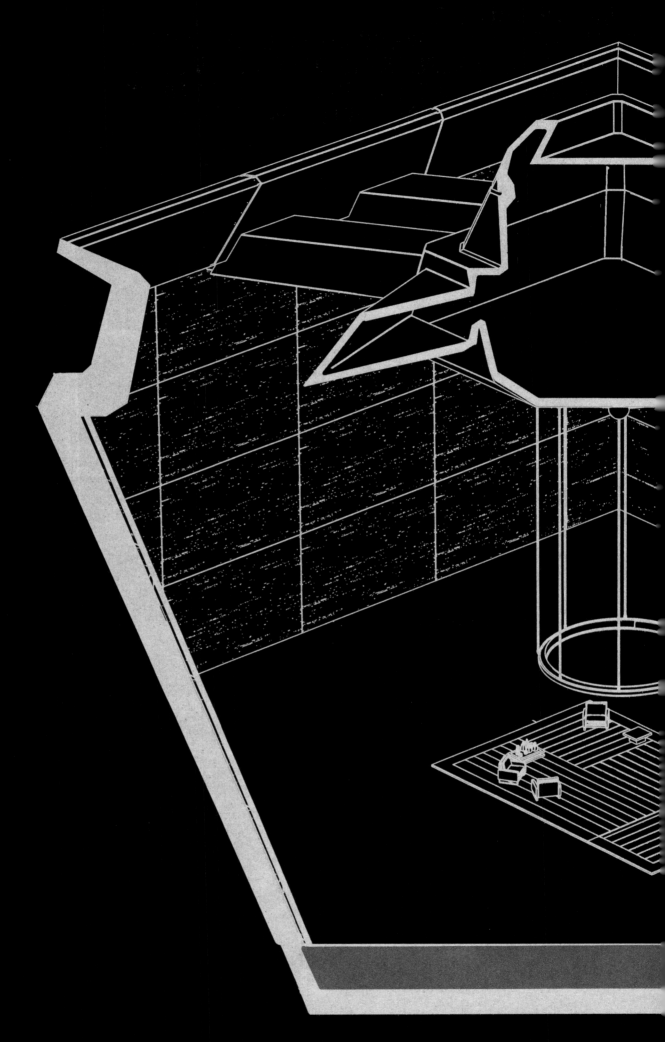

20
Isometric cutaway of Niander Wallace's
office—where K eventually confronts the android-
maker—shows the relationships of the central "island"
to the surrounding water and of the lighting to the
space. Architectural illustration. Carlos Fueyo. 2019.

FILM **THE GHOST WRITER**

VILLAIN **ADAM LANG**

LAIR **MARTHA'S VINEYARD RETREAT**

FILM

Roman Polanski's twisty and paranoia-soaked political thriller was his first film in five years. Rather than spend that downtime coming up with a grand statement, the director returned with a guilty-pleasure confection crafted with the crackerjack precision of a major filmmaker. Ewan McGregor stars as an ambitious and anonymous ghostwriter ("the Ghost") whose job is to turn bad authors into, if not good ones, then at least bestselling ones. His latest assignment is to jazz up the stodgy memoirs of former British Prime Minister Adam Lang (Pierce Brosnan). The Ghost is summoned in the middle of winter to join Lang at his publisher's house on Martha's Vineyard, but the rewrites take a back seat to more pressing matters: Lang has just been snagged in a scandal involving handing terror suspects over to the U.S. government to be tortured, which may or may not have something to do with the death of Lang's previous ghostwriter. Can this new ghostwriter unravel Lang's secrets before becoming another casualty of his power?

Release
2010

Director
Roman Polanski

Production Designer
Albrecht Konrad

Art Director
David Scheunemann

Cinematographer
Paweł Edelman

Cast
Ewan McGregor
Pierce Brosnan
Kim Cattrall
Olivia Williams
Tom Wilkinson

Screenplay
Robert Harris
Roman Polanski

Studio
Summit Entertainment

Lair
The exteriors of the beach house were constructed on the island of Usedom, Germany. Scenic exterior shots were filmed on the island of Sylt, Germany, and some B-roll exterior footage was filmed in Martha's Vineyard and Boston. The interiors were filmed at the Babelsberg Studio in Potsdam, Germany. The interior design includes many pieces by Walter Knoll.

Images
All photographs are from The Ghost Writer and all architectural illustrations and renderings are based on spaces in the film.

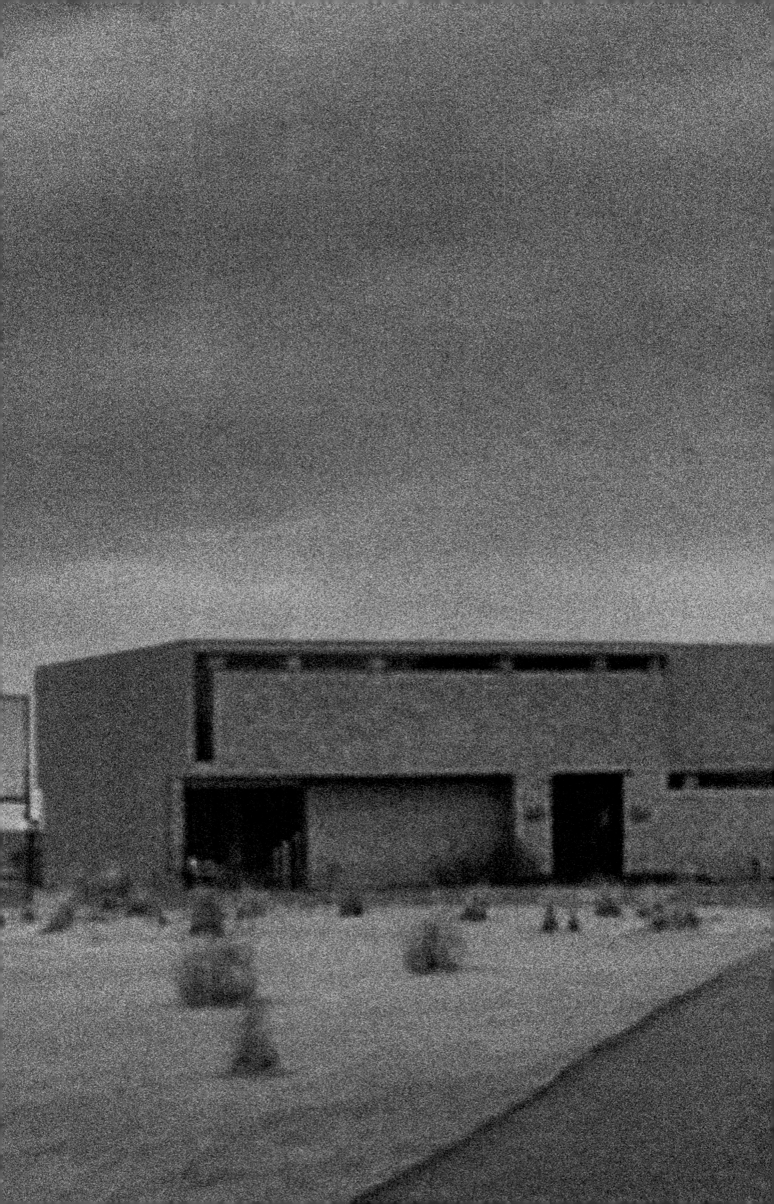

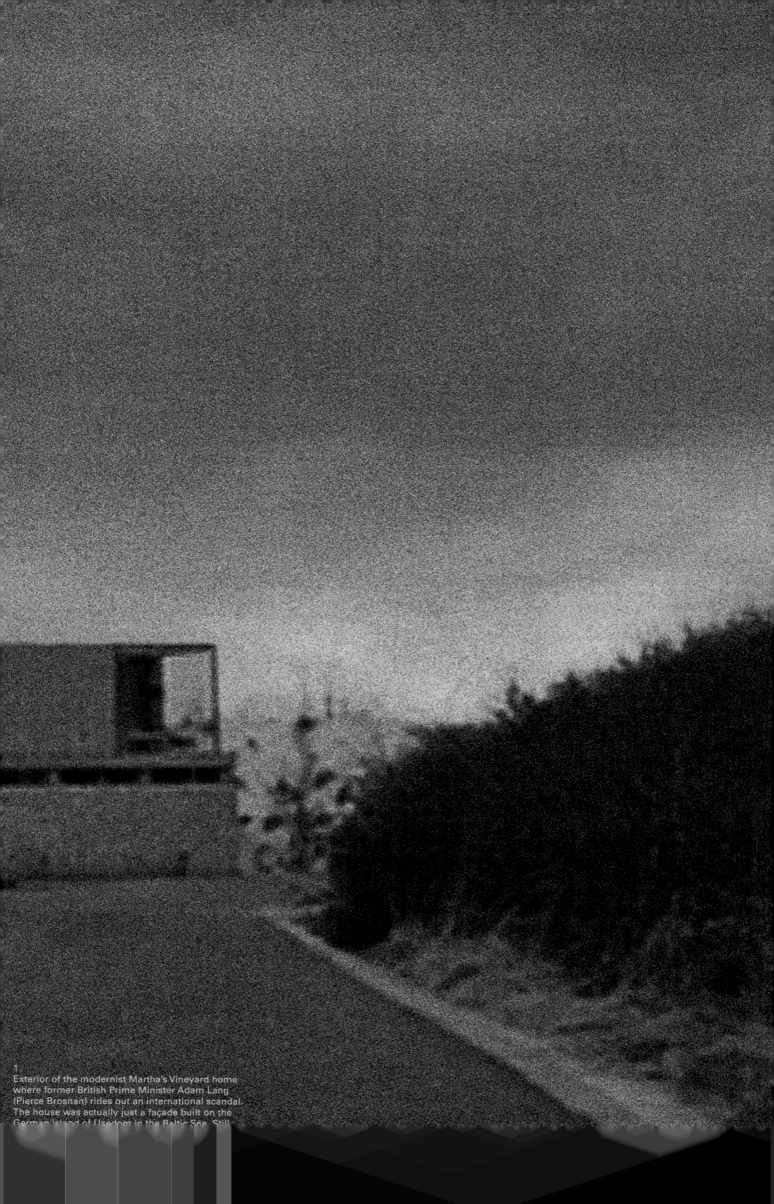

1.
Exterior of the modernist Martha's Vineyard home where former British Prime Minister Adam Lang (Pierce Brosnan) rides out an international scandal. The house was actually just a façade built on the German island of Usedom in the Baltic Sea. Still

VILLAIN

It doesn't take much squinting to see that Brosnan's Adam Lang is clearly modeled after former British Prime Minister Tony Blair. He's outwardly charming and likable, but also cocky and entitled. He's not used to hearing the truth, just the assent of yes men. When McGregor's ghostwriter first meets Lang, the Cambridge-educated politician sits on a leather sofa in his study with a Bloody Mary in hand. He's a born seducer who's used to getting what he wants, and before long the eager-to-please writer is tangled in his web. But Lang is also vain and short-fused when he lets his mask down, prone to outbursts aimed at either his wife (Olivia Williams) or any member of his hovering army of assistants who happens to deliver bad news. What makes Lang especially interesting as a villain, though, is the actor playing him. Brosnan, of course, is best known for his four-film cycle as James Bond. We're used to seeing him take on villains—watching him play a bad guy is one of the film's many deliciously perverse thrills. But Polanski doesn't leave it at that. Adding another twist to a story already loaded with them, Lang isn't the only schemer in the family. His wife, Ruth, is far from the pushover political spouse we're used to seeing on film and TV. She's got her own agenda—and an insatiable thirst for power that rivals her husband's.

2
Pierce Brosnan as the cocky, cornered Adam Lang. After four turns squaring off with villains as James Bond, the actor got to play one himself. Still. *The Ghost Writer.*

LAIR

Like the film's wintry Martha's Vineyard setting, Lang is isolated, untouchable, and hard to reach. His publisher's island home is an imposing and austere modernist box that sits on windswept dunes. It looks like a fortified bunker. Everything that happens inside of this gorgeously chilly place is top secret. In fact, the first thing that McGregor's ghostwriter is required to do when he enters the house is sign a confidentiality agreement. Inside, the house is all muted colors, reclaimed wood, and abstract contemporary art. The office that the Ghost is assigned to work in is stunning, but it's also severe enough to be off-putting. A huge glass window looks out on grey skies and weed-covered dunes leading to a dark, choppy sea—the same dark, choppy sea where his predecessor was recently found dead. If it looks intimidating, well, it's supposed to be. This is a sleek prison, a gilded cage with Walter Knoll furnishings. And if our hero is meant to feel out of his element, mission accomplished.

What's interesting from a technical point of view about Lang's lair in *The Ghost Writer*, beyond all of the high-end design, is that what we're looking at isn't actually Martha's Vineyard. It's not even the United States, because Polanski can't work here—if he stepped foot in the United States, he'd be arrested.

Exterior perspective looking into the house through the window of the office. Architectural illustration. Carlos Fueyo. 2019.

4, 5
Outside of the Lang's borrowed vacation home, showing (left) Ewan McGregor's ghostwriter and the gardener standing on the multi-level wooden deck leading to the windswept dunes and the choppy winter ocean beyond, and (right) the garage and the gravel driveway whose crunching sound under tires announces the arrival of unwanted visitors. Stills. *The Ghost Writer.*

6
Olivia Williams as Lang's scheming wife, Ruth. Her cool, hard-to-read personality matches the abstract art that lines the home's walls and the sleek décor, such as the pair of Mies van der Rohe Barcelona chairs to the right. Still. *The Ghost Writer.*

7
Brosnan's Lang just after a meeting with his advisors. The concrete bunker of a house is chic, darkly lit, and meticulous, making it a perfect fit for the Langs, who are a couple used to being in control of their environment. Still. *The Ghost Writer.*

3
4 5
6 7

Taking the level of movie-magic artifice one step further, consider this: Lang's house in the film isn't even a house at all. It's a façade created by supervising art director David Scheunemann on the German island of Usedom in the Baltic Sea. Most of the exterior shots of the Martha's Vineyard town of Old Haven were filmed on another German island, Sylt, in the North Sea near the Danish border. All of the interiors of Lang's house were filmed on sets constructed at the German film production studio Babelsberg, in Potsdam.

During post-production, Polanski traveled to Switzerland to be honored, where he was quickly detained and confined to house arrest for ten months—he edited the film there. Ironically, he must have known, better than anyone, how McGregor's imprisoned ghostwriter felt.

Views of the Martha's Vineyard home where the Langs are vacationing. Plan (top) showing the residence's streamlined layout and multi-tiered outside deck to the right. Longitudinal section (bottom left) and transverse section (bottom right) of the structure provide an overall understanding of the home's layout not evident in the film. Architectural illustrations. Carlos Fueyo. 2019.

"THE HOUSE WAS AN EXTREMELY IMPORTANT ELEMENT OF THE FILM…AN EXISTING HOUSE OF THIS SORT—ISOLATED, ON THE SEA—IT'S…IMPOSSIBLE TO USE…THE BIG MODERN BAY [WINDOW] WITH THE VIEW OF THE OCEAN. IT LOOKS GOOD IN THE MOVIE, BUT IT CAN'T BE USED BECAUSE THE LIGHT, IT CHANGES CONSTANTLY BEHIND THE WINDOW. THE WEATHER CHANGES, AND IT DOESN'T NECESSARILY FOLLOW YOUR SHOOTING SCHEDULE. SO IT HAS TO BE BUILT, AND WHATEVER YOU SEE THROUGH THOSE WINDOWS, IT HAS TO BE ADDED. AND I'M REALLY HAPPY THAT PEOPLE DON'T REALIZE THAT IT WASN'T SHOT IN A REAL HOUSE."[1]

—Roman Polanski

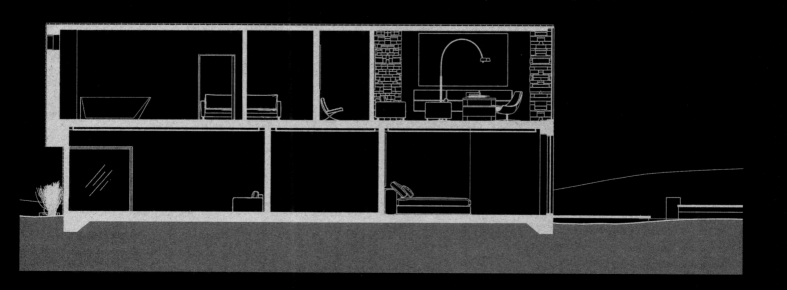

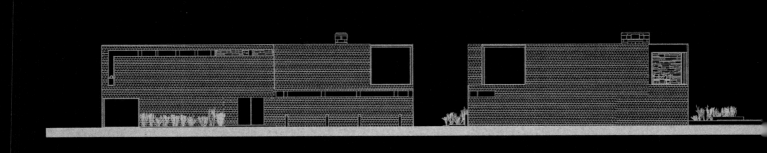

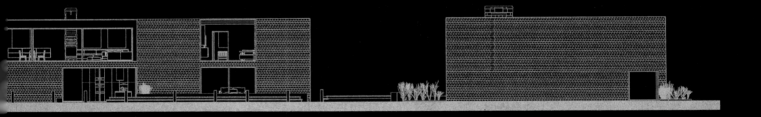

12
Composite of exterior elevations of all four sides of the compound. For the film, art director David Scheunemann built only a façade of the home on the German island of Usedom. These renderings imagine what the structure would look like as a complete building. Architectural illustrations. Carlos Fueyo. 2019.

DESIGNING A HOUSE WITH A STRIPPED SOUL
A CONVERSATION WITH DAVID SCHEUNEMANN, *THE GHOST WRITER'S* ART DIRECTOR

In *The Ghost Writer*, German art director David Scheunemann pushes the trope of the villain's lair, managing to imbue a sense of darkness into a seemingly innocent seaside vacation home. The forty-one-year-old Scheunemann has helped create the look of such Hollywood films as *Inglourious Basterds*, *The Hunger Games: Mockingjay - Parts 1* and *2*, *Atomic Blonde*, and *Deadpool 2*. Still, his most indelible lair appears in *The Ghost Writer*. The film is set on the wintry, windswept dunes of Martha's Vineyard, where ex-British Prime Minister Adam Lang (Pierce Brosnan) is vacationing as he rides out a scandal, but Scheunemann couldn't simply find an existing modern home on the Massachusetts island—Polanski's legal inability to travel to the United States prevented that. Instead, he created the house using a combination of twenty-first-century technological wizardry and a dash of old-school Hollywood magic. Scheunemann spoke with Tra Publishing about building a lair for the ages.

TP **Tra Publishing: How much did Roman Polanski influence your design for the house in *The Ghost Writer*?**

DS David Scheunemann: Roman was quite involved in every single area. He was intrigued by the idea of creating a modern home that is in a strange way a little bit of an alien house that incorporated both true classic modernism and also sort of a hostile environment. I'm an architect myself, which was why this was so particularly fantastic to work on. It was kind of like the building you wanted to build but hadn't built yet.

TP **Polanski is known to be an exacting perfectionist, obsessing over every last detail. How did that play out on *The Ghost Writer*?**

DS He's a true perfectionist. He has a certain philosophy about how to photograph and how to direct an image. The key thing in his movies is to shoot with relatively wide lenses and to be sure he is directing the background properly. It's a theory about peripheral vision in moviemaking. He takes so much care about every level of detail that it sometimes takes time before the image looks right to him. For actors, it can be nerve-wracking. There was a scene where Ewan McGregor is in a bathtub, and Roman was basically directing his toes. He's *really* precise about everything.

TP **Legally, Polanski is not allowed to come to the United States. Did that present challenges in terms of making a film set in Martha's Vineyard?**

DS It was actually quite simple. We built [elements of] the house in three different places for the film. We shot the exteriors on the island of Sylt, in northwest Germany. Then we chose another island, Usedom, which is in the northeast of Germany, for the exterior of the house. We built a façade there. Then we built the interior of the house on a stage at Babelsberg Studio in Potsdam. Between the two islands, we found enough environments to create a convincing replacement for Martha's Vineyard. But we also shot in Boston and on Martha's Vineyard.

TP **How did you manage that?**

DS We had a second-unit crew there shooting exteriors, and Roman was connected via live link. We called it "Skype directing."

TP **Tell me more about the exterior of the house that you built on Usedom. It looks so real that it's hard to imagine that it's a façade.**

DS We built an exterior façade and a front yard, tennis court, and garage. And the views from the house we shot in Sylt. All of the walks on the beach and backyard stuff was on Sylt. But for the house on Usedom, we had the first twelve or fifteen feet built within the entrance. Behind that was just scaffolding. Actually, it's pretty sad when you look at these things.

TP And when you're looking out the window of the office where Ewan McGregor is working and you see the sea, what are you looking at?

DS That's a green screen, and then we shot the sea on Sylt. It was a bit of a puzzle.

TP What does the house say about the character of Lang and his scheming wife, who's played by Olivia Williams?

DS The structure gives you the feel of a stripped soul. It has a roughness to it that shows you are dealing with a character whose soul maybe was never there. He's a puppet of modern politics. It was always meant to be a slightly hostile environment to the human being.

TP It's a place of secrecy and confidentiality and coldness. The space tells you a lot about the character that the dialogue doesn't necessarily convey.

DS Yes. Absolutely. You've got it right.

TP Was it important to shoot there in the winter, to look cold and chilly and grey?

DS It was absolutely key to do it in the winter, because we needed the leaves to be gone or brown so it looks sad. The weather and rough seas and grey skies contribute to the atmosphere.

TP Are people disappointed when you tell them the house doesn't actually exist?

DS Oh, yes! We had to take it down when we were done. That's what you have to do. That land is owned by the state. It's where they built V-2 rockets in the 1940s. So it does have a dark history to it. It was one of the launching pads for the rockets that they sent off to London. Maybe that evil makes its way into the film subconsciously.

TP Generally speaking, going all the way back to the homes of villains in the James Bond films, what role does architecture play when it comes to movie villains?

DS It's one of the most important character-defining roles for these sorts of movies. And I think the discussion around that is pretty underestimated. There are so many great examples in movie history of how architecture helps draw the character. I don't even mean if it's good or bad architecture. Sometimes bad architecture can help define a character, too. The place you select for your character is *creating* the character. It influences the actor as well. When you had Pierce Brosnan and Ewan McGregor walking into the house, it did something for them. It changed their perception of their roles. They adjusted to that modernist hostility that the house was giving to the scene. I think the typical James Bond villain on a Ken Adam set would say the same thing.

TP There have been so many villains associated with modern architecture. Do you think that it gives modern architecture a bad rap, because it's repeatedly associated with evil?

DS I would say it gets an *interesting* reputation. In the 1930s and 1940s in Europe, they created great architecture, but they also had real-life villains. So the perception through the movies probably has something to do with the architecture, but the architecture also reflects its inhabitants. I've always felt that architecture can start to affect the ideas of the inhabitants.

FILM **DANGER: DIABOLIK**
VILLAIN **DIABOLIK**
LAIR **CAVERN HIDEOUT**

FILM

The lovechild of 1960s James Bond films and the kitschy *Batman* television series, *Danger: Diabolik* is a Technicolor feast of Italian comic book camp featuring Diabolik (John Phillip Law) a suave, masked supercriminal whose daring money heists confound the police and rattle the gangster underworld. With his comically arched eyebrow and way-too-skintight costume, Diabolik and his icy bombshell girlfriend, Eva (Marisa Mell), slink around town in their Jaguar E-Types, boosting $10 million from armored cars and absconding with emerald necklaces, Pink Panther-style. In hot pursuit are the shrewd Chief Inspector Ginko (Michel Piccoli) and the government's inept Minister of the Interior (Terry Thomas), who claims Diabolik's "very name reveals his antagonism to the established values of our society." Both are aided by slimy gangster Valmont (Adolfo Celi, who also portrayed one-eyed mastermind Emilio Largo in 1965's *Thunderball*), eager to destroy the antihero he considers his competition.

Release
1968

Director
Mario Bava

Production Designer
Flavio Mogherini

Cinematographer
Antonio Rinaldi

Cast
John Phillip Law
Marisa Mell
Michel Piccoli
Adolfo Celi
Terry-Thomas

Screenplay
Dino Maiuri
Brian Degas
Tudor Gates
Mario Bava

Studio
Paramount Pictures

Lair
Sets were built at Fiat's Lingotto factory, Turin, Italy, and some location shooting took place at the Blue Grotto in Capri, Italy. Parts of the lair were created through glass matte shots.

Images
All photographs are from *Danger: Diabolik* and all architectural illustrations and renderings are based on spaces in the film.

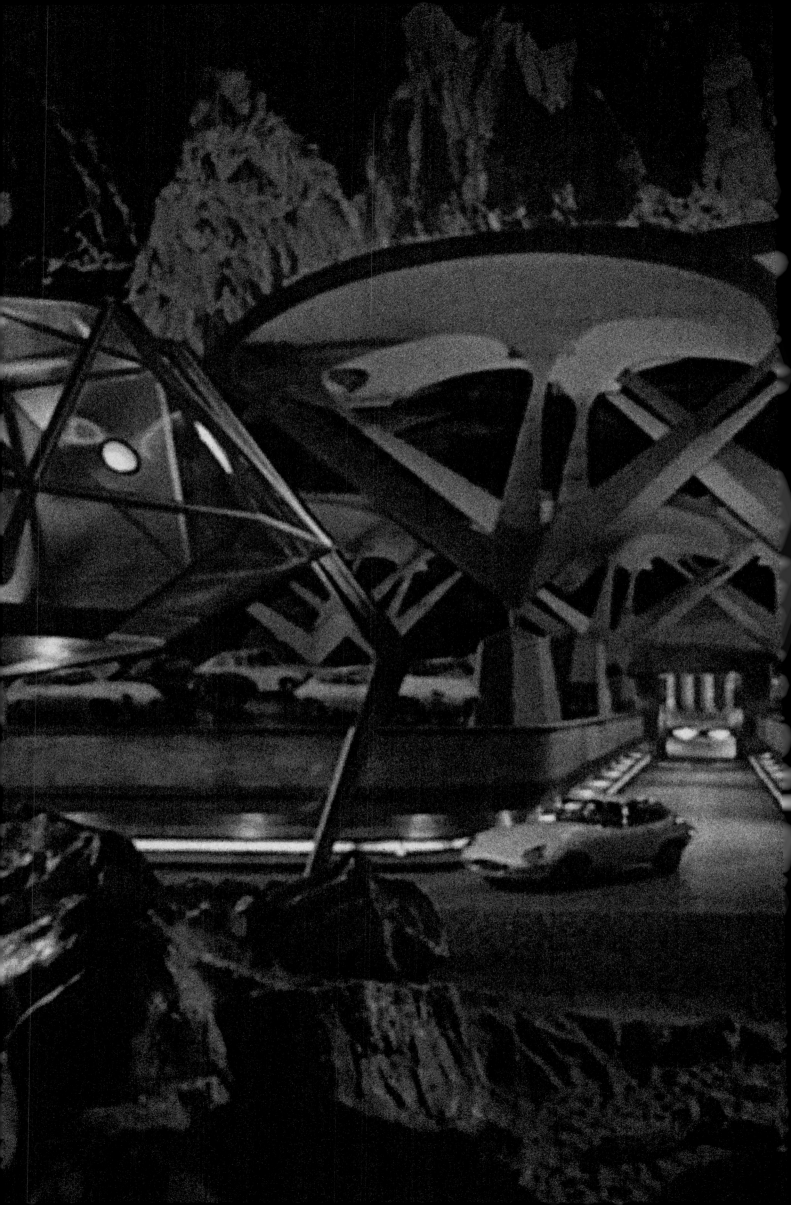

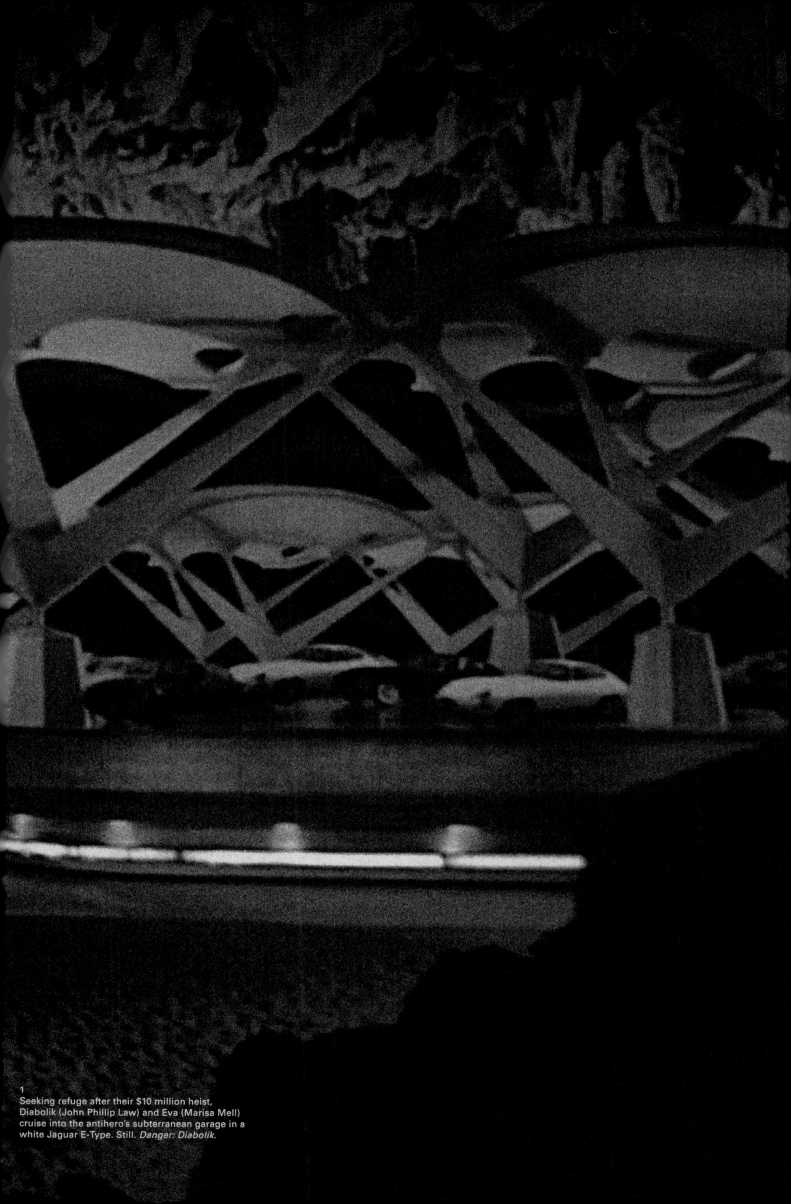

1
Seeking refuge after their $10 million heist,
Diabolik (John Phillip Law) and Eva (Marisa Mell)
cruise into the antihero's subterranean garage in a
white Jaguar E-Type. Still. *Danger: Diabolik.*

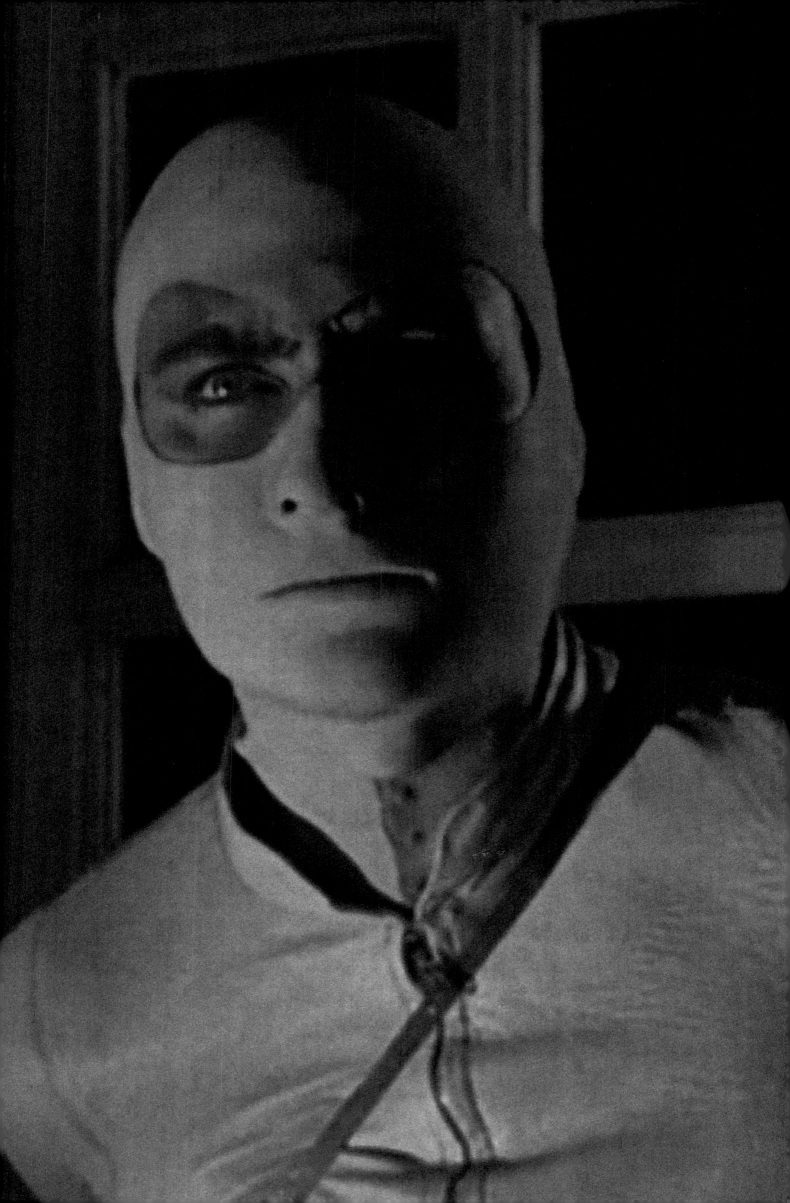

VILLAIN

Adapted from Angela and Luciana Giussani's comic-book series of the same name, *Diabolik* features an astute super-criminal whose thirst for casual sex and violence tapped into the 1960s counterculture's deep mistrust of stuffy authority figures. Although his black leather suit conjures associations of Spider-Man in a fetish dungeon, Diabolik is no virtuous superhero, but he does represent a better class of villain. He's fabulously wealthy, which hardly stops him from ludicrously stealing the country's entire gold supply—a twenty-ton gold ingot—using a submersible jet and inflatable balloons. "In view of the bad use to which the government has put the public money, I shall take steps to remove it from circulation," the anti-capitalist Diabolik writes in one letter to police, which leads to a montage sequence of tax offices blowing up, utterly crippling the Italian economy.

2
American actor John Phillip Law as Diabolik, the anti-capitalist masked supercriminal. Still. *Danger: Diabolik.*

LAIR

Think Dr. Evil's lair by way of *MTV Cribs*: Diabolik's subterranean man-cave is an exercise in mid-century lifestyle porn, with its diamond-shaped glass rooms, glowing crystals, and collection of identical Jaguar E-Types. His underground bunker is an opulent, psychedelic pop dream, lush with the latest mod furnishings, such as massive his-and-hers baths with waterfall-style shower heads. On one occasion, worn out from a hard day of swindling the government, Diabolik and Eva celebrate on his vast, rotating, multilevel circular bed, which during their lovemaking is covered with more stolen cash than is in Scrooge McDuck's vault.

The lair is accessed through a very hidden entrance into a cave. With the press of a remote switch, the ground itself lifts up and a tunnel whirrs open, allowing Diabolik's Jaguar to rumble inside and through a honeycomb of darkened passageways. A flash of the Jaguar's headlights prompts fake boulders to open into a doorway, granting access to a gleaming tunnel that leads to the lair's car elevator. The car elevator is a highlight—an ultra-cool, rotating, diamond-shaped space that transports Diabolik deeper into the cavern, which houses a high-tech vault and his living quarters.

To pull off Diabolik's cavernous base, director Mario Bava used a series of matte paintings and foreground miniatures to create the illusion of immense scale. Before he began directing Italian cult films in the 1960s, Bava studied painting and learned extensively from his cinematographer father, a special-effects guru, both of which served him well on *Danger: Diabolik*.

4
5

3, 4, 5
The vehicular entrance to Diabolik's lair, camouflaged by coastal turf, whirrs open at the press of a remote switch. Next, Diabolik and Eva drive through the honeycomb of darkened tunnels. Diabolik flashes the Jaguar's headlights twice, fake boulders part, and they proceed through a gleaming tunnel en route to the next step in the process: the lair's car elevator. Stills, *Danger: Diabolik*.

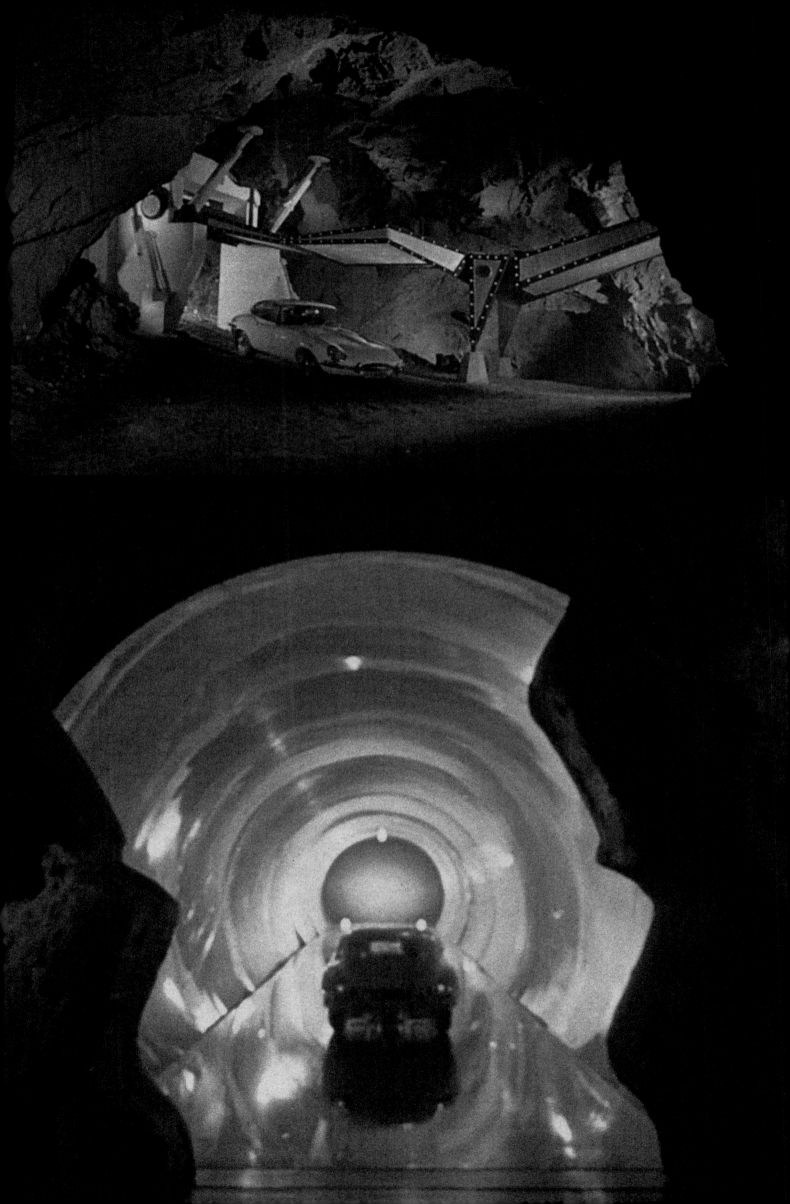

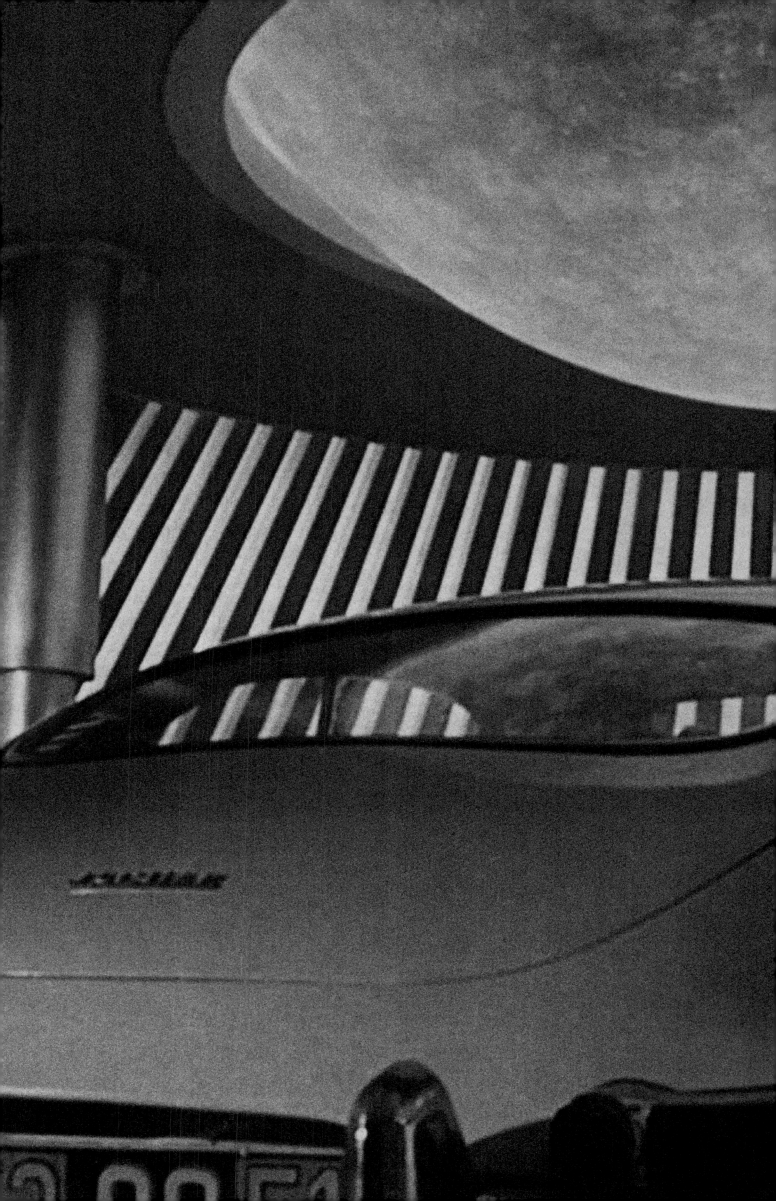

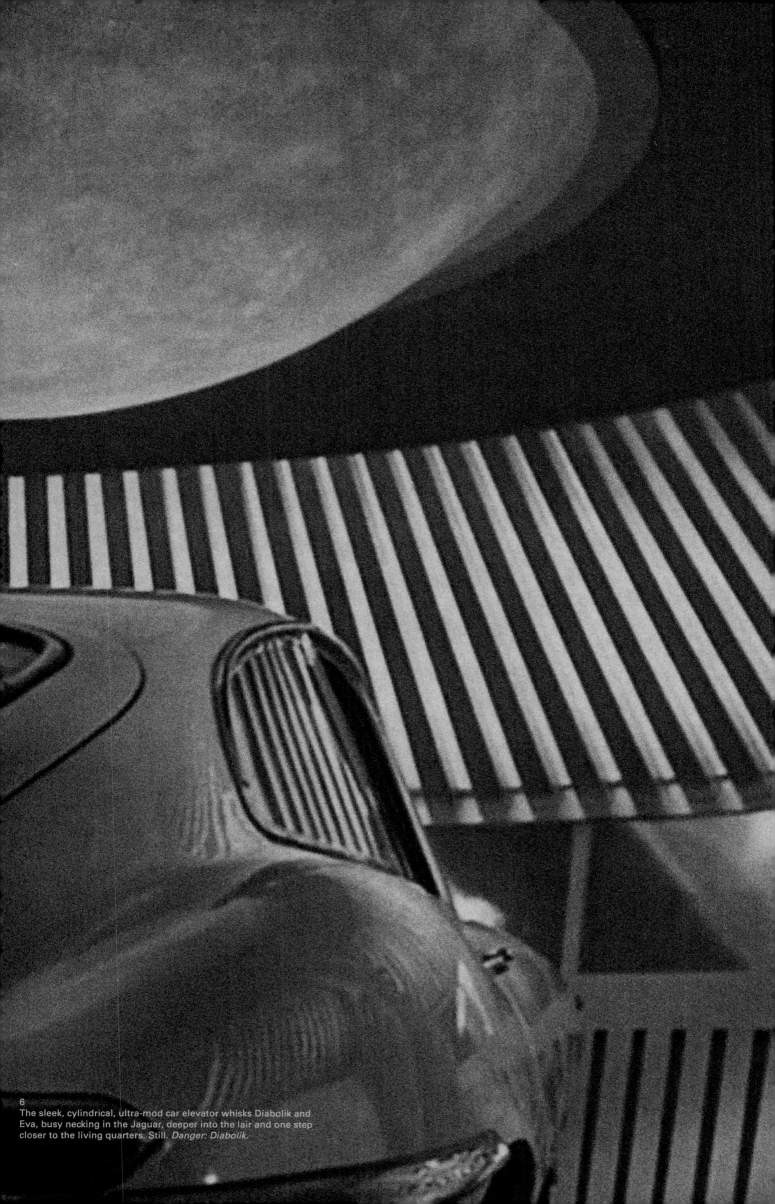

6
The sleek, cylindrical, ultra-mod car elevator whisks Diabolik and Eva, busy necking in the Jaguar, deeper into the lair and one step closer to the living quarters. Still. *Danger: Diabolik.*

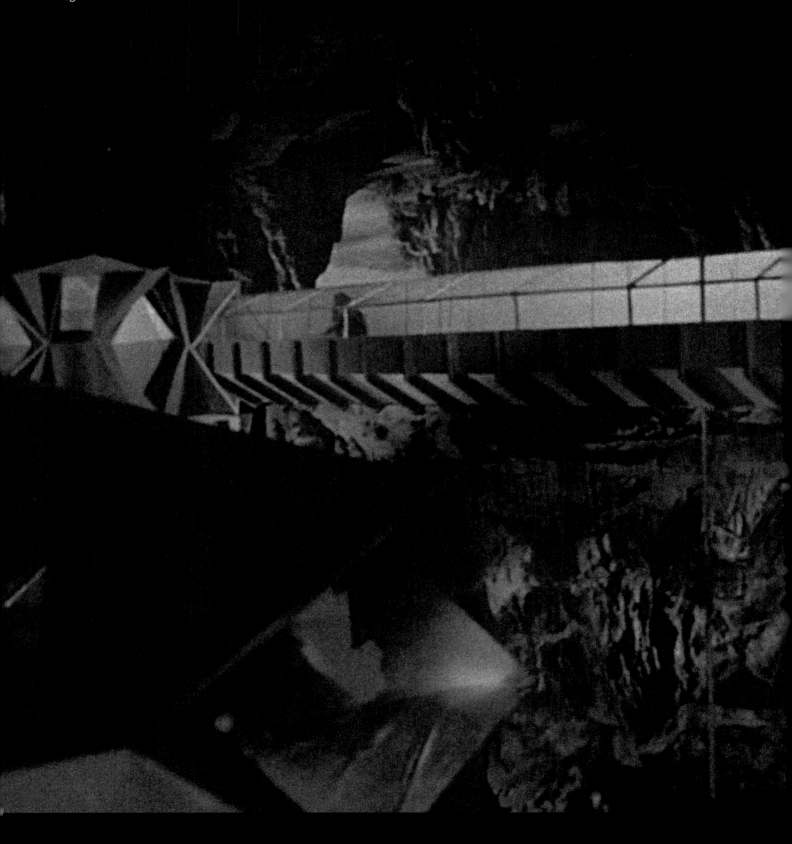

"DIABOLIK [IS] A SUPERCRIMINAL WHO LIVES UNDERGROUND IN HIS ELECTRONIC HIDEOUT WITH A SEXY BLONDE... AND MILLIONS OF DOLLARS' WORTH OF GADGETS. (DIDYA EVER WONDER HOW THESE GUYS PULL OFF THE LARGEST UNDERGROUND CONSTRUCTION PROJECTS IN HISTORY AND KEEP THEM A SECRET?)"[1]

—Roger Ebert

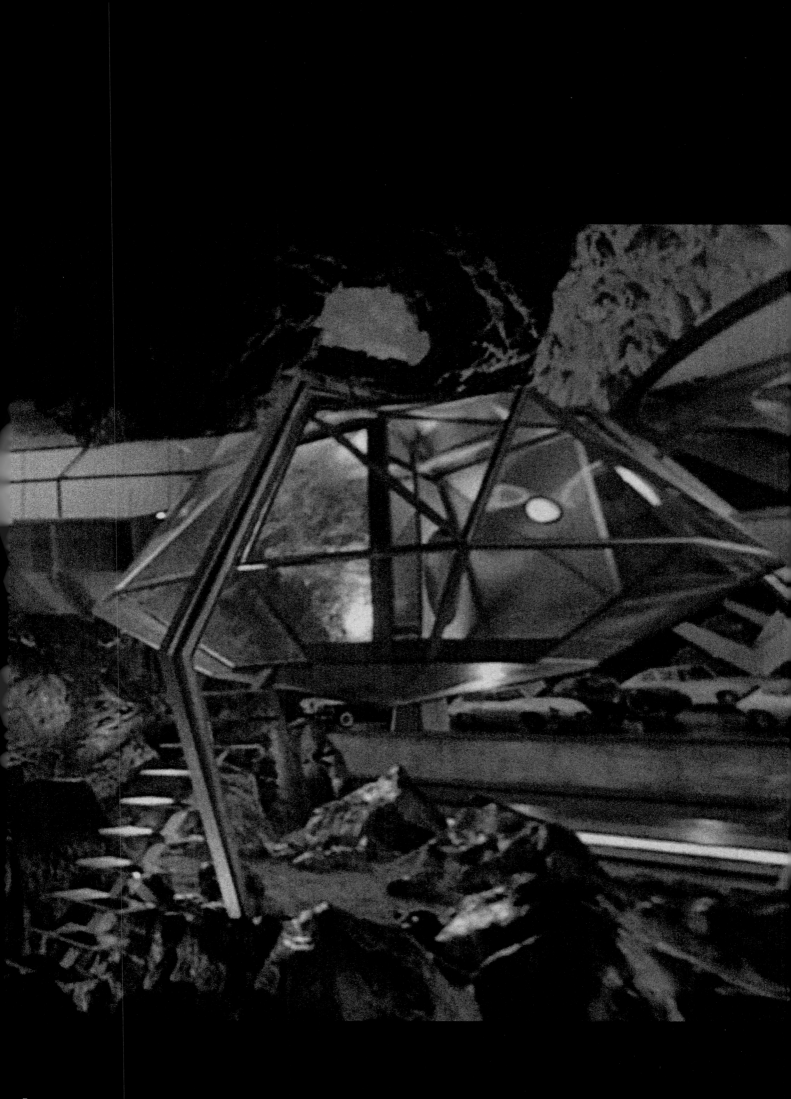

7
Almost there: Eva climbs the stairs and crosses the
glass-roofed skybridge into Diabolik's lavish den.
Still. *Danger: Diabolik.*

Armed with his trusty laser gun, Diabolik fires a hole into his
latest pilfered prize—a twenty-ton ingot—melting it into smaller
gold bars. Still. *Danger: Diabolik.*

9, 10
Plants lend a homey touch to the his-and-hers showers, which
feature conveniently placed privacy circles and waterfall-style
showerheads—the perfect antidote after a long day of swindling
the government. Stills. *Danger: Diabolik.*

11
Diabolik and Eva and a whole lot of money, enjoying his rotating,
multi-level bed. Still. *Danger: Diabolik.*

8
9
10
11

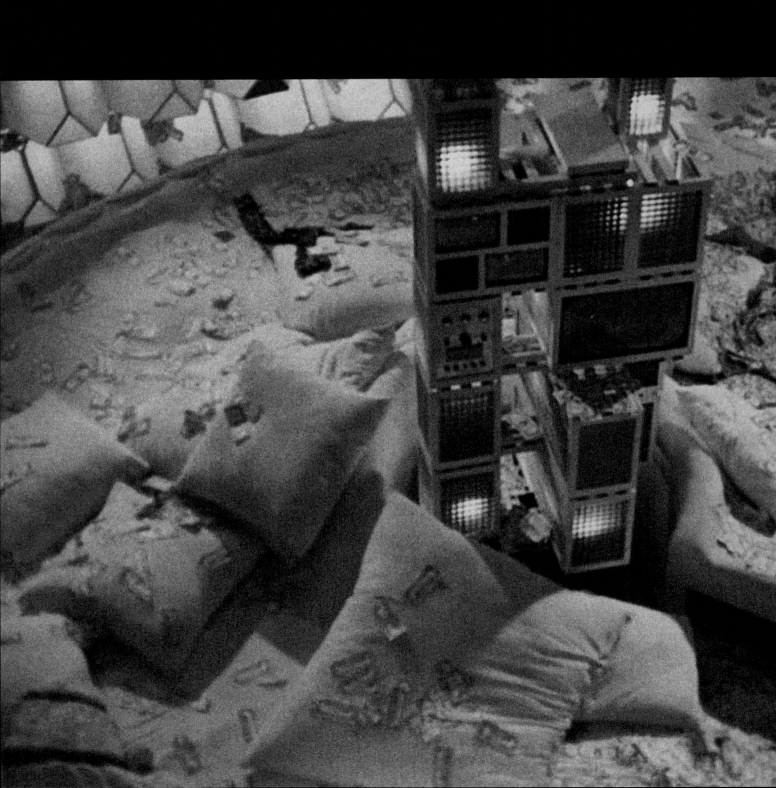

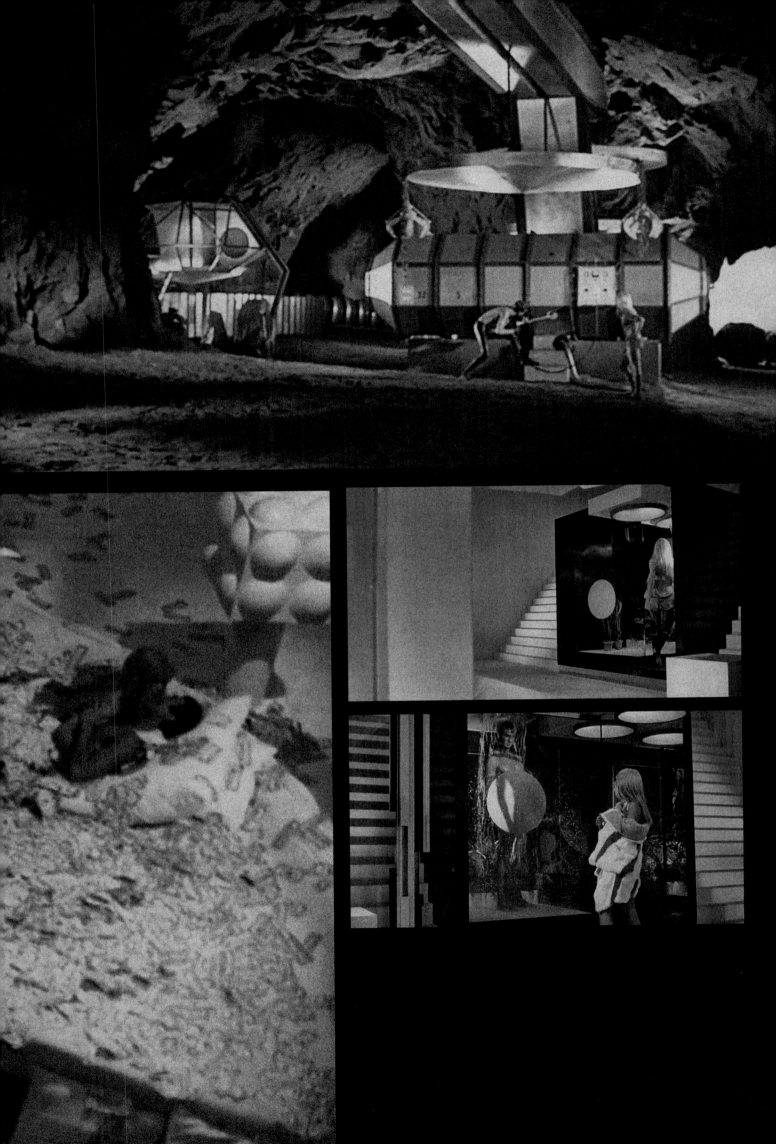

Law, who portrayed *Diabolik*, recalled Bava's low-budget ingenuity when it came to set design: "I walked onto this big empty set. There wasn't a set, you know? There was a camera, but no props, nothing except the place where they put the Jaguar. I climbed up [onto the catwalk] and took a look through this camera. [Bava] had two big pieces of glass that held all these cut outs of that whole cave where Diabolik lived."[2]

Diabolik is set in Clerville, a fictional coastal town in what is presumably Italy. The movie was largely filmed at producer Dino De Laurentiis' studios in Rome and on location at a Fiat plant in Turin, Italy. For one scene, in which Diabolik tows a giant gold ingot underwater, Bava filmed at the Blue Grotto sea cave on the island of Capri.

The film revels in its casual anarchy. Diabolik boasts bottomless wealth and more high-tech gadgetry than the paranoid city bureaucrats chasing after him. The film glorifies his criminality while making it clear that he was motivated in part by a frustration with the government and the tax system. The film's trailer compares him to Robin Hood, albeit an entirely self-serving one: "He robs from the rich to give to the girls." The bad guys simply have more fun than the cynical government types, who are just as vapid as the film's two-bit criminals. Still, there's a stifling loneliness to Diabolik's vast bunker. The film concludes with our antihero trapped inside his lair and encased in a shell of molten gold—perhaps a moralistic twist warning us to be wary of the Midas touch.

12
Plan of Diabolik's vast bunker, created for the movie with the help of matte paintings and miniatures. Architectural illustration. Carlos Fueyo. 2019.

13
Longitudinal section cutting through the rock of Diabolik's lair, revealing the car elevator, the tunnel to the living quarters, and a bank of concrete columns that presumably shield Diabolik's many cars from falling stalactites. Architectural illustration. Carlos Fueyo. 2019.

12 13

Architects' Commentary
Highlights from Oppenheim Architecture's round-table discussion of Danger: Diabolik

"The thing that's so interesting about all these films is how they inspire. This film is super cool, super sexy, super swanky. It's incredibly inspiring."

"The design is so powerful, and there are so many great touches. Diabolik's lair is this cavernous place, full of curves and interesting shapes—even the way the ceiling is streamlined is fantastic. There are so many details that we could pick up on, that we could try to do."

"There's a very intriguing contrast between the organic and the man-made, which we see over and over in these villains' lairs. Here, it starts with the entrance and how, when they drive in, the ground literally opens for them. Of course, it's thanks to technology that nature opens this way. So we have Diabolik manipulating nature to his aims, but at the same time, nature is protecting him—nature is the camouflage for the lair. And you have the stark contrast of going through a cave, which is primitive and natural, and into the lair, which is techno-futurist."

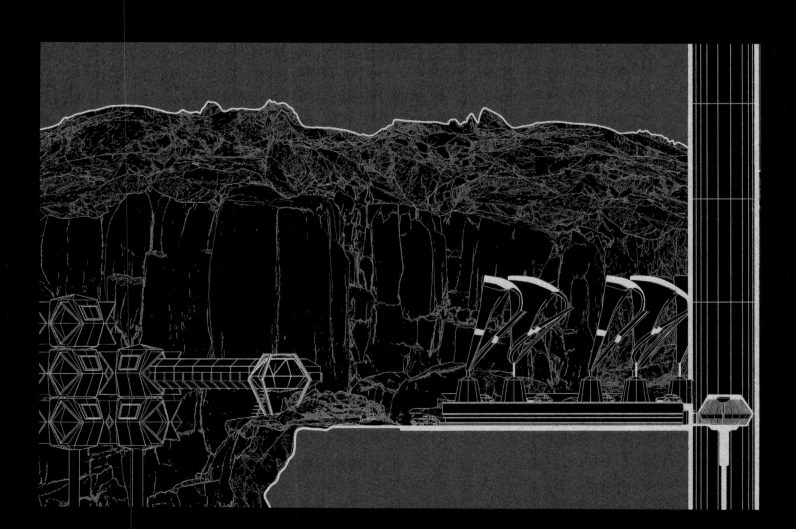

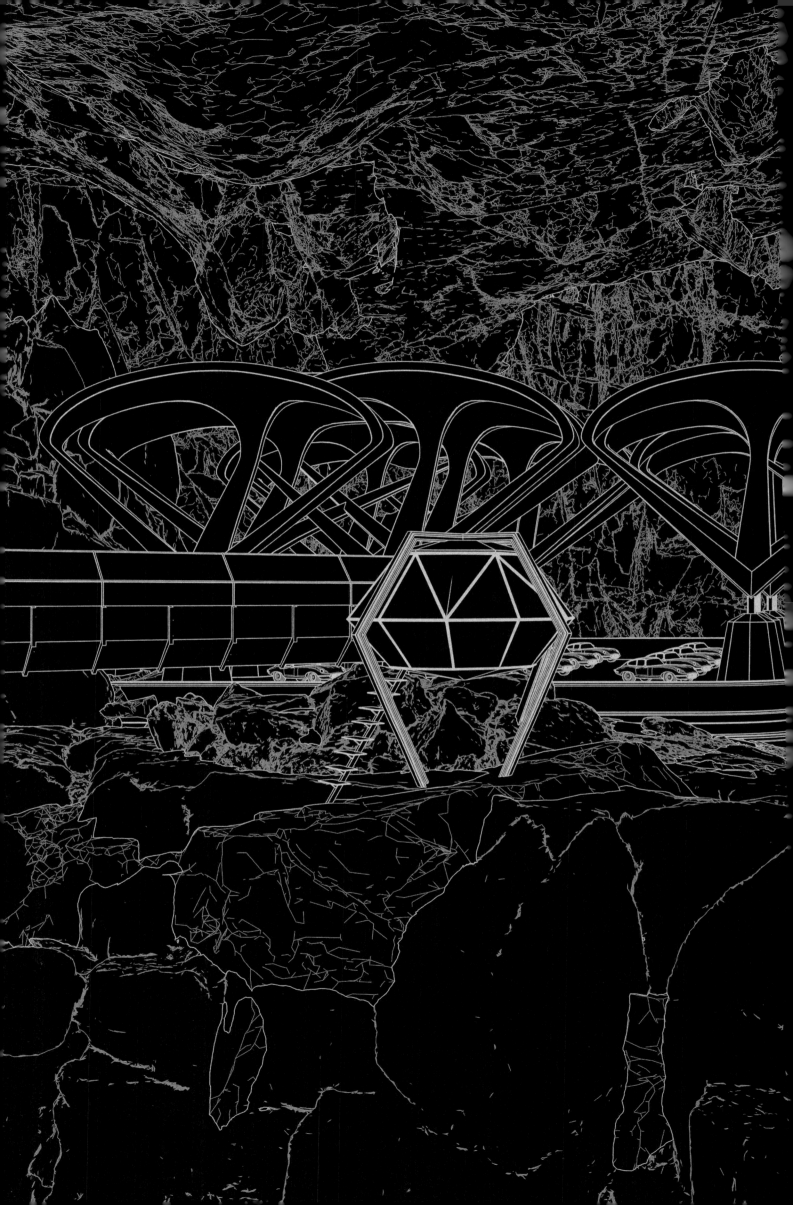

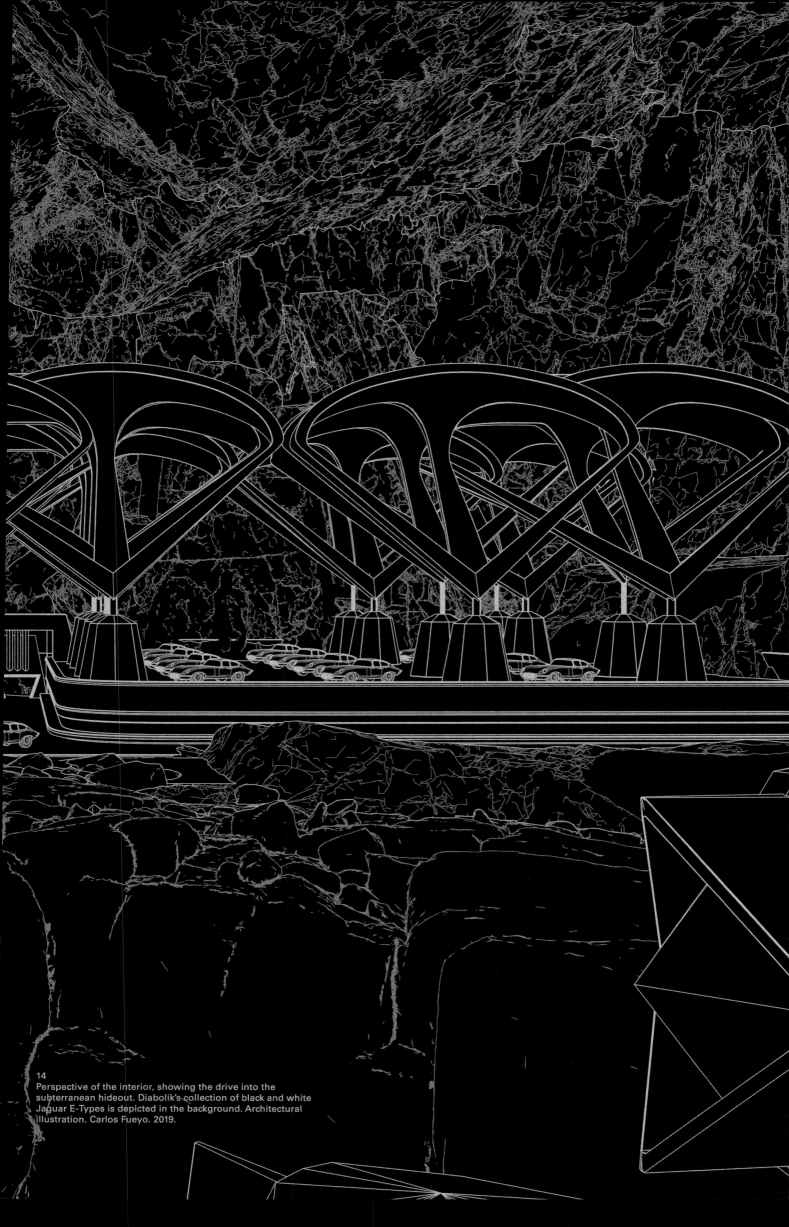

14
Perspective of the interior, showing the drive into the
subterranean hideout. Diabolik's collection of black and white
Jaguar E-Types is depicted in the background. Architectural
illustration. Carlos Fueyo. 2019.

ABOUT THE IMAGES: IN THE SHOES OF CINEMATOGRAPHERS AND PRODUCTION DESIGNERS
A CONVERSATION WITH CARLOS FUEYO, CREATOR OF *LAIR*'S ARCHITECTURAL ILLUSTRATIONS AND RENDERINGS

Carlos Fueyo, an architect-turned-film professional, created the architectural illustrations and renderings seen throughout *Lair*. These images allow readers to view and spend time with the spaces in the films, often beyond what is presented on-screen or from alternate vantage points. His painstaking work (six hundred-plus hours of it) involved analyzing each film, building meticulous, digital three-dimensional models, and then generating a selection of views for each film. Fueyo, who is the creative director of Miami's playard studios, has fifteen years of experience in film and has worked on several major motion pictures, including *Avengers: Age of Ultron*, *Super 8*, *Priest*, and *Independence Day*. Tra Publishing talked with him about the work involved in generating the images.

TP **Tra Publishing: Can you tell us a bit about your background in architecture and in film?**

CF Carlos Fueyo: Film and architecture have been constants throughout my life. Like many people, I have always loved and been intrigued by film. The virtue of storytelling and the process of filmmaking have always been of great interest. I've also never questioned my inclination toward design and architecture; the profession's philosophy and problem-solving nature have allowed me to find a form of expression that resonates deeply for me. When I realized just how similar both fields were, I became determined to integrate them both into my work. Designing a building is very much like making a film. In both, one is constantly trying to maintain control of concept and form. Every space in a building is designed from the human point of view in the same way that a shot in a film must be framed from that same point of view. They both try to influence the user/viewer by suggesting which direction they should go in and how they should be feeling. They both tell a story in a linear way and have something to say.

TP **How have you combined these interests in your career?**

CF I have been lucky enough to have been part of both of these worlds. I have been fortunate enough to briefly collaborate with Lebbeus Woods, my idol all through architecture school and someone who influenced both industries. I have also been fortunate to work on amazing projects in film and commercials. Whether it is helping to bring Vision to life for the *Avengers*, creating a larger-than-life hangar for *Independence Day*, envisioning a post-apocalyptic desert outpost for *Priest*, or manufacturing a train crash in *Super 8*, I continue to look for satisfying projects that involve both film and architecture. Every project is a new lesson, a new problem to solve, and I hope to never stop learning.

TP **Can you describe the work you have done for *Lair*?**

CF When playard studios was first approached about this project, it was to create some interesting additional illustrations on a rather modest scale. However, that changed dramatically. Once I began to work on the first film, I quickly realized that in order to do justice to these films and the set designs, I would have to dig a lot deeper. This began an analytic process of every one of the films in the book. I developed a process that would yield a set of illustrations that could be as detailed and accurate as possible while giving the viewer information and a perspective of the spaces that they had not seen before.

TP **Can you explain the process itself—what technology is involved in creating these images?**

CF All of the images are derived from a three-dimensional model. There are two reasons for this. Initially I gravitated to this because I felt there was no other efficient way to generate so many images in such a tight timeframe. It became clear during work on the first film that creating three-dimensional models of these spaces was really the only way to accurately represent them and maintain continuity throughout the book. We developed a process to render the spaces using a toon shader, which is a cartoon material. This shader gives me control over line thickness, outlines, etc. Once the research and development of this shader is done, I use this methodology to generate "drawing-like" sections, elevations, and floor plans. We also developed a look for the black-and-white, three-dimensional renderings that gives accurate light information and hints at materiality without aiming for photorealism. It is all done in order to allow the viewers to see beyond what is presented in the movies—to have access to unobstructed views of these sets.

TP Taking a step back, what research do you conduct in order to create the model?

CF It begins by watching the film in its entirety and collecting as much information as possible. I am especially focused on screen grabs of the sets and architecture, details, and clips that can hint at the unseen. I also analyze each film's storyline and characters from the point of view of each set's geography in order to extract further clues that may have influenced and informed the set design. Part of this analysis is to follow the characters as they move through the set geography in order to figure out how they move from room to room. Some directors, like Hitchcock and Kubrick, tend to treat the sets and architecture as characters and are very aware of the geography's continuity. Once this data is collected, I begin to sketch a general geography. You can think of it as a CAT scan, which with every pass gathers more information and reveals a clearer picture. With this general sketch, I then begin to create a three-dimensional spacial analysis. As a square foot is built, it begins to create a space, and that space informs the next move, and so on. Sometimes that move will lead me to reconsider the previous decisions. In the end, a complete architectural picture is revealed.

TP What criteria do you use to decide which specific views to present for each project?

CF The main criteria for the sections, elevations, and plans is to make sure that the cuts happen at a place that gives the most amount of information. When we watch a film, we rarely get to perceive the spaces in such a technical and clear manner. As far as the interior views, they are mostly a framing and aesthetic decision. I play with the composition and place the camera where it exploits the space in the same way the director of photography might have done while setting up the shots. I also have in mind the opportunity to provide new insight to the reader through the images.

TP You have been refining the process as you've progressed with the work. Can you describe that?

CF Everything in life is about refinement, and that is particularly true when we talk about design and visual arts. The process inherently required me to create and erase over and over, thus refining the space on every pass. This also means that my understanding of the process and the films had to be revisited and refined with every set.

TP Is this process or approach unique?

CF I don't necessarily think that my approach was unique in terms of its technicality. I do think, however, that my analytical approach coupled with my background in film and architecture created the opportunity for a unique combination of expertise and talents to come together. I wanted to make sure that I stayed as true as possible to the films, and in doing so, I tried to put myself in the shoes of the cinematographers and production designers who had worked so hard to create these experiences. I know from personal experience that when creating environments, creatures, or vehicles for a film, little is left to chance. There is always some reasoning for the design decisions being made, some backstory or justification. I just hope that I was able to come close to them.

DR. STRANGELOVE OR: HOW I LEARNED TO STOP WORRYING AND LOVE THE BOMB

1 Terry Southern, "Check-Up with Dr. Strangelove," *FilmMaker: The Magazine of Independent* Film, Fall 2004.

2 Christopher Frayling, *Ken Adam: The Art of Production Design* (London: Faber and Faber, 2005), 108.

3 Ibid., 111.

4 Southern, "Check-Up with Dr. Strangelove."

3 Miller, "The Unlikely Inspiration Behind *Blade Runner 2049*'s Futuristic Design."

THE GHOST WRITER

1 Laurent Bouzereau, "Roman Polanski Interview, *The Ghost Writer*." *The Ghost Write* © 2010 Summit Entertainment, LLC. YouTube video, 8:39, https://www.youtube.com/watch?v=XSS9AR5Bl-g.

DANGER: DIABOLIK

1 Roger Ebert, "Danger: Diabolik," Roger Ebe (website), December 4, 1968, https://www.rogerebert.com/reviews/danger-diabolik-1968

2 Tim Lucas, *Mario Bava: All the Colors of the Dark* (Cincinnati, Ohio: Video Watchdog, 2007), 738.

CONTRIBUTORS

Sir Christopher Frayling is a cultural historian, professor, broadcaster, author of more than twenty-five books, and is well-known as a champion of arts education and everyday culture. He was rector of the Royal College of Art (RCA) in London, and he served as chairman for the Arts Council England, the Design Council, and the Royal Mint Advisory Committee. In 1979, he was appointed professor of cultural history at RCA—at that time, he was the youngest professor of the humanities in the UK—and he set up pioneering postgraduate courses at RCA on design and curatorial studies. In 2000, he was knighted by Queen Elizabeth II for "services to art and design education." His books include *Ken Adam: The Art of Production Design, Sergio Leone: Something to Do with Death, The 2001 File, Frankenstein: The First Two Hundred Years, The Art Pack*, and *On Craftsmanship*. He has long been a regular broadcaster on network radio and television. His series for BBC television include *The Face of Tutankhamun, Strange Landscape*, and *Nightmare: The Birth of Horror.*.

Carlos Fueyo is the creative director of playard studios, a production, post-production, and creative studio in Miami that works with multimedia content including film, commercials, AR/VR/XR experiences, VFX, and product prototyping. He received his undergraduate degree in architecture from Florida International University and has over fifteen years of experience working on film, commercials, game cinematics, and dark rides. He has worked on many major motion pictures, including *Avengers: Age of Ultron, Super 8, Priest*, and *Independence Day*. As a VFX supervisor, Carlos helped bring environments and characters to life by designing, modeling, lighting, texturing, compositing, and animating. He also played an integral part on and off set in the creation of visual effects for other films, such as *Mission Impossible: Ghost Protocol, After Earth, Jane Got a Gun*, and *Terminator: Genesis*.

Andrea Gollin is an editor, publishing consultant, and writer who serves as Tra Publishing's managing editor. She has edited dozens of books and exhibition catalogues, including *Robert Winthrop Chanler: Discovering the Fantastic* (The Monacelli Press). She is a graduate of Princeton University and received an MFA from the writing program at University of Virginia. She has been on staff at several publications, and her journalism, book reviews, and fiction have been widely published in outlets including the *Washington Post, Miami Herald, Newsday, Salon*, and *Entertainment Weekly*.

Yonel Hernández is an award-winning graphic designer, illustrator, and educator. He is co-founder of the graphic design and illustration studio Inés & Bernardo as well as co-founder of the independent publishing company Barco de Piedra. Books he has illustrated include *El espanto, La fábula de los cochinos*, and *Arte y punto*.

Michael Mann is a director, screenwriter, and producer, and a four-time Academy Award nominee. After writing and directing the Emmy-winning television movie *The Jericho Mile*, Mann executive produced the television series *Miami Vice* and *Crime Story*. In 1990, he won an Emmy for the mini-series *Drug Wars: The Camarena Story*, which he co-wrote and executive produced. Mann made his feature-film directorial debut with *Thief*, and he went on to write and direct *Manhunter, The Last of the Mohicans, Heat, The Insider, Ali*, and *Miami Vice*, and to direct *Collateral, Public Enemies*, and *Blackhat*. Mann also has a book imprint with HarperCollins.

Amy Murphy is an associate professor at USC School of Architecture. She holds both BArch and BFA degrees from Rhode Island School of Design, as well as an MFA degree in film production and a Ph.D. in media studies from USC School of Cinematic Arts. In addition to running her own design practice between 1996 and 2008, she held the position of director at Filmforum, Los Angeles' oldest non-profit dedicated to experimental media. Amy designed the LACMA exhibit *Haunted Screens: German Cinema in the 1920s* in partnership with Michael Maltzan Architecture. Her written scholarship focuses on the relationship between media and urban experience. As this book went to print, Amy was completing a manuscript entitled *After the Symphony: Cinematic Representation of the American City 1938-1978*.

Chad Oppenheim is a Miami-based architect whose work has been praised for its ability to transform the prosaic into the poetic. A graduate of Cornell University and a Fellow of the American Institute of Architects, Oppenheim has lectured widely and has taught at several architecture schools, including Harvard University's Graduate School of Design. In 1999, he founded Oppenheim Architecture (Miami, Basel, New York), which has garnered global recognition for large-scale urban architecture, hotels and resorts, private residences, interiors, and furnishings. Oppenheim Architecture has received more than seventy industry awards and distinctions, including the Silver Medal for Design, the highest distinction bestowed by the Miami Chapter of the American Institute of Architects, and the Cooper Hewitt 2018 National Design Award. The firm's work has been featured in numerous media outlets, including the *New York Times* and *Architectural Record*. A monograph on the firm, *Spirit of Place* (Tra Publishing), was published in 2018.